*Jonas Gavel*

## COLOUR

*A study of its Position
in the Art Theory of the
Quattro- & Cinquecento*

*Jonas Gavel*

# *COLOUR*
## *A study of its Position in the Art Theory of the Quattro- & Cinquecento*

**Almqvist & Wiksell International**
Stockholm — Sweden

Cover: illustration
based on Alberti's self-portrait,
by the author

ISBN 91-22-00296-0

Printed in Sweden by
Rosenlundstryckeriet AB
Stockholm 1979

# Contents

5

6

# Acknowledgements

The University of Stockholm has supported this study by a scholarship, grants for its colour-plates, its inclusion in this venerable series and grants for a sojourn in London, where I spent a memorable time among the exquisite collection of clean pictures at the National Gallery and in the library of the Victoria and Albert Museum. This support would not have been granted without the recommendations of Professor Patrik Reuterswärd and Lars-Olof Larsson Ph.D. at the Institute of the History of Art at the University of Stockholm—both have constructively criticized and encouraged me. I would also like to express my great gratitude to Professor Mario Alinei at the University of Utrecht, to Mr. Jacob Hoogvliet at the Royal Thalens, Apeldoorn, to the Consultative in Colour Research at the Scandinavian Colour Institute in Stockholm, Mr. Anders Hård, Pehr Sällström Ph.D. at the Department of Physics at the University of Stockholm, Picture Restorer Jan Boström, Stockholm, Professor Walther Björkman, Thorild Dahlström Ph.D. and Ingrid Waern Ph.D., all in Uppsala, Professors Dag Norberg and Gunnar Berefelt, Stockholm, and Elsie Dickson B.A., Stockholm. Particularly I would like to thank Diana Wormuth Ph.D., Stockholm, who has, with incredible patience, efficiency and enthusiasm corrected and enriched the English of my chaotic manuscript. None of the above-mentioned persons must of course be blamed for the erroneous facts, interpretations or conclusions in my study. My wife, Charlotte, her family and my own family have supported the study and provided help and encouragement, not only when the original manuscript was stolen in January 1977. I dedicate the study to Charlotte and our daughters, Mim and Sanna.

Stockholm in February 1979
J. G.

# Introduction

"It is understandable that the romantic amateur loves the
rust and haze of the varnish, for it has become a veil behind
which he can see whatever he desires." Horsin Déon, *De la
conservation et de la restauration des tableaux,* Paris 1851;
quoted from Ruhemann 1968 p 85.

A painting, it has rightly been said[1], "is the embodiment of a system of
thought in one of its manifestations: and the form the picture takes is deter-
minated by this way of thinking, rather than by a principle of imitation
either of a physical object or of an exemplar or archetype in the mind."
This is, certainly, extremely applicable to pictures of the Italian Renaissance,
a period which, perhaps more than any other, stressed the scientific, theo-
retically regulated character of painting, not only of its imitative function
but of its aesthetic qualities as well. The ambition of this study is to estab-
lish what theories and conventions we may expect to find embodied in the
colour of Italian Renaissance pictures. With one exception, no references
other than those made by Renaissance writers to individual pictures will be
found, but it is understood that the pictures, in order to be adequately
studied as embodiments of these theories and conventions, have to be in
original — or what may be expected to be close to — their original state,
i.e. complete and cleaned by competent restorers. My own, however limited
practice and studies of restoration and conservation of pictures have, once
and for all, convinced me that no adequate judgements of art may be based
on pictures, disfigured by an unintentionally coloured and irregularly affect-
ing layer of dirt and varnish which has lost its original tranparency[2]; con-
sequently, I disagree completely with those[3] who—even on an exceptionally
rare documentary support in isolated cases—hold that painters generally
calculate such a decay and even regard it as the perfection of their paint-
ings. For brevity's sake, I have had to exclude an investigation of colouristic
changes in an oil-painting at the removal of an old, discoloured varnish,
using a spectrophotometer. It confirmed, in objective numerical values, the
observations made by Helmut Ruhemann in his admirable *The Cleaning of
Paintings;* the aspects of this subject are, however, summarized in the last
section of the conclusions.

Colour is, in the studies of art and aesthetics, a surprisingly neglected
subject[4]. The reason, I assume, is threefold: on the one hand, the most
characteristic property of physical light and chemical colour as a pheno-

menon is its changing, accidental and relative nature; on the other hand, the perception of this phenomenon is, from a physiological and psychological point of view, often regarded as highly subjective and impossible to grasp in terms of a general validity. Thirdly, colour as a chromatic and luminous quality is often regarded as an ornamental, essentially superfluous element in a context which is structurally complete without it—a medium, in brief, for other formal and ideational qualities. Science, aiming at objective criteria, tends to avoid such a subject, assigning it to a 'congenial' emotional, poetic domain, neglecting, however, that the formal and ideational qualities in visual art appear and are perceived in terms of light and colour and thus depend on their nature.

I have preferred to use a wide definition of art theory—wherever opinions or theories with relevance to the use of colour in painting have been found, they have, just like contracts, recipes and the like, been used here. As a consequence of the exclusion of individual pictures, no attempts are made to relate theory and practice.

The contents reflect—I hope—the theories, conventions, opinions and aspects of my sources; the disposition, however, is the result of a choice between different possibilities. The one I have chosen, reflect in my opinion most faithfully their internal relation—unavoidable overlaps, the influence of ancient traditions and internal relations between the chapters are indicated in the text. The constant references to Antiquity and those—less frequent—to the Middle Ages, have justified a section—which mainly rests on modern surveys over the vast subjects—where the adequate theories of light and colour, perception, the four elements and formal beauty are presented and discussed. In some cases of more restricted dependence, the ancient sources are discussed at the proper place in the Renaissance section. This—almost exclusively based on my own analyses of the Renaissance sources—is divided in an introducory part, in which the organization of colour, the current terminology and its application are examined, and a part, where the different aspects are referred and discussed. The volume of the chapters is not, of course, proportional to the importance of the aspects discussed.

Due to the stepmotherly treatment of colour by modern art historians, adequate terms for the analysis of the sources are frequently lacking; such terms of a more particular application will be proposed at their proper places, but my general terminology will be presented here.

Terms used in modern colour systems may originally have had quite a different meaning. The modern systems, moreover, are several, but though they sometimes use the same term in different ways, they all claim a general validity. Most of these systems have been developed in order to enable a standardized nomenclature with regard to *individual surface-colour,* observed under similar conditions. Such a nomenclature has, of course, a limited

relevance for the descriptions of paintings, in which the colours are technically applied irregularily and—above all—related to each other; a description of a lyrical, emotional kind of their structural character, internal relations, total effect, relation to the subject and to the artist's personality etc., is in this case indeed more adequate and precise than an enumeration of the data of the individual colours. But well defined and consequently applied terms are a condition for the analysis and description of ancient colour systematization and systems of colour-sequences for illusionistic or aesthetic intentions. For my purposes, the Swedish NCS-system[5] has proved to be useful; it is based on Ewald Hering's[6] assumption that there are six *elementary colours,* which represent a limited number of basic sensations to which everybody may refer: the *unchromatic* (W) white and (S) black, and the *chromatic* (Y) yellow, (R) red, (B) blue and (G) green. To this is added a system for the definition of a particular colour, based on comparision to another; any colour may be sufficiently described in terms of *hue* (Y, YR, R etc.), *saturation* or *chromaticness* (the relative strength with which the particular hue appears), and *lightness.* The lightness-criterion, which is most distinct in the unchromatic white-gray-black sequence, defines the *tonal* character. A necessary divergence from this system is the term *intensity* and its opposite, *indistinction*[7], which I use to denote the particular distinctness with which a colour appears in relation to other colours, often depending on the particular optical properties of the paint, regardless of whether it is chromatic or unchromatic, saturated or unsaturated, light or dark. White, gray and black may, for instance, serve as intense accents in a chromatic context. As a designation of the mixtures, gray, (YR) reddish yellow, (YRRY) yellow-red, "orange", (RY) yellowish red, (RB) bluish red, "purple", (RBBR) red-blue, "violet", (BR) reddish blue, "lilac", (BG) greenish blue, (BGGB) blue-green, "turquoise", (GB) bluish green, (GY) yellowish green, (GYYG) green-yellow, (YG) greenish yellow—of the six elementary colours (Fig.), I use the term *derived colours,* in order to avoid confusion with the term *secondary colours,* which denote mixtures of the *primary colours,* the proper 'building-stones' of the chromatic colours; the unchromatic (W) white and (S) black and the chromatic (Y) yellow, (R) red and (B) blue. (G) Green is, then, considered as a secondary colour, together with gray and the chromatic "orange" and "violet"[8]. In connection with the rainbow, I use the term *spectral colours,* the result of refraction in a lens, conventionally designated as red, orange, yellow, blue, indigo and violet—actually an irrational confusion of elementary, derived and a variant of the derived colours (indigo). Finally, I use the term *local-colour* to designate the object's own colour. When these terms are used or intimated in the sources with another signification or content, I put them in quotation marks. Further terms and qualifications will be introduced in their proper places.

10

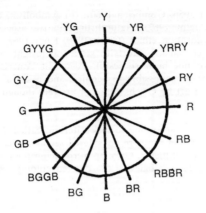

Elementary and derived chromatic colours.

1. Elliot 1958 p 470.
2. The diasastrous effect of traditional varnishes is due to a combination of several factors. When drying, the surface becomes penetrated by fine cracks which scatter light; the tonal contrast and the chromationess are reduced by the white scattered light and diminished transparency. At the same time, the varnish develops a colour of its own, a brownish or yellowish hue, which according to the laws of subtractive mixture in layers of paint, affects the underlaying colours irregularly; those similar to the colour of the unintendidly coloured layer become darker and more saturated due to manifold, inwards reflection, whereas dissimilar colours, in particular blue, are radically altered—blue turns to green. In conclusion, we find no saturated colours, no white, black or blue colours, and we certainly do not see the colours once painted by the artist. An extremely odd, quasi-scientific argument, brought forward in defence of "patina" is that we, due to adaption, would take no notice of the alterations caused by an old varnish; the case would be analogous to that of looking at nature throught sun-glasses, when we, only seconds after having put them on, take no notice of the colouristic changes—we perceive the sky as blue and the grass as green because we expect them to have that colour. The argument is certainly relevant for those who consider art as a faithful, anonymous reflection of reality.
3. In particular C. Brandi, E. Gilson, E. H. Gombrich, L. Hautecoeur, R. Huyghe and O. Kurz.
4. It seems to be impossible to assign the different works which treat colour in connection to art to coherent, unambiguous categories. The following, then, is only an unpretentious designation of the most important categories, with typical representants within brackets: Historic, (a) general studies (Schöne 1954, Barasch 1960); (b) studies of individual theorists and artists (Siebenhüner 1935, Posner 1954); (c) studies of particular aspects: elementarey, humoral and temperamental doctrines, astrology and magic (Klibansky-Panofsky-Saxl 1964, Walker 1958); the aspect of materialized concepts (Chastel 1959, Dresden 1967). Aesthetic aspects (von Allesch 1925). Phenomenal aspects; physics, optics (Evans 1948, 1974). Material aspects; chemistry, techniques (Pope 1949, Ruhemann 1964). Systematic aspects (Katz 1911, Strauss 1972). Perceptual aspects, (a) physiology,

psychology (Arnheim 1956, Gombrich 1960); (b) symbolism, expressivness (Kandinsky 1912, Leijonhielm 1967). Naturalistic-imitative aspects (Edgerton 1969, Shearman 1954). Restoration ethics (Clark 1938, Kurz 1962). Concerning works not consulted, I regret that my efforts to get a full insight in the content of M. Rzepinska 1970 have not been succesful. A recent American dissertation on colour in art has not been possible to acquire, and a survey of the Italian Renaissance literature on art by Olschki has not arrived, though ordered years ago.

5. Cf. Hård 1975.
6. Hering 1878.
7. Individual colours are, according to this criterion, called *distinct* and *indistict*.
8. Green, orange and violet are here considered secondary colours, laying in the middle between their constituents. Only by introducing the odd concept "tertiary colours" can one express analogies to the derived colours like purple, lilac and turquoise.

# PART ONE. BACKGROUND

## Chapter I. Light and Colour

The general theories of light and colour in Greek and Roman Antiquity may be separated in two rather different traditions—one Platonic, meta-phoric-symbolic, in which the physical reality of light is in no way denied, but less essential than the symbolic interpretation of light and colour—and one Aristotelian tradition, based on observations of the physical and che-mical propertiies of light and colour. Colour is generally considered as a form of light; but in the Aristotelian tradition it is considered as the visual result both of a general confrontation of light with material substances and of heat energy, acting upon the chemical composition and unveiling the elementary properties[1] of individual physical bodies.

In the Early Christian and Middle Ages these two traditions were partly brought into a synthesis, which is still noticeable in the Italian Renaissance, which, however, also draws directly on the sources of Antiquity. The im-portance of the general old theories of light and colour for Italian Renais-sance art theory was of course tremendous, but concerns most of all the systematization of surface-colours, the illusionistic, aesthetic and symbolic use of colour.

### Platonic Tradition

Plato's aspect of light is dualistic; on the one hand he recognized the sense-perceived light, emitted by the sun or by fire and revealing the colours of corporeal things; on the other he made this light analogous to an invisible, spiritual emanence from the Supreme Idea[2], whose primary function was—in accordance with Pythagorean tradition—to demonstrate a mathematically defined order, analogous with the Idea. This emittance, directed towards the human intellect, was considered prior to the physical light, to which he devoted limited interest, proportional to his low opinion of the physical world as a weak reflection of the world of Ideas[3]. Plotin differentiated strictly between mentally and sensually perceived light, but thought of both as primarily having a function of order, clarifying limited and hierarchially related units in a dark chaos[4]. By emphasizing the function of light as a transmitter of divine influence he initiated the Medival synthesis of Platonic light symbolism and Aristotelian physics and natural science. Under Neo-Platonic influence Augustine associated spiritual light and corporeal form;

the effect of the former was revealed by the clarity (*splendor, claritas*) with which mathematically defined related quantities were perceived. Thus he could adhere to the 'classical' definition of formal beauty (Chap. IV below), defined as *concinnitas*—harmonic proportions between the parts and their colours[5]. The union of the idea of light as a principle of order and the positive interest in physical light, considered analogous to the supersensual, was also expressed by Ps-Dionysius[6] (ca 500 A.D.) and by his transmitter, Johannes Scotus Eriugena (florid ca 840) as a hierarchy of material beings, among which the relative strength of light and colour was a sign and measure of divine influence; figure, proportion and colour determined their positions in the hierarchy[7].

## Aristotelian Tradition

In the works of Aristotle light is almost exclusively treated in connection to colour. His colour theory—if this term can at all be used—which was the main source to Italian Renaissance art theory, is however a vast subject, difficult to grasp; apart from the general difficulties caused by the frequently broad meaning of the Greek colour names, his views are manifold and sometimes contradictory and the texts preserved—of which the chronology is under discussion—are sometimes corrupt or incomplete. In modern texts, an Aristotelian colour theory is often either presented as expressed in a single work, or excerpts from different works are combined as to form a coherent theory, thus overlooking, among others, his contradictory theories of vision, which are of the greatest importance for the theory of perceived colours[8]. To make a careful analysis of his theories of light and colour is impossible in this limited study; I will restrict myself to a short summary and discussion of the views presented mainly in *Meteorologica, De anima* and *De sensu;* to these should, however, be added *De coloribus,* ascribed to Theophrastus, but considered a genuine work of Aristotle during the studied period.

The four aspects of colour which may be identified in these works may be called (A) physical, (B) physiological, (C) local—chemical and (D) conceptual colour.

(A) The perceived colour is defined as an immaterial potentiality in a transparent medium, actualized by light; "Whatever is visible is colour."[9] It may either be caused by reflection of light from diluted substances in unlimited bodies, particularly from humidity in the air[10], or originate in limited bodies, viewed through the medium, i.e. the air. Since reflection affects light, the perceived colours are in both cases changed by distance[11]. The local colour of a limited body may also be changed by reflections from the surroundings, as in the case of reflection on a cloud from water[12].

(B) The physiological colours are due to the properties of the sense organ and caused by contrast[13]. What is called the 'weakness of sight'[14] is only apparently physiological; in fact, perception is here intermingled with physical theory in a confusing manner. The rainbow is said to be a reflection[15] in the humid air from a halso around the sun, consisting of an inner, bright white ring and an outer, apparently[16] black ring—the impression of blackness is caused by the strong light. The strongest reflection in the outer band of the rainbow, nearest the light source, is perceived as red, since white light through a dark medium or against a dark background appears red. Since light diminishes with distance, the more distant[17] and thus weaker reflections from the middle band appear green, and the most distant and thus weakest reflections from the inner band appear blue[18]. The yellow colour, on the other hand, between red and green, is explained as a 'secondary', physiological effect, caused by contrast[19]; only red, green and blue are considered 'primary' colours. Aristotle's use of the term "reflection" is ambiguous[20], particularly when connected to his visual theory; when he— in the chapter on the rainbow—says that *sight* is reflected, he evidently means that what is *seen*—i.e. the coloured light in the small mirrors formed by water in the air—is a reflection of the white light of the sun, which due to a successive decrease of illumination undergoes a consequent darkening with distance, ending in complete darkness; the *reflected light* is weakened, not sight. Darkness may be thought of as a lack of activity and cause, and the chromatic "rainbow-colours" its effect.

(C) Local-chemical colour, located at the limit of determinately bounded bodies[21], is defined as the "envelope" which separates and prevents the mutual penetration of the body's content and the surrounding void[22]. It is caused by either chemical change of the elementary composition under the influence of heat[23], or chemical union through juxtaposition of two different pigments[24], or by 'optical' blending through superposition of a layer (glaze) of transparent colour over another layer[25]; the result in the latter cases is said to be quite different from each of the two components, which are related to each other in certain proportions, equivalent to the tones of the musical tone-scale[26]. The confusing fact that Aristotle says that the two components are white and black will be analyzed below under (D).

(D). Conceptual colour forms a bridge which Aristotle tries to stretch over the gorge between the delicate, purely visual phenomenon of (A) physical—(B) physiological colour and the palpable, down-to-earth character of (C) material, chemically defined surface-colour (local colour). Out of the dynamic physical and physiological context (*Meteorologica*) where the confrontation of light and humidity in the medium causes red, one's vision yellow, light again green and blue, and the privation of light eliminates its progression in darkness, Aristotle in *De sensu* (442 a) discusses the perceptual qualities of colour and flavour; the latter are, he says, just like the

chromatic colours, the result of a certain proportion of two contraries. Through the following analogy between white-sweet and black-saline, light is transformed to white and darkness to black. The kinds of flavours, it is stated, are almost the same as those of the colours. An ambiguity is created by the statement that there are seven kinds of each, the colours according to two alternatives of the eight actually mentioned: either white, yellow, red, violet, green, blue and gray/black or white/yellow, red, violet, green, blue, gray and black; i.e. either yellow is considered a form of white or gray a form of black. The first alternative is said to be preferable. (COLOUR PLATE I.) The main principle of this scale is evidently the relative lightness[27] and not the hue; with green and blue in opposite order it would have formed a scale based on the latter criterion, which seems to have been used in *Meteorologica*, where yellow was placed between red and green, followed by blue. The main difficulty, however, consists in grasping how Aristotle mixed two completely different aspects of colour in the analogy between flavours and colours; the strange deformation of the physical context becomes apparent in the following sentence: "And just as black is an absence of white in the transparent medium, so brackish and bitter is an absence of sweet in moist food." According to the ambigous explanation[28] offered by Aristotle (*De sensu* 439 a—b), transparency is not a quality exclusivly belonging to unlimited bodies like air and water, but belongs also to limited bodies; the colour at the limit of such a body, then, is regarded as the result of a 'defectively ' proportioned transparency within it, whereas perfect transparency is regarded as the result of a 'perfect' proportion. However utopian the assumption that white and black are the constituents of the chromatic colours may seem, it first of all offered a basis for a coherent theory, involving the systematization, evaluation and—possibly—even perception[29] of colour, founded on Pythagorean number-symbolism; secondly, a certain truth of the theory could be testified through experiments with pigments, which by then did not possess any high degree of chemical and optical purity; even today, the mixture or superposition of certain white and black pigments may—as also Plato noted—result in a bluish shade[30].

To sum up what might be called Aristotle's colour theory is extremely difficult, even apart from the reasons indicated in the beginning and for the moment neglecting the works of Theophrastus. It might be said, at least, that light with its 'concretion' white and darkness with its 'concretion' black are considered the two constituents—and thus separated from—the chromatic colours.

Theophrastus presented in *De coloribus* a remarkably advanced, coherent theory of perceived colour, based on the assumption that it is the result of different kinds of light sources, the influence of the medium and reflections from the surroundings[31]. Most of this work, however, deals with (C)— changes caused by heat in the vegetative and animal world[32]. He identifies

three 'primary' colours: (I) white, (II) yellow heat and (III) blackness. White might in this context be called 'subject-colour', yellow heat 'cause-colour', and blackness 'effect-colour'. Blackness represents in fact a wide range of colours—yellow causes white to blacken into different 'secondary' colours. According to the main principle, white represents in nature, among plants as well as animals, both a humid, unburnt or underfed, and a dry, combusted state, whereas blackness is a sign of active combustion. Though Theophrastus describes numerous examples of an organic, dynamic process and does not intend to systematize the phenomenon of colour as such, a typical cycle under the influence of heat yellow in the plant world may be reconstructed: white (+black=) green (+black=) red (+black=) blue (+black=) black (+black=) white[33]. In the animal world, white is also a sign of unburnt humidity of the puerile state, darkness or redness of active combustion of the virile state, and whiteness again a sign of finished combustion and lack of greedy in the senile state. It may be concluded, that in this accumulative system, the chromatic colours are regarded—just as by Aristotle—as a darkening of white. In the *On the Causes of Plants,* Theophrastus repeats Aristotle's (*De sensu* 442 a) analogy with flavours; after naming eight of the latter (VI.1.2), he later (VI.4.1.) says that they are seven, like the colours, since gray is regarded a form of black; he thus supports the first alternative of Aristotle: white, yellow, red, violet, green, blue, gray/black. (Colour plate I.)

Neither Plato, Aristotle nor Theophrastus paid any great interest in the propagation of light. However—since they all talk about sight or light rays and Aristotle and Theophrastus mention reflection—it is clear that they adhered to the rectilinear description which derived from Pythagoras.

### The Medieval Synthesis of the Platonic and Aristotelian Traditions

The Platonic Influence, transmitted by Augustine among others, is particularly noticeable in the work of Robert Grosseteste, who initiated the study of optics among the Franciscans in Oxford in the thirteenth century. Aristotle was, however, the main source for the Dominicans Albert the Great and Thomas Aquinas and his influence is also noticeable in Grosseteste, but most of all in his 'perspectivist' followers Erasmus Vitello[34] and the Oxonians Roger Bacon[35] († 1292) and John Pechman[36] († ca 1294). The most direct influence on the latter derived from the Arab Alhazen[37] († 1039), who rationally analyzed the nature of light, differentiating, among others, between natural and artificial light sources, primary and secondary emitted light and between direct, reflected and refracted light rays, emanating in all directions from the source.

The fusion of the Neo-Platonic light philosophy and Aristotelian natural

science in Medieval theology is often called "light metaphysics[38]." As Lindberg[39]—whom I cite below—has shown, that term is rather vague and fits only to one, and one of very limited influence, of the four kinds of metaphors used by Grosseteste and his followers: (2) the regarding of "light as the first corporeal form and the material world as the product of the self-propagation of a primeval point of light." As to the others—(1) "the epistemology of light, in which the process of acquiring knowledge of unchanging Platonic form is considered analogous to corporeal vision through the eye", (3) "the etiology or physics of light, according to which all causation in the material world operates on the analogy of the radiation of light" and (4) "the theology of light, which employs light metaphors to elucidate theological truths"—the pedagogic character is evident; the analogies motivated and justified the study of physical light. The analogies were consciously used as such, i.e. only in a wider sense was physical light regarded as something else than a certain energy emitted by a physical light source[40]. No important contributions to the knowledge of physical light were made in the optical studies of the Middle Ages[41], and as a whole the genuine medieval influence on Italian Renaissance art theory was rather limited[42]. Finally, since the art of the Middle Ages is such a striking example of the materialization of a theological concept, it is worth noticing, that the light metaphors of the fourth kind above included rather trivial analogies between the infusion of divine grace in men of varying goodness and the infusion of physical light in different kinds of substances[43]. The medieval, Christian use of colours and materials, some of which reflect and thus 'repel' the divine influence, and some of which—like precious stones and glass— through inwards reflection, transmission or scattering, receive and become 'saturated' by light and grace[44], shows that these analogies had relevance to the artistic practice: Theophilus'[45] justification for his instruction for the making of polychrome glass-windows may serve as an example: ". . . I have greatly laboured to inform myself, by all methods, what invention of art and variety of colour may beautify a structure and not repel the light of day and the rays of sun. Applying myself to this exercise, I comprise the nature of glass . . ."

1. Cf. below chap. III.
2. *Meno* 75 b—76 a; Gomperz 1922— II p 289; Guthrie 1971— IV p 248.
3. *Rep.* VI 508 d—509 a.
4. *Ennead.* I.6.3.; Panofsky (1924) 1968 pp 27 ff; Gilbert-Kuhn (1939) 1972 pp 114, 142.
5. *Confessiones* X.34.; *De civ. Dei* XXII.19; *Epist.* III.4; Baeumker 1908 pp 351 ff; Panofsky *op.cit.* pp 35 f and n 2; Ciardi 1973— I xxxc n 9; cf. Elliot 1958 p 457.
6. *Corpus Areopagiticum; De divisione nominibus; De coelesti hierarchia;* Panof-

sky *loc.cit; ibidem* 1955 pp 126 ff; Barasch 1960 pp 224 ff; Pochat 1973 pp 94, 108, 156 f.

7. *Expositiones Ioannis Scoti super ierarchia coelesti S. Dionysii.* Cf. Gilson 1955 pp 120, 341 f.

8. For instance Düring 1966 pp 393, 563.

9. *De anima* 418 a, 419 a.

10. *Meteor.* 371 b—378 a.

11. *De sensu* 439 b.

12. *Meteor.* 372 a.

13. *idem.* 373 a, 375 a.

14. *idem.* 372 a. Cf. below chap. II.

15. With reference to the primary rainbow. The reversed order in the secondary bow was explained by A. as reflection. The correct explanation—double refraction—was found by the monk Theodric (*De radialibus impressionibus*) in the fourteenth century; Hoppe 1926 p 23 and n 28.

16. It is rather strange that the blackness, which is said to be a purely physiological effect caused by contrast, can cause physical changes of light.

17. The distance between the light source and the observed colour; the observer's position is not specified.

18. Generally translated "violet". Cf. n 28 below.

19. This may be regarded an early observation of the complementary relation between red and green: Cf. Düring *op.cit.* p 393.

20. In fact he admits in *De sensu* (438 a) that "in general the whole theory of things mirrored and reflected is so far not clear."

21. *De sensu* 439 a.

22. Cf. *Categories* VI. 5 a; *Phys.* IV. 203 a, 209 b, 211 a.

23. *De gen. et corr., passim; De mundo* 396 b; *De part. anim.* 646 a; *Metoeor.,* Book IV; Warry 1962 p 103; Edgerton 1969 p 118.

24. *De sensu* 439 b—440 a.

25. *idem.* 440 a.

26. Cf. below chap. IV. On synaesthesis, see Wellek 1931 and 1935.

27. The associations to light and darkness seem to be based on the potential qualities of the colours; in spite of the general association between blue—the potentially darkest colour—and black, A. in *De gen. anim.* (779 a) called blue eyes *glavkoi,* which apart from "light, brilliant" also means blue. Cf. Düring *op.cit.* p 393, who claims that the Greeks did not have any particular word for blue.

28. According to this explanation, as far as I understand, any impression of the areas around the observer would be like the bands of the rainbow. The odd transformation of light and darkness to white and black is much discussed; Kucharski 1954 p 359 writes: "A la lumière et à l'obscurité dans les 'transparents' proprement dits, répondent, dans les corps composés, le blanc et le noir, la quantité du premier devant être, semble-t-il, proportionelle à celle de diaphane qu'ils renferment, c'est-à-dire à la quantité d'air et d'eau qui s'y trouve contenue." This interpretation takes the medium and distance into consideration; the more air and water contained in the medium between an object and the observer, the more white, or rather the closer to white within the 'white region' of the colour scale (yellow, red), will the colour of the object appear. Consequently, nearness would change the appearance towards black (green, blue). This interpretation is—if I have rendered it properly—not correct; only the first conclusion, that lightness and darkness in the medium correspond to whiteness and blackness at the surface of limited bodies may be drawn from the text.

29. Cf. below chap. II, post-ocular perception.
30. In the same way a kind of olive green may be obtained by mixing certain proportions of black and yellow pigments.
31. *De col.* 792 b—794 a: *lumine et per quae apparet lumen, ceu aqua et aere, et tertio subiectis coloribus, a quibus contingit lumen refrangi.*
32. Theophrastus identifies so-called structure-colour, caused by diffraction and not by any pigment; *De col.* 792 b.
33. It is also said *en passant* that yellow and black give green. Cf. above note 30.
34. *Perspectiva;* in Risnerus 1572; Baeumker 1908 p 131; Barasch 1960 p 229; Ciardi 1973— I p 204.
35. *Opus maius;* Hoppe 1926 p 20; Huyghe 1962 p 240; Pedretti 1964 pp 20, 41 note 23.
36. *Perspectiva communis,* published by Fazio Cardano, Milan 1482 and by Luca Gaurico, Venice 1504; Schlosser 1924 pp 159, 206; Zubov 1968 pp 102, 139.
37. Abu 'Ali al-Hasan ibn al-Hasan ibn al-Haytham.
38. Coined by Baeumker 1908.
39. 1975 p 95.
40. Particularly evident in an interesting review of four older theories of light by Thomas Aquinas (*In libros de anima expositio;* in Bourke 1960 pp 83 ff): the Aristotelian theory is criticized as materialistic: "statements on the movements of reflection of light are metaphorical"; Plotin's concept of the spiritual nature of light is also regarded as a metaphor, concerning intellectual functions. A third, unindentified opinion (Alhazen?) that light is colour, is refuted; so is the fourth, the light is a material effluence (the Atomistic theory): Thomas himself defines light as an "active quality".
41. The value of the medieval optics and light philosophy consists in the transmission of the observations and distinctions made by Ptolemy, Alhazen and others.
42. Restricted to the Neo-Platonic circles.
43. Bacon in *Opus maius* pt. 4; Lindberg *op.cit.* p 99 and note 74; good men receive grace as by a perpendicular ray; imperfect as by a refracted ray and sinners repel the grace as a mirror reflects light.
44. That the exposure to reflected light was thought to offer "spiritual illumination" (Panofsky 1955 p 129; Barasch 1960 p 225) is one soloution of this problem.
45. Tenth century? *Diversarum Artium Scedula;* in Holt (1947) 1957 I pp 4 f.

# Chapter II. Perception

The ambition in this chapter is in no way to make a detailed analysis of the origin and development of visual theories until the Renaissance; with, above all, Lindberg's eminent survey[1] of this vast subject as a basis, only the relevant aspects of direct and primary importance for the theories in the period studied will be taken into consideration. In some cases, however, both the nature of light and colour and the causes of colour are explained through a visual theory. The theories of ocular and post-ocular perception has a particular importance for the theories of perspective and

of the materialization of inner concepts in the art theory of the Italian Renaissance.

## Ocular Perception

Three different Greek theories, transferred or developed by Arabian and European scholars during the Middle Ages, were the basis for the Renaissance theories of ocular perception. With few exceptions, they have in common the idea of a geometric, linear progression of rays; the differ, however, regarding the opinions of the nature and direction of the rays. The purely geometrical aspect, dominating (1) the emission theory, neglects the physiological and psychological implications of vision, which are taken in account in (3) the immission theory[2]. (2) The emission-immission theory shares with the pure emission theory the emphasis on the *active* character of vision, an aspect which generally complicates the definite location of the different opinions in one of the three theories.

(1) The emission theory is based on the assumption that the eye becomes seeing by sending forth visual power, generally in the form of visual rays. The theory emanates from the successors of Pythagoras, and was later advocated by the Stoics[4]; Cicero, among others, thought that optical *pneuma,* a mixture of fire and air, emanates from the mind through the eyes and activates or 'excites' the air, which becomes an extension of the mind and 'sees' together with us[5]. The condition was, however, that the sun rarefied the air; its resistance was thought to reduce the strength of vision and make it impossible in darkness[6]. Galen († ca 199 A.D.) shared this theory[7], which was transferred to medieval Europe by the Arab Hunain ibn Isahq († 877), in the West known as Johannitus[8].

The geometric model of formal optics was defined by Euclid[9], whose influential but partly corrupt *Optica* is based on seven theorems: (1) Rectilinear, indefinitely diverging rays proceed from the eyes; (2) The visual field is a cone with its vertex at the eye and its base at the thing seen; (3) Only the things upon which the rays fall are seen; (4) Things seen under a larger angle at the eye appear larger, under a smaller angle, smaller; (5) Things seen by higher visual rays appear higher, by lower, lower; (6) Things seen by rays to the right appear to the right, by rays to the left, left; (7) Things seen under more angles are seen more clearly.

The most striking feature of this model is its static nature; within a fixed visual field only the points upon which the rays fall are visible—at a great distance an object disappears because it ends up between the rays. The successors of Euclid, Hipparchus († ca 125 B.C.), Hero of Alexandria[10] (florid ca 62 A.D.) and Claudius Ptolemaeus[11] (florid ca 127—148 A.D.) also adhered to the emission theory. The latter advocates, against Euclid, in his

influential but fragmentarily preserved and corruptly translated *Optica,* that the conical visual field is homogenously filled with rays and consists of a kind of ether, which is modified by colours, through which other properties of the object observed, such as figure, are perceived[12]. Like Plato, the Stoics and Galen he thought that colour is not perceived without the assistance of exterior light; vision comes into being through visual radiation, colour and exterior light. His theory that the perpendicular ray is stronger than the lateral because it is shorter[13] was of great importance; within a fixed, homogenously filled visual field, the center is, then, perceived more distinctly than the sides. The Arab Al-Kindi[14] († ca 866), influential in Islam and the West, shared Ptolemy's theory of a homogenously filled visual field, but explained the varying visual distinctness by the assumption that the rays which were emitted from the whole surface of the *cornea,* are more concentrated in the pupil than around it. He gave a certain relevance to the emission theory by emphasizing the active character of vision; we locate and consciously register what we see[15]. In spite of the great influence of Euclid, Ptolemy and Al-Kindi, and in spite of Augustine's advocacy of the emission theory, its adherence was very limited in the West.

(2) The emission-immission theory postulates a confluence of energy emitted from the eyes and coming to them. Possibly it emerged from Empedocles[16] († ca 433 B.C.), but had its most influential adherent in Plato[17], whose visual theory, in spite of his criticism of Democritus, explicitly departs from his Atomistic immission theory. He shared Empedocles' similar theory, that the colours enter the eye in the form of differently shaped material, elementary particles through 'pores' of the same shape, but emphasized the condition of cooperating exterior light[18] and thought that the eye emits a similar kind of 'fire'. When the particles of the emitted rays are of the same size as the intromitted, a sensation of transparency is caused; otherwise different colours are perceived, or rather, originate in the eyes. In accordance with Democritus, Plato assumed four 'primary' colours[19]: 'shining' (in Democritus' version yellow), white (small fire-particles), red (medium-sized particles) and the 'passive' black (large, irregular water-particles). Plato said he was unable to specify the exact proportions of the components of the individual colours, but gave an account of these components: white+black=gray, but also blue; 'shining'+red+white=yellow; red+blue (white+black)=purple; yellow ('shining'+red+white)+gray (white+black)=brown; brown (yellow+gray)+black=green. An addition of white also creates lighter variants of yellow and blue. In all, it is remarkable that several of the examples reveal a practical experience with pigments.

A complex problem, which can only be intimated here, is how the notion of sight as an activity coincides with the theory that the light emitted from the eyes, according to Neo-Platonic tradition, is a manifestation of the

divine character of man. The last interpretation is exemplified by Basil[20] († ca 379), who fused Empedocles' doctrine of sympathy with Neo-Platonic light symbolism and Platonic visual theory; like Augustine[21], he ascribed to the confluence of interior and exterior light a spiritual character. Robert Grosseteste[22] was one of the few Christian 'perspectivists' of the thirteenth century who adhered to the Platonic visual theory; he used, however, the Aristotelian denomination *species* for the images, perceived through the fusion of emitted visual rays and immitted exterior light rays.

An important tradition of quite another nature was incorporated into the emission-immission theory: magic, popular anecdotes about seeing in the dark, transferial of power (fascination) and infections, etc. Derived from Pliny the Elder, Solinus[23] (florid third century?) and others, they found their ways into the works of William of Conches[24] († ca 1154), Thomas Aquinas[25] and others.

(3) The immission theory departs from the Atomists. Leucippus[26], the mythical teacher of Democritus, Democritus[27] († ca 400 B.C.) and Epicurus[28] († ca 270 B.C.) advocated the theory of material effluences, flowing from the objects observed to the eye, a theory which was dressed in poetry by Lucretius († ca 55 B.C.), who called the effluences *simulacra*[29] and said that over a distance their outlines are dispersed due to friction against the air[30]. He also thought that the excess of fire-atoms in strong light burn the eye and cause pain. The colour was thought of as one of several properties of an object, but the one through which knowledge of the other properties is gained. Democritus held, in contrast to Empedocles, that white, black, yellow and red are a kind of atomic, material 'primary' colours[31], the blending of which causes other colours.

The contradictory character of Aristotle's theory of vision is due to development of his thoughts. In the *Meteorologica*—often referred to as a late work[32]—he advocates emission, a theory which, however, is quite the reverse to his general notion of all sense-perception as an exterior provocation of the sense-organ. In *De sensu*[33] he completely denies the probability of the emission theory and adheres there, as in other works, to the immission theory, based on the principle that vision presupposes both a potentially coloured object, light and a potentially transparent medium; the potential qualities in the object (colour) and the medium (transparency) are actualized by the presence of light. Colour, then, has fundamentally a dualistic phenomenal nature[34]; it is the limit of determinated material bodies, and the immaterial impressions of such bodies flowing through the transparent medium. That which is visible is colour, i.e. it is in terms of colour that we perceive all noticeable qualities of the observed object. Generally, then, he presupposed that neither the medium nor the eye themselves share any of the qualities with that which passes through them[35]; when the eye sees, it becomes coloured like the observed object[36], and since its interior

is transparent, like the air, a continuos medium between the object and *sensus communis* is achieved[37].

Aristotle did not, as far as I know, consider the geometric construction of the visual field. In Ps-Aristotle's *Problemata,* however, the assumptions that the central rays in the conical visual field are the strongest, and that the strength successivly decreases towards the circumference are used to explain why distant objects tend to look round; distance is, according to this construction of the visual field[38], said to cause the change of a square body to a polygonal and finally to a circle[39].

Aristotle's theory that the pleasant colours consist of harmonic proportions of white and black is fused with the Atomists' theory that excesses hurt; the eye is irritated by the extremes white and black but stimulated and recreated by yellow and green[40].

Aristotle's later adherence to the immission theory was the point of departure for the rejection of the emission theory by several Arabic scholars[41]: al-Razi[42] († ca 923), al-Farabi († ca 950), Avicenna († 1037), Averroës († 1198) and Alhazen. Of these, the latter two were the most influential; Averroës, who otherwise generally rendered Aristotle faithfully, corrected him by assuming that the *sensus communis* was located in the brain[43]. Alhazen was, however, most influential[44]. He regarded rectilinear rays as a geometric abstraction, but maintained that if they are to be used, it must be assumed (with al-Kindi) that each point on the surface of a body radiates in all directions: "form each point of a coloured body, illuminated by any light, issue light and colour along every straight line that can be drawn from that point[45]." In order to explain how confusion does not result in the eye from the mass of differently directed rays, he assumed that only the unrefracted, perpendicular rays are active in the formation of images, since they are not weakened by refraction[46]. However, realizing that he had not sufficiently explained why the oblique rays, though feeble, do not cooperate in the formation of images in a confusing way, he later added the absurd theory that they do, though 'corrected' by refraction and thus perceived as actually perpendicular[47]. Aside from these ambiguities, he argued that the variation of strength in the visual field may be consciously controlled: the strongest perpendicular, unrefracted central ray[48], the image of which passes directly into the optical nerve, constitutes, when directed at the observed object, a means for certification, called *intuitio,* of qualities which are not clearly perceptible in the general view, *aspectus*[49]. He also noted, however, that distance has a generally dissolving effect. Like Ptolemy, the Atomists and Aristotle, he stated that it is through impressions of colour—called *formae*[50]—that we perceive a number—twenty-two to be precise[51]—of formal qualities in the observed object; light, colour, figure, size, position, continuity, etc[52]. As an argument for immission he not only stated that strong light causes pain[53], but that all visual perception is a kind of exter-

nally provoked pain[54]. After-images, which mean that strong colours 'leave' an impression in the eye, also support immission[55].

This theory dominated among the medieval, Christian authors who discussed visual theory; it agrees, in point of principle, with the concept of light as a divine effluence. Confusion is, however, caused by a general ambition to conciliate diverging opinions, and many limited discussions of particular problems of detail reveal a lack of innovation[56]. Albert the Great and Thomas Aquinas both dismissed as well the pure as the combined emission theories and adopted, in commentaries and other works, Aristotle's immission theory. The dissolving effect of the medium on the immaterial *similtudinis* is described by Thomas: an undecided kind of body, observed from a great distance appears, somewhat nearer the observer as an animal, nearer still as a human being and from a relative short distance, finally, as a Socrates or a Plato[57]. Roger Bacon aimed at a synthesis of several Greek, Roman and Arabic theories[58]; he repeats Alhazen's theory that the perpendicular ray, being shorter, eliminates the effect of the refracted rays[59], and Alhazen's list of twenty-two visible intentions. On the other hand, he agrees with Grosseteste, that the eye emits a power, which in the form of *species* bounds back to the eye; "seeing is nothing other than the visual power coming to the thing seen[60]." The active influence "ennobles" the observed object, which sends back its image to the eye[61]. Bacon stresses the immaterial character[62] of the *species* and uses the synonyms *lumen, idolum, phantasma, simulacrum, forma, intentio, similtudo, umbra, virtus, impressio* and *passio*[63]. Alhazen was the most important source also for John Pecham[64] and Erasmus Vitello[65], who both, at least indirectly[66], were in touch with Bacon, whose synthesis—however superficial—was accepted by Pecham. Vitello, on the other hand, explicitly adhered to immission[67]. The importance of Bacon, Vitello and, in particular, of Pecham, is due to their intermediation of Alhazen's theories[68], above all that the *species* of light and colour are the medium through which all visible intentions—shape, size, number, motion etc.—are perceived[69]. To the little investigated optical and perceptual theories of the theological writers in the later Middle Ages, William of Ockham († ca 1349) contributed in a significant but not very influential way; he denied the existence of *species* for 'economical' reasons —since the object observed is perceived, there is no reason to assume any intermediator[70].

## Perception of Distant Objects

The very existence of the great number of different explanations to the changes caused by distance, proves that the phenomenon was observed. In my opinion, it is extremely improbable that a fundamental natural phenom-

enon, such as the successive dissolving of the image of an object which is viewed in open-air daylight, remained unobserved for more than a thousand years of documented human investigation of nature. Making an exception from the principle that no paintings are used in this study to illustrate the theories of light and colour, I must, in this case, refer to the wellknown imaginary landscapes with Odysseus at the Laistrygons, Roman wall-paintings from a building in the Esquilin, copies of Greek paintings from the first century B.C. (the Vatican). Distance is here, no doubt, represented with a successive dissolving of the local colour into a whitish vapour[71]. In such scenes, the condition for vision, expressed by the Stoics, Galen, Empedocles, Plato and Aristotle, that the sun illuminates the medium, is fulfilled. The Euclidean construction of the visual field apparently neither accounts for the physiology of the eye, the psychology of perception nor the properties of the medium; it contains, however, the notion that "things seen under more angles are seen more clearly[72]." The lack of visual distinctness, then, is proportional to distance. Ptolemy's theory that the perpendicular ray is strongest because it is shortest implicates, too, that the rays are enfeebled by distance[73]. But the assumption, also made by Alhazen, that distance, reflection and refraction decrease the strength of the rays does not—as far as I understand—rest on purely geometrical considerations; it involves the dynamic or mechanical aspect of a loss of energy due to a *resistance* of some sort in the medium, i.e. the illuminated air.

In spite of Aristotle's definition of light as the actuality of the colourless transparency[74], he admitted in *De sensu* (438 b) that air indeed has a colour of its own, which causes a colouristic change of an observed body. Theophrastus was more explicit about the nature of this colour: "The air, when observed at a short distance, does not seem to have any colour; since it is rare it is conquered and broken through by the rays, which are more powerful and shine through it. But when air of some depth is observed, it appears blue, if it is still rare enough. Because where light decreases, darkness takes hold of the air and makes it appear blue. But when it is dense, air becomes, like water, white[75]."

The appearance of illuminated air at a distance depends, then, on its nature: (1) if the air is rare (dry), the area which is distant from the source of light appears blue, because the lack of light enfeebles the rays[76]; (2) if the air is dense (humid), the distant area appears white, the colour of the element water, which over a distance exercises a resistance stronger than the propagated power of the rays.

Aristotle defined the objects of the five senses and differentiated between the 'common' sensibles like shape, size, motion and number[77], which can be perceived by more than one sense, but in fact are all perceived by vision[78], and the 'particular' sensibles, perceived by one sense only. Since colour is said to be the proper object of sight, and since it is in terms of

colour that we perceive the other qualities—the 'common' sensibles—it seems to follow, that if colour is changed, so are the other qualities. At a distance, then, a colouristic change, due to the resistance of the medium, change the appearance of shape, size, etc.

If light—which according to the prevailing opinions, is a condition for visibility—does not illuminate the air, quite a different situation arises; darkness constitutes another kind of resistence to, or rather a lack of vehicle for, light. In terms of contrast, the effect of distance in darkness is—however different in appearance—the same as in illuminated, humid air; whiteness, particularly in the form of mist, means the same total absence of cognitive, perceptual stimulus as does blackness and, however less frequent, any monochrome totality. This fact draws attention to the double signification of the Latin *obscurus* and *fuscus;* like *latens* they mean both "dark" and "concealed, obscure". These words and their opposites, *lucidus* and *clarus* play a fundamental role for the interpretation of the sources from Antiquity, relevant for the theories of colouristic rendering of distance. Edgerton[79] has drawn attention to their occurrence in some sources—Pliny and Ptolemy—which may have influenced the Renaissance theories of perspective. They are both said to support the idea that distance is to be rendered with dark colours. The example of Pliny[80] does not, however, refers to the rendering of distance, but of volume; when depicting a black bull, Pausias did not do like the other painters, who used light colours for the progressing parts of the body and black for those receding. In Ptolemy's *Optica*[81], on the other hand, the effect of distance is indeed described: he advices the painter to use *colorem . . . lucidum* for the parts of the area depicted intended to look nearer, and *colorem . . . magis latentem et obscuriorem* for the parts intended to look more distant. In his *Cosmographia*[82], he again advocates that the distant parts of the landscape are to be depicted in *oscuriores colores* than the parts which distinctly appear to the eyes. I do not, like Edgerton, find it self-evident that Ptolemy refers to the lightness of the colours; only a careful analysis of the subject, which I have not been able to do[83], can establish whether he did refer to the lightness or to the saturation and intensity of the colours, i.e. that *lucidus* means distinct or saturated, and *latens,* just as *obscurus,* means indistinct or unsaturated colours. It will be remembered, that saturation was in general thought to be connected to dark colours[84]. Whatever Ptolemy meant, the possibility that he was later interpreted in this way must be acknowledged.

## The Eye

The dominating conception of the inner anatomy of the eye was, roughly speaking, until the end of the Renaissance, that of Galen[85]. The discussion

of the first phase of post-ocular perception—from the eye to the *ultimum sentiens*—deals mainly with the projective problem of maintaning the original order of and relation between the image-forming rays as they pass into and between the humours of different density and shape; in spite of later experiments with the *camera obscura*, little attention was paid to the problem of reduced lightness and distinctness within the eye. With the exceptions of the Atomists' mechanical and the Stoics' pneumatic theories, no explanation was, as far as I understand, offered to the question of exactly how the luminous and chromatic images which pass into the eye or originate there were apprehended by the mental faculties. The assumption of immateriality of the *species* and transparency of the medium and the eye does not answer that question, but simply banishes it to another region; perhaps it was understood that immateriality, being a common quality of the *species* and the mind, made them structurally consistent with each other, and that transparency, being a common quality of the medium and the eye, offered the means of unhindered transferal[86].

The Aristotelian claim[87] of the importance of the sense of sight was very influential in medieval thought; a frequent affirmative expression in Christian literature is *oculata fide*, used to grant the certainty of an eye-withness to the written word[88]. The pedagogic advantages of the universal communication through visual images added to the Christian claim of the priority of sight.

## Post-Ocular Perception

It has already been established that before the Renaissance no coherent theory was presented regarding the exact tranformative process of visual impressions to mental concepts. Shape and size, numerically representable, constitute, according to Pythagorean tradition, the medium between the material world and abstract reasoning. Aristotle, who held that visual impressions are immaterial images of light and colour, in terms of which we perceive other properties like shape, size and number, emphasized that these impressions—present as well as stored—constitute the raw-material of conceptual, abstract reasoning[89]. In spite of his fundamental divergence from Plato[90] as to the reliability of sense-perception, they both held that the mind compares earlier, stored images, which have left impressions in the mind like a seal in wax[91], to present sensations. Aristotle laid the foundations of the very influential scheme, according to which the impression passes from the sense-organ to the common sense and to the memory, where judgement compares it to old impressions, using criteria abstracted from earlier sensual experience[92]. In the Latin translations of and commentaries to *De anima*, the result of this process was called *species, intentio, simil-*

*tudo, formae,* etc.; the same words, then, were used to designate the immaterial likenesses of objects and the mental concepts of them[93]. This is in accordance with Aristotle's original intention in *De anima,* that what senses and what is sensible are the same, just as what intellects and what is intellected. But how, we must ask, did Aristotle conceive a structural likeness between colours and the mind? In my opinion this can only be guessed, but possibly the answer lies in the application of his theory that the chromatic colours consist of certain proportions of white and black (*De sensu* 439 b, 442 a) to his general statement that perception is a proportion (*De anima* 426 b); the mind would, then, identify and conceptualize the colours, like the tones, according to the numerical ratios of their constituents.

In the period between Aristotle and Plotin, great attention was devoted to the psychology of perception, in particular to the concreative role of the beholder of suggestive, incomplete images. Theophrastus[94] wrote on literary style: "Not all points should be punctiliously and tediously elaborated, but something should be left to the comprehension and interference of the hearer." Pliny[95] reproved Protogenes for not knowing when to take his hand from the picture, since "too much care may often be hurtful", and Horace[96] noted, certainly with reference to scenic painting, that some paintings are to be seen at close hand, others at a distance, some at good light, others in dim light. Philostratus the Elder († ca 244—49)[97] made rich observations of the beholding of blurred images and the creative importance of imagination, but the most systematic study of this kind of perception was made by Ptolemy[98], whose observation that subconscious syllogisms are used to complete the suggestive image was very influential in the Middle Ages; via Alhazen[99] it was transferred to Grosseteste, Bacon and Vitello[100], and even found its way into the popular *Roman de la Rose*[101].

1. Lindberg 1976, below abbreviated L. It will be observed, however, that I introduce other sources and draw conclusions which are not always found in L.
2. Albert the Great used the terms *intus suscipientes* and *extra mittentes*—the former used by ten Doesschate 1962, the latter by L. For the sake of brevity I prefer the terms immission and emission.
3. Alcmaeon of Croton (early 5th century B.C?) and Archytas of Tarent († ca 365 B.C.); L. pp 3 f and nn 18, 19; ten Doesschate *op.cit.* p 315.
4. Chrysippus and Apollodorus, however, presupposed a conical visual field, the rays of which touched the object "as if by a stick"; L. p 9 n 56. About Seneca, cf. L p 87 and n 5.
5. L. p 9.
6. Cf. Hoppe 1926 p 6 f.
7. He equated the sensible field of vision to nerves in *De placitis Hippocratis et Platonis;* L. pp 10 f and nn 59—70.
8. Translated at the end of the eleventh century by Constantinius Africanus; L. pp 34 ff and nn 46, 59.

9. L. pp 12 ff. On the translations to Latin of *Optica* cf. L. p 210; It was published in Italian by E. Danti, *La prospettiva di Euclide ... colla prospettiva di Eliodoro Larisseo,* Firenze 1573. Cf. ten Doesscate *loc.cit.* Zupnic 1976 pp 469 f makes an unfortunate application of the Euclidean model to the art of Giotto as an explanation of his ground spatial depth and Duccio as an explanation of his "reversed-perspective".

10. *Catoprica;* L. pp 14 f and nn 84—87.

11. *Optica* 2. 16; ed. A. Lejeune, Louvain 1956 p 18; L. pp 14 ff and n 86.

12. L. p 16 and n 98;Al-Kindi agreed to this; L. p 24 n 29.

13. *Optica* 2. 20; *ed.cit.* p 18; L. p 17 and nn 101, 102. Edgerton 1969 p 119, intimates that this was Euclid's opinion.

14. His *De radiis stellarum* and *De aspectibus* influenced, among others, Grosseteste and Bacon; L. pp 18 ff.

15. *De aspectibus* prop. 9 pp 11 f; L. *loc.cit.*

16. The theory of Empedocles is debated. Based on the principle of sympathy, it probably meant that the eye, consisting of hot fire (white) and cold water (black) becomes seeing when its fire and water are reflected from the same elements, which in the form of differently shaped, material particles enter the eye through pores of the same shape. Different colours, then, originate through a mixture in different proportions of white and black; L. pp 4 f and nn 23—29. Cf. Guthrie 1971— II pp 442, 446, with references to *De sensu* 438 a and Theophrastus' *De sens.* 50, 80.

17. *Timaeus* 45, 68; *Theatetus* 154; *Meno* 76; cf. Siebenhüner 1935 p 26; ten Doesschate *op.cit.* p 318; Guthrie *op.cit.* II p 232; L. *loc.cit.*; Nowotny 1969 p 22. The influence of Platos' visual theory was secured by the translation to Latin by Chalcidius (florid early fourth cent?); L. pp 88 f and nn 13—18.

18. Theophrastus' (*loc.cit.*) misinterpretation of Plato has been passed on by many recent historians; L. p 5 n 30. On Empedocles, cf. Nowotny *op.cit.* p 21 and n 18.

19. *Timaeus* 68; Guthrie *op.cit.* II p 446 n 1.

20. Gilbert-Kuhn (1939) 1972 p 145: "For our eyes are informed with a luminous matter, a fire, that on the principle of like to like, makes kind meeting with the fires in nature."

21. *De trinitate,* XI, iv, 4; *De genesi ad litteram,* pt. 1; *De musica,* VI, v, 10; Walker 1958 p 7 n 4; L. p 90 nn 19, 20.

22. *De iride;* L. pp 94 ff, 100 f.

23. Pliny, *Nat. Hist.* XI, 54; Solinus, *Collectanea rerum memorabilium;* L. pp 87 f and nn 6—12. Cf. Gifford 1958; ten Doesschate *op.cit.* p 315.

24. *Glossae super Platonem,* ed. E. Jeauneau, Paris 1965 pp 237 f; *Dragmaticon (Dialogus de substantiis physicis),* Strassburg 1567 p 283; *Philosophia mundi;* L. pp 91 f and nn 29, 30.

25. Walker *op.cit.* p 160; Heaton 1968 p 82. Cf. Ficino below p 119 n 4 and Joannes Versoris († ca 1482, *Questiones super parva naturalia cum textu Aristotelis* qu. 4, ff 4 v—4 r; L. p 138 and nn 70, 71), who state that the emitted visual rays of women during menstruation contain blood.

26. Diels-Kranz A 29—30; ten Doesschate *op.cit.* p 317; L. p 2 n 6.

27. *ibidem* A 135; L. *loc.cit.*

28. *Letter to Herodotus;* L. *loc.cit.* and n 9.

29. *De rerum naturae* IV; L. pp 2 f and n 10.

30. Cf. Hoppe *op.cit.* p 7.

31. Cf. Ps-Aristotle, *De Mundo* 396.

32. According to L. pp 6 f n 39, *Meteor.* is a work of the early period of Aristot-

les' career, when he was still under Platos' influence. In *De gen. anim.* (780 b—781 a) he takes an intermediate position.

33. 437 b—441 a.

34. Cf. above chap I; local-chemical colour corresponds to colour as the limit of determinated bodies; physical colour corresponds to colour as immaterial impressions.

35. Cf. below p 26, where A. in fact acknowledges the influence of certain properties of the medium.

36. *De anima* 418 a; L. 58 and n 3.

37. *De sensu* 438 b; L. pp 8 f and nn 50—52.

38. Similar to a telescope, but with the eye in reversed position.

39. *Probl.* 872 a, 911 b; L. p 57 n 150. Cf. Grayson 1972 p 109 and n 7. Geminus (first cent. B.C.) states that the proper object of optics is that which "accounts for illusions in the perception of objects at a distance, for example the apparent convergence of parallel lines or the appearance of square objects at a distance as circular;" L. p 11 n 72.

40. *Probl.* 959 a. Cf. Pliny, *Nat.Hist.* XXV, 97. The strange statement that the eye is tried by solid objects but not by moist "since there is nothing in them to resist the vision", indicate emission.

41. L. pp 42 ff.

42. Noted in *Kitab al-Mansuri* or *Liber ad Almansorem* that the pupil is contracted by strong light; L. p 42 and n 62.

43. *Epitome of the Parva naturalia;* L. p 53 and n 126.

44. He strongly influenced Bacon, Vitello, Pecham, Blasius of Parma, Maurolico and della Porta; L. p 61 and n 13; p 86 and n 133. Cf. ten Doesschate *op.cit.* pp 319 ff.

45. *De aspectibus,* also called *Perspectiva;* ed. Risner 1572, Lib. I chap. V sec. 19 p 10; L. p 73 and n 73.

46. Lib. I chap. V sec. 19; *ed.cit.* p 10 ff; L. pp 74 f. Refraction=the bending of a light ray which passes between two media of different density. Noted by Plato, *Rep.* X 602 and systematically studied by Ptolemy. Cf. Hoppe *op.cit.* pp 13 ff; ten Doesschate *op.cit.* p 316.

47. Lib. VII chap. VI sec. 37; *ed.cit.* pp 268 f; L. p 76 and nn 87, 88.

48. Lib. II chap. I sec. 8—9; *ed.cit.* p 29 f; L. p 85 n 129.

49. Lib. II chap. III sec. 65; *ed.cit.* p 67; L. p 85 n 127. Cf. Zubov 1968 p 130.

50. Lib. VII chap. VI sec. 37; *ed.cit.* p 269; L. p 76 n 1. Cf. ten Doesschate *op.cit.* p 319.

51. Cf. Panofsky 1955 pp 89 f n 63, who refers to Alhazens' *Optica* and the number of 21 visible intentions.

52. Lib. II chap. II sec. 15; *ed.cit.* p 34; L. p 112 n 37. Cf. Aristotles' common sensibles and categories, substance, quantity, qualification, relative, where, when, being-in-a-position, having, doing, being-affected; *Aristotles' Categories and De Interpretatione,* tr. and notes J.L. Ackrill, Oxford 1963, chap. 4 (I b 25) and n p 77 ff.

53. Lib. I chap. I sec. 1; *ed.cit.* p 1; L. p 62 and n 23.

54. *dolor;* Lib. I chap. V sec. 26; *ed.cit.* pp 15 f; L p 71 and n 72.

55. Lib. I chap. I sec. 1; *ed.cit.* p 1; L. p 62 and n 26. After-images were earlier discussed by Ptolemy and Alexander Aphrodisias; L. *loc.cit.* n 24.

56. The *Summa* was the typical form of synthesis, the *Lectio,* the *Disputatio* and *Questio* the typical forms of discussion of isolated problems; L. pp 143 ff.

57. *Summa theologia* I.qu. 85, resp; Roos 1965 p 92. Note the parallel to Aristotles' cognitive categories, *genus proximum—differentia specifica.* Cf. ten Does-

schate *op.cit.* pp 326, 332; Zubov *op.cit.* p 134; Pochat 1973 p 176 n 237.

58. Of these, Aristotle is the basis, Ptolemy a piece of news and Alhazen the most important; L. p 109 n 28.

59. *Opus maius* pt. 5.1. dist. 6, chap. 2; L. pp 109 ff and n 29.

60. *Op.cit.* pt. 5.1. dist. 7, chap. 2; L. pp 114 f and nn 52, 54.

61. *Op.cit.* pt. 5.1. dist. 7, chap. 4; L. p 115 and n 56.

62. *Op.cit.* pt. 5.1. dist. 9, chap. 4; *De multiplicatione specierum* pt. 1 chap. 3; L. p 113 and n 45.

63. *De mult. spec.* pt. 1 chap. 1; L. p 113 n 49. In contrast to Albert the Great and Thomas Aquinas, Bacon held that the *species* give a direct, objective image of the object observed. Cf. ten Doesschate *op.cit.* p 332.

64. *Perspectiva communis.*

65. *Perspectiva.* Cf. Baeumker 1908 *passim;* Huyghe 1962 pp 189 ff, 238; Zubov *op.cit.* p 129.

66. L. p 117 and nn 58—61.

67. L. p 118.

68. According to L. p 120, Pechams' *Persp. comm.* is rendered in 62 MSS and printed 10 times 1482—1593, Italian translations included; Bacons' *Persp.* is rendered in 36 MSS, *De mult. spec.* in 24 MSS; Vitello's *Persp.* in 19 MSS, printed 1535, 1551 and 1572; Alhazen's *De aspect.* is rendered in 16 MSS, printed 1572. As to their influence at the universities in the 14th, 15th and 16th centuries, see L. pp 120 f.

69. Cf. Bacon above, Pecham *Persp. comm.* Lib. I prop. 55; L. p 130 n 27, Henry of Langenstein († 1397) *Questiones super perspetivam,* and Blasius of Parma (Biagio Pelanci, † 1416), *same title;* L. pp 130 f and nn 27, 36.

70. *Commentary on the Sentences of Peter Lombard;* L. p 141 and n 89. Cf. Pochat *op.cit.* p 317 n 254.

71. Cf. Munro 1970 p 334.

72. Cf. above p 21.

73. Lejeune 1948 pp 68 f.

74. *De anima* 418 b.

75. *De coloribus* 749 a.

76. This has a certain affinity to Aristotle's notes on the rainbow.

77. *De sensu* 437 a. Cf. his ten categories above note 52.

78. "Thanks to the fact that all bodies are coloured ... it is through this sense [the faculty of seeing] that we perceive the common sensibles."

79. 1969 p 130 and n 57.

80. *Nat. Hist.* XXXV, 127: ... *quae volunt eminentia videri, candicanti faciant colore, quae condunt, nigro.*

81. Ed. Lejeune 1956, ii, 127 pp 10 ff: *Et ideo pictor, cum voluerit ostendere has duas figuras per colores, ponit colorem illius partis quam vult eminentem videri, lucidum; colorem vero illius quam vult concavam videri, magis latentem et obscuriorem.*—*Optica* was translated to Latin by the Admiral Eugene of Sicily in the mid-twelfth century; L. p 211 and n 17.

82. Lib. VII chap. 6: *Praeterea ut portiones quae ultra terram ponentur oscuriores colores habeant quam portiones quae aspectui offerentur ...*

83. I am indebted to Professors Walther Björkman and Dag Norberg, who have expressed doubts regarding my previous conviction that Ptolemy referred to the saturation and intensity.

84. *Saturum, profundum* and *plenus* were, in contrast to *dilutum, liquidus* and *pallidus* (unsaturated), connected to dark colours. Cf. Equicola 1525 (Barocchi 1971— II p 2155 and n 9); Telesio 1528 (Goethe ed. 1963 pp 106 ff). This

problem will, like the adherence to the different visual theories among the Renaissance authors, be discussed in connection to perspective, below chap. B III 4.

85. Particularly presented in *De usu partium (De utilitate particularum);* L. pp 34, 55 f, 61, 172, 212. The anatomical revival in the later Middle Ages and the Renaissance did not change the general outlines of Galen's theory; L. pp 168 ff. 175 and n 145.

86. It seems that the studies of perception was impeded by the ambition to adapt the anatomy of the eye to the geometric terms of formal optics; Johannes Kepler († 1630), who finally found the correct solution of the progression of rays within the eye, considered that what happens after the formation of the retinal image the business of the physicists; L. p 203.

87. In fact Aristotle (*De sensu* 437 a) ascribed a fundamental importance to the sense of sight only for the primary wants of life, whereas hearing was thought to take precedence for developing intelligence.

88. For instance Ps-Dionysius and Albert the Great; Litt 1963 p 278 n 15; Zubov *op.cit.* p 156; Pochat *op.cit.* p 94 n 32.

89. *Physica, De anima, Post. Anal.* Cf. Weil 1975 pp 94 f. Reason, however, is also immortal, timeless and able to function without the assistance of the senses; *De anima* 413 b; *Nic. Et.* 1102 b. *De anima* was translated by William of Moerbeke ca 1260—70, extant in some 230 MSS and printed more than 44 times before 1600. It was retained by Johannes Argyropylus ca 1460, rev. ca 1485; numerous MSS, printed over 40 times before 1600; Crantz 1976 pp 360 f and n 8.

90. *Thatetus* 164, 182, 184—, 192.

91. This metaphor was also used by he Stoics, who conceived of the soul as material.

92. An interesting possibility to check the opinions of the origin of inner concepts is offered by Panofsky's (1924) 1968 study of the concepts of perfect beauty. From a sense-perceptual point of view, they may be separated in two groups, the first of which—(a), (b), and (c)—acknowledge the possibility of transformation of the concept to physical manifestation and *vice versa;* at least one of them, (b), states that the concept is the result of sense-perception. In the other group, the concept of formal beauty is thought to have a spiritual, divine origin, a gift inborn in man and impossible to manifest in physical form.—(a) Comparing the physical model with a certain idea of perfect beauty, the artist may correct the former according to the latter (Seneca, Thomas Aquinas; Panofsky *op.cit.* pp 22 f, 40 ff); (b) Imitating the idea of perfect beauty, which is the result of earlier sensual impressions, the artist may liberate the slumbering potential image of that beauty in the amorphous matter (Aristotle, Philostratus the Elder, Cicero I; *op.cit.* pp 11, 16 f, 18); (c) With reference to a certain idea of perfect beauty the artist may, combining the most beautiful parts of several partly imperfect models, compose a whole, which is similar to the idea (Plato II, Cicero II, Pliny, Dionysius of Halicarnassus; *op.cit.* pp 3 f and nn 16, 17; p 15); (d) Idea is the mentally comprehended, as opposed to deceptive comprehension through the senses, concept of perfect beauty, which can only be imperfectly imitated formally (Plato I; *op.cit.* pp 4 f); (e) Imitating the idea of perfect beauty, which is implanted in the human soul and independent of sense-perception, the artist may form an image, which, however, becomes imperfect due to the resistance of matter (Plotin; *op.cit.* pp 26 ff); (f) Imitating the idea of perfect beauty, which is implanted in the human soul by God, the artist may form a physical image of the idea, which, however, compared to this idea, becomes imperfect (Augustine; *op.cit.* pp 35 ff). In the Renaissance, (b) was the prevailing theory; cf. below chap. B I 3 and Dresden 1976 p 459 n 21. The different stages of post-ocular

perception are described by Leonardo ca 1490—1510 (ed. (1883) 1972 §§ 100, 101; cf. Lindberg 1976 p 167 and nn 96, 97): the eye receives a *spetie* which via the *impresiva* passes to *senso comune*, where it is judged and passed to *memoria;* Lomazzo 1584 (Lib. IV chap. 3; ed. 1973— II p 189) names the stations eye, common sense, imagination and intellect; cf. Varchi (*Sopra il primo canto del Paradiso di Dante*, in *Opera di B.V:*, II p 350); Paleotti 1582 (ed. 1960— II pp 138, 208); R. Alberti 1585 (ed. 1960— III p 208) and below chap. B I 3.

93. Cf. Plato *Timaeus* 67: "Colour is a light, which issues from the different bodies" and his definition of shape in *Meno* 75 as "that which is always accompanied by colour". Cf. Arnheim (1956) 1972 p 323: "Strictly speaking, all visual appearance is produced by colour and brightness . . . Nevertheless it is justifiable to speak of shape and colour as separate phenomena." Cf. Crantz *op.cit.* pp 367 ff.

94. Quoted by Demetrius, *On Style*, ed. Loeb p 439; Gilbert-Kuhn (1939) 1972 p 90 and n 7.

95. *Nat. Hist.* XXXV, 80.

96. *Ars poetica* 361—62.

97. *Life of Apollonius of Tyana* II. 22, in Gombrich (1960) 1972, chaps. 6.1, 7.1, 3, 5, 8.1, 11.3; VI.19, in Panofsky *op.cit.* p 16 and n 21 and Grassi *op.cit.* p 162.

98. *Almagest; Optica* II, 74, 136; ed. 1956 pp 50, 81; ten Doesschate 1962 p 317.

99. ten Doesschate *op.cit.* p 322.

100. *op.cit.* p 331.

101. Lines 19515—19523; in Gombrich *op.cit.* 6.3: *les rois ressemblent aux peintures/ C'est l'example que l'auteur prit/ Quand l'Almagest il écrivit./ Si bien savez y prendre garde/ Quand des peintures on regarde,/ De loin elles font bon effet./ De près le paisir disparait:/ De loin semblent délicieuses/ De près ne sont plus doucereuses.*

# Chapter III. The Four Elements

The doctrine of the four elements—fire, air, water and earth—was formulated by Empedocles[1] and generally accepted during the period studied. All material conditions were thought to depend on the combination and interaction of the elements; the light fire strives, like air, upwards; the heavy earth strives, like water, downwards[2]. Aristotle assumed that they all have a set of sensible qualities in terms of temperature and moisture through which they were interrelated and could influence each other: fire and air being warm, water and earth cold; fire and earth being dry, air and water moist[3]. Any particular elementary combination could visually be established through its resulting colours; Theophrastus' numerous observations of surface-colour[4] are based on changes of the originally white elements under the influence of yellow heat; since, however, every subject to such changes had an unknown elementary composition, the colouristic changes could not be predicted and fixed in a general colour-scale[5].

# The Four Humours

Fixed relations between the four elements and colours were established through the application of the elementary doctrine in the doctrine of the four humours. It is—as has been noted in *Saturn and Melancholy*[6], which is comprehensive but somewhat incomplete in colouristic matters—the result of a fusion of three ancient, mainly Greek notions: (1) the above-mentioned theory of the four elements, (2) the Pythagorean number symbolism[7] and (3) the no less Pythagorean idea that certain number-relations result in a desirable harmony. The specific significance ascribed to the number four and the definition of physical health as the equilibrium of different qualities in the body were fused through the assumption of four kinds of bodily substances, the humours, resembling the four elements[8]; blood (red), being warm and moist corresponds to air; yellow bile (yellow), being warm and dry, to fire; black bile (black), being cold and dry, to earth; phlegm (white), being cold and moist, to water[9]. According to this so-called humoral pathology, the general outlines of which remained unchanged until the end of the period studied, health was defined as a certain equilibrium between the individually evil components, which thereby neutralized each others' harmful qualities[10]. A certain predominance of one of the four humours was, however, regarded as natural and assigning the individual to one of the four constitutions: the sanguine (blood), the choleric (yellow or 'red' bile), the melancholic (black bile) and the phlegmatic (white phlegm). The dominating component was either thought to reside permanently in the individual or to make him particularly sensitive to temporal exposure to its corresponding element. The sanguine humour was later to be regarded the 'healthy' disposition and the melancholic as either a particularly evil sickness or as a divine gift. The particular elementary composition of every individual was—in accordance with the original doctrine—legible from the complexion, i.e. the colour of the skin. In *Of the Constitution of the Universe and of Man*[11], a fixed connection between complexion and humour was established; predominance of black bile (melancholy) results in a "swarthy" complexion, of blood (sanguine) in a "rosy, well-coloured", of yellow bile (choleric) in a "yellowish" and of phlegm (phlegmatic) in a "very pale".

# The Four Temperaments

It was, from the very beginning, implicit in the theory of the four humours that the elementary composition determined also the mental status of the individual, constantly or temporarily. A connection between black bile and a melancholic state of mind was intimated in pre-Hippocratean texts, some

great tragedies and Plato's *Phaedrus*[12], but got its most influential formulation in Ps-Aristotle's *Promlemata*[13]. The original restriction of the mental-humoral connection to the melancholic humour was successivly abandoned; phlegm was the last to complete the system[14], which on the other hand was complicated by the assumption that the melancholic over-heating could affect the other humours as well[15]. When, finally, in the above-mentioned work from the second or third century A.D. a complete and extremely influential theory of the connections between the four humours and the four temperaments was created[16], the importance of colour was substantially widened; complexion became, at least potentially, a means to establish not only formal properties, like sex, age etc., but also of the mental disposition. The content of the new theory diverged, however, completely from the original doctrine, since the properties ascribed to the humours by Galen were replaced by others: the choleric temperament, originally regarded as favourable, now got its hot, violent character, and the sanguine, originally unfavourable, got its positive, well-balanced character.

Due to a general loss of interest in individual genius, culminating in the Middle Ages, the melancholic temperament, by Ps-Aristotle coupeled with the heroic and the genius and by Galen with firmness and constancy as well as mental decease, was, from now on, until the Renaissance, regarded exclusivly unfavourable and became confused with the likewise negative —originally not included in the system—phlegmatic temperament[17].

### Astrology, Magic and Alchemy

With the fusion of the humoral and temperamental doctrines, the system was enlarged, but by no means completed; astrology remained to be included. The planets, being observable and yet beyond touch, were well suited to explaining the generation and change of both physical and mental conditions. In Roman astrology, connections were established between planets and elements, substances and human physiognomy and characterology[18]. The complex problem of bringing the humoral and temperamental doctrines, based on elementary analogies, into harmony with another number of planets, which on the one hand were thought to have physical properties and exercising physical influences, and on the other were thought to be animated by ancient gods and exercising their moral and social influences, has been analyzed in *Saturn and Melancholy*. The latter aspect does not concern us very much, since by the time a system of correspondences was formed, the original properties ascribed to the classical gods were no longer valid. There existed, however, an ancient lithurgic tradition, according to which Saturn was associated with black, Mars with red, Jove with white, Mercury with different colours, Sun and Luna with yellow[19]. Mars

was furthermore traditionally associated with fire, Jove with air, Mercury and Luna with water and Saturn with earth[20]. By ascribing the Aristotelian sensible qualities of the elements to the seven planets, the difficulty of achieving an analogy between them and the four humours could be overcome: Ptolemy stated that Luna is cold and moist, Mercury varying, Venus warm and moist, Sun and Mars warm and dry, Jove warm and moist and Saturn cold and dry[21] (ordered according to their increasing distance from the earth). One problem remained: Mars, by the astronomers called "the fiery one[22]" due to its red colour and traditionally associated with fire, war and cruelty, had to be coupeled with the *yellow* bile of the choleric humour; red, the colour of blood and the sanguine humour, on the other hand, was traditionally associated with air. This problem was overcome by certain Arabic scholars of the ninth century[23] through the deduction of the planetarian properties from the elementary properties of the four humours, revealed by colour: the planet Saturn was thought to be black, cold and dry since that was the colour and nature of black bile and earth; the yellow colour, warm and dry nature of fire and 'red' bile was transferred to Mars; the red colour of blood and the warm and moist nature of air and blood was transferred to Jove; the white colour and cold and moist nature of water and phlegm was transferred to Luna.

The immediate influence of this theory on western thought was limited; astrology as a whole had been categorically refuted by the early Christian theologians. The Sun, the cult of which had been strong in Antiquity, caused through the identification with Christ or God, a particularly crucial problem[24]. But a revival of astrology and its corollary, magic, in the twelfth century again actualized the question of the nature of planetarian influences. From now on it became customary to differentiate between "good" or "natural" and "bad" or "black" astrology and magic[25]; the former was officially accepted as beneficial for medical diagnoces, forecasts of weather etc., the latter's claim on stellar influences on the free human intellect and will was officially—but no more—condemned and credited God[26].

Only one aspect respectively of magic and 'scientific' application in alchemy will be considered here: the subject of magic was to attract favourable and to repel unfavourable influences by the use of numbers, tones, scents or objects, talismans, the elementary composition of which were believed to offer means of communication with the addressed planets and powers[27]. The origin of this kind of magic is Empedocles' doctrine of sympathy, and the addressed planet which was considered most favourable was the Sun, attracted by gold, strong light and golden colour[28]. The medieval definition—based on the Christian identification of light and divine influence—of beauty as *concinnitas* and *claritas,* the studies of optics, and the general instructions to the artists to use particularly light-responding materials, often concentrated to the most sacred of the depicted personages, is

37

nothing but an application of this magic.

In alchemy, the properties of the metals were studied with the ambition of making gold; by finding and isolating the *quinta essentia* one hoped to achieve desired rearrangements of the elementary composition of less valuable metals[29]; increasing the fiery component one hoped to transform them to gold in a process which also symbolized a spiritual ascension[30]. The metals were associated to the planets, but ranked in an hierarchic order which does not quite corresponds to either criteria of distance[31] or to beneficial influence[32]. According to the most influential scheme, derived from Hermes Trismegistos, gold was associated with the Sun, silver (white) with the Moon, copper (blue) with Venus, quicksilver (mercury; brown) with Mercury, iron (red) with Mars, tin (green) with Jove and lead (black) with Saturn[33]. The colouristic associations seem to be derived either from the colours of the metals themselves or from their oxidations (iron, tin). In a restricted sense, alchemy had relevance for the development of artificial pigments[34] and for the study of chemical reactions between pigments, mediums and environment[35].

1. Guthrie 1971— I p 264; II p 147; Klibansky *et al.* 1964 pp 6 f; Nowotny 1969 pp 19 f and n 10.
2. Platon, *Timaeus* 63, 85; Aristotle, *De caelo* 277 b, 305 a; cf. Litt 1963 p 46; Seeck 1964 pp 38 ff, 106 ff; Nowotny *op.cit.* p 22.
3. On Aristotle's absurd conclusions in *De gen. et corr.,* see Seeck *op.cit.* pp 14 ff, 18. Cf. Nowotny *op.cit.* p 21 and n 15.
4. Cf. above chap. I.
5. Possibly Empedocles' associated the elements with four colours, white, black, red and yellow; Nowotny *op.cit.* p 21 and n 17. Cf. above chap. II and n 18. For other associations between the elements and colours, cf. Hieronymus *Epist.* LXIV, 18, 8 ff, quoted by Equicola 1526; Barocchi 1971— II pp 2153, 2155: fire-red, air-yellow, water-violet, earth-bluegreen, and Bartolomeo da Sassoferrato (fourteenth cent.; Baxandall 1971, pp 114 ff, 168 f) who connected the two lightest elements, fire and air, with the two most expensive pigments, gold and ultramarine-blue.
6. Klibansky *et.al.* 1964 pp 4 ff.
7. Cf. below chap. IV.
8. Stated by Philistion; *op.cit.* p 7.
9. First formulated in *On the Nature of Man* by Hippocrates or Polybus; *op.cit.* p 8. Cf. Antiochus of Athens (second cent. A.D.); Nowotny *op.cit.* pp 24 f and n 31. How the black bile, generally associated with over-heating, could become associated with the cold element earth can only be explained through the assumption that the result was aimed at, i.e. something combusted and actually cold, not burning.
10. *Klibansky et.al.* p 10. Cf. Galen, *De Placitis Hippocratis et Platonis,* V, 3, quoted below chap. IV n 10.
11. Greek anonymous from the second or third cent. A.D.; *op.cit.* pp 58 f and n 162.
12. 244 A on "divine frenzy"; *op.cit.* pp 16 f and nn 49, 50.

38

13. XXX, I.
14. *Op.cit.* p 57.
15. According to Rufus Ephesius and Galen, the blood and yellow bile could be affected. Avicenna also acknowledged a phlegmatic form of melancholy; *op.cit.* pp 52 ff, 86 ff.
16. *On the Constitution of the Universe and of Man. Op.cit.* pp 60 ff.
17. *Op.cit.* pp 61 ff.
18. From now on, it was common to talk about Saturnine, Jovial, Martial, Solarian, Venusian, Mercurial and Lunar people; *op.cit.* p 145.
19. Cf. Pliny, *Nat. Hist.* XVIII; Cicero, *De nat. deor.* II pp 52, 673 ff, 851; Barocchi 1971— II p 2156 n 5. Except for Sun, Luna (not mentioned) and Venus (yellow), the same associations are found in Ptolemy's *Tetrabiblos* II, 10; cf. Bouché-Leclercq 1899 p 314 and n 2; Nowotny 1969 p 24 and n 30.
20. According to Antiochus of Athens; Rouchette 1959 p 31 n 1. For other associations elements-colours, cf. above n 5.
21. *Tetrabiblos* I 4; Litt 1963 pp 222 f.
22. Klibansky *et al.* p 136.
23) 24. In particular Abû-Màsar († 885), *Introduction to Astrology,* Book IV; *op.cit.* pp 127 ff; translated in the twelfth cent. by Johannes Hispalensis, *MS Corpus Christi College,* Oxford No 248; quoted in Klibansky *et.al.* p 128 n 5. Cf. Nowotny *loc.cit.*
24. Panofsky 1955 pp 257 ff and nn 57—89, in particular p 260 and n 72: "St. Augustine had to warn vigorously against carrying the identification of Christ with Sol so far as to relapse into paganism."
25. Arabic magic *(Picatrix)* and Jewish Kabbala were introduced by Ramon Lull in the late thirteenth cent.; cf. Walker 1958 pp 54 ff; Klibansky *et.al.* pp 337 f; Ciardi 1971— I p xxxv ff.
26. Klibansky *et.al.* pp 180 ff; Walker *loc.cit.* and pp 214 f; Litt 1963, chap. 1, 6, 7, 9; Rouchette 1959 p 27 and n 2; Kristeller 1961— II p 58 f; Ciardi *op.cit.* I pp xl and n 114, p xlv and n 126; Pochat 1973 pp 150 f and nn 179, 180: pp 289 ff.
27. Cf. Ficino, *De vita coelitus comparanda,* in *De Triplici Vita;* Walker *op.cit.* pp 12 ff; Pochat *op.cit.* pp 288 ff.
28. Cf. Walker *op.cit.* pp 22 f (Plotin), 30, 32 f (Diacceto), 40 *(Asclepius),* 50.
29. Walker *loc.cit.;* Pochat *loc.cit.* The three main colours of alchemy, apart from gold—black, white and red—represent both chemical and spiritual evolution; black=prime matter and guilt, origin, latent forces; white=quicksilver, 'minor work' and first transmutation; red=sulphur and passion. The scale of evolution was preceded by a scale of declination, from yellow via blue (the sky), green (nature) to black. Cf. *A Dictionary of Symbols,* pp 5 f, 55 ff, 60, 171. *Dictionnaire des Symboles,* p 246, adds, without any reference, grey as a symbol of earth.
30. Dampier 1948 pp 50 f.
31. The sun, moon and Mercury have different positions.
32. Silver, the second most valuable metal, was associated to Luna, which was held to exercise a fundamentally evil, variable influence.
33. Bourché-Leclercq 1899 pp 315 f and nn 4, 5; Rose 1959 p 262; Rouchette *op.cit.* p 36; cf. below chap. A I.
34. Cf. Cennini ca 1400 chap. XL; ed. 1971 p 40: *Rosso è un colore che si chiama cinabria, e questo color si fa per archimia.*
35. Below chap. B I 4.

# Chapter IV. Formal Beauty

Formal, aesthetic beauty, in the modern sense, was not a very important concept of beauty in Antiquity[1]. When it occurs, however, it is generally[2] expressed in quantitative terms of relations between the size, shape and colour of the parts and the whole of bodies. This kind of definition includes two major categories, one designated 'organic beauty' and the other 'unity in variety'. There exists a certain divergence in the modern interpretations of these categories; some scholars hold that there is not any fundamental difference between them[3], wheras others[4] hold that 'organic unity' is a quite different concept, which originates in Aristotle's demand that the *mythos* must be a unity, consisting of a beginning, a middle and an end[5]. This does not—and I agree with Grassi—refer to any abstract formula of beauty, but simply states that the internal order, according to the actual case, must be adapted to the demands of unity. The principle that all the elements of a whole are to be marked by a mutual function[6] justifies, from a colouristic point of view, the rather trivial conclusion that all elements are to have the same colour[7]. 'Unity in variety', on the other hand, concerns aesthetic beauty, based on abstract formulas, derived from Pythagorean number-mysticism. For Pythagoras (ca 550 B.C?) and the actual Pythagoreans, the numerical definition of bodies had no aesthetic relevance; it was regarded as the result of a mystic-sacred, material manifestation of order in the *Aperion,* the unlimited, formless chaos[8]. Certain numbers—4, 6, 10 and 12—were considered perfect because they are easily divisible. Its first known application to art was the lost *Kanon* of Polyclitos[9], but it is also mentioned, in general terms, by Xenophon[10]. Plato[11] in particular departed from the Pythagorean musical theory[12]; he held that the rhythms and keys of music consist of the same numerical ratios as the different moods of the soul, which it imitates and influences. Aristotle's adherence to the quantitative definition of formal beauty will be discussed below. Through later philosophers, physicians and art theorists like Chrysippus[13], Vitruv[14], Galen[15], Cicero[16] and Lucian[17], it became the prevailing, 'classical' definition of formal beauty in Antiquity[18]. Plotin dismissed the 'classical' formulation but not the quantitative definition[19]; just like the Pythagoreans, he regarded form—the shaping, differentiating, ordering and manifesting principle—as the victory over unlimited, shapeless, obscure and amorpous matter, a victory which was revealed by light and brightness[20]. "Practically everyone asserts," he wrote, "that visible beauty is produced by symmetry of the parts toward each other and toward the whole in combination with pleasant colour; to be beautiful would, for visible objects and in general for all others, mean to be symmetric, to have measures. For the advocates of this theory, then, it is impossible for something single to be beautiful; there exists only a beauty of composed bodies, the

parts of which, however, may individually lack beauty but contribute to it in the composed body. But when the whole is beautiful, its elements must also be beautiful, since a beautiful thing cannot consist of ugly parts, but the beauty must comprise all parts[21]." The naive analysis is followed by examples of 'single beauty' or 'unity in unitariness'; he holds that the 'classical' definition cannot embrace either individual colours, "since they are single and their beauty does not depend on symmetry", or single tones[22]. Plotin's effort to revise the 'classical' definition was contradictory and not very influential. On the contrary, the latter dominated the Middle Ages through Augustine's famous definition of *concinnitas* as the union of discordant elements and his emphasis on the pedagogic advantages of a contrast of ugliness and beauty, a notion which he in fact took from Plotin[23]. Even the similarly Neo-Platonic Ps-Dionysius[24] adhered to the 'classical' definition, and still Albert the Great[25] and Thomas Aquinas[26] defined *consonantia* as *debita proportio* and *claritas*. The examples Plotin gave of 'single beauty' are very interesting; certainly it was not a coincidence that he chose colours and tones, since Aristotle in *De sensu* had made an analogy between them. Plotin, then, probably rejected, but possibly neglected or misinterpreted, the fundamental notion of Aristotle that a single colour, just like a single tone, consists of a mathematically expressable relation between two contraries; a beautiful colour is that which consists of an easily detectible proportion[27]. It seems to follow, that the beauty of a combination of tones or colours, too—in accordance with the principle of 'unity in variety'—depends on the numerical relations between its elements. It will be remembered, that Aristotle held that it is in terms of colour we receive information about other qualities of an observed body, like shape, size etc. When he wrote[28] that "Not even the most beautiful colours offer, if they are applied without a system, the same stimulation as a portrait, sketched in black and white," he probably, then, did not only refer to the mimetic and ideational requirements, but to the systematic, harmonious application of the numerical values of colour[29].

1. Grassi 1962. Cf. the survey in Pochat 1973 pp 31 ff.
2. Cf., however Plutach (*Moralia* 16 c; Lee 1940 p 202 n 26), who compared colour to plausible fiction in poetry and held that it "stimulates more than linear drawing because it is life-like and creates an illusion."
3. Emond 1964 pp 36 f; Osborne 1970 pp 99 ff.
4. In particular Grassi *op.cit.* pp 142 f.
5. *Poetics* 1450 b, 1451 a, 1459 a; cf. Emond *op.cit.* p 64. Aristotle here develops what Plato wrote in *Phaedrus* 264 C and *Rep.* IV 420 D. Grassi *loc.cit.* writes that "Diese Ordnung und Grösse darf nicht abstrakt, sondern nur aus dem, was im Poetischen als das Wirkende gilt, verstanden werden: der Mythos bestimmt Einheit und Ordnung der Teile, er ist der Rahmen, in dem alles Erscheinende in seiner Daseinsform und Gliederung erschlossen wird" ... "Ordnung der Teile

und Grösse eines Kunstwerkes, seine Schönheit, ist nicht abstrakt von irgendwelchen Massen und Proportionen abzuleiten."

6. Cf. Danti 1567 below, chap. AII.

7. Cf. Alberti 1435—36 below, chap. BII and n 48.

8. Grassi *op.cit.* pp 49 ff.

9. Known only through later references, in particular by Galen (*In Placitis Hippocratis et Platonis,* V 3; Diels-Krantz fr. A 3; quoted by Panofsky 1955 p 64 and Grassi *op.cit.* pp 52 f): "Beauty, on the other hand, he [Chrysippus] thought, does not like health consist in the symmetry of the elements, but in the symmetry of the parts, the proportion of one finger to another, of all fingers to the rest of the hand and the wrist, of these two to the forearm, of the forearm to the upper arm, in fine of all parts to all others, as it is written in the Kanon of Polyclitos." Cf. Osborne 1970 pp 99 f.

10. Xenophon defined formal beauty as proper function, but at least acknowledged the existence of proportional beauty in *Memorabilia* III 10, 12, where he writes, with regard to the proportions of a metal harness: "You [Pistias] don't seem, remarked Socrates, to refer to the well-proportioned *per se,* but in relation to the user, as when you say that a shield is well-proportioned to whom it fits, and it seems to be the same with a cloak and similar things..." Cf. Panofsky (1924) 1968 p 29 n 41.

11. *Philebos* 25 e, 26 b, 55 e; cf. *Timaeus* 31 b, 32 c, 87 e and *Nomoi* II 665 a; Grassi *op.cit.* pp 91f.

12. *Timaeus* 35 b—36 z, 41 d, 43 d, 90 a, b; *Rep.* 399 a, 616 a. This tradition was transmitted to the Renaissance by Macrobius, *Comm. in Somnium Scipionis,* (in particular II i, 7 ff, 14 ff, 21 ff; Walker 1958 pp 14 f; Ciardi 1973— I pp xxii and n 86, xxxi n 91; Pochat 1973 pp 106, 147), Augustine, *De musica* (VI 10, 25; cf. Pochat *op.cit.* p 87 f and n 18) and Boëthius, *De musica* (I 9, 27); cf. below chap. BII.

13. Cf. note 10 above; Grassi *loc.cit.;* Osborne *op.cit.* p 100.

14. *De architectura libri decem* I 2, 3; 4; in Panofsky 1955 p 68 and Grassi *op.cit.* pp 163 f, 222; cf. Wittkower 1949.

15. Cf. note 10 above; Galen *(loc.cit.)* added "That the beauty of bodies, then, lies in symmetry, is held by all physicians and philosophers."

16. *Tusc. Disp.* IV 13: *Et ut corporis est quadem apta figura membrorum cum coloris suavitate eaque dicitur pulchritudo*; Panofsky (1924) 1968 p 29 n 41. According to Panofsky, the Stoa was the first philosophical school which formulated the doctrine of proportional beauty.

17. *De domo* §§ 7, 8; *Zeuxis* or *Antiochus* § 5; Panofsky *loc.cit;* Grassi *op.cit.* pp 245 ff.

18. Panofsky *loc.cit.* On its interpretation in the Renaissance, cf. below chap. BII.

19. I disagree with Panofsky *op.cit.* pp 29, 54.

20. *Ennead.* I 6, 3; Grassi *op.cit.* p 163. Grassi does not, however, mention Plotin's notion that the infusion of form is subject to resistance of matter; cf. Panofsky *op.cit.* pp 27 f and above chap. II n 92; below chap. BI 3.

21. *Ennead.* I 6, 4—6; Grassi *op.cit.* pp 259 f.

22. *Ennead.* I 6, 6; Grassi *loc.cit.*

23. See below chap. BII. Cf. *De civ. Dei* XXII. 19: *Omnis corporis pulchritudo est partium congruentia cum coloris suavitate;* Panofsky *op.cit.* p 36 n 2: cf. Pochat *op.cit.* pp 86 ff.

24. *De divin. nom.* IV. 7, quoted in Panofsky *loc.cit.*

25. Cf. Pochat *op.cit.* p 157.

26. *Sum.Theol.* I. qu. 39, a. 8; quoted in Panofsky *loc.cit.* and Pochat *loc.cit.* and n 222.
27. Below chap. BII. Cf. the similar theory of Plato above chap. II.
28. *Poetics* 1450 a, b.
29. This aspect is further developed below in chap. BII. It is very tempting to systematize Aristotle's analogy between the colours and the tones. He remarked that the relations 3:4 and 2:3 were instances of the easily detectible relations which made up the beautiful colours like red and purple. In order to make the numbers of elements analogous in both scales and to place violet at the center, we have to combine the two alternatives in *De sensu,* according to which either grey is considered a variant of black, or yellow a variant of white. Expressing the interval numbers of the octave—c 1/1, d 9/8, e 5/4, f 4/3, g 3/2, a 5/3, h 15/8, c 2/1—in percentage, making violet the center of the chromatic colours, and black analogous to the basic tone (c), and the basic tone of the following octave analogous to white, we get the following scale: (c) black 0 %, (d) grey 12,5 %, (e) blue 25 %, (f) green 33,2 %, (g) violet 50 %, (a) red 66,5 %, (h) yellow 87,5 %, (c) white 100 %; the interval number of (g) violet corresponds to one of the examples of desirable ratio. However, this proposition is altogether speculative and must not be seriously considered. Cf. Arcimboldo's colouristic note-system below chap. BII, and Wellek 1935 pp 348 f, 352.

# PART TWO. THE RENAISSANCE

## A. Organization and Terminology
## Chapter IA. Colour Scales

Of the characteristic qualities in and differences between colours, mentioned above, hue and lightness are those, according to which they adapt to serial orders[1]. The latter is most suited for practice; relative lightness was, however, of great importance for *rilievo* and for transferring tonal values from polychrome to monochrome techniques or *vice versa*. The criterion of lightness, inherited from Aristotle, was given a particular significance during the Middle Ages, when light, according to Neo-Platonic tradition, was associated with divine influence. Such scales, based on relative lightness, are thus to be considered a kind of hierarchic scales of value.

The principle of hue presupposes the differentiation of chromatic and unchromatic colours. The former are related to each other in a naturally fixed way—yellow can be either greenish or reddish, red yellowish or bluish, blue reddish or greenish, green bluish or yellowish. The linear series thus formed have arbitrary terminal points, which in modern colour-systematization have been closed as to form a circle (See fig. above p 11), separated from the unchromatic linear scale of gray tones, limited by white and black.

This reiteration is motivated, since it is stated even in qualified studies on colour theory that the very definition of a colour scale is that it begins with white and ends in black[2].

In order to relate the conceptions of a limited range of colours among the Renaissance art theorists to previous conceptions, emanating from light, perceptual and chemical theories, I will briefly summarize them and add a few without the necessary qualifications: Empedocles thought of white and black as two 'primary' colours, creating other colours. Democritus and Plato thought that white, black, yellow—Plato replaced yellow with 'shining'—and red were 'primary' colours. Aristotle, in connection with the rainbow, stated that red, green and blue were the three 'primary' colours, produced by reflected light in a successivly darkening medium; yellow, produced by contrast, was included as a 'secondary' colour. In another work he wrote that white and black, when mixed in different proportions, result in five distinct—a kind of 'elementary'—colours: (white) yellow, red, violet, green, blue (black). Theophrastus indicated how the surface colours change during the general process of organic combustion: the yellow heat

acts upon the white embryo and causes it to a 'blackening', i.e. to a chromatic change which can only be generally described, as for instance from white to black via green, red and blue. Galen refers to a Pythagorean range of four 'primary' colours: white, black, red and the ambiguous *pallidum*[3]. Finally, a few authors from Antiquity described a limited range of colours used by particular artists; Pliny states that Apelles, Aetion, Melanthius and Nichomachus used four colours—white, yellow, red and black; Cicero vaguely states that Zeuxis, Polygnotos and Timanthes used four colours.

Aristotle was the main source in natural science in the Middle Ages. His observations in *Meteorologica* on the three 'primary' colours in the rainbow were repeated by Averroës († 1198), Grosseteste, Bacon and Vitello[4]. His abstract scale in *De sensu*, based on lightness, was well adapted to the Christian, symbolic interpretation of light, and the number seven to the analogies of tones, liberal arts, planets, days of the week[5] etc., and was either correctly rendered—as in de Moerbeke's translation[6], commented by, among others, Thomas Aquinas—or regarded as a point of departure for similar scales; Grosseteste[7] presents a light scale with fourteen colours between white and black, and Bacon one with only three[8]; however, the concept of a colour scale was not very important in the Middle Ages[9]. The scales based on lightness was furthermore not the only system of a hierarchic character; the monetary value of pigments led to another hierarchy, of which at least the climax is known: gold and ultramarine-blue; the second lightest and the second darkest, then, held the first places[10].

## Scales Based on Relative Lightness

Since the criterion of lightness had a restricted value for the practical or artistic use of colours, it was primarily used by the Renaissance successors of the Neo-Platonic tradition to illustrate their philosophical or theological thesis. Centered around Ficino and the Platonic academy in Florence around and after the middle of the Quattrocento, its influence was again noticable in art theory a hundred years later.

Ficino[11] presents a scale of thirteen steps: black — brown — dark yellow — dark blue — dark green — sky blue and sea green — dark red — bright red — saffron yellow — white — transparent — bright — the concept of brightness; in reality, only the steps limited by white and black are colours, defined as opaque light, but including physical appearances as well as material pigments. Portio 1548 does not present a fixed scale, but agrees with Aristotle that different proportions of white and black produce innumerous colours[12]. Cardano 1563 presents several scales based on the same principle[13]; the most detailed even fixes the percentage of light in

every step: white 100 %, yellow 70—65 %, green 62 %, red 50 %[14], grass-green 40 %, purple 30 %, blue 25 %, 'dark' (*fuscus*) 20 %, black 0 %. Dolce 1565 gives another version of the scale in *De sensu;* between two extremes, white and black, there are five colours, partaking of the nature of the extremes: *E questi sono il violato, il croceo, che è il giallo, il vermiglio, il purpureo, che noi diremo purpurino, et il verde*[15]. (COLOUR PLATE II.)

In divergence with the first alternative in *De sensu,* violet has been placed in front of, instead of after, yellow—red; if we by purple understand blue, it has changed place with green in front of black[16]. The reason for this change is perhaps that the sequence yellow — red — blue — green is obtained, but since violet is not inserted between red and blue, no chromatic scale is gained. Lomazzo 1584 repeats this scale: *bianco — violaceo/ pallido — croceo/giallo — rosso — purpureo — verde — nero*[17]. Comanini 1591[18] describes a colour scale developed by Arcimboldo († 1593), quite in accordance with Aristotle's indications in *De sensu* formed as a chromatic, musical note-system, but based on a successive darkening according to the sequence white — yellow — green — blue — dark violet — brown; black, the other constituent factor, is thus neglected. Calli 1595[19] departs from the dynamic and chemical aspects of colour in Aristotle and Theophrastus; he calls yellow *impurata luce* and red *di più impurata luce* and regards light as an excessive variant of white and darkness as an excessive variant of black; white and black are not colours, but *origine e principio di questi;* black is also called *la somma perfezzione d'oscurità in tutti colori*[20]. He says that the eye is the superior systematizer of colours, but accepts a scale: white — yellow — red — green — blue (turquoise) — dark violet — black. The resemblence to the colour-cycles of organic combustion in *De coloribus* is striking.

## Chromatic Scales

It has rightly been stated, that the ambition to organize the phenomenon of colour in a rational way was an example of the ambition to secure a high social and scientific status for painting[21]; certainly also the practical necessities of the fabrication and trade with pigments were contributing factors[22]. Pigments hold a peculiar position as a phenomenon; they constitute neither an immaterial form of light nor the limit of a body; they are both and neither one simultaneously. This confusing relation has caused problems; Aristotle noticed the difference between the two forms of colour, but was unable to separate them rationally. Theophrastus, however, claimed that one cannot know the true nature of colour by mixing pigments. It is interesting to compare his attitude to Leonardo's—the latter thought

that the physical appearance of colours—like the rainbow—could only be explained by experiments with pigments[23].

Cennini ca 1400 lists pigments without making any attempt of a scale[24]. His list will nevertheless be discussed here, since it has been argued[25] that Cennini, by instructing the painter to use dark colours in the distant zone in order to give an impression fo distance, represents an 'atelier practice' of Aristotle's colour theory; *chiari* should not, according to this practice, mean colours mixed with white, but the colours within the 'white' region of Aristotle's colour scale, i.e. white, yellow, red and green; *scuri* should not mean colours mixed with black, but those within the 'black' region, i.e. violet, purple, brown, blue and grey. *Chiari* should also refer to 'warm' and 'approaching' colours, *scuri* to 'cold' and 'receding'. This interpretation is based on several mistakes—in particular that green in the Aristotelian colour scale—which upposedly alludes to the analogy in *De Sensu* though it is said to include purple and brown—belongs to the 'white' region (in reality only yellow and red belongs there). Furthermore it is suggested that the colours in the Aristotelian colour theory were associated with temperature and distance in a definite way (in reality the analogies to temperature were only indicated by and differentiating between Aristotle and Theophrastus).

Lebègue ca 1410 states[26] in an introductory glossary that the colours, like the planets, are seven; two extremes, white (*albus*) and black (*niger*), and five intermediate, blue (*lazurius*)[27], red (*rubeus*)[28], yellow (*croceus seu aureus*)[29], green (*viridis*)[30] and sanguine/purple/violet/brown (*sangineus*[31] *seu purpureus*[32] *aut violetus*[33] *vel fulvus*)[34]. The chromatic colours are not related to the extremes and the order does not correspond to *De sensu*; except for violet, again not placed between blue and red, the chromatic colours are arranged properly and separated from the unchromatic.

Alberti 1435—36 begins the discussion of light and colour by stating their mutual dependence; if light is lacking, so is colour; when light returns, so does colour[35]. In *De Pictura* he goes on with a—apparently contradictory—presentation of the Aristotelian theory in *De sensu*; between the extremes white and black, five colours are grouped around a center, on the sides of which a couple of undetermined colours, related to the extremes, are placed. He does not want to reject this theory, but immediately adds that he does not like to be contradicted by those who claim that white and black are the cause of the colours. What he evidently means is, that it is acceptable to order the colours according to their relative lightness, but unacceptable to think of white and black as the constituents of the chromatic colours. The continuation is common to *De Pictura* and *Della Pittura*: Alberti presents his own colour theory, adapted to painting. There are only four true colours, corresponding to the four elements: red (*rosso*) is the colour of fire, blue (*cilestrino*) of air, green (*verde*) of water;

47

*terra vero cinereum colorem habet (De Pictura); et la terra bigia et cene-riccia (Della Pictura).*

Before considering which colour he associated with earth, we may establish the fact that Alberti rejected the theory that white and black are the origin of the other colours, which are said to be four. He thus draws the logical conclusion of the separation of the chromatic and unchromatic colours; of the former *genera* the addition of white or black creates many *species* without the transformation of the *genus:* white and black are not true colours but modulators *(alteratores)* of the true, i.e. the chromatic colours. Thus, the fourth colour, in order to fit into the system, ought to be a chromatic colour, which is revealed by the following examples Alberti gives of the variations of the four elementary colours, now ordered as green, blue, red and the colour of earth, by the addition of white: "We see green fronds lose their greenness little by little until they finally become pale. Similarly, it is not unusual to see a whitish vapour in the air around the horizon, which fades out little by little [as one looks towards the zenith]. We see some roses which are quite purple, others like the cheeks of young girls, others ivory. In the same way the earth[en colour], according to white and black, makes its own species of colours[36]." That yellow is referred to as the earthen colour is also revealed by the fact that he adds that "you never find white and black unless they are mixed with one of these four colours[37]".

Herbert Siebenhüner is the only art historian who has claimed that by the exclusion of white and black Alberti ushered the colour systematization into a new era[38]; however, he did not react against the inconsistency created by the interpretation of the unchromatic grey[39] as the elementary colour of earth. The prevalent opinion, based on this interpretation, which in also indicated in modern dictionaries, is logically that Alberti did not present any colour scale[40]. Those who have commented upon the lack of yellow in the consequently incomplete colour scale, have either maintained that yellow was an unstable and poisonous pigment[41] or that Alberti, because of his Aristotelian dependence, could not accept yellow as an elementary colour[42]. The latter theory is quite improbable since Alberi explicitly rejected the Aristotelian theory that white and black are constituents of chromatic colours; his pragmatic ambitions made it impossible to accept a theory, according to which a mixture of white and black resulted in yellow. In a way, however, there are certain affinities between his and the Aristotelian theory: yellow was not accepted as a 'primary' colour in *Meteorologica,* but it was indeed included among the 'elementary' colours in *De sensu,* and above all, white and black were indeed separated from the chromatic colours. The association of the colours and the four elements was indicated by Aristotle and clearly stated by Theophrastus. Albertis' associations to the elements are, however, partly independent of tradi-

48

tion[43]; they are based on natural observations without regard to humoral pathology or astrology.

The first three colours, red, blue and green, make up a continous chromatic range, which would be perfected by yellow, which via orange turns to red[44]. Yellow is indeed identified as a surface-colour by Alberti, who in other places, however, uses its pigment designation, *croceo*[45].

In order to clarify which colour Alberti associated with earth, it is instructive to compare his theory with Filarete and Leonardo, who certainly had knowledge of his colour scale. Filarete 1451—64 includes white and black in a scale of six—not seven—colours: black, white, blue, red, green and *yellow*[46]. Black and white are separated from the four chromatic colours, which however, are not ordered continously. His dependence of Alberti[47] is also revealed by the practical explanation of his inclusion of black[48] in his scale: *perchè sanza esso non si può fare, noi l'abbimo messo nel numero d'essi*. The associations to the elements—another revelation of an Albertian influence—differ from both tradition and Alberti: blue for air and red for fire is in accordance with the latter, but green is associated with verdure—*erbe*—and yellow with gold.

Leonardo's general knowledge of and influence by Alberti is well established[49]. He agrees with Alberti concerning white and black[50], but in almost the same words he refers to the same practical reason for their inclusion as had Filarete: *perchè il pittore non po fare senza questi, noi li metermo nel numero degli altri*[51]. Like Alberti he associates the four chromatic colours with the elements: *e'l giallo per la terra, il verde per l'acqua, el l'azurro per l'aria, e'l rosso per fuoco*; without any comment, motivated by another divergence from his predecessor, he includes yellow and associates it with earth.

The meaning of Alberti's *bigia e cenericcia* may also be clarified by a comparison with other Renaissance texts dealing with colour theory. I have found *bigio* mentioned in eleven texts: (1) Cennini ca 1400, (2) Filarete ca 1451—64, (3) MS Marciana ca 1503—27, (4) Alciato b. 1550, (5) Dolce 1565, (6) Vasari 1547 and (7) 1568, (8) R. Borghini 1584, (9) Lomazzo 1584, (10) Calli 1595, and (11) Zuccari 1607. Of these, (1), (2), (3) (5), (6), (8) and (9) contain more detailed information about *bigio,* whereas (4), (7) and (10) state that it may occur as a complexion. (2) Filarete[52] says that a mixture of white and black *fa bigio,* and (9) Lomazzo[53] that white *col nero fa il color bigio*. Also (8) R. Borghini[54] defines *bigio* as a *color mezzano fra il biancho e il nero* but adds, that there are several kinds of *bigio*—some tending towards dark, others towards white, dark violet, . . . *Il bigio chiaro, macciato di piccole punte di rosso . . . Il bigio cenerognolo, per essere di color di cenere . . .*, others tending towards black and one called *bigio argentino*. (5) Dolce[55] also defines *bigio* as a colour *tra il bianco e'l nero,* but adds that sheep's wool *per lo più è de tal colore*

and that *Del quale per umiltà si vestono i frati di San Francesco* ... *Ma onde avviene che volendo significare un uomo cattivo, si dice volgarmente anima bigia o berettina, e parimente l'Ariosto chiamò i diavoli dell'Inferno spiriti bigi* ... Also (6) Vasari 1547[56] defines, in an ironic analogy between the *paragone* and *una lite* .. *ne'frati bigi e neri, della Concezzione, bigio* as the colour of the Franciscan dress, i.e. a beige colour, greyish yellow. A yellow hue is furthermore indicated in (1) Cennini[57], who describes the preparation of *tinta berettina, o ver bigia:* ...*Prima togli un quarro di biacca grossa, quanto una fava d'ocria chiara, men che mezza fava di nero,* in (3) MS Marciana[58]: [per fare] *Bigio, piglia biacca, verde terra, ocria, et nero,* and in (8) R. Borghini[59]: *Et il color bigio si farà con un quarto di biacca, quanto una fava d'ocria chiara, quanto un ceco di nero.* (7) Vasari 1568[60], in a description of his "Adoration of the Magi" in Sa. Maria de'Scuola d'Arimini, where the members gathered from different courts could be differentiated and associated with their continent and king by their complexion: *alcuno hanno le carnagioni bianche, i secondi bigi, ed altri neri* ... (4) Alciato[61], (10) Calli[62] and (11) Zuccari[63] touch upon *bigio* in a general way; the first two ascribe a negative significance to it due to its undetermined character and expression as a complexion. The analogy between *bigio* and *berettino* indicated in (1) and (5), is interesting; *berettino* is more frequent than *bigio*[64], and just like that, though often defined as gray, it has preserved into our own times both a chromatic meaning—grayish green—and a negative significance—bad, evil.

It may thus be confirmed that *bigio* in the majority of the more precise definitions was thought to have a yellow hue. A preliminary etymological study of the meaning of *bigio* has generously been offered to me by Professor Mario Alinei[65], who draws attention to the following problems: *bigio* lacks a convincing etymology— the prevalent view is that it is derived from the Latin *bombyceus,* of *bomyx,* silk-worm. If that origin is accepted, *bigio* would be associated with its yellow-brown colour. The French *beige* lacks, according to Prof. Alinei, etymology, and consequently a probable connection cannot be certified. *Bigio* is not an active or productive word in modern Italian, but is still used in Toscana; an investigation based on interviews ought to be undertaken. Its use in the case of Alberti, finally, refers to a historical era.

Professor Alinei has examined the colours of birds, in whose regional and common denominations *bigio* is an integral part—*bigino (Riparia riparia), bigiola (Sylvia atricapilla), bigione (Sylvia simplex), bigiarella (Sylvia hortensis);* except for one, the colour af all these is described in ornithological literature as grey-brown. Also studies of contemporary literature confirms that *bigio* was held to have an unsaturated, dark-yellow hue; reference to the Franciscan dress and the still common *pane bigio* point in the same direction. Professor Alinei concludes "that Alberti meant

'yellow' and not 'grey' by *terra bigia,* seems to me quite acceptable."

The case of *cenericcio,* however, is less clear; the association with yellow and the colour of ashes is supported by ancient Greek, in which yellow was associated with the colour of sand, ashes and earth[66]. It is also indicated by the French *cendré,* above all used to describe a feeble yellow hue in grayish hair. The colour of ashes depends on what has been burnt—*bistro,* the yellow-brown ink, was prepared from ashes of resinous wood. Yellowish ashes are thus quite conceivable, and *cenericcio* was connected with *bigio* by R. Borghini, who gave a recipe for *bigio,* containing yellow ochre. That Alberti meant something different than saturated yellow, however, is revealed by his advice for combination of colours: white is beautiful between *cinereum* and *croceum*[67].

In my opinion, then, the facts referred support the general supposition, based on the claim for systematic consistency of the separation of unchromatic and chromatic colours, that the fourth chromatic colour was yellow. Alberti presented a pragmatic system by separating the unchromatic white and black from the four chromatic 'elementary' colours, red, blue, green and yellow. (COLOUR PLATE IX) The reason for his choice of the ambiguous terms *bigia e cenericcia* will be analyzed below (chap. B III 3), but it might be added that the association of *bigio* and *terra* offered a unique possibility of connecting the origin of the pigment, *terra,* with its element[68].

Filarete has already been examined; the divergences from Alberti rather confirm the dependence. It might be added that he gives more details about the relations between the four *principali,* chromatic colours and the *mischie,* the derived colours; blue and red give violet, tending to either components[69].

Also Leonardo ca 1490—1510 has been examined. Two colour-lists are preserved, of which only one, the above-mentioned, may be regarded as a scale; both, however, reveal an Albertian influence. In the list of eight pigments, white and black are included—*benché questi non sono messi fra i colori*[70]—because of their importance for the rendering of *rilievo:* white represents light, black darkness. The hues of the pigments, blue, yellow, green, ochre—*leonino, cioé taneto o vo'dire oguria*—violet and red, are separated, as with Filarete, in 'elementary' called *semplici,* and derived, called *composti.*

The real colour scale[71] bears a certain resemblance to the Aristotelian scale in *De sensu;* however, violet is excluded and replaced by blue between red and green, which have changed places; since red is placed next to black, the character of a scale based on relative lightness is eliminated, in spite of Leonardo's idea that the effect of the blue colour of the sky, produced by the mixture of scattered white light seen against the blackness of the ether, can be imitated by superposition of a white glaze over a black

underpainting. The six colours, white, black and yellow, green, blue and red, are again referred to as *semplici;* in another place[72], however, he corrects that statement and calls, aiming at the distinction between primary and secondary colours, blue and green *composti;* blue, because it is produced by light and darkness or white and black, and green because it is composed by a *semplice,* yellow, and a *composto,* blue.

The reason for the lack of a systematic discussion of rational colour scales during the Cinquecento is probably twofold—on the one hand the Albertian scale was too well established to be repeated[73], and on the other the change towards speculative art theory and a general ambition to manifest aquaintance with ancient philosophy are responsable for the apparent rebirth of the Aristotelian system.

Equicola 1526[74] considers white and black the only 'pure' colours, and Morato 1535[75], misinterpreting the Aristotelian scale, classifies white and yellow as 'primary' colours. R. Borghini 1584[76] ranks the colours according to a confusing conglomerate of their monetary and symbolical value, derived from a heraldic *trattato,* della Frata 1551[77]. The result is a completely irrational scale: yellow/gold — white — red — blue — black — green — purple. Purple, it is stated, only apparently giving the list a character of an accumulative system, is the result of all the other colours, called *principali*[78].

The same 'scale' and indication of purple is referred by Lomazzo 1584[79] as a confusing complement to the Aristotelian variant, based on relative lightness; in connection to this scale, Lomazzo constructs a system of analogies to planets, humours and elements.

1. Cf. above, introduction.
2. Cf. Barasch 1963 p 84: "If these two colours are not included (as with Alberti), or if they are not placed as the extremes (as with Cennini), the other colours lose all sequence and cannot be said to form even the loosest unit."
3. Cf. Lomazzo 1584 and nn 17, 68.
4. On Averoës and Vitello. cf. Edgerton 1969 p 120 n 24; on the diverging interpretations of Grosseteste and Bacon. cf. Lindberg 1976 p 102 n 82 and Barasch *op.cit.* p 77 and n 9.
5. Ackermann 1964 p 157 n 150; Ciardi 1973— II p 266 n 2.
6. Renders the first alternative—white, yellow, red, violet, green, blue, black; Thomas, however, misinterpreted *alurgon,* (violet) as reddish yellow; Edgerton *op.cit.* p 117 and n 18.
7. Baur 1912 p 78 f; ten Doesschate 1962 p 326; Edgerton *op.cit.* p 116 n 16.
8. A variant of Aristoteles' second alternative which excludes yellow; by excluding also violet and considering blue and gray as one distinct shade, it consists of white, gray-blue, red, green and black; Edgerton *loc.cit.*
9. I agree with Barasch *op.cit.* pp 77 ff.
10. Cf. the evolutive scale of alchemy above chap. III n 29.

11. Letter to Giovanni Cavalcanti (*Opera omnia* 1576 I p 825 ff); in Barasch 1960 p 293; *ibidem* 1963 p 80 f.

12. The relations between certain colours are indicated but not fixed; Barasch 1963 p 82.

13. p 556; *loc.cit. In De subtilitate,* Basilea 1547, Lib. 2, 13, and *De Rerum Varietate,* Basilea 1552,, 3, 14, he adhered to Aristotle's associations between colours, tones and flavours; Wellek 1935 p 348 n 3.

14. The idea that red lies in the middle between white and black emanates from Bacon, *Opus maius;* ed. Burke 1962, ii, p 611.

15. Barocchi 1971— II p 2214.

16. Green next to black is against the Aristotelian tradition, but agrees with Bacon's scale above.

17. Lib. III, chap. 3; Barasch *op.cit.* p 84; Baroocchi 1971— II pp 2231 f; ed. 1973— II p 168.

18. Ed. 1960— III pp 368 ff; cf. below chap. B II.

19. Barocchi *op.cit.* II p 2335.

20. *op.cit.* pp 2325 f.

21. Barasch 1963 p 75.

22. Claimed by Arnheim (1956) 1972 p 288; denied by Barasch *loc.cit.*

23. Windsor 19076 a; Richter (1883) 1970 I § 287.

24. Chap. 24; ed. 1971 p 35. Cf Barasch *op.cit.* p 78.

25. Edgerton 1969 p 130 f.

26. Merrifield (1848) 1967 I p 23.

27. *op.cit.* I pp xxiii and 30.

28. *op.cit.* I xxviii and 34.

29. *op.cit.* I xvii and 22; xiii and 18.

30. *op.cit.* I xxxiv and 37.

31. *op.cit.* I xxii, xxix and 36.

32. *op.cit.* I xxvii and 33.

33. *op.cit.* I xxii and 38.

34. *op.cit.* I xiv, xix and 27.

35. ed. (1956) 1967 p 49 f; Grayson 1972 p 44 f; cf. Siebenhüner 1935 pp 18 ff; Mallè 1950 p 63.

36. *ed.cit.* p 50; Grayson *op.cit.* p 47.

37. This must be regarded a concession to Alberti's pragmatic aims, since he elsewhere acknowledges white and black as local colours; *ed.cit.* p 84 f.

38. *op.cit.* pp 18 f.

39. *loc.cit.:* "Bleigrau oder Aschgrau".

40. Janitschek 1877 p 65; Spencer (1956) 1967 pp 49 f and n 23; Elliot 1958 p 459; Barasch 1960 p 291; *ibidem* 1963 p 79; Pedretti 1964 p 56 and n 61; Edgerton 1969 p 126 f; Baxandall 1972 p 81; Grayson 1972 pp 46 f. Schlosser 1924 p 108 translates it "gelb", but does not draw any conclusions thereof.

41. Spencer *loc.cit.*

42. Edgerton *loc.cit.* On the pragmaticism of Alberti, cf. Baxandall 1971 pp 121, 127 ff.

43. On the associations of fire with red and of air with blue, cf. above p 36. For a different interpretation, cf. Edgerton *op.cit.* pp 119, 121, 123 f, 129.

44. Cf. above p 10.

45. Ed. (1956) 1967 pp 50 and n 23: 84 f.

46. Ed. 1890 p 634.

47. Cf. Pedretti *loc.cit.*

48. Why he does not make any qualifications for white cannot be explained.

49. Cf. Clark 1945 p 16; Mallè 1950 p 63; Spencer *op.cit.* pp 12, 23, 121, 134; Pedretti *op.cit.* p 21; for a diverging opinion, cf. Huyghe 1962 p 232.

50. Mallè *loc.cit.* and n 1; cf. ed. 1882 TPP 213, 254.

51. TP 254.

52. Ed. 1890 p 635.

53. Lib. III chap 7; ed. 1973— I p 171.

54. Ed. 1807 I pp 202, 283 f.

55. Barocchi 1971— II pp 2220 f and n 7; The source is Telesio 1528.

56. Ed. 1960— I p 60; Barocchi *op.cit.* I p 494.

57. Chap. 15, 81, 82 and the quoted 22; ed. 1971 pp 16, 92; 24.

58. Merrifield (1848) 1967 II § 306 p 610.

59. pp 136 ff; in Barocchi *op.cit.* II p 1987.

60. Ed. 1878— VII p 684.

61. Barocchi *op.cit.* II p 2341.

62. *op.cit.* II p 2334.

63. *op.cit.* I p 706.

64. Cf. Aquilano before 1535 (Barocchi *op.cit.* II pp 2159, 2342); Morato 1535 (*op.cit.* II pp 2159, 2171); Occolti 1568 (*op.cit.* II p 2198); de'Rinaldi 1584 (*op.cit.* II p 2306); A. Beffa (*op.cit.* II p 2340); G. Beffa (*op.cit.* II p 2341); Lomazzo 1584 (ed. 1973— II p 402.

65. The following is a summary of a letter from Professor Alinei at the Instituut voor italianse taal- en letterkunde at the University of Utrecht, dated the 15th of May 1977. On *bigio* as the colour of the dress of certain religious orders, it may be added that *bigio* was the colour of the original Franciscan dress, later in particular of the capuchins. *Panno* or *abito bigio* signified umility (*humus = terra*), offering another association to the element earth. The cloth was in fact called *bigello* (Dante, *Purg.* 20—54; Michelagelo, *Rime,* ed. V. Piccoli, Torino 1944, 261—55; Vasari, *Lettere,* in *Opera,* ed. G. Masselli, Firenze 1832—38, II, 475). To enter a convent was called *"rendersi in panni bigi"* (Dante, *Inferno,* xxvii, 83; *Fiore* cxxix, 2; cf. Petrarca, *Rime,* ed. E. Chiorboli, Bari 1930, 53—60). *Suore bigi* was the name for the Elisabethian nuns. Two original *tonaci* of Franciscus of Assisi are kept as reliques in S. Francesco in Assisi and S. Salvatore in Florence, both discribed as *grigie;* the iconography of Fransiscus is said to include the colour of his dress, specified as *grigio (poi nero o marrone),* i.e. "gray, black or chestnut brown" (*Bibliotheca Sanctorum,* Roma 1964, V). See *Enciclopedia Dantesca,* I (*bigio*); *Grande Dizionario della Linqua Italiana,* II, 1962 (*bigio*); *Dictionnaire des symboles* p 126 (Brun) and cf. Vasari and Dolce above.

66. Edgerton *op.cit.* pp 116 ff.

67. Grayson 1972 p 92; ed. (1956) 1967 p 85; Elliot 1958 p 459.

68. Edgerton *op.cit.* p 127, claims that it would be natural for a Tuscan to associate the earthen colour with gray. That this is not the case is revealed by Leonardo ca 1490—1510 (ed. 1882 TP 192), who in an observation of reflections from a wet street notes that the parts of the head which face the street become coloured by its *giallezza.* Cf. Lomazzo 1584 (Lib. VI chap. 59; ed. 1973— II p 402), who in accordance with the association between Saturn and earth couples it to a black colour, but nevertheless writes that *ancora si mostra col giallo per la sua siccità,* and on *pallido,* which is said to resemble *giallino* made by yellow and white but tending to black, that *l'uomo non dà buon segno quando s'impallidisce e vien di questo color di terra in faccia.*

69. Ed. 1890 pp 634 ff.

70. Ed. 1882 TP 213. That white is not a genuine colour is also stated in TPP

86, 197, 207, 215, 247, 692, 699, 785; cf. Zubov 1968 p 141.
71. *Ed.cit.* TP 254; Libro A 51; Pedretti 1964 p 56.
72. *Ed.cit.* TP 255.
73. Cf. Biondo 1549 (ed. 1873 p 41); Armenini 1586 (Barocchi 1971— I p 955).
74. Barocchi *op.cit.* II p 2153.
75. Cf. the alchemic, evolutive scale above chap. III n 29.
76. Ed. 1807 I pp 270 ff.
77. Cf. Ciardi 1973— I p 401 n 1.
78. The source of this strange theory of purple is Theophrastus' notes in *De coloribus* on the effect of the dye derived from the Periwinkle (*Littorina littoralis, Murex* and *Purpura*); ed. Goethe 1963 § 50 p 32.
79. Lib. VI chap. 59; ed. 1973— I p 402.

# Chapter IIA. Definitions

## Bellezza: quantità e qualità

The Renaissance inherited on the one hand the Platonic, 'classical' definition of beauty, foremost associated with Aristotle and comprehended by Cicero, and on the other the Neo-Platonic and theological, medieval identification of goodness, *bonum,* and beauty, *pulchrum*[1]. The former was interpreted as to associate beauty either with functional form (Danti 1567)[2] or with that which stimulates lust (Nifo 1549)[3], and the latter to associate beauty with individual expression (Bruno)[4].

Most important in the art theory was the formal definition. It was also incorporated in the Neo-Platonic notion that formal beauty may only enter into matter which is 'prepared' to receive it as *ordine* (the relation between the parts), *misura* (the quantity) and *specie* (lines and colours)[5]. In its pure form it was—with the exceptions indicated above—generally comprehended, even though among others Ghiberti ca 1450[6], Equicola 1525[7] and Dolce 1557[8] discussed the impossibility of defining, in purely formal terms, the character of charm, *grazia* or *venustà*, which particularly in Vasari 1568 was regarded as an ideal sign of an unstrained mastery of the rules[9].

In order to illustrate the relation between the concepts of quantity and quality in connection with colour, I have chosen two rather different aspects: (1) For the medieval concept of *claritas,* the visual distinctness with which the properties of a body appear, colour played a primary role, parallel to the concept of *species* both in optical and perceptual terminology and in the Neo-Platonic differentiation of *ordine, modo* and *specie;* it means the formal distinctness with which the visual qualities are perceived, without any material quantity. Quantity, then, was not only a positive formal property, but one negatively associated to matter. This

is evident in as different works as Leonardo ca 1490—1510, Speroni ca 1570—80 and Lomazzo 1584. At the same time as Leonardo stressed the often suggested relationship between drawing and geometry in order to elevate its social status, he realized that art by this association tends to be reduced to a kind of univerally intelligible and practicable, however useful, distraction; he established, therefore, that art concerns quality and science (only) quantity[10]. Like Leonardo[11], Speroni associated quantity with sculpture: *quanto è più nobile la qualità della quantità, tanto è più nobile la pittura della scultura*[12]. Lomazzo, too, interpreted *quantità* as a negative concept, imitatively and expressivly limited and associated with matter: *dicono i filosofi che ne la quantità non si truova propriamente similtudine, ma solamente ne la qualità, et il colore ch'adopra il pittore è qualità;* in quantitative imitation there is only *equalità*[13]. (2) Quantity nevertheless held an indisputable prominent position as an abstract, mental concept due to its association with mathematics. Formal beauty in music, architecture, anatomy and its applications in painting and sculpture, depended, according to the prevalent modern view, on certain numerical relations. But the fact that the self-evident, exclusive medium of the Pythagorean number symbolism in all the visual arts was thought to be *disegno* is, in my opinion, not correct[14]; as will be demonstrated below (chap. B II), line and colour were not regarded as two structurally incomparable concepts, but, on the contrary, the same kind of numerical, quantitative definition was thought to be applicable to individual and related units of both.

### Disegno-chiaroscuro-colore

The border-lines between *disegno, chiaroscuro* and *colore* are indistinct in the art theory of the Renaissance. Whereas most authors[15] identify drawing with lines and the rendering of light with colour, Filarete ca 1451—64[16], Pino 1548[17], Biondo 1549[18], Vasari 1568[19] and Lomazzo 1584[20] regard *chiaroscuro* as a separate category, and Cellini ca 1560[21] and Armenini 1586[22] assign *chiaroscuro* to drawing. Allori 1590[23] explains the divergent opinions by irrational linguistic usage; in his opinion lines belong rationally to drawing and colour to light. Working out from this statement, we may distinguish three different criteria according to which drawing, light and colour are related: (1) technical, (2) historical evolution and (3) formal and conceptual aesthetics and pedagogics.

(1) From a technical point of view, drawing and painting were generally conceived as two different categories; the drawing has an occasional character, which sometimes even implicates its consumption[24], whereas painting has an elaborated, definitive air. But the association of pencil with

drawing and of brushes with painting[25] does not clarify the position of *chiaroscuro;* Lomazzo 1584[26] and Allori 1590[27] explain that *chiaroscuro,* in the general sense, may be achieved by a mass of lines in varying proximity. In the spontaneous sketch, we may add, there is not even any distinction between contours and the rendering of light and atmosphere; they belong, actually, to another category than colour, in the sense of chromatic colour[28]. But from a strictly technical point of view, *chiaroscuro* designated a kind of monochrome, usually unchromatic paintings, generally painted *a fresco* as exterior façade decorations; there was, then, neither any fixed relation between drawing-monochromy and colour-polychormy nor between chromatic colour and *chiaroscuro.*

(2) The linear and monochrome properties of *disegno* were emphasized in the theory of historical evolution which was presented by Quintilian[29] and Pliny[30], and constantly referred in the Italian Renaissance art theory[31]. According to this theory, painting came into being when the Egyptian Philocles or the Corinthian Cleantes circumscribed the projected shadow of a man with black lines in what the Greeks were to call *monochromaton;* from this the polychrome painting was later developed. *Chiaroscuro* is not included in this theory, which, in point of principle, means, that the different stages and physical levels of the painting—contours, light and shadow, chromatic colours—correspond to different historical levels of evolution[32].

(3) Through its connection to mathematics and geometry, drawing was though to be—in spite of the partially negative associations between quantity and matter—of primary importance. Its forming capacity also made it associated with the ideational theme or content of the image[33]; *disegno* was coupled with *invenzione* and its realization, the *istoria.* Its relative immateriality contributed to its intellectual status[34]. *Disegno,* it may be concluded, was conceived as the theoretical and intellectual basis of painting, in the same way as the physical, chromatic painting was based on an underlying, invisible drawing.

## Pittura

The position of colour in the definitions of painting in the Italian Renaissance art theory mirrors its development. R. Alberti 1604, which represents the speculative academism of the late Cinquecento, makes, before giving his own encyclpedic definition (below) a critical survey of several earlier ones: Vasari's definition[35] is refuted as a technical description without any value. Another—general and unspecified—definition of painting as an imitation of nature with lines and colours, is regarded as better since the imitative function is pointed out, but not sufficient, since painting does

57

not only imitate the visible nature but also inner concepts. The lengthy definition in Lomazzo 1584[36], which lacks this distinction, but insists on the capacity of rendering emotional states, is related without any commentary. The definitions in Dolce 1557, also restricted to imitation of visible reality, are only partially treated in the limited, Vasarian definition[37], which is again refuted. Alberti 1435—36[38], finally, is also only partially referred and refuted as unsufficient. The manifest development towards R. Alberti's kind of 'total' definition—"Painting, daughter and mother of drawing, mirror of nature's soul, true representation of all concepts which are able to be imagined and formed, and of all occurences and all graces, appears outlined with the force of light and shadow on a flat surface covered by colour, revealing every kind of form in relief without any material, bodily substance. Its manifestations come into being by a successive addition of material fluid which is not perceived by the touch, artifice which is more divine, so to speak, than human; proper instruments, pencils, material, colours"[39]—may be distinguished in three categories: (1) technical, (2) conceptual-genetic and (3) perceptual-imitative.

(1) The technical definitions implicate the evolutionary stages of a painting[40]: Cennini ca 1400 states that *El fondamento dell'arte ... è il disegno e 'l colorire*[41]; Alberti 1435—36 distinguishes circumscription, composition and reception of light; the latter is synonymous with colouring[42], which is the case as well in Piero 1482: *disegno, commensuratio, colorire*[43], and in Biondo 1549, where Alberti's terms are repeated[44]. Among the many definitions of Leonardo ca 1490—1510 there are two which are influenced by Alberti: *Due sono le parti principali nelle quali si divide la pittura, cioè lineamenti, che circondano le figuri de 'corpi finti, li quali lineamenti si dimanda disegno. La seconda è detta ombra*[45]. It is less obvious that colouring is comprised in the rendering of light and shade in the similar definition: *Dividesi la pittura in due parti principali, delle quali la prima è figura, cioè la linea che distingue la figura delle corpi e lor particule; la seconda è il colore contenuto da essi termini*[46]. The technical definition of Vasari 1568 (above) is almost repeated literally in R. Borghini 1584[47]. Armenini 1586 differentiates rendering of light and colouring— *disegno, i lumi, le ombre, il colorito, il compimento*[48]—a distinction which corresponds to the phases in the glaze-technique, based on an illuminated and shadowed linear drawing.

(2) The conceptual and genetic kind of definitions is introduced in Pino 1548: *disegno, invenzione, colorire*[49]; the sequence is irrational, since invention follows drawing, which is separated in *giudicio, circumscrizzione, prattica* and *composizione*[50]. *Colorire* is separated in *proprietà, composizione-varietà-prontezza* and *lume*[51]; the rendering of light as well as the composition are—as in Alberti—associated with colour. Dolce 1557 corrects the order of Pino's categories in another definition: *invenzione,*

*disegno e colorito*[52]; invention is associated with *la favola o istoria*, which appears in the drawn sketch: *si appresenta per la forma, e la forma non è altro che disegno*. Lomazzo ca 1564, too, adheres to the tripartition *invenzione, disegno, collorito*[53].

(3) The perceptual and imitative definitions designate the perceptual qualities and imitative domains of painting. Leonardo ca 1490—1510 enumerates in five definitions[54] the ten *discorsi* or *ofizi* of painting: *luce, tenbre, colore, corpo, figura, sito, remozione, propinquità, moto e quiete*[55]. The elaborated definition of Lomazzo 1584 above is introduced by a designation of the elements of painting, which are dedicated one part each of the *Trattato: proporzione, moto, colore, lume, perspettiva*[56]. This division appears to be a rationalization of Leonardo's categories; proportion corresponds to Leonardo's "body" and "figure", movement to "movement" and "rest", colour to "colour", light to "light" and "darkness", perspective to "position", "distance" and "nearness".

Though already Cennini ca 1400 pointed out that the painter is able to imitate mental concepts[57], and Pino 1548 (above) introduced *invenzione* as an element of painting, it was not until Paleotti 1582 that this aspect was included in the definitions of painting: *essendo la pittura arte d'imitazione e che sta tutta nel rassomigliare le cose naturali o artificiali o imaginarie al vivo o al vero*[58]; V. Galileo 1589 defined painting as *una imitazione con lineamenti e colori, non solo di tutte le cose naturali et artificiali, ma di tutte quelle cose che è possibile a immaginarsi*[59]. The exhaustive definition in R. Alberti 1604 (above) was written under the influence of Zuccari, who later, in 1607, formulated a similar definition[60] with emphasis on the importance of mental concepts for subjects of paintings.

## Paragone

The comparisions between different arts have their roots in Antiquity and were frequent in the Middle Ages. They comprised both uditive (music, poetry, rhetorics) and visual arts (painting, sculpture). In this summary only the latter will be considered. In the Cinquecento the *paragone* was also specialized as comparisions between different schools, artists or styles within the same art, or rather between the formal elements which constituted them. It was frequent during the entire period, from Cennini ca 1400[61] to G. Galileo 1612, and soon turned into a kind of humanistic distraction—in particular as a court discussion[62]—in which unrealistic, sophistic arguments were brought forward[63]. Some of the arguments, however, reflect the struggle towards an elevated social position of the arts or contribute to the definitions of the particular qualities and functions of

art. Its most conspicuous manifestation was the enquiry, organized by Varchi and published 1547[64], in which Vasari, Bronzino, Pontormo, B. Tasso, Sangallo, Tribolo, Cellini and Michelangelo participated. The adherents of painting (p) argued that (p 1) it was regarded as an *ars liberale* in Antiquity[65], (p 2) it has been supported by royalty and nobility ever since[66], (p 3) it possesses universal possibilities of expression[67], (p 4) it represents *fatica di mente* as distinguished from the *fatica di corpo* of sculpture[68], (p 5) it offers decorative adornment[69], (p 6) it offers advantages and utility[70] and (p 7) it offers beauty and gratification[71]. The adherents of sculpture (s), on the other hand, emphasized (s 1) its high estimation in Antiquity[72], (s 2) its durability[73], (s 3) its tactile 'verity' or 'truth'[74] and (s 4) its *molte vedute*[75]. Varchi's summary, which aims at a suppression of the differences between painting and sculpture, establishes that they are both *arti imitanti,* a quite commendable aim[76]. The inquiry contributed to a standardization of the *paragone* in the Cinquecento; still in R. Borghini 1584 most of the arguments are repeated, yet in another order[77]: *antichità* (new argument), *vedute* (= s 4), *utilità* (= p 6), *nobilità* (= p 1, s 1), *ornamento* (= p 5), *difficultà* (= p 4), *pregio* (= p 2), *verità* (= s 3) and emotional expression (= p 3).

1. Klein-Zerner 1966 p 177; Osborne 1970 pp 284 ff; Barocchi 1971— II pp 1609 f.
2. Ed. 1960— I pp 209 ff; Barocchi *op.cit.* II pp 1563 ff, 1682 ff, 1760 ff; cf. Panofsky (1924) 1968 p 80 and nn 13, 14; p 95 n 59.
3. Barocchi *op.cit.* II pp 1646 ff; Klein-Zerner *op.cit.* pp 178 ff.
4. *Eroici Furori,* quoted in Panofsky *op.cit.* pp 67 and n 76; 73, 94, 118 n 20; *De vinculis in genere,* quoted in Klein-Zerner *op.cit.* pp 185 ff.
5. *specie* (cf. above chap. II) was called *aspetto* by Pico della Mirandola, *Dell 'amore celeste e divino. Canzone di Girolamo Benivieni Fiorentino, col comento del Conte Gio. Pico Mirandola,* Lucca 1731 pp 112 f; quoted in Barocchi *op.cit.* II p 1673); cf. Ficino 1469 (chap. VI; Panofsky *op.cit.* pp 97, 137); Ebreo ca 1501 (Barocchi *op.cit.* II pp 1628 ff) and Lomazzo 1590 (chap. 26; Panofsky *op.cit.* pp 97, 142 f; ed. 1973— I pp 310 ff).
6. Ed. 1947 p 96.
7. Barocchi *op.cit.* II p 1614 and n 1 with reference to Cicero, *De offic.* I 28, 98.
8. Ed. 1960— pp 195 f; cf. ed. 1968 p 24 with reference to Giulio Camillo, *Tutte le opere,* Venezia 1552.
9. E.g. ed. 1878— IV p 9. Cf. Blunt 1940 pp 90 ff.
10. Ed. 1882 TP 17; Heydenreich 1953 I p 191. It was a major feature in Leonardo's notes to preserve the informative function of local colour; cf. below chaps. B III 3, B III 4.
11. Cf. below, the *paragone.*
12. Barocchi *op.cit.* I p 1000.
13. Lib. I chap. 1; ed. 1973— II p 31.
14. Cf. e.g. Gilbert 1946 pp 95, 106; Barocchi *op.cit.* II p 2121. In my opinion, Gilbert exaggerates the importance of the negative association between *colore*

and the *elocutio* of rhetoric, which means the elaboration and ornamentation of a product which is structurally complete without it. As to Daniello 1536 as a support for this low opinion, one may quote another sentence, which illustrates that the quantitative definition of colour was frequent among poets as well: *come l'imitazione del dipintore si fa con stili, con pennelli e con la diversità di colori ... così quella del poeta si fa con la lingua e con la penna, con numeri et armonie* (Barocchi 1960— I p 152 n 4). Barocchi is more moderated and emphasizes that the position of colour in the Cinquecento has been insufficiently investigated.

15. Alberti 1435—36 ed. (1956) 1967 p 70. Cf. Cennini ca 1400, Piero 1482, Leonardo ca 1490—1510, Biondo 1549, Dolce 1557, R. Borghini 1584, R. Alberti 1604 and Zuccari 1607 below. Cf. Shearman 1962 p 13 and n 3, who mentions that Ugo da Carpi's woodcuts in *chiaroscuro* were called *stampe di legno a 3 colori*.

16. Below chap. B III 3 and note 40.

17. On the other hand, Pino associates *lume* and *colore;* see below and notes 51, 89.

18. He agrees to Alberti's definition of drawing as circumscription, but mentions (ed. 1873 p 39) that Monturino and Polidoro were skilled in *chiaroscuro* but not in colouration.

19. Ed. 1878— I p 175.

20. Below and note 26.

21. Barocchi *op.cit.* II pp 1929 f.

22. Below and n 48.

23. Barocchi *op.cit.* II pp 1944 f. Cf. Paleotti 1582 (ed. 1960— II pp 448 f), who defines *disegno* as perspective, foreshortening, shadows, the rendering of planes, lines, place, distance, movements, contours, relief, proportions, variation of bodies, colour *(sic)*, the making of *modelli* in wax and clay, etc.

24. E.g. cartoons and the underlaying, covered drawing in pictures. Cf. below, chap. B III 4 n 88.

25. Cellini ca 1560; Barocchi *loc.cit.*

26. *loc.cit.*

27. *loc.cit.*

28. The tonal differences, however, may intuitively be associated with the relative tonal value of the chromatic colours—Vasari (ed. 1978— I p 175) pointed out that monochrome washdrawings give a 'foretaste' of the chromatic colours intended.

29. *De institutione oratoriae.*

30. *Nat.Hist.* XXXV, 15, 16.

31. Alberti 1435—36 (ed. (1956) 1967 p 64 and n 9); Ghiberti ca 1450 (*end of the first Commentary*); d'Olanda 1548 (cf. Rouchette 1958 pp 187 f n 1); Pino 1548 (ed. 1960— I p 123 and nn 1—3); Gilio 1564 (ed. 1960— II pp 12 f); Lomazzo ca 1564 (ed. 1973— I p 88); Vasari 1568 (*Proemio*); Paleotti 1582 (ed. 1960— II p 144); Lomazzo 1584 (ed. 1973— II pp 19 f); Allori 1590 (Barocchi *op.cit.* II p 1945 and n 3) and Possevino 1595 (*op.cit.* I pp 42 f).

32. Cf. the amusing question of the primacy of form or colour which was a part of the *paragone* painting—sculpture; the adherents of sculpture maintained that God, when he created man, first made him a sculpture to which he applied colours (e.g. Pontormo and Varchi 1547; Barocchi 1960— I pp 68 and n 13; 48). In connection with this discussion, Doni 1549 (*ibidem* 1971— I p 559) advocated that colour presupposes form: *non può essere il colore se prima non ha qualche corpo che lo riceva.* Speroni ca 1570—80 (*op.cit.* I p 1001) argued,

on the other hand, that colour is the condition for perception of form: *la quantità non si vede se non per li colori.*

33. Cf. Aristotle, *Poetics* 1450 a, b, quoted above chap. IV.

34. The importance of *disegno* in the Renaissance art theory is well documented —too well, it may seem. Cf. note 14 above and below chap. B I 1.

35. Ed. 1878— I p 171: *Un piano coperto di campi di colori, in superficie o di tavole o di muro o di tela, i quali per virtù di un buon disegno di linee girate circondano la figura ... [e] fa che ... si rilieva ed apparisce tonde e spiccato.*

36. Lib. I chap. 1; ed. 1973— II p 25: *Pittura è arte le quale con linee proporzionate e con colori simili a la natura de le cose corporee, che non solo rappresenta nel piano la grossezza et il rilievo de 'corpi, ma anco il moto, e visibilmente dimostra a gl 'occhi nostri molti affetti e passioni d'animo.*

37. Ed. 1960— I p 152; ed. 1968 pp 96 f: *imitazione della natura ... per via di linee e di colori o sia in un piano di tavola o di muro o di tela, tutto quello che si dimostra all 'occhio.*

38. Ed. 1950 p 82; ed. (1956) 1967 pp 67 f: *circonscriptione, composizione, receptione di lumi.*

39. Barocchi *op.cit.* II pp 1899 ff. Note the emphasis on the immaterial character of colour, manifested in the difference between *materia* and *colori.*

40. Cf. Lee 1940 p 264.

41. Chap. 4; ed. 1971 pp 6 f.

42. Composition, however, also comprises colour; cf. below chap. B II.

43. Ed. 1942 p 63.

44. Ed. 1873 p 24; Barocchi *op.cit.* I pp 776 ff.

45. Ed. 1882 TP 133 (ca 1492); Barocchi *op.cit.* I p 735.

46. *Ed.cit.* TP 111 (ca 1505—10); Barocchi *op.cit.* I p 734.

47. Ed. 1807 II p 197. Paleotti 1582 (ed. 1960— II pp 498 f) assigns *disegno* and *colori* as the main parts of painting.

48. Barocchi *op.cit.* I p 994.

49. Ed. 1960— I pp 113 ff.

50. Cf. Gilbert 1946 pp 94 ff.

51. Gilbert (*loc.cit.*) renders—without support in Pino—the division as *proprietà, prontezza* and *lume.*

52. Ed. 1960— I pp 164 f; ed. 1968 pp 116 f.

53. Ed. 1973— I p 86.

54. Ed. 1882 TPP 20, 36, 131 (ca 1492); 6 (ca 1500—05); Richter (1883) 1971 § 23; Barocchi *op.cit.* I pp 475 ff, 733 f.

55. Cf. the ten categories of Aristotle above chap. II n 52 and the twenty-two visible intentions of Alhazen above chap. II.

56. *Proemio: Divisione di tutta l'opera; ed.cit.* II p 23. Lomazzo 1590 *ed.cit.* I pp 247 f, 281 ff repeats these elements (chap. 1) and treats them in chaps. 11—15, but calls them theoretical, as distinguished from the practical *composizione* (chap. 16) and *forma* (motifs; chap. 17).

57. Cf. below chap. B III 1.

58. Ed. 1960 II pp 448 f.

59. Barocchi *op.cit.* I p 383.

60. Lib. II chap. 6; Barocchi *op.cit.* I p 1036: *Una scienza prattica o arte, che con artificio singolare et operazione artificiosa va imitando e ritrando la natura e quanto dall 'artificio umana è fabricato, in forma, specie et accidente con la forza de' suoi colori, e talora sì vivamente et eccellentemente con la forza de' suoi chiari e scuri, facendo appair di rilievo tutto quello ch'ella figura in piano, e con tanta ammirazione che ne resta ingannati gli occhi umani. Così*

*dipinge ancora le cose che sono invisibile e solo conosciute o dal senso interno o dall' intelletto solo senza forma alcuna delle cose.*

61. Cf. below chap. B III 1.

62. Fully developed by Leonardo during his stay at Sforza in Milan.

63. Sarcastic opinions on the *paragone* are found in, *inter alia,* Doni 1547, Vasari 1547, Michelangelo 1547, Aretino 1553 (letter) and V. Borghini ca 1560.

64. Ed. 1960— I pp 30 ff.

65. *Ed.cit.* I p 35. Pliny's (*Nat. Hist.* XXXV, 2, 70, 77) statement that *graphikè,* painting on wood panels, was part of the education in the noble families in Greece, prohibited for slaves to practice and considered *in primum gradum liberalium,* was, together with Galen's (*Protrept. ad artes,* the end) distinction between 'serving' and 'decent and free' arts, among which he included sculpture and painting, frequently quoted: Alberti 1435—36 (ed. (1956) 1967 pp 64 and nn 8, 19; Cf. Wittkower 1963 p 16); Filarete ca 1451—64 (ed. 1890 pp 627 ff; Cf. Wittkower *loc.cit.*); De' Barbari ca 1501 (Barocchi *op.cit.* I pp 66 f, 69); Lancilotti 1509 (*op.cit.* I p 743); Castiglione 1528 (*op.cit.* I pp 119 ff); Varchi 1547 (ed. 1960— I pp 35 f); Sangallo 1547 (*op.cit.* I p 71); Cellini 1547 (*op.cit.* I pp 80 f); Pino 1548 (ed. 1960— I pp 107 ff); Biondo 1549 (Barocchi *op.cit.* I p 770); Gelli 1551 (*op.cit.* I p 286); Condivi 1553 (ed. 1874 pp 110 f); Gilio 1564 (ed. 1960— II pp 11 f); Lomazzo ca 1564 (ed. 1973— I p 85); Paleotti 1582 (ed. 1960— II p 150 f, 151 n 1, 157); Lomazzo 1584 (Lib. I chap. 1; ed. 1973— II pp 9, 20, 26, 27, 39, 587); R. Alberti 1585 (ed. 1960— III pp 204 ff, 209 f); Armenini 1586 (Barocchi *op.cit.* I p 377); Lomazzo 1590 (*ed.cit.* I p 246); Paggi 1591 (Barocchi *op.cit.* I pp 192, 194) and Zuccari 1607 (*op.cit.* I p 1038).

66. Ed. 1960— I pp 37, 46.

67. *Ed.cit.* I pp 37 f, 46 f; cf. below chap. B III 1.

68. Plato (*Hip. Ma.* 294 d-e, *Rep.* X 602 b; Cf. Osborne 1970 pp 41, 47) considered the crafts more useful than the imitative arts, and since he equated utility and beauty, painting was ranked very low. Aristotle, however, differentiated between cultivating (*prakton*) and manufacturing (*poieton*) *téchne,* and condemned those which included physical strain (*Pol.* I.7; VIII, 2; Cf. Schlosser 1924 p 214; Osborne *op.cit.* pp 39 f; Pochat 1973 pp 35 ff and Varchi 1547 (ed. 1960— I pp 7 ff), who differentiates between *abiti agibile—abiti fattibile*). To these categories were added the concept of mechanical arts, taken from Ps-Aristotle's *Mekanikà;* cf. Barocchi 1960— I p 18 n 1. The adherents of painting stressed the *certezza* of painting which was regarded the result of the systematic application of its theoretical foundations; cf. Alberti 1435—36 (ed. (1956) 1967 p 18) and Ghiberti ca 1450 (quoted in Baxandall 1971 p 16 n 22). Leonardo emphasized that the *certezza* of painting was experimentally demonstrable and thus even superior to speculative, purely theoretical, scientific postulates (*Cod. Urb. Lat.* 1270, ff 1, 19; Barocchi 1971— pp 71 f; cf. Fasola 1942 p 9; Chastel-Klein 1960 pp 33 f; Zubov 1968 pp 92, 104, 165); Varchi 1547 (ed. 1960— I p 9) defined art as *un abito intellettivo, che fa con certa e vera ragione;* Biondo 1549 (Barocchi *op.cit.* I p 767) as *un abito di far cose con vera raggione;* Castelvetro 1565—71 (*op.cit.* I pp 106 f) wrote that science and art are characterized by *la fermezza delle prove, perciocché l'una e l'altra procede con prove dimostrative;* R. Borghini 1584 (ed. 1807 I p 197; Barocchi *op.cit.* I p 109) repeated, literally, Varchi; Lomazzo 1584 (ed. 1973— II p 25) defined art as *una ragione retta e regolata de le cose che si hanno da fare;* de 'Vieri 1586 (Barocchi *op.cit.* I p 168) as *un abito principale dell 'alma nostra, che con retta ragione operando;* Zuccari 1607 (*op.cit.* I p 1036) as *una scienza prattica o arte.* Cf. the titles of Biondo 1549, Armenini 1586 and Allori 1590; cf. Osborne 1970

pp 245 ff.; Shearman 1967 p 38.

69. *Ed.cit.* I pp 39, 51.

70. *loc.cit.* On Plato and utility, cf. note 68 above. Aristotle differentiated (*Metaph.* 981 b; *Eth.* 1127 b; 1176 b; *Pol.* viii, 5; cf. Osborne *op.cit.* p 40) between 'necessary' and 'entertaining' *téchne;* the latter had a secondary utility due to its recreative effect, intellectual character and moral influence. Cicero's (*De opt. gen. orat.* I; cf. Quintilian, *Inst. orat.* III, 5; Horace, *Ars poetica* 99— 100; Plutarch, *Moralia* 346—347; Philostratus the Younger, *Imagines; Proemium;* Thomas Aquinas, *Sum. theol.* II—II.q.177, a.I, ad. 1; cf. Baxandall 1971 pp 18, 100 f) claim that the perfect work of art is to be didactically useful, entertaining and moving was repeated by, *inter alia,* Alberti 1435—36 (ed. (1956) 1967 p 63); Castelvetro 1565—71 (Barocchi *op.cit.* I pp 106 f); Paleotti 1582 (ed. 1960— II pp 215 f); R. Alberti 1585 (ed. 1960— III p 212) and Speroni 1596 (Barocchi *op.cit.* I p 122).

71. *Ed.cit.* I pp 40, 52. Beauty and gratification were—like the honey which covers the doctor's bitter medicine (cf. Lucretius, *De rerum natura* IV, 10 and Daniello 1536; cf. Osborne *op.cit.* p 138)—partly a function af utility.

72. *Ed.cit.* p 40.

73. *Ed.cit.* pp 40 f; cf. below chap. B I 4.

74. *Ed.cit.* pp 41 f, 47 f.

75. *Ed.cit.* p 48 and n 3.

76. *Ed.cit.* pp 44 f.

77. Ed. 1807 I p 51; Barocchi *op.cit.* I pp 674 ff.

# B. Applied Concepts
# Chapter IB. Colour as Paint

## 1. Bellezza de'colori — artificio

When V. Borghini ca 1560 examined and summarized the arguments in Varchi's *paragone*-inquiry of 1547, he established that they were centered on the contraries *fatica—materia* and *durazione—arte;* he interpreted the arguments of the adherents of sculpture as based on immanent properties of the material[2] and not on the knowledge and skill of the artist. The tendency to condemn the dependence on immanent properties and effects was not restricted to the volume and permanence of sculpture—it concerned the immanent beauty of certain colours as well, or rather the unqualified use of that sort of beauty[3]. As early as in the beginning of the Quattrocento a change of taste makes its presence felt[4]; the splendour of colour is associated with medieval ignorance and contemporary vulgarity. Simplicity becomes the new social ideal[5], given its most influential formulation by Castiglione 1528[6], who recommended that the noble dress in dark colours like the Spaniards; people who liked to dress pompously in golden brocade and the like were ridiculed[7]. Morato 1535 condemns affected, many-coloured dresses, which he finds proper to prostitutes[8]; Armenini

1586 evidently alluds to that kind of dress when he has the provincial *parvenu* owner of a newly built palace order gaudy frescoes "like a pair of those trousers that are now so fashionable with many colours"[9]. The 'animal' pleasure to be found in the eye-catching application of strong colours was branded as ignorant, vulgar and 'foreign', in particular German[10]. The lack of knowledge and method among artists was illustrated by references or travesties of Aristotle[11], and those who appreciated gaudy effects were called *non intendenti* or *ignoranti*[12], a category which was held to consist not only of the undeducated great crowd but of everyone lacking taste, regardless of social class. As an illustrative example some writers of the Cinquecento used Sixtus IV, who in 1481 appointed Cosimo Rosselli to paint in the Sistine chapel, and was carried away by his extravagant use of gold and ultramarine-blue in the otherwise poor paintings[13]. In spite of the explicit condemnation by the Counter-Reformation of individual interpretations of holy subjects and of the seductive charm of the physical paintings[14], the nobility of the subjects[15] was thought to justify the use of rich material effects; the break with the ideal *semplicità* was tolerated or even ordered[16] with regard to gaudy colours but not with regard to invention[17].

The efforts of Alberti and in particular Leonardo in relating science to practice are based on the belief in the complete, rational freedom of the artist; he was considered as another Nature, or another "master and God"[18], able to correct and create a nature of his own. The overwhelming *varietà* of shape and colour in Nature—often exemplified with a meadow full of spring flowers[19]—was the apparently confusing result of an intriguing network of physical influences, which the artist was able to identify and systematize; he was to avoid the mere passive imitation of this indiscriminating variety of Nature, but, according to its own generating principles, surpass it through winnowing and correction[20]. With a few exceptions from the end of the Cinquecento, the ambition of art theory remained to be the demonstration of fixed rules and methods for art. However, just as a distinction was made between the immanent, irrational brightness of colours and the rational, inventive use of the formal elements, a distinction was made between the innate—and thus irrational—talent, *natura,* and the studious, rational cultivation of science, *arte;* the former was associated with *colore,* the latter primarily with *disegno*[21]. The powers which, beyond human control[22], were thought to distribute talent were named in many ways—God, Heaven, the Stars, Nature, Faith, Providence, Luck[23]—proving that the battle waged since the Middle Ages by the Church against astrology[24] was in no way concluded; it was generally accepted that superterrestial powers— not always identified with God— govern earthly conditions. Every individual was thought to receive a *natural disposizione* from the planet which dominated the sky at the moment of

his birth. The influence was, however, thought to vary according to the changing positions of the planets and the age and occupation[25] of the individual.

The acknowledgement of a few geniuses in the Cinquecento neutralized the negative interpretation of innate talent[26] and widened for a moment the province of irrationality; through Michelangelo it was associated also with drawing and shape[27]. In general, however, those geniuses' particular ways of ignoring the rules were elevated to the new rules[28] and were intergrated into academism through a new, eclectic ideal—the combination of Michelangelo's drawing and Titian's colour[29]. At the end of the Cinquecento, a tendency to deny the validity of any rules—in particular those based on mathematics—become obvious[30]; it is even stated that there are as many rules as there are artists.

1. Cf. below chaps. B I 3, (hierarchic perspective), B IV 4, where physical paint is considered without any associations to tonal or chromatic qualities.
2. *Somma della disputà;* Barocchi 1971— I p 659 ff.
3. Cf. Aristotle (*Poetics* 1450 a, b, quoted above chap. IV), Vitruv (*De re aedificatoria* VII, 7, 14) and Pliny (*Nat.Hist.* XXXV, 30); cf. Venturi 1933 (a) p 228 and n 3; Lee 1940 pp 199 ff; Mahon 1947 p 138 n 92; Hautecoeur 1973 II p 48.
4. Gombrich 1971 pp 17 f; Baxandall 1972 pp 14 f. The break-through of this ideal is testified already in the Quattrocento through an increase in the import of black cloth from the Flandres.
5. Gombrich (*loc.cit.* and p 29) calls the formation of this kind of ideal "sophistication"—"it is valued as much for what it rejects or negates as for what it is."
6. Cf. Hauser 1951 II pp 52 ff.
7. Cf. Vespasiano da Bisticci ca 1490 (ed. 1951 p 60; Baxandall *loc.cit.*) and Vasari 1568 (ed. 1878— VI p 387, on Soddoma).
8. Barocchi 1971— II p 2178.
9. Barocchi *op.cit.* II pp 1503 f; Klein-Zerner 1966 pp 167 ff; cf. Dolce 1565 (Barocchi *op.cit.* II 2223) and Occolti 1568 (*op.cit.* II pp 2198 ff) on the popular *divise,* dresses of two contrasting colours.
10. Dolce 1557, ed. 1968 pp 180 f; Vasari 1568, *ed.cit.* VI pp 267 ff. on the *maniera tedesca.*
11. See note 3 above. Cf. Leonardo ca 1490—1510 (ed. 1882 TP 236), *belli parlatori senza alcuna sententia;* Dolce 1557 (ed. 1968 pp 206 f), *belle parole senza il sugo o il nervo delle sentenze;* Gilio 1564 (ed. 1960— II p 15), similar to the author *che sa ben formar le lettere, ma non accozzar le sillabe ne' ordinare le parole;* Ligorio ca 1570—80 (Barocchi 1971— II p 1468); Paleotti 1582 (ed. 1960— II p 210). Cf. chap. B II and n 5.
12. This criterion of ignorance occurs in Boccaccio, *Decamerone* VI 5. Cf. Leonardo ca 1490—1510 (ed. 1882 TP 412, 1508—10); *L'ignorante vulgo, li quale nulla desiderano nelle pitture altro che bellezza di colori;* Pino 1548 (ed. 1960— I p 118); Dolce 1557 (ed. 1968 pp 208 f); Vasari 1568 (ed. 1878— III pp 188 f); Sorte 1580 (ed. 1960— I pp 295 f); Lomazzo 1584 (ed. 1973— II pp 41, 176); Armenini 1586 (Barocchi 1971— I p 992; II pp 1479, 2285); Zuccari 1605 (*ibid.* I p 1026): *pasce l'occhio e contenta l'ignoranzia/di bei colori, senz'alcun dis-*

segno; Agucchi ca 1610 (Mahon 1947 pp 65, 138 and n 138; Gombrich 1963 pp 171, 245 ff).

13. Vasari 1568 (loc.cit.): que colori... abbagliarono gli occhi del papa, che non molto s'intendesse di simili cose; Dolce 1557 (ed.cit. pp 206 f); V. Borghini ca 1560 (Barocchi 1971— I p 632); Armenini 1586 (ibid. II p 1492 and n 2). R. Borghini 1584 (ed. 1807 II p 125) drew, in spite of that he considered the pope come poco intendente del disegno, tirato della vaghezza de'colori, the rather crass conclusion: Dalla quale cosa si può conoscere, quanti importi a un pittore il mettere in opera belli e vaghi colori.

14. In particular in the bulletin of the Council of Trent of 1563; Klein-Zerner 1966 pp 119 ff. Cf. below chap. B I 4 (restoration).

15. Certainly also the symbolic interpretation of light contributed to this attitude.

16. Cf. the anecdote of Condivi 1553 (ed. 1874 p 50): Julius II asked Michelangelo to add gold and ultramarine-blue to the ceiling in the Sistine Chapel. Michelangelo, unwilling to do so, succeeded in escaping the task with the facetious assertion that the depicted figures indeed were poor.

17. The most obvious examples are the criticism and retouching of Michelangelo's Last Judgement and the process against Veronese in 1573; Klein-Zerner op.cit. pp 129 ff.

18. Leonardo ca 1490—1510, ed.cit. TP 13; Panofsky 1970 p 188 n 3; Pochat 1973 p 271. Gombrich 1954 p 211 and Panofsky loc.cit. emphasize that Leonardo here uses the term creare, whereas in general he avoided that term in favour of generare, the term associated with nature.

19. Cf. Lucian below chap. B I 4 n 106; Hugo of St. Victor, Didascalon VII, (ca 750; Pochat op.cit. p 150); Theophilus Rugerus, Diversarum Artium Schedula III, Prol., (tenth cent. ?; Holt (1947) 1957 I pp 7 f; Pochat loc.cit.). George of Trebizond, De suavitate dicendi ad Hieronymum Bragadendum 1429; Guarino ca 1450 (Baxandall 1972 pp 93, 156); Filarete ca 1451—64 (ed. 1890 p 642); Leonardo ca 1490—1510 (ed.cit. TP 23); Lancilotti 1509 (Barocchi 1971— I p 746); MS Marciana ca 1503—27 (Baxandall op.cit. pp 94 f and n 98); Equicola 1526 (Barocchi op.cit. II p 1621); Pino 1548 (ed. 1960— I pp 228 f).

20. Cf. below chap. B I 3.

21. Particularly obvious in Vasari 1568, for instance: vago nel colorito, pratico nel disegno (ed.cit. III p 654 on Battista d'Angelo); disegno benissimo... colorito vago e graziato (IV p 334 on Raphael); eccellente nel disegno, vago e grazioso nel colorire (IV p 463 on Dom. Puligo); bontà di disegno e vaghezza de colori (V p 602 on Perino del Vaga), and in particular the anecdote on Michelangelo, who is reported to have said of Titian, that if he fusse punte aiutato dall'arte e dal disegno, come è dalla natura... non si potrebbe far più nè meglio (VII p 447). On the expression of the artist's personality in the colours, see for instance V p 5, VI p 268 and VII p 103 on Andrea del Sarto, Pontormo and T. Zuccari. Arte included, outside this particular context of polarity, in general all rationally applied knowledge, i.e. also the harmonic and illusionistic systems for colour. Cf. Baxandall 1971 pp 15 ff.

22. Yet some efforts—among others with the help of colour—occured. Cf. above chap. III.

23. Rouchette 1959 pp 45 ff.

24. Cf. above chap. III.

25. The artist was particularly exposed to the benign or evil influence of Saturn.

26. On the negative aspect of inborn disposition, cf. below chap. B I 3.

27. On the innate giudizio naturale, cf. the inspired mania, furor divinus (on its background in the Iliad and the Odyssey and Plato, cf. Osborne 1970 pp 200 ff)

which Dolce 1557 (ed. 1968 pp 186 f) and Lomazzo 1590 (chap. 14; ed. 1973—
I pp 287 ff) ascribed to both Michelangelo and Titian.
28. Cf. Panofsky (1924) 1968 p 80, who defines Lomazzo's efforts to fix the
rules of expressive movement as "the rationalization of the unrationalizable."
29. First formulated in Pino 1548 (ed. 1960— I p 127 and n 1).
30. In particular Zuccari 1607; Panofsky op.cit. pp 73 ff.
31. Giordano Bruno, Eroici Furori I.1; op.cit. p 67 and n 76; p 73.

## 2. Fingere — pingere

In the *paragone* the imitative properties of painting and sculpture were
compared; the adherents of sculpture claimed that the immateriality of
painting was a negative, false quality, and referred to the tactile 'truth' of
sculpture. The adherents of painting were, on the other hand, aware that
this very mental, immaterial character qualified painting for an elevation
of social status; the contempt for the high degree of manual labour in
sculpture had traditionally given it a low social status. The quality of
painting in deceiving the senses, its *inganno*[1]—dismissed as *bugia* by the
sculptors—was proudly emphasized as a result of applied science. The
importance of colour was acknowledged for universal imitative capacity,
its possibility to give a life-like appearance and illusion of volume and
spatial depth on a flat surface[2]. As the speculative element in art theory
increased under the second half of the Cinquecento, new interest was
directed to the character of imitation. V. Borghini ca 1560 defined it as
*voler mostrare che una cosa sia quello che in fatto non è,*[3] and Speroni
ca 1570—80 differentiated two kinds of *dilettazione* in painting—one
general, intellectual: *è parer la cosa vera e farsi sillogizzare* h o c  e s t  h o c
—and another which in fact is nothing but a more qualified form of the
same thing, which consists of the particular, extremely advanced imitation
of colour and the third dimension on a flat surface[4].

In addition to the emphasis on the intellectual and non-manual character
of painting, the immaterial character of physical painting was stressed
under the entire period studied; from Leonardo's many notes[5] to Speroni
ca 1570—80, who wrote that a sculpture is *più materiale e per consequente
più imperfetta*[6], and the definitions of painting in R. Alberti 1604[7] and in
Zuccari 1607[8]. In the discussion of illusionism, then, colour was considered
in two ways[9]: on the one hand its abilities to imitate tonal and chromatic
qualities, on the other its painterly, material—or rather lack of—quality.
The break-through of the oil-media offered new possibilities of soft transi-
tions, maintaining the smooth structure of the tempera-technique[10]. It was
used primarily for easel-paintings—a kind of paintings which have a
pronounced character as objects and are perceived as isolated units in the

enclosed space. The 'heroic' fresco-painting, on the other hand, has—in spite of its technical and expressive limitations—greater illusionistic possibilities due to its integration in the enclosed space; by both assimilating and breaking through the structure of the enclosed space and by adapting the real light[11], this kind of painting achieves (under optimal conditions as far as point of view and light are concerned) a total effect, which—favoured by distance—diverts the attention from the relatively rough physical structure. The Venetian painters—in particular the later Titian—introduced a coarse structure in easel-painting through pastose patches of paint on a rather rough canvas. It is not surprising that this kind of painting got a cool reception. The intellectual stimulus offered by the oscillation between the scarcely perceivable physical reality of the painting and illusionism was eliminated; the painting was no longer and aesthetic object —it became a physical object of a peculiar aesthetic kind, a kind with which one was not acquainted and which deprived the art of painting of its immaterial character. Vasari 1568, typical for the opinion of the later half of the Cinquecento, indeed noted that Titian's late, pastose technique gave his paintings an individual vitality—*fa vivere le pitture*[12]—but in general he condemned this technique as an effort to hide an agonizing lack of draughtsmanship *sotto la vaghezza de' colori*[13]; his ideal was a smooth, even structure, *pulitezza*[14]—the same combination of *sfumato* and *unione* which caused Dolce 1557 to write that paintings in which contours and blotted, black shadows draw attention to the surface, look *dipinte, perciochè resta la superficie piana*[15]; Armenini 1586 called such a painting *opera e composizione di colori*[16]. However, if the ideal artist was not permitted to impress his personality in the material structure of paint[17], this did not lead to the ideal of an anonymous style which obliterates the traces of the individual in a pedantic, impersonal structure. The mastering of art was, on the contrary, thought to be revealed by quickness, *sprezzatura* or *prontezza*. Already Alberti 1435—36 had warned against an exaggerated carefulness which makes the painting seem old and dry even before it is finished, and referred the anecdote of Protogenes[18], who never knew when to take his hands from his paintings; the anecdote was also related in Castiglione 1528 in connection with the same dissuasion from an overly careful technique[19]. Pino 1548 even condemned the *velo*[20] of Alberti and recommended that the artist finish his work with *una diligenza non estrema*[21], and Dolce 1557 warned against both *troppa vaghezza de 'colori* and *troppa politezza,* illustrated by the anecdote of Protogenes[22]. The same ideal combination of a smooth physical structure and a finish with individual, quick brush-strokes is recommended by Vasari 1568, Lomazzo 1584[23] and 1590; in the latter the Venetian technique is called *colorare secondo i colori*[24]; he neither wants *troppa unione* nor *certe schizzate di pennello e cotali fierezze*[25].

1. Cf. Boccaccio, *Il Commento alla Divina Comedia; Inferno* xi, 101—5; in Baxandall 1971 p 66: *Sforzasi il dipintore che la figura dipinta da sé, la quale non è altro che un poco di colore con certo artifizio posto sopra una tavola, sia tanto simile . . . a quella la quale la natura ha produtta . . . che essa possa gli occhi de'riguardanti . . . ingannare, facendo di sé credere che ella sia quello che ella non è.*

2. Below chaps. B III 1—4.

3. Barocchi 1971— I p 614; Cf. Sangallo 1547, ed. 1960— I p 72.

4. Barocchi *op.cit.* I pp 1001 f; cf. Comanini 1591 (ed. 1960— III pp 284 f) and the definition of illusionism in Evans 1948 p 140: "an illusion is a perception of external reality which is not in accord with the evidence derived from other senses and from our knowledge of physical probability." On syllogisms, cf. above chap. II (post-oc. perc.).

5. For instance that the painting, like the image in the mirror, is *inpalpabile* (ed. 1882 TP 408).

6. Barocchi *op.cit.* I p 1002.

7. *Ibid.* II pp 1899 f.

8. *Ibid.* I p 698.

9. Cf. Zuccari 1607 (*ibid.* II p 2091), who describes what catches the interest in a painting: *prima si fissa lo sguardo nelle figure umane, e si considerono i moti, i gesti, le proporzioni, gli effetti, le vivezze loro, le tinte, i colori; tinte* seems to denote the tonal and chromatic properties, *colori* the material.

10. Cf. below chap. B I 4.

11. Cf. Sandström 1963; Sjöström 1978 pp 14.

12. Ed. 1878- VII p 452.

13. *Ed.cit.* VII p 427; cf. VI pp 590, 595 on Tintoretto and Veronese.

14. *Ed.cit.* IV pp 11, 115, 468, 569; V pp 243 f, 594; VI p 269; VII p 595. Cf. Barocchi 1958 I pp 221 ff for a different interpretation and below chap. B I 3 n 39.

15. Ed. 1960— I p 184; ed. 1968 pp 154 f. Cf. Leonardo below chap. B III 3 on *tinte*.

16. Barocchi 1971— I p 993.

17. Cf. below chap. BIV 4.

18. Pliny, *Nat. Hist.* XXXV, 80; Cicero, *Orat.* XXII; Spencer (1956) 1967 p 97 and n 21.

19. Barocchi *op.cit.* II pp 1643 f and n 2.

20. A device to render the linear projection.

21. Ed. 1960— I pp 116 f, 119.

22. Ed. 1960— I p 185 and n 6; ed. 1968 pp 154 f.

23. Lib. III, chap. 9; ed. 1973— II pp 173 f.

24. Chap. 28; ed. 1973— I p 325.

25. Chap. 37; *ed.cit.* p 356.

# 3. Idea — materia

## The Concept

The notion of a mental idea of perfect beauty underwent a change in the Reanissance[1]. After Ficino 1469[2] and Ebreo ca 1501[3], the metaphysical

nature of this mental idea was not maintained until Lomazzo 1590[4] and Zuzzari 1607[5]. The dominating notion was that is was acquired through experience by the artist himself[6]. Not even Zuccari 1607 thought of *idea* as being independent of experience; he emphasized that human reason depends on sense-perception[7]. In general, imitation was thought of as correction of nature; the anecdote of Zeuxis, who combined five partly defective models to achieve a perfect one, was repeatedly told[8]. It was understood that correction included colour[9]. Experience was necessary, but it did not guarantee perfection; to achieve that, judgement—*giudizio*— was to assist; reason, one might say, was thought to have the same relation to imagination as Zeuxis to his five partly defective models[10]. The term *giudizio dell 'occhio*—in general[11] analogous to *retto giudizio* in corrective imitation—was used to denote qualified selection of reality, based on keen judgement, advanced theortical knowledge and wide experience[12]. Even though keen judgement was considered as an innate gift, its significance was defined and standardized in the literature on art; *idea* tends to become synonymous with 'general opinion', which marks the final profanation of its original, metaphysically exalted, meaning[13].

## The Execution

### (a) Ubbedienza di mano

The materialization of the mental concept presupposed the obedience of the hand to the controlling intellect[14]; as Varchi 1549 formulated it: *quello è solo vero maestro che può perfettamente mettere in opera colle mani quello che egli s' è perfettamente immaginato col cervello*[15]. To achieve the direct and unhindered materialization of an inner notion, the artist was, according to this Neo-Platonic doctrine, to master the technical and scientific problems of art[16]; *sprezzatura,* quickness of execution was early regarded a sign of an unhindered transmission[17]. In the later Cinquecento, the philosophical character of painting was illustrated by an emphasis on *discrezione*[18] or *preordinazione*[19], the meditative definition and precision of the idea, sometimes called *disegno interno.* Gilio 1564, while not accepting the infallibility of the intellect, recommended that *giudizio* was not to examine the mental products of imagination until they hade been transported from the obscure labyrinths of the brain to material imaginations: *deve fare gli schizzi, i cartoni, i modelli, e non confider ne la mente, perchè è labile*[20].

### (b) Ubbedienza di materia

Aristotle had added a new element to the theories of *idea;* in order to describe the creative process as an actualization of potential form (*idea*),

71

he used a metaphor: the block of stone encloses the potential form of Mercury[21]. Aristotle, however, did not consider the question of any technical or material limitations for the realization of the potential form[22]. Plotin, who emphasized the spiritual 'purity' of the metaphysical idea, on the other hand, used the same metaphor to illustrate that this idea cannot enter into matter without a considerable loss of its original beauty; matter exercises resistance to form[23]. This Neo-Platonic concept reappeared in a somewhat altered form in Ficino 1469[24], Ebreo ca 1501[25] and Lomazzo 1590[26]; *idea* is considered as completely spiritual, but able to imprint itself in matter which is 'prepared'[27] in accordance with the 'classical' definition of beauty[28]. The fusion of the original Neo-Platonic notion with the Aristotelian concept was immortalized in the famous sonnet by Michelangelo, which begins *Non ha l 'ottimo artista in se alcun concetto /Ch 'un marmo solo in se non circonscriva / Con suo soverchio; e solo a quella arriva / La man che ubbedisce all 'intelletto . . .*[29] Michelangelo, then, described the heroic victory of the artist's creative power over the *durezza* of stone—the very material which exercises the greatest possible resistance to form and whose requirement of manual labour for creation led to low social status for sculptors as early as in Antiquity[30]. He was said to detest painting in general, but preferred the heavy and time-consuming fresco-painting[31] to the comfortable and conformable oil-painting, which he branded as *arte da donne e da persone agiate et infingarde*[32]. It was implicit that in fresco-painting fast decisions had to be made before the restricted area of moist *intonaco* dried up, and a mistake could only be corrected through a complete removal; in oil-painting, mistakes could be corrected infinitely until the desired result was achieved[33]. Contrary to this opinion the adherents of painting in the *paragone* continuously stressed not only the high degree of contemptible manual labour in sculpture but also the resistance to form and expressive limitation of its material. According to Lomazzo 1584[34], even Leonardo took a Neo-Platonic point of view in this discussion; the subtle, immaterial beauty of the inner *concetto* is considerably lessened when it is forced into such hard and shapeless matter as marble, iron and the like. Vasari 1568 says that in sculpture the ways of expressing inner emotions are restricted to gestures only, *per l'inobbedienza ed imperfezione della materia*[35], and Bocchi 1584 praises Donatello's ability to render, in the St. George, *costumi d'animo* without the help of *la varietà de'colori . . . che mezzanamente esprimono il costume* but against *la durezza della materia e dalla difficultà dell'arte*[36]. But not even painting, in spite of its mental character and rather comfortable practice, was regarded as quite immaterial; although oil-painting was generally praised for the very same reasons which made Michelangelo refute it[37], lines and *macchie,* spots of light and colour were eye-catching elements which were to be sparingly used and visible in the finished painting only for illusionistic

and characterization purposes[38]. Certainly, the smooth material structure was held to reflect a smooth communication between mind and hand. The *non-finito*[39] of the sketch[40] was appreciated as a sensible expression of the *concetto* and literally the basis of the polychrome painting[41], but Lomazzo 1584, who dedicated a whole chapter to the formation and transmission of the inner *idea,* regarded even the sketch as an abrupt materialization and adviced the artist to avoid the harsh contrast of white paper and black ink and use a tinted paper and a soft colour of the same hue as the paper[42]. The subtle process of materialization of the mental image must not be interrupted or disturbed by either material, technical or visual harshness; soft variations in lightness and saturation of the same hue offer a 'spiritual' medium through which the mental image may slide into matter without any friction.

The frequent claims of the immateriality of colour[43] and painting reach a peak in the encyclopedic definition of painting by R. Alberti 1604:
... *apare circonscritta per forza de' chiari e di scuri in piano coperto di colore, dimostrando ogni sorte di forma e di rilievo senza sustanza di corpo. L'opera sua si fa per via di comporre materia a materia di liquori non compresi dal senso del tatto, artifizio che ha più del divino (per così dire) che dell'umano; proprio istromento, penelli, materia, colori.*

1. Cf. above chap. II n 92, chap. A II.
2. Panofsky (1924) 1968 pp 56 f, 129 ff; Barocchi 1971— II p 1613 n 4.
3. Barocchi *op.cit.* II pp 1628 ff.
4. Panofsky *op.cit.* pp 83 ff, 95 ff.
5. Cf., however, below.
6. *Idea* or its equivalents *concetto, intenzione* or *invenzione* are found in Alberti 1435—36 (ed. (1956) 1967 pp 93, 95; Panofsky *op.cit.* pp 57 ff, 61); Leonardo ca 1490—1510 (Richter (1883) 1970 I §§ 502, 531 and in particular 572; II 836, 1170, 1175); Guarico 1504 (Barocchi 1960— I p 107 n 6; Ciardi 1973— II p 416 n 4); Rafaello Sanzio ca 1514 (Klein-Zerner 1966 pp 32 f; Barocchi 1971— II p 1530; Panofsky *op.cit.* pp 59 f); Daniello 1536 (pp 69 f; Barocchi 1960— I p 171 n 2); Biondo 1549 (Barocchi *op.cit.* I p 772); Doni 1549 (*op.cit.* I pp 558 f); Varchi 1549 (*op.cit.* II p 1323; Panofsky *op.cit.* pp 119 f); Maranta ca 1550—70 (Barocchi *op.cit.* I pp 883 f, 895); Castelvetro 1567 (*op.cit.* II p 1577 and n 3; 1581. C. denies what he calls the opinion of Aristotle that the artist holds in his mind a perfect exemplar—he advocates realism.); Danti 1567 (ed. 1960— I p 265 and n 3); Vasari 1564 (Barocchi *op.cit.* II p 1912); *ibidem* 1568 (ed. 1878— I p 168; Panofsky *op.cit.* pp 61 ff); Paleotti 1582 (ed. 1960— II p 133); Lomazzo 1584 (ed. 1973— II p 216 and n 5; L. quotes Aristotle: *niuna cosa è nell'intelletto che non sia stata prima nel senso,* but in a chapter dedicated to *idea,* (Lib. VI chap. 65; *ed.cit.* pp 415 ff) he emphasizes the importance of contemplation.); Armenini 1586 (Barocchi *op.cit.* I p 994; II p 2001); V. Galileo 1589 (*op.cit* I pp 380, 383) and Comanini 1591 (ed. 1960— III p 251). Lomazzo 1590 indeed borrows from Ficino 1469 (chap. 26; Panofsky *op.cit.* pp 141 ff; ed. 1973— I p 310 ff), but points out in the introduction (*ed.cit.* I p 244) that painting depends

on the sense of sight: *lo più degno senso del corpo umano trapassando al giudicio da dove nasce, et ivi unita rischiarandolo, la vera cognizion della bellezza;* he also holds that the purpose of art is *d'imitare e come emular la natura.*
7. Barocchi *op.cit.* II pp 2077 f. Cf. Panofsky *op.cit.* p 86.
8. Pliny, *Nat. Hist.* XXXV, 64; Cicero, *De inventione* II, i, 2 f; Panofsky *op.cit.* p 49; Pochat 1973 p 27; referred by Alberti 1435—36 (ed. (1956) 1967 p 93); Ghiberti ca 1450 (Barocchi *op.cit.* II p 1530 n 1); Pico della Mirandola (*op.cit.* II pp 1530 f n 2); Equicola 1526 (*op.cit.* II p 1614); Castiglione 1528 (*op.cit.* II 1533 and n 4); Pino 1548 (ed. 1960— I pp 99 f); Condivi 1553 (Barocchi 1960— I p 172 n 3); Dolce 1557 (ed. 1960— I p 172; ed. 1968 pp 11 f, 130 f); Paleotti 1582 (ed. 1960— II pp 494 f); Lomazzo 1584 (ed. 1973— II p 507); *ibid.* 1590 (ed. 1973— I p 88). On corrective imitation cf. below n 12.
9. Cf. below chap. B II.
10. The concept of an inner eye, *l'occhio dell'intelletto,* is used by Ebreo ca 1501 (Barocchi 1971— II p 1935) in the original Platonic sense as an inner eye directed away from the senses: *le cose belle de l'immaginazione e [de] la ragione e de la mente umana (che hai detto) non hanno già composizione di materia né forma, e pur son li più belli del mondo inferiore.* Leonardo ca 1490—1510, on the other hand, uses (*Cod. Urb. Lat. 1270 ff 5 v — 7; op.cit.* I pp 235 f) the term *l'occhio tenebroso* in order to illustrate how badly the imaginations are judged in the dusky memory: *Oh che diferenzia è imaginar tal luce in l'occhio tenebroso, al vederla in atto fuori delle tenebre.* Comanini 1591 (ed. 1960— III p 288) uses the term in the unsuccesful metaphor that the intellect rather "sees" poetry than painting.
11. Leonardo ca 1490—1510 (*Cod. Atl. f 76 r;* Richter (1883) 1970 I § 20; Barocchi *op.cit.* II p 1267 and n 3) used at one instance the term to denote slavish, indiscriminate *mimesis speculare: Il pittore, che ritrae per pratica e giudizio d'ochio sanza ragione è come lo spechio, che in sé imita le a·ssé contraposte cose, senza cognizione d'esse.* Cf. Alberti 1435—36 (ed. (1956) 1967 p 93) and Lomazzo 1584 (*ed.cit.* II p 217 n 9). *Pratica* denoted also for Dolce 1557 (ed. 1960— I p 172 and n 4) indiscriminate imitation as opposed to corrective. Michelangelo 1547 (ed. 1960— I pp 61 n 2, 82 n 2; Ciardi 1973 — I p 282 n 2; cf. Clements 1961 p 330 for another interpretation), Vasari 1547 (ed. 1960— I p 61 and n 2; cf., however *ibid.* 1568 ed. 1878— I p 151), Danti 1567 (ed. 1960— I pp 213, 233 and n 2), Armenini 1586 (Barocchi *op.cit.* II p 2013) and Comanini 1591 (ed. 1960— III p 438) used it to denote the means of *naturale giudizio,* an individual imitation, independent of rules.
12. Alberti 1435—36 (*ed.cit.* pp 92 ff); Ghiberti ca 1450 (Baxandall 1971 p 16 n 22); Leonardo ca 1490—1510 (*Cod. Urb. Lat. 1270 ff 20, 36 v;* Barocchi *op.cit.* I pp 475 ff; II p 1294; Richter *op.cit.* I § 507); Castiglione 1528 (Barocchi *op.cit.* II p 1533); Pino 1548 (ed. 1960— I pp 113 f); Dolce 1557 (ed. 1960— I pp 155 f); Gilio 1564 (ed. 1960— II pp 24 f); Vasari 1564 (Barocchi *op.cit.* II pp 1912 f) *ibid.* 1568 (ed. 1878— I pp 165 f; Rouchette 1959 p 96 n 1); Lomazzo 1584 (*ed.cit.* II pp 216 f and n 3; 417; Barocchi *op.cit.* II p 1857 nn 1, 2); Zuccari 1607 (*op.cit.* II p 2086).
13. Alberti 1435—36 (*ed.cit.* pp 96 ff) advises the painter to consult his friends before the work is finished; Leonardo ca 1490—1510 (*Cod. Urb. Lat. 1270 f 38;* Barocchi 1960— I p 56 n 6; *Libro A 95;* Pedretti 1964 pp 78, 130); Varchi 1547 (ed. 1960— I p 56); Pino 1548 (ed. 1960— I p 134); Lomazzo 1584 (*ed.cit.* II p 217); *Che se il pittore dipingesse solo per sodisfare et appagar se medesimo e non volesse che l'opere sue fossero di altri vedute, allora potrebbe egli far le figure a suo senno e modo.*

14. Normally, of course, the artist's own hand, but talking of Raphael, who used to let his apprentices and collaborators do a good deal of his paintings, V. Borghini ca 1560, in the margin of his MS (*La somma della disputà;* Barocchi *op.cit.* I p 665 n 2) wrote: *i maestri operono ne'loro descipoli, mostrando loro di mano in mano quel che hanno a fare e corregendo e'nsegnando e ritoccendo e finendo* ...

15. Barocchi *op.cit.* II pp 1324 f; cf. Michelangelo below; Klein-Zerner 1966 p 96.

16. Cf. below chap. B III 4, clarity perspective.

17. Filippo Villani 1381—82 on *prontezza di mano sensibile* (Brunello 1971 p xi and n 9). The meaning of *sprezzatura* was, however, widened in the Cinquecento. Castiglione 1528 (I, xxvi; ed. 1947 p 63) had *sprezzatura* to denote an elegant social ideal, which was applied to the unaffected character of the painting of the Cinquecento in particular by Vasari 1568 (ed. 1878— IV pp 9 f; cf. Lomazzo 1590, chap. 37; ed. 1973— I p 355) as opposed to what was regarded the tedious, crammed character of the painting of the Middle Ages and the early Quattrocento. The concept got, through the introduction of the new, pastose technique of Titian and Tintoretto, a negative meaning, synonymous to *fretto*—quick, careless; Pino 1548 (ed. 1960— I p 199) wrote that *la prestezza nell'uomo è disposizion natural et è quasi imperfezzione* ... *per non esser tal cosa acquistata da lui, ma donatagli dalla natura,* and Aretino finishes the same year his flattering letter to Tintoretto with an exhortation: *et beato il vostro nome, se reduceste la prestezza del fatto in pazienza del fare.* On *sprezzatura* as a threat against the material endurance of the paintings, cf. Vasari 1568 (*ed.cit.* VI pp 590 f); Armenini 1586 (Barocchi 1971— II pp 1594, 2289). Cf. note 33 below.

18. Alberti 1435—36 (*ed.cit.* p 95); Varchi 1549 (Barocchi *op.cit.* II p 1324); Danti 1567 (ed. 1960— I p 265); Vasari 1568 (*ed.cit.* I p 168; Panofsky (1924) 1968 pp 61 f); Lomazzo 1584 (Lib. VI chap. 65; ed. 1973— II p 415).

19. Armenini 1586; Barocchi *op.cit.* I p 994. As to Leonardo ca 1490—1510, he certainly recommended solitude and contemplation (*ed.cit.* TP 50; cf. *Cod. Atl.* 175 v), but also company (cf. Zubov 1968 pp 208, 211 f). According to Vasari 1568 (ed. 1878— V p 47), his imagination was so rich and his ideas so etheric that they could not be materialized: *conciossachè si formava nell'idea alcune difficultà sottili e tante maravigliose, che con li mani, ancora, ch'elle fussero eccellentissime, non si sarebbono espresse mai.* Cf. Gantner 1958 p 39. Lomazzo 1584 (Lib. II chap. 14; *ed.cit.* II p 139), who had access to his notebooks, cites him to illustrate the importance of *discrezione.*

20. Barocchi *op.cit.* I p 318; cf. Castelvetro 1567, *op.cit.* II p 1577.

21. *Metaphys.* IX, 6, 1048 a: *In lapide est forma Mercurii in potentia;* cf. *Nat. ausc.* I, x; Panofsky *op.cit.* pp 17, 30 n 43; Barocchi *op.cit.* II p 1333 and n 1, with reference to Tolnay 1964, pp 96 f. Cf. Grayson 1972 pp 120 f and note to p 140, with reference to A. Parronchi, *Sul della statua albertiano,* in "Paragone" 1959 p 13. The metaphor was used by as different writers as Ps-Dionysius and Thomas Aquinas; cf. von Einem 1959 p 78 n 22; Dresden 1976 p 462.

22. Panofsky *op.cit.* p 28. Cf. Varchi 1549; Barocchi *op.cit.* II, note to p 1324 f; 1333 and n 1.

23. Panofsky *loc.cit.* Cf. Dante, *Paradiso* I 127—129: *Vero è che, come forma non s'accorda | Molte fiate all'intenzion dell'arte | Perchè a responder la materia è sorda.*

24. Chap. VI; Panofsky *op.cit.* p 137.

25. Barocchi *op.cit.* II pp 1629 f.

26. Chap. 26; Panofsky *op.cit.* pp 143 f.

27. The 'preparation' concerns *ordine,* the differences of the parts, *modo,* the quantity and *specie,* lines and colours.

28. Above chap. IV.

29. Panofsky *op.cit.* pp 117 ff. Cf. Varchi 1549 (Barocchi *op.cit.* II pp 1322 ff); Vasari 1568 *(ed.cit.* VII p 274). The Aristotelian metaphor regards the subtractive technique, *levare,* of sculpture. Dresden 1976 (pp 459 ff), has drawn attention to the curious fact that Michelangelo also applied it to the additive technique of drawing, *aggiungere* (Dresden, however, associates *penna* and *inchiostro* to authorship and literature): *Si come nella penna e nell'inchiostro | E l'alto e'l basso e'l mediocra stile | E ne'marmi l'amigin ricca e vile..;* Frey 1964 pp 54, 89, 207. Cf. Panofsky *op.cit.* p 30 n 43.

30. Thus Leonardo could use the metaphor from a strictly technical point of view (ed. 1882 TP 36): *fa per forza di bracchia e di percussione che eccede la figura che dentro a quella si rinchiude.* On the distinction between *aggiungere* and *levare,* cf. Alberti ca 1464 (ed. 1972 pp 120 f; note to p 140; Panofsky *op.cit.* p 116 n 15); Bronzino, Michelangelo, Sangallo and Varchi 1547 (ed. 1960 I pp 66, 82, 76, 49); Vasari 1568 (Barocchi *op.cit.* I p 999 n 1); V. Broghini ca 1560 *(op.cit.* I p 616); Speroni ca 1550—80 *(op.cit.* I p 999); Zuccari 1607 *(op.cit.* I p 698 and n 9). Cf. Lomazzo 1584 (ed. 1973— II p 287) and R. Alberti 1604 below.

31. Clements 1961 pp 305 f.

32. Vasari 1568; *ed.cit.* VII p 240.

33. One of the arguments in the *paragone* of the adherents of sculpture. Pino 1548 (ed. 1960— I p 120) underlines the *presta resoluzione* necessary for frescopainting: *è più ispediente, ond'io esprimo con maggior prestezza il mio concetto.* Cf. Lomazzo 1590 (chap. 21; *ed.cit.* I p 304), who also writes that frescopainting demands *prontezza d'ingenio e velocità di mano* and gives *maggior gloria* than the conformable oil-painting.

34. Lib. II chap. 14; *ed.cit.* II pp 138 f: *Però che tal arte non è manco sogetta alle materie grosse che alle sottili, cioè alle imaginazioni della mente, li quali non possono in maniera alcuna essere espresse dove vi è interrompimento di cosa a loro contraria. Il che si vede chiaramente essere nella scultura, dove v'interviene marmo, ferro et altro simili materie di fatica e strepito, tutte cose nemiche de lo studio, il quale non può mai mettervisi et applicarvisi, che tuttavia però per questa cagione grandamente non s'interrompa, e l'opera non riesca in gran parte men bella e perfetta di quello che l'artefice, avanti che dasse di piglio allo scalpello, s'aveva nella sua idea concetto et imaginato.*

35. Ed. 1878— I p 99.

36. Ed. 1960— III pp 144, 164.

37. For instance Pino 1548 (ed. 1960— I p 120), Vasari 1568 *(ed.cit.* I p 185) and Armenini 1586 (Barocchi 1971— II p 2286), who says that oil-painting is *il più perfetto per cagion de l'esprimer meglio ogni suo concetto.* Dolce 1557 (ed. 1960— I p 197) praises Raphael for having surpassed in fresco the oil-paintings of several other artists. This kind of comparison is particularly frequent in Vasari 1568 *(ed.cit.* II pp 133, 563; III p 469; IV pp 138, 177; V pp 60, 125, 340, 615, 623; VI p 257).

38. Cf. below chap. B III 3 on the importance of *sfumato* and the function of *lustro.*

39. The complex concept of *non finito* in the Renaissance has been interpreted in many ways (cf. Barocchi 1958; Gantner 1959 pp 47 ff; von Einem 1959 pp 69 ff; Chastel 1959 pp 83 ff; Dresden 1976 pp 453 ff). According to my observations, the rough physical structure of the Venetian technique was not, with the

exception—however not total—of the Venetian art theorists and critics, generally appreciated. Leonardo, who with regard to oil-painting represents the Flemish tradition fought an unsuccesful battle against corruptible techniques and discolourating varnishes. That *disegno*, in particular the preliminary sketch, was regarded as the purest—and in this respect the most perfect—manifestation of the mental *concetto* (Gantner pp 55 f; Dresden p 463) has, in my opinion, very little to do with the concept of *non finito;* the general ideal was, as far as painting is concerned, perfection or *finito* (Chastel pp 86 f. Cf. Dresden *loc.cit.*) Chastel (p 84) characterizes the opinion of Bocchi 1581 (ed. Cinelli 1667 pp 138 f), who wrote, with reference to Buontalenti's arrangement (in the *grotte* of the Boboli gardens) of Michelangelo's unfinished slaves, that they were *più maravigliose in questa guisa che se del tutto fossero compiute,* as a manifestation of a later Mannerist ideal. In my opinion, however, this admiration of the *non finito* is due to the legendary nature of the artist, in the same way as already Giovio ca 1523—27 (a) (Barocchi 1971— I pp 8 f) wrote about the damaged *Last Supper* of Leonardo: "but the grief over the unexpected damage seems to have contributed, to a very high extent, to the fascination of the interrupted work" (*cuius inexpectatae iniuriae iustissimus dolor interrupto operi gratiae plurimum addidisse videtur*). Cf. Pliny *Nat. Hist.* XXXV, 145, quoted in Dresden p 458.

40. Cf. Gilio 1564 and Zuccari 1607, who differentiated between *disegno interno* and *esterno.*

41. With a travesty of Aristotle one might say: *In linea color picturae est in potentia.*

42. Lib. VI chap. 65; *ed.cit.* II p 417: ... *formato che si ha una cosa nell'idea, la qual si vol poi disegnare, più facilmente si disegnerà sopra materia che non sia estrema, come sarebbe a dir sopra carta bianchissima, e con istromenti che non sia estrememente acuto, come sarebbe penna tinta nel inchiostro, ma sì con penna sottilissima tinta nella sola acquarella, over con pietra tedesca e rossa, e sopra carta tinta, sì che sendovi poca differenza tra 'l colore del disegno e la carta* ... *per non generar confusione nella mente in vedere due colori estremi che insieme contendono, com'è il nero inchiostro sopra la carta biancha.*

43. Note the difference between *materia* and *colori.* Cf. above chap. A II.

## 4. Durabilità

The argument in the *paragone*[1] that sculpture is superior to painting due to its greater material durability[2], *durabilità* or *eternità,* was rejected with a range of arguments, in particular that sculpture comes into being through contemptible manual labour, *fatica di corpo,* whereas painting is a physically unburdening but mentally demanding realization of advanced theortical knowledge, *fatica di mente.* Yet the argument was experienced as embarrassing and answered inconsistently. On the one hand Leonardo, among others, maintained that the argument was inadequate since the durability was not a result of the scuptor's skill but of an immanent quality in the material[3]; on the other hand the same Leonardo—just as if the argument he had dismissed was indeed adequate—vindicated painting in enamel-colours on metal or *terracotta* as being 'eternal' too[4], and with reference

to the fact that even bronze statues—the very emblem of *eternità*[5]—were melted down and turned into arms in times of war[6], empasized that nothing in the sub-lunar world is perpetual[7]. The sculptors' argument demanded, in spite of a tendency to an increasing aversion to technical questions in the Cinquecento[8], a ranking of the relative durability of painting-techniques. The first rank was shared by mosaic[9], fresco-painting[10], enamel-painting on metal or *terracotta*[11] and the method invented by Sebastiano del Piombo of painting in oil-colours on stone or walls[12]. Tempera held a medium rank[13], whereas oil-painting was ranked as the least durable technique[14] together with methods such as gouache[15] and pastel[16]. This ranking order was relevant for correctly applied techniques and presupposed knowledge about chemical reactions between pigments and mediums[17] and pigments/ mediums—air[18]. A quick execution—desirable for other reasons[19]—was not allowed to result in a rough surface; *pulitezza,* the result of a careful layer-technique with time-consuming interjacent drying became the ideal[20], and the Venetian, pastose technique was—if it not, as with Titian, was the result of a careful process, only apparently seeming to have been done quickly[21]—considered a threat against material endurance[22]. Vasari 1568 reports that Titian was forced to paint anew *The Holy Spirit and the Apostles* for S. Spirito in Venice since the original picture had quickly degenerated[23]. References to Antiquity were made in order to authorize the endurance-motivated claim for *pulitezza*[24]. The ranking order also took the 'normal' aging process—sometimes called 'the influence of time'— into consideration; the consequences of the open-air location of certain monumental paintings[25], the discolouration of varnishes, general deterioration of polluted air, dampness etc. of paintings located indoors, and the resistance against current cleaning. Accidental damage, on the other hand, was not taken into consideration; the mass of examples in Vasari 1568 may be divided in two main categories, the first that of calcualted interference—the commissioner's order of retouching or destruction and replacement for aesthetic[26], moral[27] or technical[28] reasons, and the other that of *force majeure*—political states of agitation[29], war[30], fire[31] and general damage[32].

## Oil-Painting and Varnishes

The technique of oil-painting—the great technical innovation imported from the North—had a range of ideal qualities. But in spite of its ductibility, speed, expressive possibilities (among others due to the choice between transparent or opaque application for the imitation of such phenomena) and brilliance, it was accompanied by at great disadvantage, aside from its general fragility[33]; the oil is subject to a certain discolouration. Possibly it was thought from the beginning that the glossy paint did not

need any varnish[34], but after the discovery of the yellowing of the oil medium and its grave consequences, varnishes again became prevalent in the hope of isolating the oil from the harmful influence of the air with a mixture of oil and resin, which was—erroneously[35]—thought to be less yellowing.

Varnishes have been used since Antiquity[36]; the designation, however, has four quite different significations: opaque, chromatic glossy paint, transparent, colourless, glossy paint used either as a medium[37], as isolation between two layers of paint which would otherwise react against each other[38], or as a final coating. Whether the last kind of transparent, colourless varnish was used in Greek and Roman Antiquity is debated[39]; the relevant text of the main source. Pliny's *Naturalis Historia*[40], is partly corrupt. Full agreement of its meaning is restricted to its beginning and end: "He [Apelles] invented things in the arts which also others profited from, but one thing no one could imitate; this was that he coated his finished works with *atramentum*[41], so thin that while it "..." and protected the painting from dust and dirt, it was visible only to one inspecting it close at hand; but this also involved considerable theoretical calculation, lest the brightness of the colours offended the eye, as in the case of those who look through a semi-transparent stone[42], and also so that from a distance the same device might, though hidden, give somberness to the colours which were too bright." The controversial part, missing above, has been rendered in different ways, which have in common only the statement that the *atramentum* accentuated or brought out something—either (1 a) the reflection of the brightness of the colour, or—actually the same ting—(1 b) of all colours; (2 a) a luminous white colour or (2 b) the brightness of the white colour, or finally (3) another colour[43]. Though the original meaning of Pliny's text does not have a primary importance in this context, it may be established that he indeed described a final over-all coating which is transparent, but also coloured. Since the dominant variant of oil-painting in Renaissance Italy was the Flemish layer-technique, it is not surprising that Pliny's text caused confusion; a glaze is indeed a semi-transparent coloured layer, but it is not applied as a final coating of the entire picture, but applied locally and to a varying extent. The *atramentum* of Apelles, then, seems to have been something different from both a glaze and a picture-varnish. One of the functions of the final, transparent and colourless varnish on oil-paintings was—and still is—to eliminate reflections at spots from the glazed areas and thus to unify the over-all response to real light. In other words, any discussion of *atramentum* must be based on a clear distinction between the locally applied, coloured, semi-transparent glaze and the colourless and transparent varnish[44], applied over the entire picture. The edition *princeps* of Pliny in the Renaissance was that of Cristoforo Landino 1476, where we read: *Ma una cosa nessuno pote*

*imitare. Imperoche i piastrava lopere gia finite con si sottile atramento che quello per reflexione de lumi exitava lo splendore a glocchi & conservava la pictura dalla polvere & da ogni bruttura*[45]; Landino evidently conceived *atramentum* as a glossy, protective over-all coating The continuation directs our attention to an apparently contradictory property of this glossy surface: to somehow strengthen while—at the same time— subduing the colours by preventing the splendour from offending the eye: *Onde la medesima cosa dava occultamente una certa austerità a colori floridi*[46]; Landino did not see any contradiction in this, and he was right, since a varnish actually increases the saturation of the colours and at the same time makes them darker[47]; *floridus*[48], then, was interpreted as intense, and *austerus* as saturated, probably quite contrary to Pliny's intention[49]. The same interpretation is found in Maranta ca 1550—70[50], Adriani 1586[51], R. Borghini 1584[52] and Possevino 1595[53]; *atramentum* is conceived as an over-all, final coating of the finished painting, which gave life either to some colours (Adriani), the feeble or 'dead' colours (Maranta, R. Borghini) or to all colours (Possevino) and at the same time reduced the brightness of those that were too bright. Dolce 1557[54] and Armenini 1586[55], however, refer to *atramentum* rather hastily, but it is not unlikely that at least the latter thought of it as a kind of glaze.

As to the varnish used by the Renaissance painters, the older type was of the traditional, medieval kind, made of oil and resin; Cennini does not give any recipe for the *vernice liquida,* to which he refers in many places[56], but he emphasizes that is must be *lucida e chiara la più che si possa trovare.* In the MS Bologna ca 1425—50, three recipes for similar types of oil/resin-varnishes are given[57]; Leonardo recommends sandarac and nutoil[58], which yellows less; the MS Marciana ca 1503—27 contains several recipes of this kind, accompanied by exhortations and promises that the varnish will be as clear as possible[59]; this type is still found in the MS Padua ca 1580, again with emphasis on the clearness[60], and in R. Borghini 1584 [61] and Armenini 1586[62]. But already[63] in the MS Marciana ca 1503 —27[64] a new—in fact the modern—kind of varnish, which is said to remain very clear, is introduced: resin dissolved in alcohol or essential oils, a kind which is also found in the MS Padua ca 1580[65], R. Borghini 1584[66] and Armenini 1586[67]. It seems rather likely that this new type was introduced when the great disadvantages of the old oil-resin type were noticed; the removal of the yellowed varnish[68] must have caused problems, since it contains the same medium as the paint-layer. Leonardo ascribed the yellowing to the resins, which *col tempo pigliano un certo giallo che pende in nero*[69]. That the oil, too, undergoes discolouration he explained by an unsufficient removal of the inner coat of the nut. He was aware of the possibility of isolating certain instable colours from the influences of a superimposed glaze with a layer of varnish[70], but also aware of the

yellowing of the final oil/resin-varnish when it is exposed to the air. His efforts to solve this problem take an almost tragi-comical expression; he recommends an *etterna vernice* by application, in the still wet varnish *d'olio vecchio chiaro e sodo,* of a *vetro cristalino colla vernice ben chiara,* which he hoped would eliminate the yellowing of the old type of varnish of nut-oil and amber. Though his observations of the effects of a yellow filter do not have any connection to the yellowing of varnishes, they summarize its irregular influence: some colours, he says, 'improve' when seen through a coloured glass filter, whereas other deteriorate; if the glass is yellow, *questo peggioramento in tal color di vetro accaderà alli azuri e neri e bianchi*[71]. At any rate Leonardo is perhaps the most pronounced case of the ambition—rather self-evident with regard to the great importance he ascribed to colour, in particular to the blue colour, for the rendering of distance—to avoid colour-changes and preserve the paintings[72]. But he was not unique in this respect; Vasari 1568 agrees with il Moro, who held that *il vernicare le tavole le guastasse, e le facesse più tosto che non fariendo divenir vecchie;* therefore, il Moro applied the varnish only to the black areas and used purified oils; *e così fu il primo che in Verona facesse bene i paesi*[73]. Vasari also relates Beccafumi's opinion that an oil-painting ages quicker than a tempera-painting[74]. R. Borghini 1584 recommends nut-oil instead of linseed-oil as a medium, *perché è più sottile, e non ingialla i colori*[75], and notes that an excess of oil in the varnish *scema grandamente la vivezza de'colori*[76]. Armenini 1586 also recommends nut-oil[77] and warns against an excessive use of oil, which *li ricopre la sua vivezza, e lo appanna di modo che in breve divien gializza*[78]. In connection with his recipes for varnishes, which, as in R. Borghini, include the same less yellowing and easier removable pure resin-varnish, he concludes the three functions of an ideal varnish: *di ravvivare e cavar fuori i colori; mantenerli lungissimo tempo belli e vivaci; discoprire ancora tutte le minutezze che sono nella opera e farle apparer chiarissima,* i.e. to increase the saturation and intensity of the colours, to preserve them in that state and to increase and preserve the contrast.

The tedious examination of these technical questions proves, I hope, once and for all, that the yellowing of the oil, both as a medium and as a component in varnishes, was considered distastrous and hoped to be eliminated. By isolating the paint layer with an over-all layer of varnish—which indeed was the rule and not exceptional[79]—one attempted to eliminate changes of colour, but when—at the beginning of the Cinquecento—the disadvantages of the old type of oil/resin-varnish had become obvious, it was replaced by a pure, easily removable, resin-varnish. The ideal varnish was to be completely colourless and transparent; when it no longer had these properties, the varnish should be removed[80] and replaced.

Not only oil-paintings were cleaned; one of the arguments[81] against retouches done *a secco* in an *a fresco* was exactly that they were dissolved when the painting was cleaned with water[82]. The purpose of cleaning was to remove any dirt or uncalculatedly coloured layer on top of the original paint and—in the case of oil-paintings—to replace that foreign layer with a clear varnish. This kind of proper restoration and conservation is motivated by, and part of a natural process, which is completely different from the kinds of accidental interferences, which lead to destruction, removal, repainting, retouching and overpainting. The latter cases raised the ethical problems of intrusion upon the personal *maniera* of the artist, including his colouristic and technical characteristics[83]; Pino 1548 held that damaged parts of a sculpture may be completed with a certain probability of correctness, *ma se la figura dipinta si guasta, o nella faccia o in altra parte, chi è quello che la possi acconciare*[84]? Three examples illustrate the low opinion[85] of *restauro pittorico:* Dolce 1557 reports that when Titian saw Raphael's *The Miracle of Bolsena* in the Stanza della Segnatura, which had been damaged by German soldiers during the Sack of Rome and retouched by Sebastiano del Piombo, he asked the latter, unknowing that indeed he was the one, who the ignorant bungler was who had disfigured Raphael's work[86]. In a letter of 1604 the owner of a damaged picture, G. B. Marino, informs the painter that it has been restored by a *cavalier* Arpino, who restricted his retouching to the most damaged areas, *perché gli pareva dificilissimo il potere imitar bene la sua maniera e far che i colori nuovi e freschi non si conoscessero dagli altri temperati per altra mano*[87]. Vasari 1568 even formulated an important doctrine of ethics of restoration: *E, nel vero, sarebbe meglio tenersi alcuna volta le cose fatte da uomini eccelenti piuttosto mezzo guaste, che farli ritoccare a chi sa meno*[88]. It is, then, again confirmed that the artists and theorists of the period, or at least of the Cinquecento, regarded the artist's work, in the state at which he committed it—to both the contemporary commissioner, owner, critics and the public and to posterity—as a personal investment of knowledge and talent; the qualified work of art guarantees *eterna gloria*[89] to the artist. The Church, however, did not show any respect for the independence and creativity of the artist; in fact the program for the arts of the Counter-Reformation, which was expressed in "Canons and Decrees of the Council of Trent" at its 25th session[90], bears witness of an explicitly negative attitude towards the aesthetic, sensual qualities of the images: "not for that reason is the divinity represented in pictures as if it can be seen with bodily eyes or expressed in colours or figures", . . . "the images shall not be painted and adorned with a seductive charm" . . . The program, which had its most influential adherents in Gilio 1564[91], Molanus 1570[92], Borro-

meo 1577[93], Paleotti 1582[94], Comanini 1591[95] and Possevino 1595[96], prescribes a return to the medieval, absolute authority[97] of the Church, motivated by the awareness of the effectiveness of pictures as didactic instruments for religion, *libri degli idioti*[98]. Clarity was demanded, both comprehensive and visual; possibly the Neo-Platonic identification of light and bright colours with divine influence contributed to this demand. The care of the religous pictures was neither motivated by aesthetic arguments nor by respect for the artist's creativity; the pictures *"per se stessi non sono cose, ma segni di cose, onde pigliano la sua condizione da quello che rappresentano"*[99]; the images of the most important holy persons were too important to become and stay dirty or incomplete[100]. In addition, the demand for emotional expressiveness[101] played an important role for the demand of clean pictures.

## Leonardo

Leonardo was not unique in his efforts to preserve his paintings intact (above p 81), but the extent to which this ambition was to dominate his thoughts is indeed unique. His search for unchangeable colours and invariably transparent varnishes is only apparently contradictory to his notorious incapacity of finishing and to, when this occurred, making his paintings technically satisfactory. Before long[102], however, it was proposed that he was a Neo-Platonist[103], for whom the meditation on a transcendental beauty was more important than the materialization of it. But not only his experiments with new techniques, but his whole activity, bent on a practical synthesis of natural observations and theoretical studies, is contrary to such a philosophy; he was indeed an Aristotelian[104]. In the *paragone*[105] he stressed the durability of painting and described the unique painting as a materialized synthesis of the painter's knowledge and skill, in which the vanishing beauty of nature is preserved for eternity[106]. He was aware that painting, in order to qualify for a scientific status, had to possess both theoretic *virtù* and material invariability[107]. In the course of time, however, Leonardo was to experience that not even the limited number of paintings which he finished remained intact[108]. That not even the materializations of his efforts to lift objects and phenomena out of the passing time and changing appearance lasted, must have confirmed for Leonardo the destructive, ever-changing property of nature—that very nature, which he thought would one day become possessed with a frenzy which would extinguish life and demolish everything, so that in the end, when this final storm had passed away, only the four elements remained[109]. His paintings would not offer him any eternal glory, but were as corruptible as himself: *O tempo, consumatore delle cose, individiosa antichità, tu distrugge tutte le cose, e consumate tutte le cose dai duri denti della*

83

*vecchiezza, a poco a poco con la lenta morte*[110]. Vasari 1568[111] relates that Leonardo during his late visit to Rome, when he had received a commission for a painting from Leo X, immediately started to destill oils and herbs[112] for the preservation of a painting which was not even begun. Heydenreich[113] justly characterizes his behaviour as a self-deception and points out that during the last decade of his life Leonardo abstained from painting[114].

1. With reference to Seneca, *De brev. vitae* I: *Ars longa, vita brevis*, which is a travesty of Hippocrate's *Aphorisms* I, 1.
2. Argued by, among others, Petrarch, *De statuis* XLI; Baxandall 1972 pp 52 ff, 141 ff. Cf. Horace, note 5 below.
3. Ed. 1882 TP 37. The argument is repeated by Varchi 1547 (ed. 1960— I p 41), Bronzino 1547 (ed. 1960— I p 65), Pontormo 1547 (ed. 1960— I p 69), Pino 1548 (ed. 1960— I p 129 f), V. Borghini ca 1560 (Barocchi 1971— I pp 632 f), il Lasca ca 1560 (ed. 1882 pp 84 f; Barocchi *op.cit.* I p 600 n 1), Vasari 1568 (ed. 1878— I p 95), Speroni ca 1570—80 (Barocchi *op.cit.* I p 1003), R. Borghini 1584 (*op.cit.* I pp 682 f), Zuccari 1607 (*op.cit.* I pp 698 f), G. Galileo 1612 (*op.cit.* I p 710).
4. This argument was repeated by Varchi 1547 (*loc.cit.*), Pontormo 1547 (*loc.cit.*, Zuccari 1607 (*op.cit.* I p 701) and indirectly confirmed by the descriptions and discoveries of mosaic and lime paintings from Roman times. Cf. Pliny, *Nat. Hist.* XXV 17; Vasari 1568, *ed.cit.* VI p 549; Previtali 1964 p 30.
5. Cf. Horace, *Ode* III 30. 1: *exegi monumentum aere perennius;* I have [in my poetry] raised a monument more eternal than bronze. Cf. Bazandall 1971 p 88 and n 83.
6. For instance Michelangelo's statue of Julius II; Vasari 1568 (*ed.cit.* VII pp 171 f). Cf. Doni 1549 (Barocchi *op.cit.* I p 581) and Paleotti 1582 (ed. 1960— II p 331).
7. Leonardo, Varchi, Pontormo and R. Borghini, *loc.cit.*
8. Such questions illustrated the character of handicraft. Cf. Gilbert 1946 p 89 n 10; Klein-Zerner 1966 p 95.
9. Doni 1549 (Barocchi *op.cit.* I p 587), Vasari 1568, *ed.cit.* I p 196, III pp 237 and 258, where he relates the opinion of D. Ghirlandaio that the other painting-techniques are related to mosaic—*la vera pittura per la eternità*—like drawing to painting.
10. Pino 1548 (*ed.cit.* I p 120), Doni 1549 (Barocchi *op.cit.* I pp 557, 583), Vasari 1568 (*ed.cit.* I p 182, II pp 564 ff, VI pp 549 ff), Lomazzo 1584 (ed. 1973— II p 168), Armenini 1586 (Barocchi *op.cit.* II p 2286), Lomazzo 1590 (ed. 1973— I p 304) and Zuccari 1607 (Barocchi *op.cit.* I pp 700 f).
11. Cf. Leonardo above.
12. Varchi 1547 (*loc.cit.*), Vasari 1568 (*ed.cit.* I p 188, V p 579). The older method, examplified by the technical disaster of Leonardo's *Battle of Anghiari* 1505 (cf. Giovio 1523— 27 (a), Barocchi *op.cit.* I p 8; Billi ca 1520 (ed. 1892 p 51); Vasari 1568 (*ed.cit.* IV p 43); Lomazzo 1590 (*ed.cit.* I p 286) was rejected as a corruptible method. Cf. Doni 1547 (Barocchi *op.cit.* II p 1909), Pino 1549 (*loc.cit.*), Doni 1549 (Barocchi *op.cit.* I p 582), Vasari 1568 (*ed.cit.* V p 580) and Armenini 1586 (*loc.cit.*).

13. Doni 1549 (*loc.cit.*), Vasari 1568 (*ed.cit.* I p 183, V p 648), Lomazzo 1590 (*loc.cit.*).
14. Vasari 1568 *ed.cit.* IV pp 236, 258, however, gives some rather imaginative examples of its resistance to water.
15. Pino 1548, *ed.cit.* I p 121.
16. Lomazzo 1584 *ed.cit.* II p 170.
17. Cennini ca 1400 (ed. 1971 pp 35, 42, 45, 52 f, 57 f, 61, 63, 85); Leonardo ca 1490—1510 (Richter (1883) 1970 I § 634); Sorte 1580 (ed. 1960— I p 288); R. Borghini 1584 (ed. 1807 I pp 198, 202, 257); Lomazzo 1584 (*ed.cit.* II pp 169 ff). Cf. Varchi 1564 (ed. 1874 p 108) who relates that Michelangelo prepared his colours himself, without the aid of manufacturers or his assistants, since he did not have any confidence in them.
18. Cennini ca 1400 (*ed.cit.* pp 42, 47, 50, 54, 61, 85 f. He mentions also reactions between different pigments—pp 85 f, 94); cf. Leonardo ca 1490—1510 (*op.cit.* I § 625; cf. Barocchi *op.cit.* II pp 2151 f); Vasari 1568 (*ed.cit.* I pp 182 f, IV pp 26, 377 f, V pp 580, 684); Armenini 1586 (Barocchi *op.cit.* II pp 2287, 2291).
19. Above chap. IV.
20. In particular Vasari 1568 (*ed.cit.* IV p 567) on Lorenzo di Credi: *il lavorare pulito a olio è necessario a volere che l'opere si conservino.* His care made the works of other painters, when compared to his, seem *abozzata e mal netta.* Cf. above, chap. B I 3 and n 17.
21. Vasari 1568 *ed.cit.* II p 452.
22. Cf. Lomazzo 1584 Lib. III chap. 4, 9; *ed.cit.* II pp 169, 174 and n 3. Cf. above, chap. B I 3 n 17.
23. *Ed.cit.* VII p 444. For similar 'guarantees of durability', cf. *ibid.* VI p 541 and Baxandall 1972 p 20, who cites a contract of 1445, in which Piero della Francesca is obliged to remedy any defect caused within ten years by the materials used or the painter's lack of skill.
24. Pliny, *Nat. Hist.* XXXV 102 f on Protogenes; Plutarch, *De amic, mult.* 94 on Zeuxis; both are said to have answered the criticism of excessive slowness that it was necessary for the sake of durability. On Protogenes, Lomazzo 1590 (ed. 1973— I p 285); on Apelles (!), Possevino 1595 (Barocchi *op.cit.* I p 45); on Zeuxis, R. Alberti 1604 (*op.cit.* I p 1020). Cf. Vasari 1568 (*ed.cit.* III p 574) on some pictures by Perugino, which were damaged in the underlaying shadowed parts due to a too quick application of the top layers.
25. Dolce 1557 (ed. 1968 pp 84 f); Vasari 1568 (*ed.cit.* III p 8).
26. Destruction: *ed.cit.* V p 97, VI p 319, VII pp 89, 175. Replacement with new paintings: II pp 491 f, III p 579, IV pp 326, 361, V p 527, VI p 385, VII pp 37, 67, 90, 94, 174.
27. *Ed.cit.* VI p 383, VII pp 65, 383. On Michelangelo's *Last Judgement,* cf. Schlosser 1924 p 382; Blunt 1940 pp 112, 118 f, 124; Klein-Zerner 1966 pp 119, 122 ff; Abbate 1965 p 46.
28. *Ed.cit.* I pp 685, 687, III p 8, V p 625, VI p 25.
29. *Ed.cit.* III p 539, VII p 8 f.
30. *Ed.cit.* II p 490, III p 570, V pp 48, 125, 611.
31. *Ed.cit.* V p 344.
32. *Ed.cit.* I p 672, III p 146.
33. Among others due to damage to the support of insects; Vasari 1568 *ed.cit.* V p 579.
34. According to Vasari (*ed.cit.* II 564 ff) the oil-medium was the soloution found by Jan van Eyck to the search for a kind of paint which did not need

85

any additional varnish.

35. Ruhemann 1968 pp 102 f, 272, 399. On the changes in old varnishes, cf. above, introd., n 2.

36. Laurie 1911 p 27; Lucas 1934 p 56; Sanpaolesi 1934, *passim;* Gettens-Stout (1942) 1966 pp 56 ff.

37. *Il Codice Magliabechiano* (ed. 1892 pp 111 f) states that Leonardo painted the *Battle of Anghiari "con vernice";* Posner 1974 p 19 n 102.

38. Cf. above nn 17, 18.

39. Gombrich 1962 (b) pp 51 ff: *ibid.* 1963 (a) pp 90 f; Lepik-Kopaczyska 1958 pp 79 ff; *ibid.* 1962 pp 23 ff; Plesters 1962 pp 452 ff; Posner 1974 pp 17 f.

40. XXXV 97: *Inventa eius et ceteris profuere in arte, unum imitari nemo potuit, quod absoluta opera atramento inlinebat ita tenui ut id ipsum ... excitaret custodiretque a pulvere et sordibus, ad manum intuenti demum apparet, sed et tum ratione magna, ne claritas colorem aciem offenderet veluti per lapidem specularem intuentibus, et a longinquo eadem res nimis floridis coloribus austeritatem occulte daret.*

41. Earlier—XXXV 41—43—Pliny makes it clear that *atramentum* was a kind of black from burnt ivory.

42. Probably selene; cf. Posner *op.cit.* p 19 and n 24.

43. Cf. Gombrich 1963 (a) p 91 and n 8; (1 a) *repercussu claritates colorum;* (1 b) *repercussum, colorum omnium,* cf. Pollitt 1965 p 168; (2 a) *colorem album,* cf. Ferri 1946 pp 173 ff; (3) *colorem alium.*

44. Cf. Plesters *loc.cit.* The confusing result of neglecting this distinction may be studied in Kurz 1963 pp 94 ff, who actually denies that it can be made in connection to Renaissance painting, since over-all applied varnish would be exceptionally rare in that period (!).

45. Posner *op.cit.* p 18 n 88. "By reflecting light, it increased the splendour (of the colours) in the eyes of the beholder." Cf. note 43 above.

46. Posner *loc.cit.*

47. Evans 1948 pp 70 f. Cennini ca 1400 chap. 155; ed. 1971 pp 160 f: *La vernice è un licore forte, ed è dimostrativo, e vuole in tutto essere ubbidito.*

48. Cf. above chap. II and n 84.

49. Pliny did not explain the meaning of *austerus* and *flodirus;* he merely said (XXV, 6) that these two kinds of colours are either found in nature or produced artificially. According to Lepik-Kopaczynska 1962 pp 23 ff, *austerus* designated opaque, mat body-colours and *floridus* transparent, glossy glaze-colours; the function of *atramentum* would be to reduce the gloss of the latter. This interpretation seems probable, since the combination of a black pigment and the scattered light in the mat surface would reduce saturation and intensity.

50. He praises (Barocchi 1971— I p 812) Titian's *colori svegliati e vivi, ma non tanto lucenti che offendano la vista; della qual cosa si gloriò a' suoi tempi Apelle, il quale, dopo avere finita ciascuna sua opera, quella con una certa tintura nera dolcemente copriva per affievolire* [subdue] *i colori troppo lucidi* [= *floridus*] *et eccitare gli smorti, oltre che li defendava dalla polve ... Atramentum* revived the feeble colours.

51. In Vasari 1568, *ed.cit.* I p 38. He describes the invention of Apelles as a *color bruno, o vernice che si debba chiamare ... il quale con la sua rinverberazione destava la chiarezza d'alcuni dei colori e li defendeva dalla polvere ... acciochè la chiarezza d'alcuni accesi* [= *floridi*] *meno offendesse la vista di chi da lontano, come per vetro, li guardasse ... Atramentum* brought out some colours.

52. Ed. 1584 p 278; Posner *op.cit.* p 90 n 90: *Solo in una cosa non si trova mai*

*chi lo Apelles sapessi imitare, cioè in una vernice, che egli sopra l'opera già finite distenda, la quale con la sua transparentia e virtù destava i morti colori, e tutti insieme, acciò che l'uno più dell'altro la vista non offendesse, gli univa, e dalla polvere difendea.* Atramentum made the "dead" colours come alive; cf. Maranta above.

53. Translation of Possevino's Latin text (Barocchi 1971— I p 45): *Soleva spalmare le opere terminate con uno strato di vernice nera così sottile che, riflettando, accresceva la luminosità della vista, ma insieme le protteggeva dalla polvere e dalla sporcizia* [dirt], *e lo vedeva chi guardava da vicino, ma però serviva da ben calcolato schermo per gli occhi, che non fossero offesi dalla varietà dei colori, come si fosse guardato a distanza attraverso una lastra di talco, e ciò dava una certa austerità ai colori troppo vivaci* [= *floridus*]. Atramentum brought out the splendour of the colours; cf. Landino above.

54. Ed. 1960— I pp 183 f; ed. 1968 pp 152 f: *Il bruno si legge essere stato frequente da Apelle tale schietezza e purità di colore.*

55. Barocchi *op.cit.* II p 2286: *un liquor come vernice, col quale egli ravvivava tutti i colori, ricoprendoli col più e col meno.* Armenini here describes a varying local application, probably intended to give all colours an equal gloss. The reviving effect of varnish is emphasized elsewhere by Armenini (below p 81).

56. Chaps. 91, 97, 99, 101, 107, 129, 151, 153, 155, 162, 173, 174, 176, 178. On the traditional kind of varnish, cf. A. Bezzoli, *Supporte, imprimiture, olivernici e medium nelle pitture a olio per le belle arti,* in "Pitture e Vernici" XXXIX, no 1 1963; Gettens-Stout (1942) 1966 pp 56 ff. In general it consisted of sandarac from *Callitris quadrivalvis* or, more commonly, from juniper or mastic from *Pistachia lenticus,* dissolved in linseed oil.

57. Merrifield (1848) 1967 II pp 480 ff, 520; §§ 206, 207, 262.

58. Richter (1883) 1970 I § 636; cf. §635; Mc Mahon 1956 pp 364, 635 f; Posner *op.cit.* p 19 n 91.

59. Merrifield *op.cit.* pp 630 ff: § 398: 1 sandarac, 1 *incenso* (resin from the Boswellia-tree), alum and 3 nut-oil, all *chiari;* § 399, equated to *uno specchio di vetro;* 1 linseed-oil, ½ *pece greca* (resin from pine-trees), ½ mastic; § 400: 3 linseed-oil, ½ mastic, alum; § 401: 1 mastic, ½ *olio petronio* (naphta), ½ nut-oil *chiaro;* § 402, called *ottima chiara;* 2 nut-oil, *chiaro et bello,* 1 *peca greca chiara et bella,* ½ mastic, *chiaro et bello;* § 403: *olio di abezzo* (resin from *Pinus picea*), nut- or linseed-oil exposed to the sun, which makes it *più chiara,* or naphta; § 405: 2 linseed-oil *chiaro et buono,* 1—2 *pece greca chiara et bella,* alum.

60. Merrifield *op.cit.* II pp 670 ff; § 45, called *sottila e chiara:* Venetian turpentine (resin from *Pinus larix*), spike-oil (destilled of *Lavandula spica*); § 46: 1 mastic, 1 linseed-oil, *ogli d'abezzo;* § 47: 1 mastic, 1 linseed-oil, *raggia* (resin); § 48: *oglio d'abezzo,* naphta, mastic; § 49: 1 linseed-oil, 1 mastic, *oglio d'abezzo,* naphta; § 52: 1 mastic, 1 turpentine, 1 naphta, 2 *oglio d'abezzo;* § 53: *oglio d'abezzo,* mastic; § 55: linseed- or nut-oil, spike-oil, mastic; § 57: mastic, linseed- or nut-oil; § 92: turpentine, amber, turpentine-oil.

61. Ed. 1807 I p 257: 1 *olio d'abezzo,* 1 naphta, 2 nut-oil, 1 mastic; 1 spike-oil, 1 sandarac.

62. Barocchi 1971— II p 2292: 1 *olio d'abezzo,* 1 naphta; mastic, nut-oil, alum; mastic, sandarac, nut-oil, pine-oil.

63. Gettens-Stout *op.cit.* p 58, state that this type was not introduced until about a hundred years later.

64. Merrifield *op.cit.* II pp 328 ff; § 396: 5 destilled alcohol, 1 *bengivi* (benzoin, resin from *Styrax benzoin*); § 397: *resta molta chiara;* destilled alcohol, benzoin.

65. Merrifield *op.cit.* II pp 690 f, 696 ff; § 94, *vernice lucidissima:* 7 destilled alcohol, 2 sandarac *ben chiara,* 2 *olio d'abezzo;* § 104, *vernice chiara:* destilled alcohol, turpentine, mastic, sandarac; § 106: 1 sandarac, ¼ *oglio d'abezzo,* ½ destilled alcohol.

66. Barocchi *op.cit.* II p 2292: 1 destilled alcohol, 4 Venetian turpentine, 1 mastic.

67. *Loc.cit.:* alcohol, sandarac, *peca greca;* resin, spirit.

68. Below p 82.

69. Richter (1883) 1970 I § 630.

70. *Cod. Urb. Lat.* 1270 ff 67 v — 68 r; Barocchi *op.cit.* II p 2151.

71. Ed. 1882 TP 254; Mc Mahon 1956 p 176; Pedretti 1964 p 57; Posner 1974 p 19 n 91.

72. Thus, I do not agree with Posner as to the possible connection between Apelle's *atramentum* and Leonardo's "dark manner"; the reason for his preference for a weak illumination will be analyzed below chap. B III 3.

73. Ed. 1878— V p 287; note the connection between the elimination of yellowed varnish and the successful rendering of landscape.

74. *Ed..cit.* V p 648: *gli pareva che più fussero invecchiate le cose di Luca di Cortona, di Pollaiuolo, e degli altri maestri, che in quel tempo lavorarono a olio, che quelle di Fra Giovanni, di Fra Filippo, di Benozzo e degli altri che colorirono a tempera inanzi a questi.*

75. Ed. 1807 I p 202.

76. *Ibid.* I p 257.

77. Barocchi *op.cit.* II p 2287.

78. *Ibid.* II pp 2290 f.

79. Cf. Kurz' contrary opinion above note 44.

80. Lomazzo 1590 (ed. 1973— I p 286) reports that he owned two paintings by Mantegna and Bramante, which were covered by *una certa acqua viscosa* which he removed and *fattili venire come se fossero pur ora fatti;* cf. Vasari 1568 (*ed.cit.* III pp 618, 633, 685, V p 580; VI p 551), who repeatedly praises the *freschezza* of the colours and their ability to *se mantenire.*

81. Another was that the 'heroic' fresco-technique put the *resoluzione* of the artist to the test; cf. above chap. B I 3.

82. Vasari 1568 (*ed.cit.* I p 101, II p 510). That indoor frescoes were cleaned at intervals is also clear from the statement of Gaspare Celio 1620 that Raphael's *School of Athens* had been "cleaned again"; Abbate 1965 p 43 n 24.

83. It was obseved that the problem was particularly coupled to certain areas of the painting which were more expressive than others, such as faces and, in particular, the eyes; cf. Pino 1548 (ed. 1960— I p 128); Dolce 1557 (ed. 1968 pp 96 f); Vasari 1568 (*ed.cit.* VII pp 171 f, 454); Maranta ca 1550—70 (Barocchi *op.cit.* I p 883) and Bocchi 1584 (ed. 1960— III p 135); cf. chap. B IV.

84. *Ed.cit.* I p 130.

85. Objections to cleaning are hard to find, but seem to concern cases of insufficiency; Abbate *op.cit.* p 43 n 24.

86. Ed. 1968 pp 90 f and n 238.

87. Abbate *op.cit.* p 45.

88. *Ed.cit.* III p 685. Cf. II p 212. Abbate *op.cit.* pp 41, 46 f points out Celio, whose *Memoria* of 1620 was published in 1638, as an eager opponent against *restauro pittorico;* he considered restored works as destroyed and mentioned them always in the imperfect tense, as if they had ceased to exist. Vasari 1568 reports with symphathy about transferals of frescoes in connection to construction works (I p 386, III p 258) and points out the importance of documentation

through copies (V p 611, V VI p 434, VII p 491); cf. R. Borghini 1584 (ed. 1807 II p 235), who proposes that all important fresco-paintings ought to be reproduced in engravings *per eternarle; gli originali sono periti o per muramenti o per intemperie di stagioni.* But he also mentions several cases of completions and 'renovations' of pictures (II p 596, III pp 50 f, 498, 685) and sculptures (III p 367, IV pp 579 f, VII pp 8 f), between which and pure forgeries the difference is sometimes rather small (cf. VII p 141 on Michelangelo, who "of love to the art" traded artificially aged—in fact smoked—drawings made by himself for genuine antique ones); cf. Wittkower 1963 p 204, who takes T. Terenzi († 1621) as an example of a far from unique forger, who, with the help of pigmented varnishes tried to cheat the public. Panofsky 1955 (pp 169 ff) and Blunt 1940 (p 99 and n 4) underline Vasari's respect for medieval art; however, in connection to a commission for a convent, he did not refrain from cutting the medieval decorations—*quella vecciaia e goffezza di sesti*—to pieces and replace them with *lavori moderni* (*ed.cit.* VII p 674); cf. Previtali 1964 p 9 and Abbate *op.cit.* p 41.

89. Thus the criticism against the habit of letting the assistants paint important parts of the work as Raphael did; Vasari 1568 (*ed.cit.* IV p 377). Of course, a bad painting guaranteed eternal disgrace; according to Leonardo (ed. 1882 TP 65) such a painting *lungo tempo darà testimonianza della ignoranza tua.* Cf. Alberti 1435—36 (ed. (1956) 1967 pp 63, 97), Sangallo 1547 (ed. 1960— I p 76), Biondo 1549 (Barocchi 1971— p 775), Vasari 1568 (*ed.cit.* VI p 491).

90. Klein-Zerner 1966 pp 120 ff. Cf. Schlosser 1924 pp 378 ff; Blunt 1940 pp 106 ff; Barocchi 1960— II pp 521 ff and n 4; III p 42 n 2 and in general, Dejob 1884, Mâle 1932 and Zeri 1957.

91. Ed. 1960— II pp 1 ff.

92. In particular p 127.

93. Ed. 1960— III pp 3 ff; Previtali 1965 p 23; Abbate 1965 pp 40 f.

94. Ed. 1960— II p 117 ff; Schlosser *op.cit.* p 383.

95. Ed. 1960— III pp 237 ff.

96. Barocchi 1971— I pp 42 ff, 455 ff.

97. The artist must "only represent what is proposed by holy doctors and accepted unanimously by the Church, without adding, removing, or changing anything, either in content, or of the way of expression or other particulars." Paleotti (*loc.cit.*). The doctrine was applied to Michelangelo's *Last Judgement* and in the trial against Veronese in 1573; it also caused Ammanti 1582 to beg the Churche's pardon for taken "liberties" (ed. 1960— III pp 117 ff); cf. Schlosser *op.cit.* pp 378 ff.

98. Paleotti 1582 (ed. 1960— II p 408); Klein-Zerner *op.cit.* pp 124 ff. For the same reasons the Council of Trent aimed at a prohibition of polyphonic church-music, which was regarded as sensually seductive and didactically ineffective, but in the end saved by Palestrina, who succeeded in adapting it to the demand of clarity. Cf. Blunt *loc.cit.* On the communicative universality of pictures, cf. above chap. II.

99. Paleotti 1582 *ed.cit.* pp 408 ff. He also dedicated a chapter (Lib. V chap. 19: *Delle imagini antiche cancellate dal tempo et oscurate)* to the importance of curing and cleaning of religious paintings. Molanus, too, prescribes that religious paintings are to be taken care of with the same accuracy as religious texts; Previtali *op.cit.* pp 23, 33 f; Abbate *loc.cit.*

100. Paleotti *loc.cit.* Cf. the monetary hierarchy of pigments in medieval and early Quattrocento painting, above chap. A I and hierarcic perspective below chap. B III 4.

101. Schlosser *op.cit.* pp 380 f; Blunt *op.cit.* pp 133 ff.

102. In particularly in Vellutello's *Commentary to Petrarch* 1545, 45 b, cited in Gombrich 1954 p 211. Cf. Vasari 1568 above chap. B I 3 n 19 and Lomazzo 1584. This theory is advanced by, among others, von Einem 1959 p 77.

103. Cf. above chap. B I 3 and n 34.

104. Cf. Schlosser *op.cit.* p 159; Blunt *op.cit.* p 25; Heydenreich 1953 pp 24, 133, 175; Gantner 1958 pp 39 f, 218; Pedretti 1964 p 20; Zubov 1968 *passim;* Stites 1970 pp 366 f.

105. Cf. ed. 1882 TP 8, where L. advocates that the *singolarità* of the painting made it more valuable than a sample of reproduced work; cf. Zubov *op.cit.* p 160. Cf. above, chap. A II.

106. *Ed.cit.* TP 23: *ma tal bellezza di tale armonia il tempo in pochi anni distrugge, il che non accade in tal bellezza imitata dal pittore, perchè il tempo lungamente la conserva.* Cf. Mc Mahon 1956 II, f 16 ff and Stites 1970 p 367. Like others, Leonardo uses flowers as a symbol of *vanitas;* cf. Lucian *De domo* § 9 (ed. Loeb I pp 177 ff; Gilbert-Kuhn (1939) 1972 p 109; Grassi 1962 p 245): "The frescoes of the walls, the beauty of their colours, and the vividness, exactitude, and truth—each detail might well be compared with the face of spring and with a flowery field, except that those things fade and wither and change and cast their beauty, while this is spring eternal, field unfading, bloom undying . . ."

107. For example *ed.cit.* TP 31 B: *quella cosa è più nobile, che ha più eternità.* Cf. TPP 23, 37, 38 W, 513. Cf. also Richter (1883) 1970 I p 76 n 32: "Leonardo made a point of proving that painting was as lasting as sculpture . . . because he wished to prove that painting was an equal of the sciences which ranked with the Liberal arts, and durability or rather invariability was in scholastic circles thought to be a necessary attribute of all science."

108. Heydenreich 1953 pp 41, 53.

109. Heydenreich *op.cit.* pp 166 ff; Gantner 1958 *passim;* Zubov *op.cit.* pp 204 ff. I do not feel quite convinced that Leonardo was essentially an optimist (cf. Zubov *op.cit.* pp 278 f; Gantner *op.cit.* p 219; Stites 1970 p 367), but I agree that the consequences of his observations of nature were tragic.

110. *Cod. Atl.* 71 r.a.; Gantner *op.cit.* pp 221. Cf. Zubov *op.cit.* p 221 with reference to Ovid, *Metamorphoses* XV 232—236.

111. *Ed.cit.* IV p 47; Heydenreich *op.cit.* p 61; Gantner *op.cit.* p 218; Posner 1974 pp 17, 19 and n 92.

112. Possibly for spike-oil, which is destilled from lavender; Posner *loc.cit.* Spike-oil is mentioned in the MS Marciana as a constituent of varnish.

113. *Op.cit.* pp 61 f.

114. Cf. Lomazzo ca 1564 (ed. 1973— I p 86 and n 15), who asserts that Leonardo died from grief over being an inferior *coloritore.*

# Chapter IIB. Colour as a Visual Stimulus

## Armonia

One of the most significant properties of phenomenal light and colour is its changing character, which is a conspicuous feature in Aristotle's con-

cept of both nature in general[1] and of colour, and in Theophrastus' observations of surface-colour in nature. The divergent opinions about light and colour among ancient philosophers, theologicans and scientists were also noted in the Renaissance[2], and to this bewildering impression was added the perishable and variable nature of material paint. Nevertheless, it was extremely rare to find, in the art theory of the period studied, the question of aesthetic preferences dismissed as an accidental and uncalculable matter or taste[3]; even in the later Cinquecento, when a tendency to defend the independence of rules makes itself felt in art theory, the peculiar colourism of Titian became the new ideal which was to be followed. The very *raison d'être* of art theory was to establish rules for painting, including the aesthetic use of colour[4]. At the same time as it was constantly emphasized that the beauty of painting does not depend on the artist's material but on the knowledge and skill with which he makes use of it[5], and that the use of that empty, immanent beauty revealed the artist's lack of ability[6], at the same time authoritative objections against a general condemnation of the beauty of individual colours might be raised—e.g. with references to Plato's positive acknowledgement of the stimulation of certain colours as a "pure" delight[7], Plutarch's praise of colour at the expense of drawing[8], Plotin's accentuation of the beauty of single colours, the general Neo-Platonic and medieval, Christian light symbolism and the theories of physiological influences of certain colours. The most important reference for a positive and regulated theory of the beauty of colours, however, concerned both individual and calculatedly related colours. As has been established, Aristotle offered the basis for such a system, since he had stated in *De sensu* that chromatic colours consist of certain proportions of white and black; certain colours, which consist of an "easily detectible" proportion, are beautiful. Though it is not explicitly said, it seems highly probable that he held that the beauty of a combination of colours in a similar way depends on the proportions of its constituents. Aristotle had the concept of contrast among colours[9], the meaning of which may be understood with reference to his colour scale in *De sensu:* contrasting colours probably means either the unchromatic relation of white and black, or the chromatic relation of two 'derived' colours which are dissentiently proportioned, i.e. two colours in which white and black have an inverted relation; yellow —blue and red—green[10]. If my interpretation[11] is correct, Aristotle's concept of contrasting colours corresponds to the modern concept of *complementary colours,* i.e. colours which apparently activate each other through mutual reinforcement of their relative differences, in general in terms of lightness and intensity and with regard to the chromatic colours also in terms of hue and saturation[12] They are: (Y) yellow—(RBBR) red-blue or "violet"; (YR) reddish yellow—(BR) reddish blue, "indigo" or "lilac"; (RY) yellowish red—(BGGB) blue-green or "turquoise"; (R) red—(G)

green; (RB) bluish red or "purple"—(GYYG) green-yellow. Their contrary positions may be illustrated on a somewhat adjusted colour-circle[13], containing only twelwe colours (Fig.)

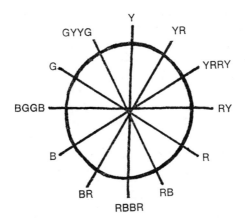

Contrast in general was given a moral-didactic content by Plotin[14] through the polarization of good and evil; he claimed—though this contradicted his revised definition of formal beauty[15]—that low characters are part and parcel of the drama. Augustine agreed to this: in good plays the heroes are to be contrasted to clowns and villains[16]. The implicit concept of *union of contrasts* was emphasized in his famous definition of harmony or *concinnitas: harmonia est discordia concors*[17]. The medieval interpretation of light as a symbol of God made it convenient to oppose it to darkness; Alexander of Hales wrote, for instance, that "just as the black colour, in its proper place, is fitting in painting, the universe, with all its defects, is beautiful[18]." The didactic principle that the beauty of one element is reinforced by the contrast to another is, however, only a variant of 'unity in variety'[19], which was a leading principle in Renaissance aesthetics[20] and has its roots in the 'classical' definition of formal beauty as the harmony of all the parts with each other and with the whole in combination with pleasant colour. The great importance of this definition for music, anatomy and architecture has been thoroughly investigated, whereas its importance for colour, which is just as great, has—as has been stated above (chap. A II)—been almost completely neglected. In my opinion, the 'classical' definition was, as far as the beauty of colour combinations are concerned, reinterpreted as "the harmony of the colours of the parts with each other and with the chromatic whole[21]."

Two ancient traditions are fused in this redefinition: (1) the well-established fact that colour is the medium through which the formal properties

of a body are revealed and perceived[22], and (2) the Pythagorean number symbolism and numerical expression of harmony, which is implicit in the 'classical' definition of beauty and was most elaborated in musical theory[23]. Aristotle's deduction of the chromatic colours to the different proportions of white and black was, in spite of Alberti's refutation of the theory, very influential in Italian Renaissance art theory. Aristotle also intimated the analogy between colours and tones[24], a concept which was normally expressed in rather general terms. But there is a late instance of its practical application: Giuseppe Arcimboldo († 1593) developed, at the court of Rudolph II in Prague, a chromatic note system[25], by which—according to Comanini 1591[26]—the violinist Maoro Cremonese played. According to the reporter, Arcimboldo applied the Pythagorean interval numbers in the note system, which consisted of horizontal lines with coloured points indicating the tones (COLOUR PLATE III). Each part began with a certain colour: white for the bass, yellow for the barytone, green for the tenor, blue for the alto and dark violet (*morello*) for the soprano. The eight tones of the octave of each part were designated by a successive 'darkening' and change of hue of the introductory colour: white changed to yellow, yellow to green etc., so that the colour of the last tone in one part was the same as the introductory note of the following, except for the soprano, which was ended in brown (*tanè*). It is, then, an inverted lightness-scale, successively darkening in the order white — yellow — green — blue — dark violet — brown. The division of eight steps between the two colours results in a lack of distinctness which made the system a paranthetical curiosity[27].

Is an analogy[28] between the musical tone-scale and a colour-scale at all possible? The octave consists of eight conventionally stipulated, clearly distinguishable steps on a continuous sequence of successively increasing numbers of oscillations of sound-waves, causing a sensation of successively increasing lightness; the last step is different in lightness but tonally[29] equivalent to the first step. In a similar way, the spectral colour scale—which is the only scale possible to use in this context—consists of steps at similar intervals[30] on a continuous sequence of successively increasing numbers of oscillations of light-waves; the last step (violet) is chromatically related to the first step. But here the analogy ceases; the steps of the conventional spectral colour scale are not ordered according to the increasing relative lightness; the basic tone, the dominant or fifth interval and the subdominant or fourth dominant certainly hold particularly important positions in the octave from a melodic and harmonic point of view, but they do not correspond to the concepts of primary or elementary colours; the fact that *e—f* and *h—c* represent an interval of half a step among otherwise full step-related tones does not make *c* and *f* any kind of 'secondary' or 'derived' tones. There are, finally, no actual counterpart among the

tones to the concept of chromatic and unchromatic colours[31]. While lacking both competence and space to do a complete analysis of the relations between tones and colours, I believe it is justified to establish that there is, in fact, no ground for the thought of an analogy in the full sense of the word. However, to the few affinities which do in fact exist may be added the similarity that the tones, like the colours, are related to each other so as to change each other's properties, and so as to form a whole, consisting of certain 'figures' in a certain rhythm. The partly common terminology has contributed to a deeply rooted and generally held *belief* in the existence of an analogy. Since this belief was prevalent in Italian Renaissance art theory, the consequent question to be studied concerns the relations between two units of tones and colours respectively. Again ,the differences between the systematization of this kind of auditive and visual experiences become evident; whereas according to European musical convention the combination of two adjacent tones is considered as disharmonic[32], this is not the case with the colours—there is not, in point of principle, any obstacle to the combination of two primary colours or of a primary and a secondary colour or an elementary and a derived colour. On the contrary, this kind of combinations seems to be one of the two most relevant criteria for the subsequent analysis of the expressed aesthetic preferences —the other is the combination of two contrasting colours. To denote these two kinds, I will use the terms *unison contrast* and *polar contrast*. It will be observed, that I refer both to the modern systematization of the elementary colours—in my opinion introduced by Alberti—according to which unison contrast means the relation between two adjoining elementary or an elementary and an adjoining derived colour, and between two equally very unsaturated, very light, dark or indistinct colours, regardless of hue. With polar contrast, I understand both the relation between two complementary colours and between any two very different chromatic or unchromatic colours, with regard to hue, saturation, intensity and lightness; the most significant example of the latter is the combination of white and black. When the terms unison and polar are used in the sources with reference to another system, I indicate this by quotation marks. In the following survey, the opinions expressed on colour combinations are grouped according to these two principles. It will be noted, however, that they must both be considered as belonging within the framework of the 'classical' definition of beauty, and that it is more a question of dominant tendencies than exclusive adherence to one of the principles.

## Polar Contrast I

The many instructions for *rilievo* by a tripartition of the volume in Cennini ca 1400 contain both unison and polar contrast (COLOUR PLATE VIII);

the discontinuity and plastic inconsistency which result from this lack of a coherent theory would later lead to the condemnation of pictures made according to similar methods; Vasari 1568 equated its effect to a *tappetto colorito*[33], Lomazzo 1584 to a *pianezza empiastrata et un arco di colori senza rilievo o forza*[34], and Armenini 1586 to an *arazzo colorito*[35]. Alberti 1435—36 presentes a coherent theory of colour[36]. He stresses the importance of *convenienza*[37], but also of *copia* and *varietà*[38]. Colour is part of composition, but *convenienza* also refers to the completely different concept of 'organic unity', i.e. that each part of a body must have the same colour[39]. *Grazia* is achieved when two colours which are different in lightness and hue are combined[40]. There exists, according to Alberti, an *amicizia* among certain colours, through which they heighten each others beauty when placed side by side. Such colours (COLOUR PLATE IV) are rose—green, i.e. polar contrast[41] of complementary colours, but also rose —blue and white—gray or yellow or "almost any other colour.", i.e. unison contrast. In *De pictura*[42], on the other hand, it says that red *between* green and blue, and white between grey and yellow is fitting, i.e. Alberti recommends 'chords' of three colours. He prescribes a general polar contrast of lightness, but emphasizes that impressions of lightness and darkness are relative[43]. Filarete also notes the property of certain colours to *confare*[44]; he recommends the following combinations, which he claims to have taken from nature: green—blue, green—yellow, red—blue (unison contrast); white—black, white—red (polar contrast). In particular he praises the complementary, polar contrast red—green and condemns the unison contrast yellow—red[45] (COLOUR PLATE V). Evidently, his reference is Alberti. Leonardo also speaks of the beauty of polar contrast[46]; in a great number of prescriptions[47] he states that a light or white part must border upon a dark or black part, or *vice versa*[48]; otherwise, an artificial line must separate the object from its surroundings[49]. He notes that polar contrast changes the individual properties of the two colours contained; they appear lighter or darker[50], more saturated or unsaturated, intense or indistinct[51], and the coloured areas appear bigger[52] or smaller[53]. Polar contrast is a general principle of Leonardo's—beauty is, e.g., heightened by ugliness[54] —and with regard to colours he prescribes that a colour is most beautiful when contrasted to its *retto contrario*[55], both with regord to hue and lightness[56]; light violet—red[57], green—blue[58], white—blue[59], green—dark violet or dark lilac[60] and white—black are mentioned as particularly beautiful, all—in particular the last—examples of polar contrast in lightness, but chromatic unison contrast[61]. He also—like Alberti and Filarete—praises the polar, complementary contrast red—green and adds yellow—blue[62] (COLOUR PLATE VI). Certain contrasts increase, he says, the beauty of both colours[63], whereas one component of others, e.g. light violet, adds to the beauty of the other, red, on the expence of its own beauty.

Generally, the most beautiful colour is the most saturated, a quality which may be increased by similar contrasts to unsaturated or indistinct colours[64]. Among the adherents of polar contrast we must include Equicola 1526, who recommends polar contrast of colour which "have less in common[65]", such as white—black rather than white—greenish gray (*beretino*). Equicola is an exception to the rule that Plato's colour theory had no importance in the Italian Renaissance; he condemns the combinations green—black and white—yellow since green, according to Plato, is the product of a mixture of yellow and black, and yellow the product of a mixture of white and red; green—black and white—yellow represent, according to this theory, 'unison' contrast.

## Unison Contrast

The first instance of what is interpreted as a shift in preferences are rather vaguely expressed. What Castiglione 1528 understood by (*ben misurato e composto con) una certa gioconda concordia di colori distinti* and *una ordinata distantia*[66] is not explained, but since he was one of the advocates of a somber moderation of the gaudy splendour of colour, it seems unlikely that he referred to the polar contrast of chromatic colours[67]. The same tendency seems to be visible in Biondo 1549, where the combination of *colori o membra dissimili* is condemned[68]. Doni 1549 praises *consonanza* without any qualification[69], and Dolce 1557[70], who 1565 explicitly adheres to a variant of the Aristotelian colour scale of *De sensu*[71], prescribes a moderation and unification of the colours, but does not specify what he understands by this. *Unione* is the ideal for Vasari 1568 as well; he writes that *L'unione nella pittura è una discordanza di colori diversi accordati insieme*[72], which sounds like a paraphrase of Augustine's definition of *concinnitas*. However, he immediately differentiates between two kinds of *discordanza* by condemning colours which are *messi in opera accesamente e vivi con una discordanza spiacevole, talchè siano tinti e carichi di corpo;* he illustrates his theory that the discord must not be too pronounced with an unfortunate analogy to music; just as the ear is offended by music which is strident, discordant and harsh, the eye is offended by colours which are *troppo carichi o troppo crudi*[73]; *unione* is achieved through the combination of vivid and weak colours, which give *una discordanza accordissima*[74]. Polar contrast of lightness is permitted only for *cose notturne,* where such effects are proper and natural[75]; *unione* is one of Vasari's criteria of exellence[76], coupled with *dolcezza, morbidezza* and *sfumato*[77].

## Polar Contrast II

The shift back to the preference for polar constrast is, just like the change away, not sudden and articulated; a sonnet in Carbone 1575 praises the

96

combination white—black because *l'un per l'altro il suo colore affranca*[78]. Lomazzo 1584, who adheres to Aristotle's theory that the chromatic colours are the products of different proportions of white and black, agrees with Alberti that the colours have *amicizie et inimicizie naturali, così per materia, come per apparenza*[79]. He condemns the 'unison' contrasts yellow —red, white—dark violet and white—red, which are related to his interpretation of the Aristotelian colour scale in *De sensu;* the 'polar' contrast of white and black is recommended, since they are the *estremi de i colori.* In the same way he condemns, when discussing[80] the combinations in *cangianti*, the rendering of volume on hue-changing material, the polar, 'unison' contrasts of red—green and yellow—blue. But Lomazzo is not consistent; among the thousands of recommended combinations for *cangianti*, proudly announced to be achievable by a certain system[81], we find white—rosy, white—light violet, yellow—rose and yellow—red, which were all, from a chromatic point of view, condemned earlier; if the system is developed, it also includes the polar, 'unison' contrast red—green. The only leading principle is that colours of similar lightness are fitting in combination, regardless of hue. The impression that Lomazzo, in fact, recommends here unison contrast, is reinforced by the praise of the combination rose—dark violet, which is chosen as an example of Raphael's admirable manner of combining colours *che hanno familiarità e convenienza*[82]. (COLOUR PLATE VII) Unison contrast is explicitly recommended in the chapter "*Come si comportano i colori nelle istorie*"; elementary and derived colours which have *vicinanza*, yellow—red, red—purple and several others of the same kind—are now recommended, whereas the polar contrasts red—green and white—black are condemned—the last one for exactly the same reason which made it fitting before: *come estremi, non vi possono star appresso, per essere l'uno troppo chiaro e l'altro troppo oscuro.* The inconsistency of Lomazzo's opinions depend on his blindness, which made him lose control over his work, which was successively enlarged by additions, which were not always in agreement with the original manuscript[83]. A more articulated adherence to polar contrast—within the framework of *unione*—is found in Armenini 1586[84], who makes a better analogy to music than Vasari: *Una bella varietà di colori accordata rende a gli occhi quello che all'orecchi suol fare una accordata musica, quando le voci gravi corrispondono all'acuto el le mezzane acordate risuonano: sí che di tal diversità si fa una sonora e uasi una maravigliosa unione di missure . . . La somma [di] tutta la scienza del colorire si rivolta intorno a questo, che, componendosi con ordine diverse sorti di colori mescolati e scietti, ne nasca una ben divisata et unita composizione . . .* i.e. he emphasizes that there must be a pronounced distance between the two components. Though he does not give any examples of such combinations, his general admiration for chromatic *purità* makes it even more likely that he

refs to polar contrast. In Calli 1595, polar contrast is explicitly comprised in the ideal *unione*. Though he condemns too strong a contrast of lightness for physiological reasons—the polar contrast of white and black is painful to the eye[85]—he recommends, just like Armenini with an analogy to music, a pronounced distance between the components of a combination; the colours must be *luntani convenevolmente, perché 'an simmetria sensibile;* but not too distant, because such colours cause, just like a couple of tones too distant between themselves, while not discordant, *un non so che d'orridezza e di monstruosità;* he specifies that he does not mean by *per luntananza convenevolmente distinti* a combination of *perfetti* (elementary) and *imperfetti* or *seguaci* (derived) colours, because they are *immediatamente congiunte; avvenga che i colori hanno proporzion, musica et aritmetica simmetria.* Like Leonardo, he finds a general didactic-moral value in polar contrast; beauty is promoted by ugliness, the perfect by the imperfect. R. Alberti 1604 contains a lecture by G. Coscia[86], in which the relationship between painting, mathematics and music is again emphasized. Just as the octave rests on the relation 1:2, painting uses it for anatomical proportions and colour combinations: *E così come il musico si serve anco delle dissonanze per far parere più dolce e più soave l'armonia, così il pittore, volendo che li colori faccino più bell'effetto e rendino maggior vaghezza a'riguardanti, usi i contrarii l'uno a l'altro*[87] ...; whether he refers to the true Aristotelian colour scale (*De sensu*) or adheres to the definition of polar contrast stipulated here is irrelevant; if my interpretation is correct, *contrarii* means, in both cases, complementary contrast.

1. That is not to say that Aristotle's concept of nature was chaotic. He believed in a fundamental stability, but in the sense of an active, permanent transformation of its elements; cf. *Nic. Et.* 10994 a: "what is proper and what is just, the object of political science, is so changable and so different according to the case, that it seems to exist only by convention, and not by nature."
2. For instance Equicola 1526 (Barocchi 1971— II pp 2152 ff) and Calli 1595 (*op.cit.* II pp 2324 f, 2333).
3. Morato 1535 (*op.cit.* II p 2177) states that *la varietà delle voglie umane esser diversa e ogni palato aver il gusto suo,* only to continue with regulations for systematic use of colour. Biondo 1549 (ed. 1873 p 41) writes about colour that "in this matter no fixed advice may be given, since it is the painter's affair what he pleases and his art demands", but soon adds that painting is governed by *vera raggione.* Cf. Shearman 1967 p 38.
4. Recipes are to-day generally considered as a 'primitive' expression of a lack of theory, Cennini being regarded an example of the medieval tradition. However, it is worth noticing the resemblance between e.g. Gaurico 1504 or Giorgi 1525 (Panofsky 1955 p 91 and n 65), who applied the interval numbers of the octave to the proportions of the human body, and Cennini and Lebègue, who give numerical rules for the relation of the colours of the three parts of a volume.

5. Alberti (ed. (1956) 1967 p 64) writes that a statuette of cheap lead by Phidias or Praxiteles is more valuable than one of silver by a less skilled master, and (*op.cit.* p 85 and n 84; Clark 1945 pp 14 f; Baxandall 1972 p 16) that the imitation of gold in painting is superior to real gold. The theme recurs in different formulations in Leonardo (ed. 1882 TPP 60, 74 = Richter (1883) 1970 I § 501): *Già una certa generatione di pittori, li quali per loro poco studio bisogna che viveno sotto la bellezza de l'oro et de l'azzurro;* TP 123: *Li colori sol fanno onori alli maestri, che li fanno, perchè in loro non si causa altra maraviglia che bellezza, la quale bellezza non è virtù del pittore, ma di quelli, che gli ha generati...;* Cellini 1547 (ed. 1960— I p 80); Pino 1548 (ed. 1960— I 11, 117 f, 128); Dolce 1557 (ed. 1968 pp 154 f, 206 ff, 214 f); cf. Aretino, letter to B. Valdaura; ed. 1957— I pp 107 f); V. Borghini ca 1560 (Barocchi 1971— I pp 626, 630, 632 f, 668 ff); Gilio 1564 (ed. 1960— II p 15); Vasari 1568 (ed. 1878—, in particular III pp 188 f, VII p 170, where he has Michelangelo furiously answering Francia, who had expressed his admiration of the bronze Michelangelo had received for the statue of Julius II: *Io ho quel obligo a papa Giulio che me l'ha dato, che voi agli speziali che vi danno i colori per dipingere;* VII p 427, where he praises Titian, who stands in a beneficial contrast to those of low ability who *avere a nacere sotto la vaghezza de'colori lo stento del non sapere disegnare*); Ligorio ca 1570—80 (Barocchi *op.cit.* p 1468); Lomazzo 1584 (Lib. I chap. 4; Lib. III chap. 9 where he attacks the Venetian technique, 10, 11; ed. 1973— II pp 41; 174 ff, 177); Armenini 1586 (Barocchi *op.cit.* I p 992; II pp 2274 f, 2285); Lomazzo 1590 (chap. 19; ed. 1973— I p 300; he condemns the artists who profit on *la vaghezza esteriore di colori*); Comanini 1591 (Barocchi *op.cit.* I pp 402 f) and Zuccari 1605 (*op.cit.* I p 1026).

6. Cf. chap. B I 1.

7. *Philebos 51 b, c;* caused by something which is beautiful in itself, irrespective of anything else—basic geometrical forms and certain colours; Gilbert-Kuhn (1939) 1972 p 38; Emond 1964 p 41. Quoted by Ficino 1469 (chap. 3; in *Opera,* Basle 1576 II pp 1336 ff; partly in Panofsky (1924) 1968 p 129 and n 2); Ebreo ca 1501 (Barocchi *op.cit.* II pp 1629, 1633); Nifo 1529 (*op.cit.* II pp 1661 f); cf. Osborne 1970 pp 87 f; Barasch 1960 p 282 and n 2 with reference to Plotin, *Ennead.* I.6.1; cf. above chap. IV. Plato also made a statement of the relative beauty of individual colours: in *Rep.* (IV 420 d) he said that purple is "the most beautiful colour." Emond 1964 pp 63 f.

8. *Moralia* 16 c; Lee 1940 p 202 and n 26: P. compared colour in painting to plausible fiction in poetry and held that it "stimulates more than linear drawing because it is life-like and creates an illusion."

9. *De Mundo* 396 b; Warry 1962 p 103: "In the same way as the natural universe and the human society consist of opposed forces, painting makes use of contrasting colours." Cf. *De caelo* II 3 286 a where A. states that where one of two contraries is found in nature, the other will be found too.

10. Yellow and red have the same relation to white as blue and green to black.

11. Cf. above chap. IV.

12. Noticed by Goethe, but systematically investigated by E. Chevreul 1839, partly in Holt (1947) 1957 III pp 328 ff. Among the physical (spectral) colours, a mixture of two complementary colours gives white light; among pigments a mixture gives gray.

13. Cf. fig., introd. Missing are the derived (BG) greenish blue, (GB) bluish green, (GY) yellowish green and (YG) greenish yellow.

14. Gilbert-Kuhn *op.cit.* p 138.

15. Cf. above chap. IV.

16. *De ordine;* in Svoboda 1933 pp 20 f.
17. Cf. Osborne 1970 p 286; Pochat 1973 pp 88 and n 17, 94, 108, 271 and n 145.
18. *De pulchritudine universo,* ed. Quaracchi, Firenze 1924—48, II p 501; quoted in Pochat *op.cit.* p 157 and n 193.
19. Emond 1964 pp 52 ff; Osborne 1970 pp 284 ff.
20. Emond *op.cit.* p 54; Osborne *op.cit.* p 146; Baxandall 1972 pp 131 (on *copiosum*), 133 (on *copia* and *varietà*), 135 (on *compositione*).
21. Cf. Pacioli 1497 (Barocchi 1971— I p . . .) who, comparing music and painting, talks about *debita distantia e varietà de colori;* Equicola 1526 (Barocchi 1971— II p 1614): *convenienza de parti ben colorite, piena di grata concordia e proporzione;* Varchi 1549 a (*op.cit.* II p 1674) who agrees with Pico della Mirandola as to the difference between formal *belezza* and *grazia,* stating that some women are ugly, though they *e nella quantità e nella qualità sono benissimo proporzionate; grazia* may occur even if she *nella figura e ne'colori potesse esser meglio proporzionata.* Cf. above chap. A II; Castelvetro 1567 (*op.cit.* II p 1578): *le proporzione delle membra, e di ciascuna per sé e di tutti insieme e de' colori.*
22. Cf. above chap. II.
23. Cf. above chap. IV. On its influence and, at instances, literal interpretation, cf. Panofsky 1955 pp 88 ff and n 65.
24. On the Pythagorean musical theory, transmitted by, above all, Plato, Macrobius, Augustine and Boëthius, cf. Walker 1976 pp 249 ff. It was in particular adhered to in the Renaissance by Nicolas of Cusa 1450 and 1459 (Ciardi 1973— I p xxxii n 87), and in Italy by Ficino 1469. *De div. fur., De christ. relig., Comm. in Jonem* (Walker 1958 pp 3 ff; Ciardi *op.cit.* I p xxxiv n 91), Gaufforio 1496; *ibid.* 1508; *ibid.* 1518 (Panofsky 1955 p 158 and fig. 38; Walker *op.cit.* p 26; Ciardi *op.cit.* I p xxxi n 83; Pochat 1973 p 405 n 158); Giorgi 1525 (Panofsky *op.cit.* p 91 n 65; Walker *op.cit.* pp 113 ff; Ciardi *op.cit.* I pp xxx f nn 81, 82; xxiv f and n 91; xxxvii ff; 343 n 3); Cirillo 1549 (Barocchi 1971— I pp 270 ff) and Zarlino 1558; *ibid.* 1588. The emotional influence of music was explained by its mathematical structure—the numerical structure of the tones and the rhytm. Zarlino 1588, who considered the different *modi* as expressions of *habiti morali e costumi dell'animo,* suggested the analogy between colours and tones; he equated *sono—audire* to *colore—vedere* in *Opera,* Venezia 1589 I pp 90 ff; quoted in Barasch 1960 p 289.
25. Wittkower 1963 p 283 describes it as "a kind of colour-piano"; cf. Levi 1954 pp 90 ff.
26. Ed. 1960— III pp 368 ff.
27. Levi *op.cit.* p 92 f.
28. The first systemathic analogy between the spectral colour scale and the seven tones of the major scale was made by Isaac Newton (*Opticks* 1704): c-red, d-orange, e-yellow, f-green, g-blue, a-indigo, h-violet. Transferring the interval numbers of the major scale—1, 9/8, 5/4, 4/3, 3/2, 5/3, 15/8, 2—to the numbers of oscillation of the conventional spectral colour scale, postulating that red has the number 435, the average of 400 and 470, the analogy is, with the exception of green and violet, rather good; actual numbers of oscillation within brackets: red 435 (400—470)—orange 489,37 (470—520)—yellow 543,75 (520—590)—green 580 (590—650)—blue 652,5 (650—700)—indigo 725 (700—760)—violet 815,62 (760—800). Cf. Wellek 1935 pp 351 ff.
29. "Tonal" is, in this exceptional case, used as an equivalent to "chromatic".
30. Actually e-f and h-c have, in principle, an interval of only half a step, whereas the other tones have an interval of a full step.

31. It would possibly be what is commonly referred to as "noise" or sounds without resonance.

32. Another difference is that the most frequent kind of tone-combination, the chord, consists of three or more units, whereas colour-combinations generally contain only two; three units are, however, the result of the instructions for the rendering of volume by a tripartition of the visible surface, in particular when it consists of a hue-changing material, *cangianti;* cf. below chap. B III 3 and Alberti below here.

33. Ed. 1878— I p 180; Vasari probably refers to an oriental carpet.

34. Lib. VI chap. 7; ed. 1973— II p 267.

35. Barocchi 1971— II p 2275.

36. Cf. above chap. A I.

37. Ed. (1956) 1967 p 72.

38. *Ed.cit.* pp 75, 82; Baxandall 1972 p 131.

39. *Ibid.* p 74: "I should also like the members to correspond to one colour, because it would be little becoming for one who has a rosy, white and pleasant face to have the breast and the other members ugly and dirty." Cf. Emond 1964 pp 61 ff; Osborne 1970 pp 284 ff.

40. Cf. Elliott 1958 p 460; Emond *op.cit.* p 54. For a completely different interpretation, see Edgerton 1969 pp 109, 133 and n 68.

41. Cf. Barasch 1960 p 284.

42. Ed. 1972 pp 92 f.

43. *Ed.cit.* pp 54 f.

44. Ed. 1890 pp 642 f.

45. Runge (1810) 1969 pp 20 f, held that unison contrast e.g. yellow-red, is monotonous.

46. Cf. Barasch *op.cit.* p 285.

47. Ed. 1882 TPP 258, 258 C (ca 1492); 190, 190 A, 204, 253, 258, 628 (ca 1505 —10).

48. *Ed.cit.* TPP 229, 233, 246, 423, 441, 485.

49. The reason for this—with regard to Leonardo's ideal *sfumato*—apparently surprising advice is, that he depicted his models in an artificially illuminated and coloured studio. Cf. below chap. B III 3.

50. *Ed.cit.* TPP 231, 238, 769, 770, 771, 773.

51. *Ed.cit.* TPP 231, 238; cf. Gould 1947 p 230 with reference to *Windsor Castle* no 12, 412.

52. Light against dark; *ed.cit.* TP 258 A.

53. Dark against light; *ed.cit.* TP 445.

54. *Ed.cit.* TP 139. Cf. below chap. B III 4 (hierarchic perspective). L. makes an original application of Alhazen's notion that perspective can promote beauty on the hierarchic perspective; the beautiful, saturated colours are to be placed in the foreground, and the ugly, unsaturated colours in the background.

55. *Ed.cit.* TPP 258, 258 C, 628. Cf. above note 12.

56. *Ed.cit.* TP 154.

57. *Ed.cit.* TP 190.

58. *Loc.cit.;* probably refers to dark ultramarine-blue.

59. *Loc.cit.*

60. *Ed.cit.* TP 253.

61. Like Alberti he does not mention the unison contrast yellow-red, which was explicitly condemned by Filarete. Cf. note 45 above.

62. *Ed.cit.* TPP 190, 253, 258.

63. *Ed.cit.* TPP 154, 190.

64. Cf. below chap. B III 3.
65. Barocchi 1971— II pp 2157 f.
66. *Op.cit.* II pp 1673 f n 2; cf. Panofsky (1924) 1968 p 59 n 45.
67. On the other hand, the combination of black and white, which is implicit in his ideal, is indeed a polar contrast.
68. *Op.cit.* I p 767. It is, however, possible that Biondo refers to the same "organic unity" as Alberti above and note 39, i.e. that all members of the same body must have the same colour.
69. *Op.cit.* I p 562.
70. Ed. 1968 pp 154 f.
71 Cf. above chap. A I.
72. Ed. 1878— I pp 179 f.
73. *Loc.cit.*
74. *Ed.cit.* I p 181. According to my definitions, the combination of intense and indistinct colours is polar contrast, but in its context, this recommendation does not change the general impression of unison contrast.
75. *Loc.cit.* and VII p 453.
76. *Ed.cit.* III p 198, IV pp 92 f, 138 f, V pp 9 ff, 193, 313, 565, VI pp 269, 270 ff, VII pp 411, 467, 612.
77. For instance *ed.cit.* IV pp 92 f, 463, V pp 9 ff, 567. *Sfumato* cannot, from a chromatic point of view, be achieved in polar contrast.
78. Cian 1894 pp 30 f; Barocchi *op.cit.* II p 2158 n 6. Cf. Leonardo above chap. A I.
79. Lib. III chap. 2; ed. 1973— II p 166.
80. Lib. III chap. 10; *ed.cit.* II pp 175 f. However, he recommends the combination of rosy—dark violet, though it is, chromatically, 'unison'.
81. Cf. below chap. B II 3.
82. *Loc.cit.*
83. Cf. Ackerman 1964, *passim.*
84. Barocchi 1971— I p 995 n 1.
85. Barocchi *op.ict.* II pp 2274 f. Instead, he recommends grey or yellowish grey *(bigio)*—black.
86. *Discorso che portò M. Gio. Coscia all'Academia la quarta domenica di marzo* 1594; Barocchi *op.cit.* I pp 1017 ff.
87. *Op.cit.* I p 1020; cf. Aristotle above chap. IV.

# Chapter IIIB. Colour as an Illusionistic Medium

## 1. Universalità

By universality is here understood the imitative capacity of painting, and in particular by colour[1]. In a general sense, this aspect was touched upon in the discussion of whether the artist was able to imitate only the exterior appearance of objects—*il di fuori*—or as well their inner, actual nature —*il di dentro*[2]—and whether the artist imitated visible nature only, or inner concepts as well, either constituting his only object of imitation, or one, to which he related his impressions of visible nature[3]. Another general

question was that of how to imitate, with material paint, the immaterial impressions received by the eyes—the exact instructions for the imitation of particular objects or effects are due to the imitative limitations of mediums and techniques. Oil-painting offered the greatest imitative possibilities, in particular through the capacity of actually copying the physical structure of the imitated body, e.g. by imitating the effect of transparent cloth over a body with transparent glazes over an opaque underpainting[4].

In Cennini ca 1400 the universality of painting is emphasized generally, but in a way which reveals the ambition of achieving an elevation of the social status of painting; it is an application of science, and deserves to be placed next to it, in company with poetry, which also has a universal imitative ability: "Just as the poet, with his theoretical knowledge, is free to compose and arrange as he pleases, the painter is given freedom to render a figure sitting, standing, half-man, half-horse, as he pleases, according to his imagination[5]." He does not, however, consider the imitative power of colour, which was to become a part of the *paragone* between painting and sculpture. Leonardo ca 1490—1510 stressed the incapacity of sculpture of imitating light and shadow, local-colour and of rendering colour- and clarity-perspective[6]; he gave many examples of the different kinds of structures, substances and effects which painting, thanks to colour, is able to imitate, for instance "the clear, many-coloured pebble-stones on the pure sand on the bottom of the river, surrounded by greenish vegetation under the water[7]". Similar enumerations were to become frequent as an illustration of the universality of painting; Castiglione 1528, for instance, wrote on sculpture: *Non po mostrar il colore de'capegli flavi, ne'l splendore dell'arme, non una oscura notte, non una tempesta di mare, non que'lampi e saette, non lo incendio d'una città, no'l nascere dell'aurora di color di rose, con que'raggi d'oro e di porpora; non po in summa mostrare il cielo, mare, terra, monti, selve, prati, giardini, fiumi, città né case; il che tutto fa il pittore*[8]. The examples include important, rare or particularly eye-catching kinds of surface-colour as well as luminous and chromatic effects of meteorological phenomena, which are 'impossible' to render[9]. The function of surface-colour was to reveal the *quality* of the depicted object. This function of *signum individuationis* implied that the full meaning of *pittura* included chromatic colours, whereas *disegno* primarily included quantity. In Aristotelian terms, drawing can only reveal the *genera*, but painting the different *species* of objects. The most important kind of characterizing surface-colour was *incarnatione*[10], the complexion, treated separately (below chap. B IV 2). As particularly difficult and eye-catching examples, the diversification of different kinds of cloth[11] and the reflection of light on metal arms[12] are frequent.

1. As distinct from the communicative universality; cf. above chap. II.
2. Cf. complexion, chap. B IV 2.
3. Cf. the definitions of painting, chap. A II.
4. Such instructions are frequent in Sorte 1580.
5. Chap. I; ed. 1971 pp 3 f. Cf. Holt (1947) 1957 I pp 137 f. Cennini evidently alludes to Horace, *Ars Poet.* 9 f: *Pictoribus atque poetis | Quidlibet audendi fuit aequa potestas;* cf. Lee 1940, who does not, however, mentions Cennini.
6. Ed. 1882 TP 36.
7. *Ed.cit.* TP 41. The source of this kind of enumerations is Philostrates the Elder, *Life of Apollonius of Tyana* II 22; in Grassi 1962 pp 249 f.
8. Barocchi 1971— I pp 490 f and n 1 p 491. Cf. Vasari 1568 ed. 1878— I pp 101 f.
9. The source is Pliny, *Nat. Hist.* XXXV 96: *Pinxit [Apelles] et quae pingi non possunt, tonitrua, fulgetra, fulgura . . .,* "thunder, strokes of lightning and lightning". The same references are found in Varchi 1547 (ed. 1960— I p 37); Pino 1548 (ed. 1960— I p 110); Gilio 1564 (ed. 1960— II p 22 and n 4; 42); Lomazzo 1548 (ed. 1973— II p 167); *ibid.* 1590 (ed. 1973— I p 287). Cf. Aretino, letter to Alfonso d'Avalos 1540 (Barocchi 1960— I p 184 n 9).
10. Il Lasca ca 1560 (Anton Francesco Grazzini, whose defense of painting was analyzed by Cellini; Barocchi 1971— p 600 n 1) gives an unusual example of the differentiation between the 'complexion' of a toad and a frog: *Chi non vede alla fine | che la pittura è più ampia e maggiore | e più somiglia il ver, dando il colore? | Ella fa lo splendore del ciel, del Sole, del fuoco e degli occhi, | e discerne le botte da i ranocchi.*
11. Castiglione 1528 (quoted above); Varchi 1547 (ed. 1960— I p 37 and n 5); Vasari 1547 (ed. 1960— I p 63); Pino 1548 (ed. 1960— I p 117); Doni 1549 (Barocchi *op.cit.* I p 557); Dolce 1557 (ed. 1968 pp 154 f); Vasari 1568 (*ed.cit.* I p 61, IV p 177, V p 575 ); Lomazzo 1584 (ed. 1973— II p 167); Armenini 1586 (Barocchi *op.cit.* II p 2286); Lomazzo 1590 (ed. 1973— I p 287 and n 8); R. Alberti 1604 (Barocchi *op.cit.* II p 1710). Cf. Dolce's letter to Ballini 1544 (ed. 1960— I p 182 n 4) and Aretino's to M. Stampa 1531 (*op.cit.* I 182 n 3). On the kind of cloth which change hue when painted, cf. below chap. B III 3 on *cangianti.*
12. Alberti 1435—36 (ed. (1956) 1967 p 84); Castiglione 1528 (above); Varchi 1547 (*ed.cit.* I p 39); Pino 1548 (*ed.cit.* I p 116); Vasari 1568 (*ed.cit.* VII p 657); cf. Aretino's letter to d'Avalos 1540 and to Bonniret 1550 (ed. 1957 I p 162; II p 382).

## 2. Vivacità

The naturalistic demand for and praise of "life-likeness" is extremely common in Italian Renaissance art theory, and so is the recognition of the importance of colour in achieving that effect[1]. The affinity between the use of *vivacità* and *vivezza,* the vital character of certain colours, is only apparent, and since the demand for "life-likeness" was general and included dead or vegetative objects[2], *vivacità* often corresponds to the general terms *proprio, vero* or *naturale*[3], and also presupposed the company of *rilievo.* Pliny's anecdotes[4] on the grapes, painted by Zeuxis, which deceived birds into pecking at the panel[5], on the curtain, painted by Parrhasios, which

Zeuxis took for real[6], on the horse, painted by Apelles, which attracted others[7] and on the Venus, painted by Praxiteles, which excited love in the beholders[8], were often-quoted examples of such a general "life-likeness".

But in particular the term *vivacità*—as in the cases of Apelles' horse and Praxiteles' Venus—referred to the depiction of *living* individuals and the particular category of depiction *di naturale*, after a model, often—but not necessarily—portraiture. New anecdotes[9] in the manner of Pliny were added about *ritratti di naturale*[10], in particular about Titian[11] and Figino[12]. According to Vasari 1568, Giotto ended *quella goffa maniera greca* by introducing painting after living models[13]; his figures were, according to Sorte 1580, so life-like, *ch'l visivo senso degli uomini vi prese errore, quello credendo esser vero, ch'era dipinto*[14]. The admiration for the 'pleasant deceit', *inganno*[15], offered by the realistic, natural and life-like quality of complexion—*la principal difficultà del colorito è posta nella imitazion delle carni*[16]—had its purest expressions in Vasari's description of the *Mona Lisa*—*non colori, ma carne*[17]—and Maranta ca 1550—70 on Titian's *The Annunciation*—*non già colori o pur tela colorita par vedere, ma veri e vivi membri umani, verissimi e naturalissimi panni*[18]. But decency, *decorum*, put a limit to realism; Danti 1567[19] notes the difference between *ritrarre*, the indiscriminate, exact imitation, and *imitare*, the corrective imitation[20], a distinction which was also expressed in newly-interpreted Platonic terms[21] by Comanini 1591 in the categories *imitatione icastica*— the representation of a physically existing, visually perceivable subject— and *imitatione fantastica*—the representation of an inner concept[22]. The didactic advantages of *vivacità* were noticed by the moralists of Counter-Reformation, Gilio 1564[23], Paleotti 1582[24], R. Alberti 1585[25] and Comanini 1591[26], who all emphasized its noble purpose.

1. Cf. Plutarch above chap. B II note 8.
2. For instance Vasari 1568, ed. 1878— VI p 274.
3. For instance Equicola ca 1525; Barocchi 1971— I p 259 f. Cf. below chap. B IV 1.
4. *Nat. Hist.* XXXV 36, 66, 95.
5. Filarete ca 1451—64 (ed. 1896 p 629); Lancilotti 1509 (Barocchi *op.cit.* I p 744); Varchi 1547 (ed. 1960— I pp 38, 46); Pino 1548 (ed. 1960— I p 112); Dolce 1557 (ed. 1968 pp 152 f. Cc. his letter to Contarini, *ed.cit.* pp 214 f); Gilio 1564 (ed. 1960— II p 10); Paleotti 1582 (ed. 1960— II p 220); Bocchi 1584 (ed. 1960— III pp 163 f); Lomazzo 1584 (ed. 1973— II pp 52 f); R. Alberti 1585 (ed. 1960— II p 215); Lomazzo 1590 (ed. 1973— I p 93); Comanini 1591 (ed. 1960— III p 280); Speroni 1596 (Barocchi *op.cit.* I p 1000).
6. Filarete ca 1451—64 (*loc.cit.*); Varchi 1547 (*ed.cit.* I p 38); Pino 1548 (*loc.cit.*); Dolce 1557 (*loc.cit.*); Paleotti 1582 (*loc.cit.*); Bocchi 1584 (*ed.cit.* III p 164); Lomazzo 1584 (*ed.cit.* II p 164); R. Alberti 1585 (*loc.cit.*).
7. Filarete ca 1451—64 (*loc.cit.*); Varchi 1547 (*ed.cit.* I p 46); Pino 1548 (*ed.cit.*

I p 111); Dolce 1557 (*loc.cit.*); Paleotti 1582 (*loc.cit.*); Lomazzo 1584 (*ed.cit.* II pp 164 f); R. Alberti 1585 (*loc.cit.*).

8. Filarete ca 1451—64 (*loc.cit.*); Pino 1548 (*ed.cit.* I p 129); Gilio 1564 (*ed.cit.* II p 79); Bocchi 1584 (*ed.cit.* III p 162); R. Borghini 1584 (Barocchi 1971— I p 676).

9. Pino 1548 (*ed.cit.* I p 112 and n 4) mentions a painting destroyed by an agitated cat; Vasari 1568 (*ed.cit.* II pp 496 f; V p 102) writes that Bramantino painted horses which attracted real ones, and that Barnazano painted strawberries so life-like that peacocks tried to eat them; Lomazzo 1584 (ed. 1973— II p 165) repeats these anecdotes and add new ones on Mantegna, Baltasar da Siena and Cesare da Sesto. Cf. Guarino, letter to Pisanello 1430, in Baxandall 1971 pp 92, 156.

10. The importance of direct imitation was already stressed by Dante (Venturi 1964 p 240) and Cennini ca 1400 (chaps. 27, 28; ed. 1971 p xiii and n 12). With the change towards a more conceptualistic and speculative kind of art theory in the later half of the Cinquecento, the attitude towards *ritratti* became unfavourable; cf. Panofsky (1924) 1968 p 30 n 47.

11. The portrait of Paul III; Vasari 1547 (ed. 1960— p 62); Varchi 1547 (*ed.cit.* I p 38); Pino 1548 (*ed.cit.* I p 112); Dolce 1557 (*ed.cit.* pp 108 f); Bocchi 1584 (*ed.cit.* III p 147).

12. A portrait of pater Panigarola; Comanini 1591, ed. 1960— III pp 244, 255, 280.

13. *Ed.cit.* I p 372.

14. Ed. 1960— I p 286 and n 3; taken from Boccaccio, *Decamerone* VI 5; cf. Lee 1940 p 203 n 33.

15. Cf. above chap. B I 2.

16. Dolce 1557 ed. 1968 pp 154 f.

17. *Ed.cit.* IV p 40.

18. Barocchi 1971— I p 879.

19. Cf. Aristotle, *Poet.* ii, 2, 1448 a.

20. Ed. 1960— I pp 264 ff. Cf. Panofsky *op.cit.* p 81 and n 17; Chastel-Klein 1966 pp 182 ff.

21. *Soph.* 235—236; Barocchi *op.cit.* I p 388 n 1.

22. Ed. 1960— III p 256. The difference was noted by Cennini ca 1400 (quoted), and in the Cinquecento by Gilio 1564 (Barocchi *op.cit.* I p 321); Paleotti 1582 (ed. 1960— II pp 139 ff, 219); Lomazzo 1584 (*ed.cit.* II pp 25 f); Mazzoni 1587; G. Galileo 1589 (Barocchi *op.cit.* I p 384 n 3); R. Alberti 1604 (*op.cit.* I pp 1011 f). Plato used the terms to illustrate the general worthlessness of imitation in connection to monumental images; *eikastike* means that the artist renders the correct proportions of the model, which appear disproportional when seen from below; *phantastike* means that the artist consciously renders the proportions distorted in order to achieve a correct appearance. Cf. Panofsky *op.cit.* pp 5 f and n 11; 62 n 51; *ibid.* 1955 p 63 n 11; Gombrich (1960) 1972 pp 184 f; Pochat 1973 pp 34 f and n 49. Cf. *eurytmia* below chap. B IV 4 and n 9. Geminus (first cent. B.C.) lists *skenographia*, scene-painting, as a part of optics; Lindberg 1976 p 11 and n 72.

23. Ed. 1960— II pp 315 f.

24. Lib. I chap. 6—12; *ed.cit.* II pp 149 ff, 214 ff.

25. *Ed.cit.* III pp 226 f.

26. *Ed.cit.* III pp 248 f, 305 ff.

# 3. Rilievo

*Rilievo,* the illusion of volume on a flat surface, was constantly mentioned as one of the greatest marvels of painting[1]. Its main problem, summarized by Theophrastus in *De coloribus,* is the relation of the local colour to the altering influences of differently coloured illumination and of differently coloured reflections from the surroundings. The dominating method, a division of the visible side of the volume in three parts—illuminated, local-colour and shadowed part—of which lustre was regarded as a subdivision of the illuminated part, is already described by Pliny. According to him, polychromy and the rendering of light and shade had developed from monochromy: *Postea deinde adiectus est splendor, alius hic quam lumen. Quod inter haec et umbras esset apellarunt* tònon, *commissuras vero colorem transitus* harmogèn[2]. The beginning of the second sentence has been translated[3] "The relation of light and shade they called the strength of painting." In my opinion, however, *tònos* means neither "strength" nor "tension"[4], but "tone", referring to the particular part and quality of the body which is neither illuminated nor shadowed; Pliny, then, describes a sequence of parts of the volume: lustre (*splendor*), illuminated part (*lumen*), local-colour part (*tònos*) and shadowed part (*umbra*); *Harmogè,* on the other hand, is the tonal graduation and chromatic transition between the different parts, corresponding to *sfumato,* which was to become a general claim in the art theory studied[5]. The influence of Alhazen's observations of physical light, intermediated by Bacon, was secured through Ghiberti ca 1450[6], whereas the influence of the Neo-Platonic[7] notion of supersensual light was non-existent on the pragmatic art theory.

Cennini ca 1400 expresses pragmatic aims; instead of elaborating any theory of light, he underlines its function to create volume. The skilful artist judges the motif with his *luce dell'occhio*[8], particularly the effects of the real light[9], *luce del sole,* which, directed through window-openings may cause problems due to its changing nature; in such cases, the artist is to adapt the represented light to *la più eccelente luce*[10]. He advocates three different methods for the chromatic rendering of *rilievo,* all within a system of tripartition of the volume. According to the first, the 'standard' method, the artist is to use three colour-containers, for (A) the illuminated (local-colour) part, (B) the local-colour part and (C) the shadowed (local-colour) part respectivly[11]. (C) is the basis for the mixture of (A) and (B), and consists either of black or, in general, of a certain chromatic pigment and a little white. (A) is achieved through a cinsiderable addition of white to (C); (B) is finally mixed by equal parts of (A) and (C). The successive darkening sequence (A)—(B) = (A+C)—(C) means that the greatest saturation of the relatively dark pigment lies in the shadowed part, which becomes most visually articulated (COLOUR PLATE *VIII:1*). According to

the second method, which concerns primary and secondary colours, the general system (A)—(B) = (A+C)—(C) is still valid, but the colour of (A) consists of the lightest of the two components of the secondary colour, and the colour of (C) of the darkest, for instance (A) yellow—(B) = (A+C) green—(C) blue[12] (COLOUR PLATE *VIII:2*). In the third, and least frequently recommended method, which concerns relatively light pigments, the colour of (A) the illuminated part is mixed by an addition of white to (B) the local-colour, whereas (C) is mixed by an addition of black to (B); the general system is no longer valid, and the greatest saturation will be found in the local-colour part (COLOUR PLATE *VIII:3*). White volumes are impossible to render according to any of the three methods—the local colour will necessarily be found in the illuminated part.

The "flattening, surface-stressing tendency"[13] and the plastic inconsistency which results from the lack of a single method is further accentuated[14] by additional advices for *cangianti,* the chromatic division of the volume, visually reminiscent of the second method above, but motivated by illusionistic aims—the effect of certain cloths, in particular silk, in which the woof and warp are of different hues[15]. Though some of the examples of *cangianti* given by Cennini follow the general system mentioned above[16], real *cangianti* mean that disparate hues are combined, such as (A) green earth —(B) rose—(C) ultramarin-blue[17]. In spite of this, he advocates *sfumato;* the transition between the three parts of the volume is to be made *a modo d'un fummo bene sfumate*[18].

The general impression that the standardized, conventional use of colours and the attraction to decorative colouristic effects in Cennini has a medieval character, is testified by a MS[19], compiled by Jean Lebègue ca 1410, in which the sections which concern *rilievo*—thought to emanate from Eraclius, supposed to have flourished in the tenth century[20]—describe a practice almost identical with Cennini's. The illuminated volume is to be rendered in three parts[22]; for relatively dark pigments[23] the greatest saturation lies in the shadowed part, (Cennini's first method), the colour of which is enlighted with white according to (A)—(B) = (A+C)—(C). As in Cennini (third method) an alternative is (A) = (B)+white—(B)—(C) = (B) +black.[24]. The two *cangianti* described are, however, exclusively made up by the naturally related hues[25] of the chromatic elementary colours.

In Alberti 1435—36, the general concept of light is the Aristotelian; light becomes visible through friction against *materia*[26]. Colour is a kind of light; that he calls colouring *receptione de lume*[27] reveals the great importance he ascribed to *rilievo*[28]. Judging from the advanced observation that the perceived colour depends of the place[29] and light[30], and from the probably Theophrastian distinctions of natural and artificial[31] light sources and of direct and reflected light[32], one might expect to find a system, in which these considerations are comprised. Alberti, however, neglects them

completely; instead, he introduces a radically new system of unified colouristic rendering of *rilievo*. In order to achieve that, he had to neutralize the varying relative lightness of the four elementary colours as it appeared in the pigments used, a variation which according to Cennini's methods resulted in plastic inconsistency and tonal and chromatic division of the volumes Alberti's new system is an application of his organization of surface-colours; it also explains his apparently strange terminology[33]— *rosso, cilestrino, verde, bigio e cenericcio*. The unusual names for blue and yellow specify their saturation and lightness; *cilestrino* means unsaturated, grayish or pale blue, *bigio e cenericcio* unsaturated, grayish and rather dark yellow. Through a reduction of the lightness of the yellow pigment (probably saffron)—the lightest chromatic colour—and an increase of the lightness of the blue pigment (ultramarine)—the darkest chromatic colour—he made them approximately equivalent in tonal terms to the red and green pigments, the medium-light chromatic elementary colours. (COLOUR PLATE *IX*) To the consistency resulting from the tonal unity was added the chromatic continuity of the local-colour, which dominates all parts of the volume and always remains most saturated in the local-colour part. By neglecting the influence of the source of light in the illuminated part and of the reflections from the surroundings in the shadowed part, a simple rule follows: light is white, darkness black. The addition of white to the illuminated part and of black to the shadowed part do not change the hue of the local-colour (white and black are not actual colours but modulators of them). The method has two exceptions: white and black may also be local colours; the local-colour part of a white volume, however, must be painted with a colour "much below the highest whiteness" and becomes white only in the illuminated part; the local-colour part of a black volume, on the other hand, must be painted in a dark colour, which becomes black only in the shadowed part[34].

The importance of this method cannot be overestimated[35]; it gives a formula that is easy to understand and apply; it preserves the characterizing local-colour, the *signum individuationis,* in the same place and at a medium-high level, which guarantees a maximum *rilievo* through the greatest possible distance to pure white and black. (COLOUR PLATE *X*) The white reflections of light in the illuminated part of volumes with glossy surfaces are to be rendered as spots, *macole*[36], but generally Alberti advocates *sfumato*[37]. Since his own practice of painting[38] refers to panel-paintings, the question of adaption of the represented light to the real light is not considered.

Filarete ca 1451—64 initiates the *paragone* of painting and sculpture[39]; he praises the intellectual character of the illusion of volume on a flat surface. He treats *rilievo* from a technical point of view; it is defined as the perfection of drawing, done with colour, but not necessarily chromatic

colour[40]. He describes the fully developed glaze-technique of oil-painting; *rilievo* is not achieved through modifications of the top-layer of colour, but by heightening with white and lowering with black on the underlaying drawing[41]; finally, the figure is glazed in the proper chromatic colour, and *rilievo* is reinforced through adequate additions of white or with white enlightened colours. Filarete, too, emphasizes the importance of *sfumato*[42].

Piero della Francesca ca 1482 just remarks, in his definition of painting, that *rilievo* is the effect of light on colour, with which light is to be rendered; the continuation deals, however, exclusively with drawing[43].

Leonardo ca 1490—1510 takes a great interest in the theory of light; he adheres to the rectilinear description of formal optics[44]; *razzi luminosi* are emitted by a *corpo luminoso* and give rise to *razzi ombrosi* in the illuminated body, from which an impression by *razzi visuali* reach the eye. He differentiates between *luce*, the general nature and source of light, and its emittance and result on a body, *lume*[45]. The coloured light of the light source—called *lume originale*—influences the local-colour of the illuminated object[46], called *lume derivativa*[47], which gives rise to a shadow on the object, *ombra primitiva,* and one falling from it, *ombra derivativa*[48]. The *ombre primitive are* separated into *semplici* and *misti,* depending on whether they are mixed with reflected colour from the surroundings or not[49]. He also notes the difference between direct light, *lume diretto,* or *particolare*[50] and scattered, indirect *lume universale*[51]. The illuminated body is—according to tradition—separated in three parts: illuminated part (*lume*), local-colour part (*ombra mezzane*) and shadowed part (*ombra principale*[52]); *lustro,* the direct reflection of the light source on glossy surfaces, may occur in the illuminated part[53]. Like Alberti, he observes that different kinds of structures and figures respond to light in different ways[54]. He observes that perception of shape and size is conditioned by the light— light from below deforms[55], white figures against a dark background seem to expand[56], dark against a light background seem to contract[57]. As a rhetorical argument in the *paragone* he maintained that a painting is independent of exterior light[58], but in a pragmatic context he demanded that the direction of the represented light should be adapted to the real light[59]. In spite of the fundamental importance he ascribed to *rilievo*[60], and in spite of his love for saturated, bright colours[61], he preferred the soft, indirect *lume universale* which gives *grazia; lume particolare,* which is said to generate a better relief[62] and make the brightness of the colours come out, is rejected since it gives *crudezza* and makes the objects stand out as *tinte*[63]. The transition between the volume and its background is to be soft; no lines are to be visible[64]. The influence of the Aristotelian concept of *continuum*[65] and the observations in *De coloribus* result in a range of observations of the chromatic changes of the local colour—in the illuminated part due to the colour and strength of the source[66] of light, and in

the shadowed part due to reflections from the surrounding[67]. The extremities of the volume, then, become chromatically consistent with the surroundings. He gives detailed examples of this consistency: the artist is to measure the angles of the incident light on the round object, theoretically abstracted to an octogonal (Fig.) (A) Opposite to the source of light, where the incident light rays fall at a 90° angle on the volume, light is to be twice as strong as on the sides ($B^1$, $B^2$), where the angle is 45°; in the first case, (A), one part of the local colour is to be mixed with two parts of the colour of the source of light; in the second case ($B^1$, $B^2$), equal parts are to be mixed[68]. The problems thus created are not restricted to white and black volumes alone—the former are, according to Leonardo, 'impossible' to render since they 'lack' colour and thus become completely influenced[69], whereas the latter are not influenced at all[70]—the applications of the observations in *De coloribus* on a blue volume, illuminated by a yellow source of light in red surroundings, would result in something similar to the *cangianti* of Cennini[71]: the illuminated part would be green, the local-colour part blue, and the shadowed part violet[72]. (COLOUR PLATE *XI*) Actually denying physical reality, he condemns in a large number of notes, any influence from the surroundings as *falso* and *brutto;* the additional colour of the source of light and of the reflections from the surroundings are said to destroy the *vero* or *naturale* local colour. Since Leonardo's notes constitute a fragmentarily preserved material from different periods of his life, which he never arranged himself, no quantitative comparisions between chronological groups of notes can adequately be made; nevertheless, it is hardly a coincidence that more than 75 % of his notes[73] on the "true" properties of objects, coupled with refusal of their alterations, belong to his late period. In the long run, evidently, he considered the elimination of the fundamental function of local colour as

*signum individuationis* and of the consistency of that colour within the volume as too high a price to pay for the total *sfumato;* in spite of its scientific justifications, he developed artificial methods by which the altering effects of the source of light and the surroundings were neutralized: the colour of the emitted light is to be transformed to the local colour of the illuminated body by an intervening filter—in the case of a nude body he prescribes linen cloth[74] or flesh-coloured glass[75]. The local colour of the surroundings is either to be transformed to the local colour of the body—in the case in question, the walls are to be flesh-coloured[76] —or to be unchromatic and non-reflecting (black)[77]. The result is a chromatic consistency within the volume, but in order to restore its limits, he had to resort to artificial contrast[78]. Another problem, to which he does not offer any solution, is that the greatest saturation will not be found in the local-colour part. An alternative way of eliminating the exterior influences was to adopt the simplified solution of Alberti: in some late notes he states that light is white and darkness black[79].

In my opinion, then, Leonardo's notes on the chromatic rendering of *rilievo* show the same development towards a general fear[80] of alterations as do his notes on the durability and invariability of the material colours (above chap. B I 4).

In the Cinquecento, *rilievo,* regarded as a technical—and thus not dignified—device to achieve illusionism, disappears as an element in the definitions of painting[81], but its intellectual, immaterial character is emphasized in the *paragone,* which still flourished[82]. Very limited interest is paid to the theory of light—the theories of Antiquity, mainly Aristotle's and Plato's, are related[83], but sometimes the whole subject is dismissed as too complicated or uncertain[84]. Different light styles are, however, identified, both as indivdual peculiarities[85] and as proper variants for different subjects[86], in particular the irrational *lume divino* for religous subjects[87]. With exception made for that kind of represented light, the claim of adaption to the real light persists[88]. It is repeatedly emphasized[89] that the illusionistic effects of light are to be rendered with chromatic colours; *sfumato,* resulting from soft, indirect light remains a claim[90], and the disadvantages of direct light are often pointed out[91]. The traditional method of a tripartition of the volume is presented by Vasari 1568, who suggests, however, an additional division of each a part in two; the six parts are, however, not varied in hue, but only in lightness through additions of white and black[92]. The same tonal graduation is described in connection with wash-drawings, in which the colour of the paper represents the local colour, which is heightened with white and darkened with dark ink; the method is called *molto alla pittoresca, e mostra più l'ordine del colorito*[93]. The chromatic rendering of *rilievo,* then, is made according to Alberti's simplified principles, and he shares Leonardo's negative view

about the altering influence of reflections from the surroundings[94]. Direct reflections on, and necessary to define, glossy surfaces, are said to cause problems[95]. Vasari demands adaption of the represented light to the real light, but boasts of having introduced six different light sources in the same picture[96]. V. Borghini ca 1560, who shares Vasari's opinion about wash-drawings, refers the practice of dividing the volume in three parts to Pliny[97] (above p 107). The same method is mentioned by R. Borghini 1584[98] and Lomazzo 1584, who gives the Albertian example of a blue volume, in which the illuminated part is made of blue and white, the local-colour part of blue and the shadowed part of blue and black[99]. But when he deals with theory of light[100], he only differentiates between *lume primario,* the illuminated part of the volume, and *lume secondario,* the shadowed part[101]. His acquaintance with Leonardo's observations of exterior influences is, in spite of his adherence to the Albertian system, revealed by the statement that the colour of the illuminated part is influenced by the varying colour of the source of light[102], and the shadowed part by *lume riflesso,* reflections from the surroundings[103]. The direct reflections of the source of light on a glossy volume are called *lume rifratto*[104]. Later[105], giving detailed instructions for the chromatic rendering of *rilievo,* Lomazzo completely neglects the scientific considerations—local colour must not be lost[106]. The illuminated and shadowed parts are now divided in three parts each; the local colour is situated in the third, darkest part of the illuminated side of the volume. For the six-partition of 'unanimated' volumes, as of ordinary cloth, the simple system of additional (W) white and (S) black to (A) the local colour is applied: (A+3 W)—(A+2 W)—(A+1 W)—(3 A+1 S)— (2 A+2 S)—(1 A+3 S). A whole chapter is dedicated to *cangianti*[107], the chromatic division of the volume, imitating certain materials which respond differently to light and shadow. He presents a method, by which pigments of five tonal grades, (1) white—(2) light—(3) medium-light—(4) dark—(5) black, are combined in three groups: 1—2—3, 2—3—4, 3—4—5; only the first and second groups, he proudly notes, result in 3584 variants, which guarantees a great *varietà.* But for the rendering of *rilievo* of human bodies, where the local colour reveals the characteristic complexion of one of the four temperaments[108], a fear of losing the local colour in blackness motivates the use of a darker, unsaturated variant in the shadowed part, as red—brown. No black is used in this complicated system. For instance (COLOUR PLATE *XII*), the local colour of the choleric (A) is to be mixed of two parts red, one yellow and one (W) white; the two lighter parts of additional white: (A+2 W)—(A+1 W)—(A). The lightest part of the shadowed half is to be made of (B) two parts burnt ochre, one part raw umber and three parts of (A) the local colour; the two darker of a successive loss of local colour: (B+3 A)—(B+2 A)—(B+1 A)[109]. For the problematic rendering of white and black volumes, Lomazzo gives

complicated instructions; as with Alberti, the local-colour part cannot be white, but according to Lomazzo's system not even the most illuminated part becomes pure white[110].

Armenini 1586 refers to the practice of creating volume through a tripartition of the volume by a successive admixture of white[111]. This does not mean, however, that the local colour is situated in the shadowed part, since he later says that this is to be done by a slight admixture of black[112]; the local colour must not be lost in blackness, since *l'ombra è mancamento di lume ... e non effetto di color nero.*

Lomazzo 1590 deviates only slightly from his earlier work as to the rendering of *rilievo*[113]; the descriptive function of different kinds of responses to light is emphasized: angular bodies respond harshly, rounded softly etc; gold has a harder lustre than silver, which shines more than lead etc[114]. This phenomenon is analyzed also in Calli 1595, who differentiates between two kinds of surface-colour, *color reale,* the actual local colour, and *colore spiritale* or *apparente,* which depends on the source of light and the individual structure of the illuminated object; in particular glossy surfaces seem to have a colour which in fact does not belong to them[115].

---

1. Cf. the *paragone* above chap. A II. As late as 1612, G. Galileo (Panofsky 1954 p 5; Barocchi 1971- I p 709) would summarize the principle: *Quanto più i mezzi co'quali si imita, son lontani dalle cose da imitarsi, tanto più l'imitazione è maravigliosa.*

2. *Nat. Hist.* XXXV 29. In my opinion, the correct interpretation would be: "Afterwards a lustre was applied, which is something different from the illuminated part. That which lies behind this [the illuminated part] and the shadowed part they called *tònos,* and the transition between, or affixion of, the colours they called *harmogè.*" The influence of Pliny was secured through an ed. in 1469 and a translation in 1473 by Cristoforo Landino; Schlosser 1924 p 92; Arentz 1953 p 137; Baxandall 1972 p 114.

3. Shearman 1962 p 41 and n 93. In a translation by V. Borghini ca 1560 (Barocchi *op.cit.* I p 651 and n 1), *splendore* is made synonymous with *tònos: Dipoi si agiunse lo splendore. Questo è un'altra cosa che lume, e perchè egl'era mezzo fra l'ombre e lume, gli poson nome tuono.*

4. Pollitt 1965 p 228.

5. It is surprising that no one observed the complicated relation of that claim to clarity-perspective; *sfumato* reduces the contrast between the distict foreground and a hazy background. Cf. below chap. B III 4, hierarchic persp.

6. Ciardi 1973— II pp 188 n 2, 190 n 4, 196 n 1, 202 n 1. On the influences on Leonardo, cf. Pedretti 1964 pp 20, 41 n 23.

7. Through Ficino 1469 and Ebrero ca 1501, Neo-Platonism was to exercise a general influence, which was to culminate in the speculative art theory of the late Cinquecento. Cf. Panofsky (1924) 1968 pp 129 ff, 133, 137, 141; Chastel 1954 pp 99 ff; Barasch 1960 pp 226 f.

8. Chap. 8; ed. 1971 pp 9 f. This is, in my opinion, an early formulation of the

later more frequent *giudizio dell'occhio* and does not refer to emission of visual rays; cf. above chap. II.

9. The term is intended to correspond to Schöne's 1954 "Reallicht." For "Bildlicht" the term "represented light" is used.

10. Chap. 9; *ed.cit.* pp 10 f.

11. Chap. 71; *ed.cit.* pp 83 ff.

12. Chap. 55; *ed.cit.* p 58.

13. Shearman 1962 p 16. Neither I nor—I presume—Shearman regard this effect as a "failure" as did Hetzer 1935 pp 25 ff, 46 f, 49. Cf. Vasari 1568 ed. 1878- II p 95; Pope 1949 p 81; Schöne *op.cit.* pp 12, 87 and n 191.

14. However, frequently recommended blue nuances in the shadowed part reduce this effect; chap. 77, 78 and 79; *ed.cit.* pp 90 f.

15. According to Shearman (*op.cit.* pp 14 ff; cf. *ibid.* 1965 I pp 132 f), *cangianti*, called "colour-change", was an alternative to "simple colour-modelling", variations of saturation, intensity and lightness through successive additions of white, which reveal a lack of a coherent theory of the effects of light. In my opinion, "colour-change" was an alternative method (the second) for the rendering of ordinary volumes, but *cangianti* was a method of its own for a naturalistic imitation of particular structures.

16. Chap. 79; *ed.cit.* p 91: (A) *rosa*—B (=A+C) *lacca rosa*—(C) *lacca*.

17. Chap. 77; *ed.cit.* pp 90 f.

18. Chap. 31; *ed.cit.* p 31. Cf. Spencer (1956) 1966 p 83 n 76.

19. Merrifield (1849) 1967 I pp 1 ff.

20. *Op.cit.;* introduction to ed. 1967 p vii and n 4.

21. Panofsky 1955 p 75 n 29, notes that Cennini also concerning anatomical proportions continues a Byzantine tradition.

22. Merrifield *op.cit.* I pp 254 ff.

23. Blue *lazurium, indicus,* red *vermiculum, folium,* and green *viridis.*

24. Proposed for blue, green blended of yellow and blue, but also for green and red.

25. Yellow—red—brown; a limited range, yellow—red, is explained by the fact that yellow orpiment reacts against a mixture with lead white in the illuminated part.

26. For instance, humidity in the air results in a whitish vapour; cf. below chap. B III 4.

27. Ed. (1956) 1967 p 68 and n 22; ed. 1972 pp 66 f. Cf. Shearman 1962 p 13; Baxandall 1972 p 139.

28. Ed. (1956) 1967 p 89. Barasch 1960 p 232 interprets the association of light and colour as an expression of a limited interest in colour.

29. The change of place affects the ability of light to penetrate the medium; cf. chap. B III 4.

30. Ed. (1956) 1967 p 45; ed. 1972 p 38. Cf. Siebenhüner 1935 pp 17, 22.

31. Ed. (1956) 1967 p 51; ed. 1972 pp 46 f; cf. Siebenhüner *op.cit.* p 27.

32. *Loc.cit.;* Siebenhüner *op.cit.* p 31; "You may have noticed that anyone who walks through a meadow in the sun appears greenish in the face."

33. Cf. above chap. A I.

34. Ed. (1956) 1967 pp 83 f and n 77. Cf. Barasch 1960 p 232; Edgerton 1969 p 127 and n 49.

35. Shearman 1962 ascribes the invention of this method to Leonardo's practice (p 17) and refutes Alberti's theories as alien to the painters practice (p 36).

36. *Ed.cit.* pp 49, 70. The characteristic way of response to light is another *signum individuationis; ed.cit.* p 72.

37. *Ed.cit.* pp 68, 70, 83.
38. *Ed.cit.* p 67.
39. Ed. 1890 pp 628 f.
40. *Ed.cit.* p 626; cf. Baxandall 1972 p 139.
41. *Ed.cit.* p 643. On this technique as a possible basis for a kind of definitions of painting, cf. above chap. A II.
42. *Ed.cit.* p 625.
43. Ed. 1942 p 63. Further conclusions may be drawn from the study of his paintings; cf. Siebenhüner 1935 p 37 ff; Gilbert 1968 *passim*.
44. For instance ed. 1882 TP 251.
45. TP 549. Cf. Schöne 1954 pp 83 f, 109 f; Barasch 1960 pp 229 f, 241.
46. TPP 86, 146, 223, 224, 250, 284, 414, 479, 549, 654, 694, 702. Detailed colouristic prescriptions are given in TPP 756, 779.
47. TP 157.
48. TPP 551, 572, 573.
49. TP 94.
50. TPP 94, 489, 663, 790.
51. TPP 94, 110, 431, 498, 663; a hybride of the two kinds is scattered light directed through a window; TPP 431, 663. Cf. Rzepinska 1962 chap. IV, who characterizes Leonardo's theory of the origin of the blue colour of the sky as similar in principle to the modern explanation—diffusion of light. Diffusion, however, means a non-selective scattering of light, which in mist is perceived as whiteness. The blue colour of the sky is caused by selective scattering. Cf. Pedretti 1964 p 31 n 1; Evans 1948 pp 65, 84. Leonardo's explanation of the blue colour was that the white colour, caused by the friction of light against the water-particles in the air, is seen blended with or superimposed over the cosmic darkness; TPP 226, 254, 438 B, 661; Richter (1883) 1970 I § 300.
52. TPP 206, 207, 428.
53. TPP 158, 206, 215, 223, 224, 256, 664.
54. For instance young people's bodies, who have a certain transparency, respond softly to light. Cf. above note 36.
55. TPP 37, 258 A.
56. TPP 258 A, 457.
57. TPP 445, 457.
58. TPP 36, 38, 44.
59. TP 414; Richter *op.cit.* I § 519. An original example of the tonal adaption is the advice, TPP 419, 761, 818, that the artist is to shadow the represented local-colour with his hand, and try to imitate the result in the shadowed part.
60. Particularly in TPP 24, 25, 123, 124, 136, 413; *rilievo* is said to be the fundamental part of painting. Cf., however, TPP 122, 180, 409, 482. In the *paragone,* *rilievo* is one of the primary examples of the *fatica mentale* of painting, in contrast to the *fatica corporale* of sculpture, which "by nature" is given volume.
61. TPP 207, 245; cf. above chap B II. However, some colours are said to be more beautiful than others in the shadow; TPP 206, 692.
62. TP 475.
63. TPP 87, 93, 94, 110, 128, 138, 431, 489, 694; Richter *op.cit.* I § 516. As to the negative aspect of *tinte,* cf. above chap. B I 2.
64. "The line has in itself neither matter nor substance and is rather to be called a mental concept than a real object"; Libro A 16; Pedretti 1964 p 37. Cf. however, his artificial remedies of a too soft transition.
65. Zubov 1968 pp 144 f, 164, 221; Pedretti *op.cit.* p 37 and n 15, 52 and n 53. Cf. Clark 1952 p xiv; Gantner 1958 pp 9, 60, 221.

66. TPP 86, 146, 224, 248, 250, 414, 645, 654, 661, 694, 702, 756.

67. TPP 159, 162, 165, 166, 192, 196, 203, 214, 215, 239.

68. TP 756. The illuminated part is divided in A and $B^1$, $B^2$. It seems to follow, that $C^1$, $C^2$ is the local-colour part and that in the shadowed part, divided in $D^1$, $D^2$ and E, $D^1$, $D^2$ consist of equal parts of the local colour and the colour of the surroundings, and E of one part of the local colour and two parts of the colour of the surroundings. In another *regola*, however, L. says that the proportions are to be 1:3; TP 433 (1508—10)=Libro A 40; Pedretti *op.cit.* p 73. If Pedretti's dating (1508—10) is correct, this note may be regarded as a demonstration of the absurd consequences of direct illumination.

69. TPP 86, 196, 197, 215, 247, 471, 692, 702, 785; cf. Zubov *op.cit.* p 141.

70. TP 215.

71. Cf. above p 108.

72. Cf. TPP 214, 250, 657, 702; Richter *op.cit.* I §§ 618 f.

73. The notes concern also size and form; TPP 85, 149, 258 A, 262, 419, 756, 761, 785 (ca 1492); 95, 176, 197, 202, 207, 221, 223, 234, 239, 241 B, 245, 250, 259, 411, 428, 457, 628, 644, 645, 654, 684, 692, 702, 703, 708, 709, 710, 741, 769, 770, 779, 886, 920, 925 (ca 1505—10).

74. TPP 85, 138. If Pedretti's dating (ca 1492) is correct, L. was aware of this problem at an early period.

75. TP 709 (1508—10).

76. TPP 09 (1508—10), 709; cf. TPP 203, 217, 239, 767 (all ca 1505—10).

77. TPP 138 (Pedretti's dating, ca 1492, seems uncertain), 155 (1505—10), 703 (1508—10). Some notes indicate that L. also held that a *black* surface reflects its blackness on an adjacent body, for instance TPP 644, 708 (both 1508—10).

78. TPP 151, 154, 190, 229, 231, 233, 246, 423, 759; all, except the last, of a late date.

79. TPP 154 (1505—10), 213 (1505—10), 254 (1508—10) and particularly 703 (1508—10): *L'ombra de corpi non debbe partecipare d'altro colore che quel del corpo, dove s'aplica. Adonque, non essendo il nero connumerato nel nu° de colori, da lui si toglie l'ombre di tutti i colori de corpi...*" Cf. Shearman 1962 pp 17 f, 22.

80. His almost desperate effort to preserve the local colour is also revealed by the rather naive advice in TP 925 (1508—10), that the painter who seeks to imitate the colour of leafage is to pick a leaf from the tree and then carefully mix the colours according to it.

81. Cf. Lancilotti 1509 (Barocchi 1971- I pp 742 ff), who unsystematically lists the illusionistic elements of painting: shadows, light, reflections, foreshortenings, relief, perspective. It is regarded as clever but self-evident that the artist masters these devices—it is more important that he is a *bello inventor*. Cf. above chap. A II, the definitions of painting.

82. Pino 1548 (ed. 1960- I pp 100, 129); V. Borghini ca 1560 Barocchi (*op.cit.* I p 672); Lomazzo 1584 (*Proemio, Lib. I chap. 1; ed. 1973- II pp 16, 26); R. Alberti 1604 (Barocchi *op.cit.* I pp 1013 ff); Zuccari 1607 (*op.cit.* I pp 698, 1036); G. Galileo 1612 (Panofsky 1954 p 8; Barocchi *op.cit.* I p 707). The latter confirms Leonardo's argument that the relief of sculpture depends on directed exterior light since this effect may be eliminated by painting the illuminated parts with a dark colour.

83. Telesio 1528 (Barocchi *op.cit.* II p 2212 n 1); Dolce 1565 *(loc.cit.);* Aldrovandi 1582 (*op.cit.* I pp 924 f); Lomazzo 1584 (Lib. I chap. 3; *ed.cit.* II pp 32; cf, pp 189 f); Calli 1595 (Barocchi *op.cit.* II pp 2325 ff).

84. Equicola 1526 (*op.cit.* II p 2153); Morato 1535 (*op.cit.* II p 2176).

85. Vasari 1568 (ed. 1878-, for instance IV pp 11, 92, 134, 139, 191, 571; V pp 102, 110, 193); R. Borghini 1584 (ed. 1807 II p 217, III p 34); Lomazzo 1590 (chap. 14; ed. 1973- I pp 287 ff) associates seven *generi del lume* with seven artists: Michelangelo *lume terribile*, G. Ferrari *largo e regolate*, Polidoro *fiero e marziale*, Leonardo *lume divino*, Raphael *lume leggiadro, amoroso e dolce*, Mantegna *pronto e minuto*, Titian *terribile e acuto*.

86. Armenini 1586 recommends *lume artificiale* only for *capricci;* Lib. II chap. 1; Barocchi *op.cit.* II p 2013. Cf. Vasari below, chap. B II and n 75.

87. Maranta ca 1550—70 on Titian's *lume divino* in *the Annunciation* of 1557 (*op.cit.* I p 881): *non pare che venga dall'esterior lume, ma più tosto nasca di dentro;* Sorte 1580 (ed. 1960- I pp 294 f); Lomazzo 1584 (Lib. IV chap .6; *ed.cit.* II pp 193 f). Cf. Schöne 1954 p 112 n 242.

88. Lomazzo 1590 (chap. 29; ed. 1973- I p 325 and n 4) demands it even for easel-paintings(!).

89. Pino 1548 (*ed.cit.* I p 118 and nn 3, 4), calls *rilievo "ultima parte et anima del colorire";* Biondo 1549 (Barocchi *op.cit.* I p 779); Dolce 1557 (ed. 1968 pp 152 f: *È la principal parte del colorire il contendimento, che fa il lume con l'ombra);* Vasari 1568 (*ed.cit.* I p 171); V. Borghini ca 1560 (Barocchi *op.cit.* I pp 622 f); R. Borghini 1584 (*ed.cit.* I p 210); Armenini 1586 (Lib. II chap. 2; Barocchi *op.cit.* II p 2019); R. Alberti 1604 (*op.cit.* I pp 1013 ff); Zuccari 1607 (Lib. II chap. 5; *op.cit.* II p 2106; the latter calls the colouristic rendering of volume *"sostanza particolare d'essa pittura"* and linear drawing with additional light and shadow *"più perfetto e specie particulare di pittura."* (Lib. II chap. 6; *op.cit.* I p 1036).

90. Pino 1548, *loc.cit.;* Dolce 1557 (ed. 1968 pp 152 ff) repeats Leonardo's refusal of visible lines; Vasari 1568 (*ed.cit.* I p 172, II p 95, IV pp 11 and 92 on Giorgione, whose *sfumato* is said to be an influence from Leonardo; 134, 139, 191, 571, V p 193 and other places); R. Borghini 1584 (for instance *ed.cit.* II p 217 on Andrea del Sarto); Lomazzo 1584 (Lib. IV chap. 21; *ed.cit.* II pp 210 ff); Armenini 1586 (Barocchi *op.cit.* II pp 2013 ff; he differentiates between *lume comune* and *artificiale;* cf. above, note 86); Lomazzo 1590 (chap. 29, 37; *ed.cit.* I pp 324 f, 356) recommends *lume naturale* or *celeste* but warns against *troppa unione.*

91. The spotted, fragmentary effect of *macchine* may also be due to hard shadows; Pino 1548 (*ed.cit.* I p 134). Cf. Biondo 1549 (Barocchi *op.cit.* I p 779).

92. *Ed.cit.* I pp 171 f. He praises Lorenzo di Credi, who is said to have had thirty nuances between highlight and extreme shadow; *ed.cit.* IV p 571.

93. *Ed.cit.* I p 175.

94. *Ed.cit.* V p 102: Giovanni Bellini paid too much regard to "reflections, rays and shadows"; V p 110: Bastiano Florgorio had a harsh manner due to his habit of painting in fire-light.

95. *Ed.cit.* VII p 657. The same motif—reflections in metal arms—as was mentioned by Alberti, almost made Vasari *perdere il cervello.*

96. *Ed.cit.* VII p 663.

97. Barocchi 1971- I p 651; on wash-drawing p 650.

98. Ed. 1807 III p 34, where Pontormo is praised for a soft unison of *lume, mezzo* and *oscuro.*

99. Lib. I chap. 1; ed. 1973- II pp 32 f.

100. Lib. IV chap. 1—25; *ed.cit.* II pp 186 ff.

101. Chap. 4, 8; *ed.cit.* pp 191 f, 195 f.

102. Chap. 18; *ed.cit.* pp 206 f.

103. Chap. 10; *ed.cit.* p 196.

104. Chap. 11; *ed.cit.* pp 196 f.

105. Lib. VI chap. 6; *ed.cit.* pp 261 ff.
106. Cf. Barasch 1960 pp 263 ff, who holds that Lomazzo's views are in divergence with Leonardo's.
107. Lib. III chap. 10; cf. Cennini above chap. B III 1.
108. Cf. above chap. III and below chap. B IV 2.
109. The system, valid also for the sanguine and phlegmatic temperaments is not—probably due to a *lapsus*—used for the melancholic.
110. *Ed.cit.* II p 265.
111. Barocchi 1971- II p 2277.
112. *Op.cit.* II p 2282.
113. Chap. 22; ed. 1973- I p 305. A certain ambiguity concerns *lume riflesso,* first said to cause *lume primario,* then *lume secondo.*
114. *Loc.cit.* Cf. Alberti, Leonardo and Vasari above.
115. Barocchi *op.cit.* II p 2325.

# 4. Prospettiva

The importance of linear perspective, the direct application of geometry and optics, which in turn were traditionally regarded as applied mathematics[1], is well established. The great interest paid by modern scholars to that kind of perspective, has, however, contributed to the false impression that the linear construction of the elements in space was the only, or at least the most important means for correct and illusionistic artistic representation of space in the Renaissance. In reality, colour perspective was explicitly given an equal importance already by Leonardo, who coined the terms "linear", "colour" and "clarity" perspective. The shortcomings and restrictions in choice of subjects of linear perspective were also noted early: it presupposes a geometrical structure of the objects—artefacts of architecture —and, theoretically, a continuous, regular repetition of such equally big or familiarily sized bodies all through the depth of space[2]. Moreover, the attempts to popularize the linear construction led, in reality, to its vulgarization; Alberti, for instance, recommended the use of a technical and optical device, the *velo,* which made theoretical knowledge superfluous[3]. The ancient theories of visual perception and optics[4] were just as important for colour perspective as for linear. No important contribution to the traditional framework were presented during the period studied[5]. To the systematic ambiguities implicit in that tradition are added some linguistic, in particular caused by the contradictory meanings of *clarus-chiaro* and their opposites, *obscurus-oscuro* and *fuscus-fusco,* which are used to describe as well phenomenal as perceptual and colouristic qualities[6].

Colour perceptive has, just as linear perspective, its motivical limitations; it is applicable to the organic structure of the landscape and its constituents. The term is not—as will be motivated below—very precise, but has, in accordance with artistic practice, generally become associated to the open

landscape in daylight. In this motivical area colour gained, in the Renaissance, the same scientific dignity as the line. In the subsequent analysis of the texts, clarity perspective will be treated chronologically (Leonardo), whereas colour perspective, the application of clarity perspective to the observation of pictures and what I call structural and hierarchic colour perspective, will be dealt with within a wider context. As distinguished from the other kinds of perspective, this last one does not have an illusionistic end. As terms for the foreground, the medium-distant area and the most remote area, I use near zone, medium zone and distant zone.

## Colour Perspective

Cennini ca 1400 gives instruction[7] for the depiction of near and distant mountains; in the near zone a certain greenish colour is to be used, consisting of one part black and two parts yellow ochre[8]. *E quanto hai a fare le montagne, che paiano più a lungi, più fa 'scuri i tuo'colori; e quanto le fai dimostrare più appresso, fa'i colori più chiari.* This sentence has been interpreted in many ways[9]. Since Cennini does not present any colour scale to which the concepts may be related, its true meaning cannot be established[10].

As a point of departure, Alberti 1435—36 states that the appearence of the true local colour of an object depends on the position from and light in which it is observed[11]; in *De Pictura* it is said that the observed plane appears "deprived of colour[12]", whereas *Della Pittura* only says "of another colour[13]". He introduces visual perception in order to explain these changes, but neither adheres to the immission nor the emmission theory[14], since he considers the dispute "very difficult and quite useless to us." He relates the Euclidean principle, that when the angle of the triangular visual field, at the eye, becomes more acute, the body observed appears smaller[15]. But he soon adds another principle, adapted to the three kinds of rays which bound and fill the visual field—the extreme or extrinsic, which inform about the outline and quantity, the median, which inform about colours and lights, and the centric, which is the strongest, perpendicular to the eye and the object: "as more rays are used in seeing, so the thing seen appears greater; and the fewer the rays, the smaller." This presupposes a fixed size of the visual field, which is also a condition for the extreme rays at a very short distance falling within the outlines of the object and "becoming" median rays, and at a very long distance falling outside the outlines, in which case the median rays "become" extreme rays. Such a fixed visual field means that a certain object may only be perceived in terms of both outlines and colours from one certain position. Alberti certainly did not intend this, since he also wrote that the extreme rays bound and measure the observed body at the base of the trianuglar visual field, until

this base is reduced to a point and the visual field to a line. It must rather be interpreted as a description of how objects which are extremely close to the eye are only perceived in terms of colour, and how the extreme rays at a great distance change nature and intermediate more in terms of colour and light than of distinct outlines[16]. Irrespective of this ambiguity, he clearly explains that the change of the rays is due to a resistance in the air, "which, being humid with a certain heaviness, tires the laden rays[18]", in a degree proportional to the distance; *Onde traemano la regola: quanto maggiore sarà la distantia, tanto la veduta superficie parra più fusca*[19]. Siebenhüner[19] translated *"fusca"* "geschwächt" and refers to Janitschek's[20] translation, "farbloser und lichtloser" as the best. In terms of hue, saturation and lightness, however, this means an unchromatic, unsaturated and maximal dark colour, i.e. black. This cannot be what Siebenhüner intended, since he maintained that that Alberti in this sentence formulated, in a revolutionary way, the principles of colour perspective. Spencer[21] seems intuitively to share this opinion, since he translates *fusca* with "hazy", but he does not comment on it. I adhere to this interpretation, since Alberti, as an example of the variation—in *species* (lightness) but not in *genera* (hue)—of the elementary colour of the air, blue, referred to the phenomenon that the humidity changes it to light blue near the ground level: "Similarly, it is not unusual to see a whitish vapour in the air around the horizon which fades out little by little [as one looks toward the zenith][22]." It is clearly stated, then, that the resistance is caused by humidity, and that humid air is light blue; *suboscuriorem et magis fuscam / più fusca* means, in my opinion, "indistinct and more hazy / more hazy" —it is in accordance with the wording in *De Pictura* concerning the general effect of distance, "deprived of colour[23]." Alberti, then, anticipated Leonardo in this case too[24], but without any systematic differentiation between colouristic changes and changes in visual distinctness. His observations, however, clearly indicate that he was familiar with Theophrastus' *De coloribus*[25].

Filarete ca 1451—64 refers to Alberti[26] and relates his visual theory of three kinds of rays, without touching upon the question whether they are visual or light rays or if and how they change over a dinstance; all he says is that they *dimostrano e pigliano colori di quella tal cosa*[27] (the observed body).

Leonardo ca 1490—1510 differentiated as early as ca 1492 three kinds of perspective: *lineale, di colore* and *di spedizione*[28]. He noted that the effects of linear and colour perspective may cause conflict[29], that linear perspective alone is unsufficient for the rendering of distance[30], but that it ought to be rendered with the total effect of linear and colour perspective[31]. His interest in colour and clarity[32] perspective increased in proportion to his loss of interest in linear perspective[33]. The term "colour per-

spective[34]" is indeed very imprecise—it merely indicates that colour is the imitative means of that perspective; the term "air perspective[35]" is only apparently more precise, since it just indicates its phenomenal and physical origin. The most adequate term is "medium perspective", *prospettiva di mezo*[36], which means that the local colour of a body which is observed through a medium of a certain colour or with certain *grossezza* (density), will, in proportion to the increasing distance, be replaced by the colour of that medium or its density. It is usual, but not in point of principle necessary, that the body is located within the medium; Leonardo includes the effect of observation through coloured glass[37]. Air is said to have different properties which affect the local colour at a distance—the most common, of greatest importance for painters and constituting the 'standard' situation, the *campagna aperta*,—is its light blue colour near the ground level. The blue colour or the air is, according to Leonardo, the result of the mixture of darkness—the black colour of the hot, rare and thus not illuminated vacuum in the stratosphere—and the white light reflected in the water drops in the humid atmosphere near the earth. But Leonardo regards— strange as it may seen—also darkness/blackness as a property of the same kind, i.e. as a *grossezza* in the air, the colour of which successively replaces the local colour of the observed body with an increasing distance[38]; "air perspective" then, includes colouristic changes towards whiteness, blackness[39] and bluishness. (COLOUR PLATES XIII, XIV, XV) In accordance with Theophrastus, he states that the air *per se* lacks colour[40]. Yet the term "air perspective" refers to the most frequent 'standard' situation—the open landscape in daylight with a certain humidity in the air[41]. In point of principle, however, this is only one case of *prospettiva di mezo* —just as 'water perspective', the successive change towards the green colour of water[42]. (COLOUR PLATE XVI) Leonardo makes several observations of the successive replacement of the observed body's local colour by the light(er) blue colour of the air[43] in the 'standard' situation, but he notes exceptions from this in three cases: (1) no change takes place when the observed object is situated in higher, and thus more rare air, than the observer[44]; (2) white objects are endarkened, since blueness means darkening of most other colours[45]; (3) when many objects are observed, they appear, closely related in the distant zone, darker than sparsely in the near zone[46] In closed rooms or open landscape, where light successively decreases, the objects are darkened[47]. Other observations, which confirmed that distance causes darkening were those made by Leonardo with a *camera obscura;* he notes the quantitative and qualitative changes of an observed man—at a certain distance he appears as *uno corpo oscuro,* and at a greater distance as *uno minimo corpo rotondo e scuro*[48]. Leonardo offers a twofold explanation for this phenomenon: on the one hand, the lightness of the small image is 'consumed' by the far greater lightness of the sky, and

on the other the image becomes darkened when it passes through the small opening of the camera; thus such bodies appear *oscure e nere come fa ogni corpo picolo visto nel chiarore dell'aria*[49]. In general, however, he held, with reference to the 'standard' situation, that increasing distance causes a successive replacement of the observed body's local colour by the light blue colour of the air; he condemns the practice of a successive darkening towards the distant zone: *Molti sono, che in campagna aperta fano le figure più oscure, quanto essi son più remote dall'occhio; la qual cosa è in contrario . . .*[50]

## Clarity Perspective

*Oscuro* means, in the sentences quoted above, "dark". When Leonardo, however, gives account of his observations of the influence of a successively increasing distance on the three parts of an illuminated, glossy volume, he uses the word in quite a different sense; first the lustre disappears, then the illuminated part and finally the shadowed part—the result is *una mediocra scurità confusa*[51]. He refers to the clarity perspective, *prospettiva di spedizione*, which comprises both the visual distinctness and the relative colouristic intensity of the image perceived—it is, then, a consequence of colour perspective, or a synthesis of linear and colour perspective which includes shape. In general, the effect may be concluded as a lack of contrast[52] within the outlines of the body observed and between the body and its surroundings; it is not, then, in point of principle, restricted to any particular kind of colour, but it refers, like colour perspective, to the 'standard' situation, the illuminated, open landscape, in which the distinct properties of the observed body is successively enfeebled into a whitish vapour. It has been pointed out that *sfumato,* the dissolution of contour-lines and smoothing out of contrast in hue and lightness, fundamentally was a concession of Leonardo; through *sfumato* in the near zone, the effect of clarity perspective is gravely reduced. Leonardo notes that light and dark objects, at a certain distance, change properties—the light ones become dark, the dark light[53]—but that light objects generally remain visible longer than darker ones[54], which are 'consumed' by the surrounding strong light[55]. The most frequent names for this effect are *diminuzione* or *perdita de'cognitione*[56] or *notitia di figure e termine*[57]. Leonardo prescribes *termini confusi*[58] in the distant zone, since distinct contour-lines at a distance are *inpossibile in natura*[59]. But at the same time as he advises the painter to merely suggest the undetermined mass of the distant objects, he seems to feel sorry for the consequent loss of cognition, colouristic beauty and *rilievo*[60]; he recommends artificial contrast[61], but criticizes the practice of rendering *cose infuscate* in a sketchy, harsh blot-technique— he prefers soft, continous tonal transitions and a smooth physical struc-

ture[62]. The *confusione di termini* is not only explained by the influence of the medium Leonardo refuted the perspectivists'[63] postulate that the visual power is situated in a point (the apex of the 'visual pyramid'); instead, the whole pupil is, in a varying degree, seeing—*Li veri termini de li corpi opachi mai sarano veduti con ispedita cognitione ... perchè la virtù vissiva non si causa in punto*[64]. According to Leonardo, it may be concluded, colour and clarity perspective were important arguments in the claim for an elevated social status of painting: *La scientia della pittura si estende in tutti li colori delle superfitie e figure de'corpi da quelle vestiti et à le loro propinquità e remotioni con li debiti gradi di diminutioni, secondo li gradi delle distantie, e questa scientia è madre della prospettiva*[65].

## Colour and Clarity Perspective after Leonardo

In the Cinquecento, colour and clarity perspective seem to be firmly established, since they are not, with few exceptions, the objects of any particular interest[66]. Pino 1548 includes perspective among the elements of painting[67]; with reference to Alberti he states that linear perspective has been thoroughly investigated, but adds, that the quantitative reduction is accompanied by a loss of visual distinctness[68]. He praises Titian's and Savoldo's ability to render atmospheric effects[69]. Dolce 1557 emphasizes the importance of colour for *rilievo* and perspective, but does not associate the latter to the Venetian technique[70], and V. Borghini ca 1560 underlines the admirable artifice of giving the illusion of distance by means of colour[71]. Vasari 1568 praises Masaccio's mastery of linear and colour perspective: *lo fece di maniera con i colori sfuggire, che a poco a poco abbagliatamente si perde la vista*[72]; Domenico Puligo is credited for the ability of *il fare a poco a poco sfuggire i lontani, come velati da una certa nebbia*[73]. Sorte 1580 gives accurate instructions for the rendering of distance in open landscape; the local colours are to be successively replaced by blue or greenish blue towards the distant zone[74]; the saturated, opaque colour in the near zone is to be darker than the transparent colours of the distant zone, mixed with light blue: *sempre quella che più a noi è vicina conviene che sia più oscura di quella ch' è lontana*[75]. The direct influence of Leonardo is revealed in R. Borghini 1584; he differentiates between *diminutione di corpi, de'colori* and *della notizia;* he presents the causes of colour perspective, and its exception in the case when the object observed is situated in a higher and thus more rarified layer of air: *le parti più basse de'monti deon farsi più oscure che le più alte, e così de'monti sopra monti, perché l'aria è più grossa e più fosca quanto più confina con la terra, e più sottile e più trasparente quanto più si leva in alto*[76]. Objects at a remoteness at the same level as the observer, are to be rendered *solamente abbozzate e non finite*.

124

In Lomazzo 1584, perspective has a wide signification; from linear perspective, which is passed over quickly and coupled to formal optics[77], to different points of view, *vedute*, to *rilievo* in general and to colour and clarity perspective[78]. Lomazzo does not offer any physical explanation of the latter kinds, but his instructions to use blue colours for *paesi lontani* prove that he thought of it as a commonplace[79]. The landscape is to be divided in three zones of distinctness: the near zone distinct, the medium zone less distinct and the distant zone indistinct towards a complete lack of visibility. The change towards light blue is not, however, self-evident; among the works of artists who are praised for skill in the colouristic rendering of distance, we find landscapes and interior scenes in both daylight and as night-pieces[80].

## Clarity Perspective Applied to the Observation of Pictures

Leonardo ca 1490—1510 noted that the laws of clarity perspective also have relevance for the beholding of pictures, which preferably are to be seen from a certain distance[81]. This was—at least with regard to certain pictures—observed in Antiquity[82], just as the psychological activity—the beholder's creative, mental completion of the impressions of blurred images[83]. These observations were represented in Italian Renaissance art theory by the concepts of *sfumato, sprezzatura, non-finito* and *prospettiva di spedizione*.

Alberti 1435—36 uses the term *macola,* spot, to describe the microstructural effect of physical light on the illuminated body[84]—it does not refer to painting technique. However, he points out the importance of quickly capturing of the momentary emotional facial expression; the beholder of the painting is made to believe that he sees more than he actually does[85]. The competent painter is to combine diligence with quickness. Leonardo ca 1490—1510 does not recommend any quickness[86], and not even the blurred distant zone, a consequence of clarity perspective, is allowed to be harshly painted[87]; from a technical point of view, he belongs to the Flemish, time-consuming tradition with its smooth layers of transparent oil-colour. Pino 1548 represents, to a certain extent, the Venetian ideal: *A ridure l'opere a fine il maestro deve usarvi una diligenza non estrema*[88]. However, he points out the dangers of *sprezzatura* and adheres to the conventional ideal of perfection and high finish[89]. He describes the problems presented by hard, direct illumination which causes black spots, *macchie,* of shadow[90], and notes, like Leonardo, that distance adds to the completeness and beauty of the painting—*le tinte s'uniscono più*[91]. Barbaro 1556 states that the perfection of painting consists in the fading away of the contour lines, *che ancho s'intenda, quel che non di vede*[92]. Dolce 1557, on the other hand, makes the odd remark that these effects are produced

within the beholder, and consequently do not belong to painting[93]. Vasari 1568 notes that the rough structure and the *maccie* in the paintings of the Venetian artists—Tintoretto, Veronese and the later Titian—at close hand seem to be made "in fun", but at a distance give a perfect impression[94]. He recommends the technique for paintings intended to be placed high or at a great distance[95], but is negative to its use in easel paintings of a greater intimacy[96]. Lomazzo 1584 advises the artist to partially compensate and partially strengthen, according to what he calls *lume in prospettiva,* the loss of visual distinctness caused by interior distance and darkness by a regulated addition of white in the local colour of the depicted objects[97]. If four men, standing behind each other are to be painted high on a wall —where "behind" in the represented room is synonymous to "above" in the real room—the local colour of the nearest/lowest is to be mixed with three parts white, the second nearest/second lowest with two, the second farthest/second highest with one, and the most distant/highest without any addition of white. This will, according to Lomazzo, strengthen the visual distinctness of the nearest/lowest figures, which, according to formal optics, is the consequence of the obtuse angle of the triangular visual field, and with the additional white, emphasize the contrast to the farthest/highest, which is seen by an acute angle and not enlighted with white. The assumption of varying strength of the rays within the visual field causes, according to Lomazzo, that the outward parts of a big painting is perceived less distinctly than the central part[98]. In general, great distance to a painting causes the loss of *i due effetti del veder il disegno et il colore*[99]. *Macchie* means for Lomazzo patches of paint, particularly typical for Titian[100]. Lomazzo 1590 gives, with reference to a lost *trattato* of Bernardo Zenale, the original advice to render the figures and objects in the distant zone as distinct as in the near zone; clarity perspective works so they appear indistinct anyway, but the beholder may, at close hand, inform himself about the properties of the objects in the distant zone[101]. Armenini 1586 does not recommend too much *sprezzatura,* but reluctantly admires the quickly executed works of Tintoretto, which must not, however, be examined at close hand; he notes that a fast technique preserves the freshness of the colours[102].

## Structural Perspective

The purely material aspect of physical colour, regardless of chromatic and tonal qualities[103], has an application in structural perspective, which means that the objects in the near zone are painted with pastose patches of paint, and the objects in the middle and distant zones are painted with successively smoother structure and more transparent paint. Observed by Pope[104] in the late works of Titian, it is actually already confirmed by one Re-

naissance author: Sorte 1580[105] prescribes that *colori fissi,* defined as opaque colours of a certain body, are to be used to define the objects *più crude* in the near zone; in the distant zone, they are to be painted in transparent colour as *una maccia dolce . . . solamente una bozzatura e non finite.*

## Hierarchic Colour and Clarity Perspective

Quite apart from naturalistic ambitions, the need to settle the hierachy among the members of a composition has ever since Antiquity caused an overdimensioning of the most important or beautiful[106]. This solution was perfectly consistent with linear, colour and clarity perspective; locating the less important or beautiful members of the composition in the distant zone, it is in accordance with the physical laws that they are reduced and enfeebled. Gaurico 1504 differentiated between *perspectiva universalis* and *particolare*[107]; the former refers to the location in agreement with relative social, historical significance and importance in relation to the contents, and the latter refers to the change of the individual properties with distance. Vasari 1568 recommends that the most important members of a composition are to be rendered *chiare chiare,* whereas the less important members in the background are to be rendered, *nel colore delle carnagione e nella vestimenta, più scure*[108]; in relation to the near zone *servono quasi per campo nel colorito di questo*[109]. By this, he adds, the members are distinguished, and the near zone gains force[110]. Lomazzo 1584, too, prescribes that the *figure principali* of the near zone be painted with saturated and intense colours; via the medium zone the saturation and intensity are to be successively reduced, so that in the farthest area of the distant zone neither colours, illuminated parts or contours are visible[111]. He ignores the physical explanation of the phenomenon, but refers to formal optics, according to which the angle at the eye of the triangular visual field determines the visual distinctness: when it is obtuse, the object appears bigger and *più chiara,* when it is acute it appears smaller and less distinct; figures of the same size, then, are to be rendered successively smaller and *più abbarbagliato nella chiarezza.* The terminology of Lomazzo 1590 reveals the author's aquaintance with Gaurico: *prospettiva universale* means the rendering of a figure according to his relative importance, *prospettiva particolare,* on the other hand, *il debito acrescimento e perdita*[112]. R. Alberti 1604 recommends that the figures of the near zone be rendered in contrast to each other and related to *una lontananza chiara*[113], *o vero con figure che la distantia abbino ismorzato i colori, e con questo modo di questi sbattimenti o lontananze fanno che le principali figure allegre e con rilievo rendino una mirabile concordia*[114].

1. Richter 1961 pp 136 ff.
2. Pointed out by Ghiberti ca 1450; cf. White (1957) 1967 pp 126, 190.
3. Ed. (1956) 1967 pp 68 f; cf. Leonardo and Lomazzo below and nn 30, 77.
4. Most Renaissance theorists however, do not take any clear position to the question whether seeing comes into being through emission or immission. The Platonic compromise, which combines immission with a strong element of emission, was advocated by Ficino and the Neo-Platonists. In the *Commentary on the Symposium* (1469), Ficino presents this theory with a strong addition of ancient popular magic (cf. above chap. II.): the rays emitted contain *lo spirituale vapore* and may transmit deseases; women emit, during menstruation, visual rays containing fine drops of blood, which may stain a mirror, etc. Taken from Thomas Aquinas; Walker 1958 p 160; Heaton 1968 p 82. In other places, however, Ficino talks about immission; chap. IV; Panofsky (1924) 1968 pp 132 f.
5. Lindberg 1976 p 147.
6. Cf. above chap. II and below, Lomazzo p 127 (*chiaro*), Leonardo p 123 (*oscuro*), Alberti, Leonardo and R. Borghini pp 121, 123, 124 (*fusco*).
7. Chap. 85; ed. 1971 p 94.
8. Cf. above chap. I.
9. Cf. Edgerton 1969 p 130 and n 59; still in *ed.cit.*, *chiari* and *scuri* are supposed to be erroneously interchanged.
10. This is not to say that it is improbable that Cennini meant "hazy" by *scuro* and "distinct" by *chiaro*.
11. Ed. (1956) 1967 p 45.
12. *aut item colore fraudate;* Grayson (ed. 1972 p 38 ff) transates it "diminished in colour".
13. *d'altro colore;* ed. (1956) 1967 *loc.cit.* Cf. Siebenhüner 1935 pp 16 ff.
14. *De Pictura* ed. 1972 p 41. Cf. Lindberg *op.cit.* pp 149 ff; Schöne 1954 p 114, states that Alberti adhered to the Platonic theory of vision.
15. Ed. (1956) 1967 p 47; ed. 1972 p 42 f.
16. He does not mention that a more acute angle at the eye causes a reduced in- or outlet of light; he does not even want to participate in the discussion of the mechanism of the eye; ed. (1956) 1967 p 47; ed. 1972 pp 40 f.
17. Ed. (1956) 1967 p 48.
18. Ed. 1972 pp 42 f. Grayson translates the sentence *Idcirco recte aiunt quo maior distantia sit, eo superficiem suboscuriorem et magis fuscam videri,* "So it is rightly said that the greater the distance, the more obscure and dark the surface appears." In note p 109 he considers it evident that Alberti held that colour and light "diminish" with distance; yet he refers to Nicole Oresme (*De visione stellarum*), who indeed explained the changes of light and colour by the humidity in the air.
19. 1935 pp 22 f. Mallè 1950 p 61 n 1 shares the general (cf. Edgerton *op.cit.* p 130 n 57; ed. 1972 p 43) opinion that Alberti represents the same view as Cennini, who in turn is supposed to associate distance with darkness. He notes, however, that Alberti observed the influence of humidity in the air. Pedretti 1964 p 20 states that Alberti had intuited the study of the gradations of colour due to varying density in the atmosphere.
20. Ed. 1877 p 62.
21. Ed. (1956) 1967 p 48.
22. *Ed.cit.* p 50.
23. Otherwise, Alberti would have simply written "darkened", or "of a dark colour". Cf. the same use of *oscuro* and *fusco,* note 3 above.
24. Cf. above chap. B III 3 and n 35.

25. For other opinion, see Edgerton *op.cit.* p 124 and n 35.
26. Ed. 1896 p 587. Perspective and "declination" are included among the marvels of painting, p 621.
27. *Ed.cit.* pp 589, 595.
28. *MS A* f 98 r; Agostini 1954 p 26; Pedretti *op.cit.* p 131. He speaks, however, both at this time and later about only two kinds (ed. 1882 TPP 37, 132 (ca 1492); *Cod. Urb. Lat.* 1270 ff, 34 f (1505—10); Barocchi 1971— II p 1279), but it seems as if he with *prospettiva di colore* understood both colouristic and general perceptual changes, in the same manner as when he wrote TP 262 (ca 1492) that *prospettiva aerea* includes both contour-lines and colour.
29. TPP 258 A, 462, 477 A.
30. TP 517. Cf. Heydenreich 1953 I p 110. He even recommends the substitution of the linear construction by an optic device, TP 261; cf. Agostini *op.cit.* pp 7, 9; Richter (1883) 1970 I § 83; *Cod. Atl.* I r, in Ost 1975 p 31, where he writes: *Prospettiva non è altro che veder uno sito direto uno vetro piano e ben trasparente.*
31. TP 525; Libro A 15; Pedretti *op.cit.* p 38 and n 16.
32. Treated separately below.
33. White (1957) 1967 p 207; Pedretti *op.cit.* p 131; Ost *op.cit.* p 32.
34. Used in TPP 36, 132 (ca 1492), 41 (1508—10); the expression *diminutione de'colori* is used in TPP 136 (ca 1492), 6, 136, (ca 1500—05) and 489 (ca 1510).
35. The term *prospettiva aerea* is used in TPP 38, 262 (ca 1492); 262 is identical with MS A f 10 v; Agostini *op.cit.* p 29.
36. Used in TP 462 (1508—10). The term "atmospherical perspective", which occurs now and then in modern works, is imprecise and not used by Leonardo.
37. TP 258 B (ca 1492). Cf. TP 254 A. Cf. TPP 222, 226 and note, 243, 255, 438 B, 661.
38. Cf. above p . . .
39. Leonardo includes lightness and darkness among the colours associated to the elements; cf. above chap. A I.
40. TPP 243, 438 B; Cf. Theophrastus above chap. II.
41. In TP 785 he even states that the air is blue.
42. TP 508; Leonardo never uses this term.
43. TPP 38, 136, 150, 257, 258 A, 262 (= *MS A* f 105 v), 646 (ca 1492); 193, 194, 195, 198, 220, 222, 234, 235, 241, 425, 438 B, 446, 454, 661 (ca 1505—10); 428, 517, 527, 528, 630, 654, 698 A (ca 1508—10). He prescribes (TP 241 B) that the colours in the near zone are to be *semplice,* i.e. pure elementary colours, but in the distant zone "participating of the colour of the horizon." He even specifies the exact proportion between blueness and distance, TP 262. Cf. TPP 198, 199, 200. The colouristic beauty, which according to L. is proportional to the saturation (TPP 207, 428), then, is lost in proportion to distance.
44. TPP 149 (ca 1492); 194, 198, 199, 220, 221 (ca 1505—10); 446 (ca 1510—15). The higher parts, then, are to be darker than the low ones. This is an instance of Leonardo's use of *fusco* and *oscuro* as "hazy". Cf. R. Borghini below.
45. TPP 234 (ca 1505—10); 698 A (ca 1508—10).
46. TP 235 (ca 1505—10).
47. TPP 240 (ca 1505—10); 786 (ca 1508—10). In case of a successively increasing illumination with distance, the objects become successively whiter (TP 787).
48. *MS A* (ca 1492) f 92 v; Agostini *op.cit.* p 22. Cf. Ps-Aristotle and Thomas Aquinas above chap. II.
49. Leonardo seems to believe, in this case, that the same thing happens when

the image passes into the eye and through the dark, narrow "visual nerve". In general, his knowledge about the optical tradition was very imperfect and his views on ocular anatomy were primitive (Lindberg 1976 pp 156, 162). After ca 1492 he adhered to the immission theory, and used the terms *similtudine, spetie, impressione, forma, eidola* and *simulacra* to denote the immaterial, coloured images which transmit the properties of the observed object; *op.cit.* p 161.

50. TP 234, probably from ca 1492.

51. TP 428 (ca 1508) and Libro A 78; Pedretti *op.cit.* p 68, who translates this section "an intermediate, indistinct shade".

52. Among others TP 277 (ca 1492). Cf. above, chap. B II.

53. TP 193 (ca 1505—10).

54. TPP 257 (ca 1492), 698 A (ca 1509—10).

55. TP 700 (ca 1508—10) = *MS A* f 90 r; Agostini *op.cit.* p 21: *il minor lume è vinto dal maggiore.* Cf. *Cod. Atl.* 249 r-c. (ca 1513); Pedretti *op.cit.* p 131. Cf. above p . . .

56. TP 6 (ca 1500—05).

57. TPP 36 (ca 1492), 128, 455 (ca 1505—10), 427, 456, 740 (ca 1508—10), 489 (ca 1510).

58. TPP 135, 417 (ca 1492), 128 (ca 1500—05).

59. TPP 443 (1505—10) = Libro A 44; Pedretti *op.cit.* p 52.

60. TP 484 (ca 1505—10).

61. Cf. above chap. B II.

62. *Cod. Atl.* 119 v-a (ca 1505); Richter (1883) 1970 I § 548; Pedretti *op.cit.* p 52 n 53 translates *cose infuscate* "smoky looking objects". In the *paragone* Leonardo stated that *basso rilievo* holds an intermediate position between sculpture and painting through its ability to render perspective (*Cod. Urb. Lat.* 1270 f 22). By this he certainly referred to the combination of linear and clarity perspective. Cf. below, structural perspective.

63. He obviously refers to Brunelleschi, Alberti and the other adherents of the Euclidean construction of the visual field. Cf. Lindberg *op.cit.* p 164 and n 90, 91.

64. TP 741 (ca 1508—10). Cf. *MS E* (ca 1513—14) f 79 v; Richter *op.cit.* I § 17. Cf. Al-Kindi and Alhazen, above, chap. II.

65. TP 6 (ca 1500—05).

66. Lancilotti 1509 (Barocchi 1971— I p 746) emphasizes the importance of perspective for illusionism; in Equicola ca 1525 (*op.cit.* I pp 259 f), the means of imitation are defined as colour, lines, relief (shadows) and perspective; Castiglione 1528 (Lib. I chap. 50; *op.cit.* I p 490) also regards perspective as a condition for illusionism and repeats Leonardo's argument that painting demands a greater *arteficio* than sculpture, *per forza di linee misurate, di colori, di lumi e d'ombre,* an opinion which is echoed in Vasari 1547 (ed. 1960— I p 61 )and Varchi 1547 (ed. 1960— I p 39).

67. Ed. 1960— I p 133. Cf. Ammanati 1582 (ed. 1960— III p 118) and Paleotti 1582 (Lib. I chap. 9; Lib. II chap. 52; ed. 1960— II pp 169 f; 499).

68. *Ed.cit.* I pp 101, 121 f.

69. *Ed.cit.* I p 134 and n 2.

70. Ed. 1968 pp 152 f, 156 f.

71. The obvious similarity between green pigments and the green colour of leafage is, on the other hand, given by nature; Barocchi 1971— I p 626.

72. Ed. 1878— II p 290; cf. Siebenhüner 1935 p 51.

73. *Ed.cit.* IV p 463; cf. V pp 53 f, 544.

74. Ed. 1960— I p 287. Cf. below, structural perspective.

75. Barocchi (*loc.cit.* n 3), states incorrectly that this is in divergence with Vasari's opinion. *Oscuro* means, in this case, dark.

76. Barocchi 1971— pp 938 f. It is quite clear that Borghini means "hazy" by *oscuro* and *fosco: Laonde delle cose elevate e grande, che sieno lontane dal riguardante, la loro bassezza sarà men veduta, perché si vede per linea che passa fra l'aria più grossa;* the higher parts are seen through *aria più sottile e si fa più visibile.*

77. Lib. chap. 24; ed. 1973— II p 241. Like Alberti and Leonardo, Lomazzo recommends an optical device which may replace the linear construction. Cf. nn 3, 30 above.

78. Lib. V chap. 3; *ed.cit.* II pp 222 ff.

79. Lib. VI chap. 62; *ed.cit.* II pp 408 f.

80. *Loc.cit.*

81. Ed. 1882 TP 407: *è buona anchora lo alontarsi, perché l'opra pare minore e più si comprende in una occhiata, e meglio si conosce li discordanti et sproporzionate membra et i colori delle cose, che d'apresso;* cf. TP 415.

82. Cf. Horace above chap. II, quoted by, among others, Gilio 1564 (Barocchi 1971- I pp 311 f) and Possevino 1595 (*op.cit.* I p 455); Cf. Lee 1940 p 199; Gombrich (1960) 1972 pp 185 f.

83. Cf. Ptolemy and Philostrates the Elder, above chap. II.

84. Ed. (1956) 1967 p 49; ed. 1972 pp 44 f.

85. Ed. (1956) 1967 p 78. The quickness is not emphasized in *De Pictura,* ed. 1972 pp 80 f.

86. Ed. (1956) 1966 pp 95 f; ed. 1972 pp 101, 105.

87. Cf. above p . . .

88. Ed. 1960— I p 117. Cf. p 115, where he chooses the poets who use *la brevità* as the model for the painters, and p 116, where he even considers a careful drawing a waste of time, since it will be covered by paint in the subsequent phase.

89. *Ed.cit.* I p 119.

90. *Ibid.* p 134.

91. *Ibid.* p 101.

92. Lib. VIII chap. 5 p 188; cf. Gombrich (1960) 1972 p 210 and n. T. Tasso (ed. 1707 p 175, quoted in Gilbert 1946 p 105) wrote that he intended to do as the painter, who "constricted between the borders of a little canvas, merely indicates buildings and landscapes in the distance and consigns the rest to the imagination of the lookers-on." Cf. Shearman 1967 p 159.

93. Ed. 1968 pp 98 f: *Questa è certa immaginatione di chi mira, causata di diverse attitudine, che a cio servono, e non effetto o proprietà della Pittura.*

94. Ed. 1878— V pp 590, 595, VII pp 447, 452.

95. *Ed.cit.* I p 150.

96. Cf. above, chaps. B I 2, B I 4.

97. Lib. I chap. 2; ed. 1973— II pp 25, 32, 37 and n 7. Cf. pp 190, 211.

98. Lib. IV chap. 3; *ed.cit.* II pp 190 f. Cf. chap. II above, Ps-Aristotle and Alhazen, and Leonardo here.

99. Lib. V chap. 8; *ed.cit.* II p 232.

100. Lib. I chap. 1; *ed.cit.* II p 33. Cf. Vasari above.

101. Chap. 30; ed. 1973— I p 328 and n 5.

102. Lib. I chap. 8; Lib. II chap. 10; Barocchi 1971— II pp 1594, 1490 n 1. Cf. Bocchi 1584 (ed. 1960— III p 190 and n 3). Paleotti 1582 (Lib. I chap. 4; ed. 1960— II p 141) states, without any references to the observation of paintings, that it is the mission of painting to *supplire al difetto della lontanaza,* i.e. to

eliminate the distance which exceeds the scope of the human senses.

103. Cf. below chap. B IV 4.
104. 1949 pp 90 ff.
105. Ed. 1960— I p 283.
106. Cf. Alhazen's opinion that distance may be conductive to beauty in that it subdues imperfections and irregularities. Cf. Ciardi 1973— I p lxvii f and above chaps. I, A I and n 10.
107. Ed. 1969 p . . .; cf. Klein 1961 pp 211 ff; Ciardi *op.cit.* I p lxciii and nn 208, 209; 306 n 1.
108. Note the meaning of *chiaro* and *scuro*.
109. Ed. 1878— I p 179.
110. *Ed.cit.* I p 181. R. Borghini 1584 (Barocchi 1971— I p 937), however, gives the opposite advice: the figures of the near zone must not dominate, but should be located so as to offer room for the distant zone.
111. Lib. VI chap. 7; ed. 1973— II p 267. The fact that he mentions the illuminated part of the volume and does not mention the change of the local colour towards light blue, indicate that he refers to both day and night scenes.
112. Chap. 23; ed. 1973— I p 306 and n 1.
113. Note the meaning, "light" of *chiaro*.
114. Barocchi 1971— I p 1020.

# Chapter IV B. Colour as an Informative, Expressive and Affective Medium

The expressive and symbolic function of colour is a vast but—in relation to *Gestalt*—surprisingly neglected subject in connection to art. Since this has resulted in a lack of terminology, it seems justified, before analyzing the Renaissance sources, to propose and specify adequate terms. At a first glance, there seems to be a fundamental difference between the informative function, which presupposes objective, cognitive perception, and the expressive function, which presupposes subjective, intuitive perception. Yet the difference is not always one of type but of degree; the expression is sometimes a kind of information which is particularly noticeably perceived, though not necessarily subjectively. Disgarding, for the moment, the purely descriptive function, there is also a wider sense in which we use the term expression, without reference to any particular object. There is, then, a difference between descriptive information and a certain kind of expression, the same difference as we find between what is called *conventional symbolism*[1] and what I would like to call *universal* or *abstract symbolism*. Since the latter involves a kind of experience which, although apparently subjective, is nevertheless of a fundamental, probably biological kind, the distinction between objective and subjective loses its meaning. Instead we postulate the existence of a (I) descriptive, conventional, and cognitive kind of colour symbolism, and (II) an abstract, universal, and intuitive kind.

I. Departing from colour as *signum individuationis,* it is of great interest to examine the relation between the local colour and the figure or body to which it is attached (or which is revealed by the colour). It may seem— neglecting the perceptual argument in the parenthesis above— as if colour fulfils a secondary function as a completition of the figure, the qualities of which may, with the help of environment, attributes etc., be specified just as well in a linear technique, without the assistance of chromatic colours. If the figure is a human individual, physiognomy, gestures and mimic contribute to a description of both the general character and the accidental state; colour is, from a cognitive point of view, apparently no more than a facilitating, accentuating element. Yet there is, generally speaking, a mutual dependence between figure and colour; abstracted from its natural context, the figure can no longer give evidence of its species; a circle becomes a tomato, an orange, a sun or a moon, depending on which colour it contains. However, in Renaissance painting, the figures are generally rendered in their natural context and furnished with attributes and characteristics; the colour, thus, fills a secondary function from a cognitive point of view. As to a frequent kind of referential images, the allegory, which consists of one or more figures who, according to a stipulated convention, denote something else—a concept, a moral quality, or something similar[2]—the relation remains unchanged.

II. The symbol, too, is referential, but in another way than the allegory; whereas the latter may, theoreticall, be replaced (disregarding the aesthetic aspect) by a verbal, discursive representation, the symbol constitutes its own, irreplacable medium; it is, as Susan Langer[3] expresses it, *presentational.* The affinity between colour and light[4], of which a symbolic interpretation has a long tradition, furnishes us with the general basis for intuitively accessible analogies of an object-less kind. As to particular hues, we know today that they indeed possess expressive qualities, or rather, that they have the property of arousing certain emotions[5]. In our century, the somewhat nebulous character of the subject has led to a split into two traditions: one intuitive, lyrical and mystic, and one strictly scientific. It is a fascinating fact, that the statements of the former group—including Kandinsky[6], Itten[7] and others who mainly use the studies of Goethe[8] as a point of departure —are, in principle, confirmed by a number of scientific experiments[9]; certain types of lightness and hue cause certain psychological and physiological reactions. This is relevant not only for the elementary colours, but also for tendencies in them to turn into another colour[10]. Of the elementary colours, yellow is experienced as warm, positive and active, red as warm, positive, active and approaching, blue as cold, negative, passive and receding, green as tepid, apathetic and resting. Tendencies towards adjacent hues change the experience; yellow tending towards green, for instance, is considered strongly negative, associated with fury, insanity and falseness.

In search for a functional terminology, which is applicable to our two kinds of colour symbolism. I have found two studies of Berefelt very useful. In the first[11], he suggests the differentiation[12] of three kinds of figural object-symbols[13], based on either conventional agreement (e.g. the number seven for love), analogy (e.g. the red rose for love) or contiguity[14] (e.g. the Venus Comb for love)[15]. Whereas the arbitrary, stipulated symbol lacks a natural, original relation to its subject, and presupposes the knowledge of a code, the subject of the analogy symbol is intuitively acessible, and of the contiguity-symbol empirically accessible. I find this system, with the exception of contiguity-symbols, applicable as well to descriptive, conventional and cognitive colour symbolism. In order to synthetize and adapt these distinctions to colour symbolism, I suggest the differentiation between (1) object-bound and (2) abstract colour symbolism. (1) The object-bound symbolism, manifested as local colour, is either based on (a) convention or (b) analogy. The abstract symbolism, manifested in the tonal and chromatic totality, is based on universal, intuitive response to light and colour. Whereas the object-bound, conventional symbolism fulfils a secondary function in relation to shape, and occasionally is the product of the abstract symbolism, the object-bound, analogous symbolism is generally a product of the abstract symbolism, and is, in relation to shape, of equal importance; the abstract light- and colour symbolism is, in fact, independent of shape. Since the object-bound colour symbolism is evident either through conventions or natural associations, it may be used consciously and calculatedly. The abstract light and colour symbolism may certainly also be used consciously and calculatedly, but sometimes it shares with the notion of colour as an expression of the artist's personality the characteristic of being unconscious or subconscious. An affective theory, according to which the conscious use of the expressive powers of light and colour is calculatedly used to influence the beholder un- or subconsciously, must definitely be regarded as an instrumental theory[16].

1. Sometimes also referred to as traditional; cf. Elliott 1958 p 454; Barasch 1960 *passim.*
2. Cf. Paleotti 1582 (Lib. II chap. 45; ed. 1960— II p 462), who, however, does not make any difference between allegory and symbol: *simbolo vorrà dire una o più figure insieme, o adunanza di varie altre cose, che, oltre quella somiglianza esteriore che rappresenta, significa ancora un altro concetto più alto e sensato, appartenente alla vita nostra.*
3. Cf. Pochat 1977 p 80.
4. Cf. above chap. I.
5. Cf. Tilghman 1970 p 14; (1) the emotion expressed by a work of art is just the emotion caused in the spectator by viewing the art object; (2) the spectator's emotion is transferred to the object by some process of emphathy or projection.
6. *Über das Geistige in der Kunst.*

7. *Kunst der Farbe.*
8. *Zur Farbenlehre.*
9. Cf. Arnheim (1956) 1972 p 327; Leijonhielm 1967 pp 27, 37.
10. Arnheim *op.cit.* p 328.
11. 1966 pp 321 ff. In a later and more general study (1976), Berefelt has proposed the distinction between an *ideomorph* symbol, denoting a conceptual, discursive symbol which seems to include (A) and the aimed signification of (C) above, and an *isomorph* symbol, denoting a structural similarity between the symbol and its subject; the latter does not only—as far as I understand—refers to object-bound analogy-symbols, but to the general formal structure; it wold, then, be applicable to (II), the abstract, universal and intuitive colour symbolism.
12. Departing from Hospers 1946 p 29 and Munro 1956 pp 152 ff. Cf. Pochat *op.cit.* pp 80, 102, 105.
13. The studies deal exclusively with shape and the symbolism attached to objects.
14. Of *continguus*, adjoining, adjacent; from a fragment the totality is reconstructed. In my opinion, contiguity is a form of analogy as soon as colour is implicit.
15. This example, chosen to fit the other two, may seem more like a stipulated symbol. A better example would be a lightning-sign for bad weather.
16. Osborne 1970 p 24 comprises all expression under the heading "Pragmatic interest: instrumental theories of art; Art as an instrument for the expression or communication of emotion", but treats the un- or subconscious self-expression pp 226 ff.

# 1. Proprietà

One of the fundamental functions of colour in the art theory of the Italian Renaissance was—as has been illustrated in connection to *universalità, vivacità, rilievo* and *prospettiva*—its function as characteristic local colour, *signum individuationis*. It was continously emphasized that the local colour was to reveal the typical properties of the objects, even though occasionally local colour—particularly as cosmetics—was regarded as a delusive cover of the real, supposedly disappointing, qualities[1]. *Proprio colore*—originally derived from the concept of 'organic unity'[2]—is only part of a general claim for *proprietà* in the invention, with reference to costume, attributes, environment etc., a claim which particularly in the decrees of the Counter-Reformation was given a moral implication; every deviation from *decorum,* the appropriate, was regarded as licentious transgression[3]. In a more restricted sense, *proprietà* referred to correct rendering of the proper emotional state[4].

1. So common, in fact, that a chronological account seems superfluous; as an example may be chosen R. Borghini 1584 (ed. 1807 II p 202): *I colori poi vogliono esser fini e sottilmente macinati, vaghi ed allegri, e secondo i significati*

*loro a'luoghi, a'tempi, ed alle persone appropriati.* The naturalistic aspect of *proprietà* is further emphasized by Dolce 1557 (ed. 1968 p 184 f): *Non ha dimostro Tiziano nelle sue opere vaghezza vana, ma proprietà convenevole di colori.* As an example of the opposite attitude, cf. Dolce 1557; *ed.cit.* pp 206 f. Cf. note 185 below.

2. Cf. Plato *Rep.* IV 420 D, who wrote that the eyes of a statue must not be too carefully coloured; all parts must be formed according to "what is proper" to them; Emond 1964 p 64. Cf. above chap. IV.

3. Cf. above chap. B I 4.

4. The claim for emotional expression was typical for the entire period; cf. Panofsky 1954 p 5. It rests on the moral apprehension of art of Plato and Aristotle, which was summarized in Cicero's formula that great art must teach, entertain and move the public.

## 2. Significato

### Conventional, object-bound colour symbolism

Most of the literary evidence of this kind of symbolism is to be found in what cannot properly be called art-theoretical works, but in those which in particular treat costume, heraldry and liturgy with references to sources from Greek and Roman Antiquity and the Middle Ages, the Bible, the Patristics etc., which—like mythological and iconographical hand books— were an integral part of the references of the ideal Renaissance artist. Expressions like *mostra, dimostra, significa, insegna* and *ricopre* refer to certain conventions—a code, the knowledge of which was a sign of an outstanding education and culture. It is often, however, emphasized that the significations of the individual colours are not unambiguous; depending on the context they may even be contradictory[1].

The arrangement below (Fig.) specifies the colours of which a definite symbolism has been confirmed. Too unspecified colours have been excluded. Unsaturated, light or dark variants of elementary and derived colours are specified with the help of a triangle, the three angles of which represent (w) whiteness, (s) blackness and (c) chromaticness. The particular hue is specified on the colour circle. The unchromatic colours—white, gray and black—are in this section treated as local colours. As a function of light they will be dealt with below (p 147).

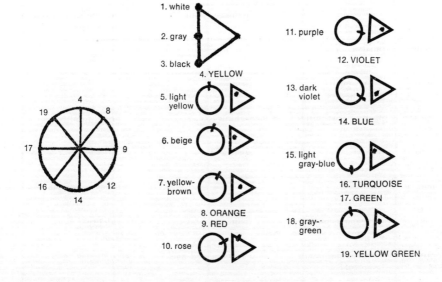

1. white

2. gray

3. black

4. YELLOW

5. light yellow

6. beige

7. yellow-brown

8. ORANGE

9. RED

10. rose

11. purple

12. VIOLET

13. dark violet

14. BLUE

15. light gray-blue

16. TURQUOISE

17. GREEN

18. gray-green

19. YELLOW GREEN

137

| | 1. WHITE<br>*biancho, chiaro* | 3. BLACK<br>*nero, oscuro* | 4. YELLOW<br>*giallo, croceo* |
|---|---|---|---|
| Sicillo<br>ca 1450 | man: honesty;<br>woman: chastity[3] | simplicity[18] | richness, nobility, envy[32] |
| Aquilano<br>ca 1500 | purity, simplicity,<br>chastity[4] | firmness, pain[19] | extinguished ardour[33];<br>joy, freedom[34] |
| Equicola<br>1526 | purity[5] | firmness[20] | joy[35] |
| Sanudo<br>before 1533 | alone: purity;<br>combined: sincerity[6] | firmness[21] | |
| Morato<br>1535 | purity[7], lost will[8] | weakness[22] | hope, fidelity[36] |
| Alciato<br>1542 | purity[9] | sorrow[23] | satisfaction[37] |
| Dolce<br>1565 | | | hope, fidelity[38] |
| Occolti<br>1568 | gentleness, purity,<br>umility[10] | firmness[24] | fidelity[39] |
| Contile<br>1574 | victory, eloquency,<br>honesty[11] | firmness, old age[25] | content[40] |
| R. Borghini<br>1584 | victory, purity,<br>innocence[12] | lowness, firmness[26] | richness, nobility[41] |
| Lomazzo<br>1584 | innocence, purity,<br>justice[13] | firmness, sorrow, pain[27] | richness, nobility,<br>fidelity[42] |
| de'Rinaldi<br>1592 | fidelity, purity[14] | sorrow, pain[28] | power, pride,<br>richness[43] |
| Calli<br>1595 | purity, fidelity,<br>simplicity, instability[15] | sorrow[29] | richness, fidelity,<br>passion[44] |
| A. Beffa | purity[16] | firmness[30] | satisfaction[45] |
| G. Beffa | purity[17] | firmness[31] | satisfaction[46] |

| 5. LIGHT YELLOW<br>*giallolino* | 6. BEIGE<br>*bigio, pallido, cinereo,*<br>*leonato chiaro* | 7. YELLOW-BROWN<br>*leonino, oguria, tanè* |
|---|---|---|
| | | rigour, rage[53] |
| | | patience, secrecy[54];<br>envy, sadness[55] |
| | | trouble[56] |
| | | simplicity[57] |
| | *(bigio)* instability[48] | |
| | *(bigio)* umility,<br>lowness[49] | |
| | | courage[58] |
| | | trouble[59] |
| desperation, falseness[47] | *(pallido)* trouble[50] | yellowish: innocence;<br>reddish: rage;<br>dark: pain[60] |
| | | strength[61] animosity,<br>fierceness[62] |
| | *(bigio)* instability[51] | |
| | *(leonato chiaro)* joy[52] | *(leonato oscuro)*<br>trouble[63] |

| | 8. ORANGE<br>*ranzato, rancio, zizolin,*<br>*giugiolino, zallolin,*<br>*ferrugineo, flammeo* | 9. RED<br>*rosso, vermiglio* | 10. ROSE<br>*incarnato* |
|---|---|---|---|
| Sicillo<br>ca 1450 | | courage; men: generosity;<br>women: obstinacy[68];<br>cruelty[69] | severity[84] |
| Aquilano<br>ca 1500 | | | health, pain,<br>passion[85] |
| Equicola<br>1526 | | pain, passion, cruelty[70] | alone: pain<br>comb.: fierceness[86] |
| Sanudo<br>before 1533 | | rage[71] | affection[87] |
| Morato<br>1535 | (= *croceo*) | fear[72] | |
| Alciato<br>1542 | | cruelty[73] | |
| Dolce<br>1565 | | fear[74] | |
| Occolti<br>1568 | courage, value;[64]<br>deceit[65] | courage, rage[75] | tenderness, sinfulness,<br>sorrow[88] |
| Contile<br>1574 | | happiness, love,<br>rage, virilty[76] | |
| R. Borghini<br>1584 | | courage, rage[77] | delight, courage;<br>pale: discourage[89] |
| Lomazzo<br>1584 | | courage, exaltedness,<br>rage[78] | health, goodness;<br>pale: desperation, pain[90] |
| de'Rinaldi<br>1592 | (= *croceo*) | rage, revenge[79] | sweetness, tenderness[91] |
| Calli<br>1595 | (*ferrugineo*)<br>gloominess[66] | courage, generosity[80];<br>rage[81] | gentleness[92] |
| A. Beffa | | cruelty, rage[82] | pain[93] |
| G. Beffa | weakness[67] | cruelty[83] | pain[94] |

| 11. PURPLE *purpureo* | 12. VIOLET *violato, violetto, violaceo* | 13. DARK VIOLET *morello, pagonazzo, pavonazzo, perso* |
|---|---|---|
| | fidelity[99] | |
| luxury; men: goodness; women: obstinacy[95] | | reticence, trouble[104] |
| | delight[100] | passion, kindness[105] |
| | | reticence[106] |
| | | reticence, passionate love[107] |
| | gentleness, contempt, coldness[101] | reticence, passionate love[108] |
| power, freedom[96] | | friendship, gentleness, love; coldness[109] |
| power, glory[97] | kindness, gentleness; coldness[102] | exaltation, passionate love[110] |
| | | solidity, strength, passionate love[111] |
| glory[98] | | seriousness, nobility, secret love[112] |
| | sorrow[103] | secret love[113] |
| | | secret love[114] |

| | 14. BLUE<br>*azurro* | 15. LIGHT GREY-BLUE<br>*cilestrino, ceruleo,<br>cesio, celeste* | 16. TURQUOISE<br>*turchino* |
|---|---|---|---|
| Sicillo<br>ca 1450 | fidelity:<br>men: knowledge;<br>women: decency[115] | | |
| Aquilano<br>ca 1500 | | envy[122] | envy[124] |
| Equicola<br>1526 | fidelity, envy[116] | envy[123] | envy[125] |
| Sanudo<br>before 1533 | envy[117] | | alone: calmness;<br>combined: envy[126] |
| Morato<br>1535 | | | exaltation[127] |
| Alciato<br>1542 | | | envy[128] |
| Dolce<br>1565 | | | exaltation[129] |
| Occolti<br>1568 | fidelity, nobility[118] | | exaltation[130] |
| Contile<br>1574 | love, humility,<br>chastity[119] | | |
| R. Borghini<br>1584 | religiousity, chastity,<br>fidelity[120] | | goodness, kindness,<br>decency[131] |
| Lomazzo<br>1584 | exaltation, glory,<br>fidelity, joy[121] | | (= *azurro*) |
| de'Rinaldi<br>1592 | (= *turchino*) | | exaltation, love[132] |
| Calli<br>1595 | | | |
| A. Beffa | | | purity, fidelity, envy[133] |
| G. Beffa | | | obstinacy[134] |

| 17. GREEN  *verde* | 18. GREY-GREEN  *berettino* | 19. YELLOW GREEN  *verdegiallo, rosa secca* |
|---|---|---|
| joy, beauty;  men: delight;  women: love[135] | | |
| hope, love[136] | trouble, sorrow[151] | |
| hope[137] | | discouragement[161] |
| hope, love[138] | | |
| weakness[139] | deceit[152] | discouragement[162] |
| hope[140] | | |
| weakness[141]; hope[142] | deceit[153] | discouragement[163] |
| light: hope  dark: death[143] | light: deceit;  dark: humility[154] | discouragement[164] |
| hope[144] | ingratitude, baseness[155] | |
| hope[145] | | discouragement[165] |
| joy, beauty, hope[146] | light: hope; dark:  hostility, desperation[156] | |
| joy, hope[147] | deceit[157] | discouragement[166] |
| fidelity, hope,  generosity[148] | trouble[158] | |
| hope[149] | trouble[159] | |
| hope[150] | trouble[160] | |

A careful analysis cannot be made of this restricted material. However, some obvious tendencies may be established. Yellow, purple, dark violet—the traditional signs of power[167]—and green[168] are, for the most part positive. Blue, often synonymous to turquoise, holds an intermediate position, whereas red, orange and yellow-green are, for the most part, negative. No marked line separates the 'cold' hues from the 'warm', and the relative lightness is irrelevant. Black is, in spite of the traditional negative association to darkness and malignity, for the most part a sign of solidity and dignity as a local colour. In short, the lack of a general system confirms the assumption that many of the significations depend on conventions—traditional or abandoned—whereas others—as will be established below—are derived from the abstract light and colour symbolism.

### Analogous, object-bound colour symbolism

The most important manifestation of object-bound colour symbolism based on analogy was the complexion. According to the old doctrine of the four temperaments, the inner disposition of the four bodily substances, which correspond to the four elements, result in certain mental dispositions[169]. Colour, then, offered a means of fulfilling the demand for emotional expressiveness[170]; the claim for *expressio,* originally a rhetoric category, was transferred to painting[171]. In the *paragone* poetry-painting[172], the adherents of painting claimed that painting, thanks to colour, was able to express the inner disposition, *il di dentro*[173], whereas the adherents of poetry in this case held the imitative resources of painting to be restricted to *il di fuori*[174]. There existed, in fact, a notion of a 'standard-complexion', *incarnato* (10 above), the variations of which designated, when necessary, the particular emotional state[175]. Cennini ca 1400 gives detailed instructions for rendering the complexion of young people; an underpainting of the shadows in *verdeterra* is to be glazed by a mixture of cinnober and white—ochre is sometimes included[176]. The complexion of old people is to be made on an underpainting of darker *verdeterra*[177]. Lebègue ca 1410 prescribes a mixture of cinnober or sinopia, white and ochre[178]; Filarete ca 1451—64 describes *incarnatione* as a mixture of red and white[179]; A. Telesio 1528 as *roseus*[180]; Nifo 1529 advocates a complexion which is "not pale, but oscillating between red and white[181]"; Morato 1535 says that flesh is to be imitated with *lacca*[182]; Sorte 1580 prescribes a mixture of cinnober and white lead[183]; R. Borghini 1584 recommends a complexion *molto simile alla rosa*[184]; Lomazzo 1584 proposes the mixture of cinnober or lake and white[185], and Armenini 1586 *terra rosa—biancho*[186]. It seems highly probable that 'standard' *incarnato* was in fact synonymous with the sanguine complexion, which traditionally was regarded as the very sign of health and mental balance[187]. Whereas the rose complexion of the sanguine

temperament traditionally corresponded to the colour of blood, and the pale complexion of the phlegmatic corresponded to white phlegm, the case was different with the choleric and melancholic complexions. The choleric's predominating yellow bile appeared as a red complexion, and the black bile of the melancholic appeared either as a blackish or—due to the confusion of the melancholic and phlegmatic temperaments[188]—as a pale complexion. (COLOUR PLATE XVII) A collection of general statements of the correspondences between the different temperaments and colours is indeed bewildering:

| | SANGUINE | CHOLERIC | MELANCHOLIC | PHLEGMATIC |
|---|---|---|---|---|
| Alberti 1435—36[189] | | red | pale | |
| Ficino 1469[190] | | | pale, grayish yellow | |
| Equicola 1526[191] | blue, violet, white | red | black | green, white |
| Aquilano b. 1535[192] | red | | black | |
| Morato 1535[193] | | | black | |
| Speroni 1542[194] | | red | black | |
| Dolce 1565[195] | | red | black | |
| R. Borghini 1584 | blue[197] | red[199] | dark violet[201] | white[203] |
| Lomazzo 1584 | blue[198] | red[200] | black[202] | white[204]; turquoise[205] |
| Calli 1595[196] | | | black | |

The correspondences bear sometimes upon elementary associations, sometimes upon the colour of the predominating humour and sometimes, finally, upon the colour of the complexion. More precise descriptions of the typical complexions of the four temperaments are, however, found in Lomazzo 1584; as a part of a complicated system for the rendering of *rilievo* of four human bodies belonging to the four temperaments, he specifies the components of their respective complexion[206]: the sanguine 1 rose

(= 1/3 red+2/3 white), 1 white; the choleric 2 red, 1 yellow, 1 white; the melancholic 1 (1/3 *biglio* + 2/3 yellow ochre), 1 white; the phlegmatic 1 (1/2 rose+1/2 *biglio chiaro*), 1 white.

However, such a system had a great disadvantage; every *accidental* emotion obliterates the typical signs of the *general* mental disposition[208]. The problem was described to the point by Occolti 1568: *Poco vale la ragione di quelli che tengono che'l bianco significhi timidezza, imperochè s'aviene che uno sopragiunta da una subita paura s'imbianchi nel volto, questo effetto aviene per accidente, onde può essere anchora che divenghi d'altro colore, secondo la spezie delle collere che predominano tal uomo; e di simili accidenti non si deve terer cura*[209]. In order to restore—at least apparently—the lost stability, astrology was consulted. According to its principles, the events and individuals of the sub-lunar world are governed by the planets, the influences of which are varying but regular[210]. According to Pino 1548, beauty depends on that the individual *sia generata in buona congionzione delle sette stelle, e sotto benigno influsso di queste seconde cause, d'equal complessione in propria porzione, che gli umori superficiali siano temperato di modo che da loro si causa una carne delicata, senza macula, lucida e candida*[211]. Maranta 1550—70 observes the connection between the sanguine temperament and the influence of Jove; he considers Titian's way of depicting the sanguine complexion of the angel in *the Annunciation* perfect and more expressive than any verbal or physiognomic description[212]. The most evident signs of planetary influences were the ruddy complexion caused by Mars and the pale or dusky complexion caused by Saturn.

According to Lomazzo 1584, Saturn causes a complexion between black and yellow, Jove a mixture of white and red, the Sun a dark colour, Venus a whitish, Mercury "neither white nor blackish" and Luna white with some red[213].

The efforts to apply colouristic analogies in a functional system for the expression of emotion is only one example of the general ambition to maintain the scientific, regulated *certezza* of painting. Yet the failure was, in this case, almost complete. But the references to a strong and well-known tradition certainly veiled the lack of system—or rather the excess of contradictory systems—and gave an illusion of coherency[214].

*Abstract light- and colour symbolism*

The abstract, universal and intuitive light and colour symbolism is not object-bound[215]; it characterizes the totality of the image. Through both the general relation between light and darkness and the dominant hue or constellation of hues, it comprises chromatic as well as unchromatic colours. Its origin seems to be four rather diverse sources: (a) Philosophy of light;

(b) Theories of psychological effects of different colours; (c) Elementary analogies and their ramifications; (d) Immanent properties of the colours, both as pigments and vehicles of hue, lightness, saturation and intensity.

(a) The identification of light with life and of darkness with death is fundamental and biologically conditioned[216]. The Christian analogies between light and goodness-God and darkness and evil-Satan is only one instance of a ritualisation, which may be found in most cultures. The pictorial rendering of light, then, was not exclusivly an illusionistic or aesthetic concern[217].

(b) The statements of physiological reactions on certain states of light and colours are sometimes difficult to distinguish from (a), as when Alberti writes "certainly by nature we love open and clear things[218]." But the completely different ancient observations and theories of reactions with physical pain, delight, recreation, or stimulation to certain colours[219], which originate in the Aristotelian adaption of Pythagorean number symbolism in analogies between tones and colours were repeated by many writers[220]. The reactions are often described as purely physiological: R. Borghini 1584 and Calli 1595 agree that green is *di grandissimo conforto alla vista / diletta e conforta la vista*[221]. However, since it was held that the eye via the *sensus communis* was connected to the soul, psychology was involved; Lomazzo 1584 writes that "where light does not enter, a hazy colour appears, troubeling and torturing the soul[222]."

(c) In spite of a disparate tradition from Antiquity regarding both chromatic associations to the elements and to temperature[223], the associations of fire-yellow/red and of air-blue seem, in a double sense, just as elementary as the associations heat-yellow/red; they, too, are fundamental, intuitive and biologically conditioned.

(d) Surprisingly many of the above-mentioned meanings of the conventional object-bound colour symbolism depart from univerally observable immanent properties[224] of the colours. White is associated with purity because it is soiled by any strain of chromatic or black colour, or with humility because it submits to any other colour[225]. The association of black with firmness similarly depends on its unaffection by chromatic influences[226], and the chromaticness of dark violet, which is almost lost in complete blackness, is associated with reticence, etc. It is also striking that light and very unsaturated hues[227], just as *cangianti*[228] and certain derived colours[229], are considered negative because of the uncertainty expressed by their lack of explicitness.

---

1. In some cases—as in Sicillo ca 1450 on yellow (below p . . . and n . . .)— one meaning (richness, nobility) is the cause of an opposite (envy). Cf. Calli below B IV 3 and n 13.
2. The NCS graphic model for colour notations. Cf. Hård 1975 pp 161 ff.

3. Barocchi 1971— II p 2340.
4. *Ibid.* II p 2343. (Cf. Ariosto, *Rime* (Son. IV) and *Orlando Furioso* (1516): chastity, purity, fidelity; Salza 1901 pp 330, 340 ff).
5. *Ibid.* II p 2156.
6. Cian 1894 p 35; Barocchi *op.cit.* II pp 2157 n 6, 2198 n 1.
7. *Ibid.* II pp 2167 f.
8. *Ibid.* II pp 2159, 2167 f.
9. *Ibid.* II p 2341.
10. *Ibid.* II p 2198 ff.
11. Salza 1901 p 325.
12. Ed. 1807 I pp 270 f.
13. Ed. 1973— II p 410.
14. Barocchi *op.cit.* II pp 2306, 2314 ff, 2322.
15. *Ibid.* II pp 2333 f.
16. *Ibid.* II p 2339.
17. *Ibid.* II p 2341.
18. *Ibid.* II p 2340.
19. *Ibid.* II p 2342. (Cf. Ariosto, *Orl.Fur.:* death, melancholy, pain, purity; Salza 1901 pp 331, 354 f, 358).
20. *Ibid.* II p 2156.
21. Cian 1894 *loc.cit.*
22. Barocchi *op.cit.* II pp 2159, 2165 f.
23. *Ibid.* II p 2341.
24. *Ibid.* II pp 2198, 2201 ff.
25. Salza 1901 pp 325 f.
26. Ed. 1807 I pp 275 ff.
27. Ed. 1973— II p 402.
28. Barocchi *op.cit.* II pp 2306, 2317 ff, 2323.
29. *Ibid.* II p 2338.
30. *Ibid.* II p 2339.
31. *Ibid.* II p 2341.
32. *Ibid.* II p 2340.
33. *Ibid.* II note to p 2159.
34. *Ibid.* II p 2342. (Cf. Ariosto, *Orl.Fur.:* lost hope; Salza 1901 p 343).
35. *Ibid.* II p 2157.
36. *Ibid.* II pp 2159, 2169 f, 2174 f.
37. *Ibid.* II p 2341.
38. *Ibid.* II p 2174 n 3.
39. *Ibid.* II p 2199.
40. Salza 1901 p 325.
41. Ed. 1807 I p 270.
42. Ed. 1973— II p 401.
43. Barocchi *op.cit.* II pp 2306, 2322 f.
44. *Ibid.* II pp 2328, 2335.
45. *Ibid.* II p 2339.
46. *Ibid.* II p 2341.
47. Ed. 1973— II p 402.
48. Barocchi 1971- II p 2341. (Cf. Ariosto, *Orl.Fur., Cinque canti* II, 133, III, 82: humility, secrecy. Salza 1901 pp 342,353).
49. *Ibid.* II pp 2220 f and n 7. The source is Telesio 1528.
50. Ed. 1973— II p 402.
51. Barocchi 1971— II p 2334.

52. *Ibid.* II p 2339.
53. *Ibid.* II p 2342.
54. *Ibid.* II p 2156.
55. *Ibid.* II p 2158.
56. *Ibid.* II *loc.cit.* n 1.
57. *Ibid.* II pp 2159, 2170.
58. *Ibid.* II p 2199.
59. Salza 1901 p 325.
60. Ed. 1973— II pp 402 f.
61. Barocchi *op.cit.* II p 2306.
62. *Ibid.* II p 2322.
63. *Ibid.* II p 2339.
64. *Ibid.* II p 2199.
65. *Ibid.* II pp 2199, 2205.
66. *Ibid.* II p 2335.
67. *Ibid.* II p 2342.
68. *Ibid.* II p 2340.
69. *Ibid.* II pp 2159, 2343.
70. *Ibid.* II pp 2156, 2158. (Cf. Ariosto, *Orl.Fur.* XXII, 32: modesty, love; destruction, rage. Salza 1901 pp 342, 348).
71. Cian 1894 pp 26, 35; Barocchi *op.cit.* II p 2199 n 6.
72. *Ibid.* II pp 2159, 2163 ff.
73. *Ibid.* II p 2341.
74. *Ibid.* II pp 2163 n 3, 2165 n 1.
75. *Ibid.* II pp 2198 f.
76. Salza 1901 pp 325 f and n 3.
77. Ed. 1807 I p 273.
78. Ed. 1973— II pp 401 f.
79. Barocchi *op.cit.* II pp 2306, 2323.
80. *Ibid.* II p 2328.
81. *Ibid.* II p 2335.
82. *Ibid.* II p 2339.
83. *Ibid.* II p 2342.
84. *Ibid.* II p 2343.
85. *Ibid.* II p 2157.
86. Cian 1894 p 35; Barocchi *op.cit.* II p 2157 n 2.
87. *Ibid.* II pp 2160, 2172 f.
88. *Ibid.* II pp 2198 f.
89. Ed. 1807 I p 282.
90. Ed. 1973— II p 402.
91. Barocchi *op.cit.* II pp 2306, 2322 f.
92. *Ibid.* II p 2336.
93. *Ibid.* II p 2339.
94. *Ibid.* II p 2342.
95. *Ibid.* II p 2340.
96. Ed. 1807 I p 279 f.
97. Ed. 1973— II p 401.
98. Barocchi *op.cit.* II p 2336.
99. *Ibid.* II p 2341.
100. *Ibid.* II p 2157.
101. *Ibid.* II pp 2198 f, 2205.
102. Ed. 1973— II p 402.

103. Barocchi *op.cit.* II p 2339.
104. *Ibid.* II pp 2159, 2342. (Cf. Ariosto, *Orl.Fur.*: chast love. Salza 1901 p 345).
105. *Ibid.* II p 2157.
106. Cian 1894 p 35; Barocchi *op.cit.* II p 2157 n 4.
107. *Ibid.* II pp 2159, 2171.
108. *Ibid.* II pp 2199, 2206.
109. Ed. 1807 I pp 282 f.
110. Ed. 1973— II p 402.
111. Barocchi 1971— II pp 2306, 2323.
112. *Ibid.* II p 2337.
113. *Ibid.* II p 2339.
114. *Ibid.* II 2341.
115. *Ibid.* II pp 2340 f.
116. *Ibid.* II p 2157. Cf. Ariosto, *Orl.Fur.* XVI, 7: exaltation; Salza 1901 pp 335, 342.
117. Cian 1894 p 35; Barocchi *op.cit.* II p 2157 n 5.
118. *Ibid.* II p 2198.
119. Salza 1901 pp 325 f.
120. Ed. 1807 I p 274.
121. Ed. 1973— II p 402.
122. Cian *op.cit.* p 26.
123. Barocchi *op.cit.* II p 2157.
124. *Ibid.* II pp 2159, 2343.
125. *Ibid.* II p 2157.
126. Cian 1894 p 35; Barocchi *loc.cit.* n 5.
127. *Ibid.* II pp 2160, 2173 f.
128. *Ibid.* II p 2341.
129. *Ibid.* II p 2173 n 4.
130. *Ibid.* II p 2198.
131. Ed. 1807 I p 282.
132. Barocchi *op.cit.* II pp 2306, 2323.
133. *Ibid.* II p 2339.
134. *Ibid.* II p 2342.
135. *Ibid.* II p 2340.
136. *Ibid.* II pp 2159, 2342. (Cf. Ariosto, *Orl.Fur.*: hope; Salza 1901 p 351).
137. *Ibid.* II p 2157.
138. Cian 1894 pp 26, 35; Barocchi *loc.cit.* n 1, p 2307 n 1.
139. *Ibid.* II pp 2159, 2160 ff.
140. *Ibid.* II p 2341.
141. *Ibid.* II pp 2161 n 2, 2223.
142. *Ibid.* II pp 2226, 2307 n 1.
143. *Ibid.* II p 2198.
144. Salza 1901 p 325.
145. Ed. 1807 I pp 278 f.
146. Ed. 1973— II p 402.
147. Barocchi *op.cit.* II pp 2306, 2307 ff.
148. *Ibid.* II pp 2328, 2336.
149. *Ibid.* II p 2339.
150. *Ibid.* II p 2341.
151. *Ibid.* II pp 2159, 2342.
152. *Ibid.* II pp 2159, 2172.
153. *Ibid.* II p 2221.

154. *Ibid.* II pp 2198, 2204.
155. Salza 1901 p 325 and n 4.
156. Ed. 1973— II p 402 f.
157. Barocchi *op.cit.* II p 2306.
158. *Ibid.* II p 2335.
159. *Ibid.* II p 2340.
160. *Ibid.* II p 2341.
161. *Ibid.* II p 2157. (Cf. Ariosto, *Orl.Fur.*: lost hope; Salza 1901 pp 345, 351).
162. *Ibid.* II pp 2160, 2175 f.
163. *Ibid.* II p 2175 n 4.
164. *Ibid.* II p 2198 f.
165. Ed. 1807 I p 281.
166. Barocchi *op.cit.* II pp 2306, 2312 f, 2323.
167. Cf. *Lexikon der Christlichen Ikonographie* II 1970, *Farbensymbolik. Patrist. und Mittelalterische Symbolbedeutung. Einzele Farben. Liturgische Farben. Abendländische Früh- und Hochmittelalter.* Yellow, however, was also a sign of criminals.
168. *Op.cit.;* associated with Paradise.
169. Cf. above chap. III.
170. Aristotle claimed that great art must reveal not only the general species but also the particular properties of the depicted individual, in particular the emotional state; *Poet.* 1450 a, b; *Pol.* 1339 b; cf. Gilbert-Kuhn (1939) 1972 pp 68 f; Lee 1940 pp 217 f, 256; Butcher 1951 p 135; Panofsky 1954 p 5; Sörbom 1966 pp 84, 88, 181.
171. Fazio 1456; Baxandall 1971 pp 163 ff, with reference to Philostartos the Younger, *Imagines..*
172. Cf. above chap. A II.
173. Varchi 1547 (ed. 1960— I p 55 and n 3; cf. Lee *op.cit.* pp 254 f); Dolce 1557 (ed. 1968 pp 154 f); V. Borghini ca 1560 (Barocchi *op.cit.* p 290); Lomazzo 1584 (below p . . .); Armenini 1586 (*op.cit.* I p 373) and Comanini 1591 (ed. 1960— III pp 289 ff). An original opinion on the informative value of surface-colour is expressed by Zuccari 1607 (Barocchi *op.cit.* II p 2081 n 1) who differentiates between *disegno sensibile* and *intellettuale;* sense-perception (e.g. sight) gives, according to Z., only evidence of the exterior properties, whereas the interior is known through an intellectual process: *si come l'occhio nostro vede i colori varii in quanto sono nel pomo, nel quadro o nel muro e pur non vede la sostanza nascosta sotto quei colori, che questa solamente conosce l'intelletto.* Cf. note 1 (*proprietà*) above.
174. Speroni 1542 (Barocchi *op.cit.* I p 261); Gelli 1551 (*op.cit.* I p 287); Aretino 1551 (*op.cit.* I p 258). According to Dolce 1557 (ed. 1960— I p 152), Aretino held that painting indeed imitates *i pensieri e gli affetti dell'animo;* Castelvetro 1567 (Barocchi *op.cit.* II p 158 and n 2); Mazzoni 1587 (*op.cit.* I p 405 n 2).
175. Dolce 1557 (ed. 1960— I p 183), however, recommends *un eolor anzi bruno.*
176. Chaps. 21, 31, 67, 147; 45; ed. 1971 pp 23, 39, 79, 151 f; 47 f.
177. Chaps. 68, 147; *ed.cit.* pp 80, 151.
178. Cf. above chap. B III 3.
179. Ed. 1890 p 635.
180. IX; in Goethe ed. 1963 p 113: *isque color proprie est, quem communis sermo incarnatum vocat.*
181. Barocchi *op.cit.* II p 1648.
182. *Op.cit.* II p 2172; *lacca* (Indian lake) is a red resin.
183. Ed. 1960— I p 284.

184. Ed. 1807 I p 282.

185. Lib. III chap. 7; ed. 1973— II p 172.

186. Barocchi *op.cit.* II p 2277. This colour is to be variated through additions of green or yellow according to *il genere, l'età e la qualità delle persone.*

187. Cf. Klibansky-Panofsky-Saxl 1964 pp 59 ff, 100 ff, 372 and below note 211.

188. Cf. above chap. III.

189. Ed. (1956) 1967 p 77; ed. 1972 p 81. Spencer holds (n 83) that Alberti "is the first to treat of the psychological effects of colour both to arouse emotions in the observer and to create a sense of vivacity and movement."

190. Barocchi 1960— III p 298 n 3.

191. *Ibid.* 1971— II p 2158.

192. *Op.cit.* note to p 2159; p 2342.

193. *Op.cit.* II p 2159.

194. *Op.cit.* I p 1003.

195. *Op.cit.* II p 2165.

196. *Op.cit.* II p 2328.

197. Ed. 1807 I p 274.

198. Lib. VI chap. 59; ed. 1973— II p 401.

199. Ed. 1807 I p 273.

200. *Ed.cit.* I pp 277, 282.

201. Lib. III chap. 2, 11; Lib. VI chap. 6, 9, 59; ed. 1973- II pp 167, 177; 264, 269, 401 f.

202. Lib. III chap. 2, 11; Lib. VI chap. 8, 9, 59; *ed.cit.* II pp 167, 177; 268, 269, 402.

203. Ed. 1807 I p 271.

204. Lib. VI chap. 9, 59; ed. 1973- II pp 269, 401.

205. Lib. VI chap. 9; *ed.cit.* II p 269.

206. Lib. VI chap. 6; *ed.cit.* II pp 260 ff.

207. *Biglio* is elswhere, (Lib. III chap. 7; *ed.cit.* II p 171), explained as a mixture of white and black. Lomazzo, then, just as Ficino designates the melancholic with a pale, greyish complexion. Earlier (below n 213), however, he wrote that Saturn causes a colour "between black and yellow." Cf. Alberti 1435—36 ed. (1956) 1967 p 77; ed. 1972 p 81. Spencer translates the *pallido* of the melancholic as "pallid", Grayson as "drained of colour."

208. Even though the general disposition of the subject to accidental emotion may known by the learned beholder, it indeed means the collapse of the entire system.

209. Barocchi *op.cit.* II pp 2200 f.

210. Cf. above chap. III.

211. Ed. 1960— I p 102. Probably a reference to the sanguine complexion.

212. Barocchi *op.cit.* I pp 894 ff.

213. Lib. II chap. 7; *ed.cit.* II pp 108 ff.

214. Therefore, I have to disagree with the opinion of Klibansky-Panofsky-Saxl 1964 p 209 that Dürer, with his *Melencolia I* "was the *first* [my italics] to realize that what was there [in the ancient notion that melancholy resulted in a blackish face] described as a temperamental characteristic, or even as a pathological symtom, could, by an artist, be turned to good account in expressing an emotion or in communicating a mood." Cf. similar conclusions in connection to Dürer's *Four Apostles* pp 366 ff.

215. The physical painting is not, of course, regarded as an object.

216. Cf. Arnheim (1956) 1972 pp 292 ff. On the polarization of light and colour, cf. Portal 1837 pp 287 ff; *Dictionnaire des symboles,* Paris 1969 pp 107 f, 536 ff;

*A Dictionary of Symbols,* London 1971 pp 56 ff.

217. Light symbolism was also expressed in object-symbols; *the Immaculate Conception,* for instance, was symbolized by the passage of light rays through a colored glass-window; Meiss 1945 pp 176 f.

218. Ed. (1956) 1967 p 84.

219. Cf. above chap. II on Ps-Aristotle, Alhazen and Albert the Great. The latter's *De homine* was translated in 1478 by Girolamo Manfredi (*El libro chiamato della vita, costumi, natura dell'omo,* Napoli) where (p 77) the soothing effect of green is emphasized. Baxandall 1972 p 148.

220. Telesio 1528 (in Goethe ed. 1963 p 109); Morato 1535 (Barocchi *op.cit.* II pp 2162); Dolce 1565 (*op.cit.* II p 2218); Vasari 1568 (ed. 1878— I pp 180 f); Maranta ca 1550—70 (Barocchi *op.cit.* I p 879); R. Borghini 1584 (ed. 1807 I pp 277, 279); Lomazzo 1584 (Lib. IV chap. 3; ed. 1973— II p 189); Armenini 1586 (Lib. II chap. 1; Barocchi *op.cit.* II p 2019); Calli 1595 (*op.cit.* II pp 2334, 2337).

221. R. Borghini *loc.cit.;* Calli 1595; *op.cit.* II p 2336.

222. *Loc.cit.: un color calignoso, il qual afflige l'animo e tormenta.*

223. Cf. above chap. III.

224. In spite of a universal application with regard to gold, costliness is regarded a conventional, temporary property.

225. Equicola 1526 (Barocchi *op.cit.* II p 2156): *per essere color semplice senza mistura;* Morato 1535 (*op.cit.* II p 2168): *non è tinto ne'velenato da alcune altro colore;* Occolti 1568 (*op.cit.* II pp 2122, 2201): *per essere egli più puro in effetto di qual altro si voglia colore . . . non partecipa d'altro colore . . . significhi umiltà perchè con umiltà riceve ogni altro colore;* R. Borghini 1584 (ed. 1807 I p 273): *riceve tutti i colori, e da niun degli altri è ricevuto;* Lomazzo 1584 (Lib. III chap. 13; ed. 1973— II p 179: *perché è facile a ricevere ogni mistura;* A. Beffa (Barocchi *op.cit.* II p 2339): *Biancho, da ogni cosa macchiato: purità.*

226. For instance R. Borghini *ed.cit.* I p 276.

227. Light yellow, grayish yellow, green and blue. On the negative signification of grayish yellow, cf. above chap. A I (Alberti). In some cases, however, it is obvious that the negative opinion depends on the associations to complexion.

228. Aquilano ca 1500 (Barocchi *op.cit.* II p 2343); Equicola 1526 (*op.cit.* II p 2158); A. Beffa (*op.cit.* II p 2340).

229. Cf. yellow-brown, orange and, in particular, yellow-green above p . . . According to Aquilano ca 1500 (*op.cit.* II p 2342), Morato 1535 (*op.cit.* II pp 2160, 2173), Dolce 1565 (*op.cit.* II p 2173 n 2), Occolti 1568 (*op.cit.* II p 2199) and de'Rinaldi 1592 (*op.cit.* II pp 2306, 2322 f), *mischio* signifies instability and corruption.

# 3. Movimento d'affetti

The philosophy of light, the theories of physiological and psychological reactions and, to a certain extent, the elementary analogies and their ramifications all imply that the beholder does not primarily *observe* certain properties in the colours but—in accordance with ancient rhetorical tradition[1]—he *experiences* them. The emotional influence of colour was acknowledged as a didactic means by the Church; Gilio 1564[2] and Paleotti 1582[3], among others, emphasize the ability of colour to express and evoke

emotion. The first study and attempt at a systematization of this ability was made by Lomazzo 1584, in connecting the affective theory of colours to ancient musical theory, according to which certain stimuli arouse certain reactions in the listener[4]; *Perché tutti i colori hanno una certa qualità diversa fra di loro, causano diversi effetti a chiunque guarda*[5]. Barasch, who in an excellent study[6] analyzed Lomazzo's chapter on colour symbolism, did not give an account for the reasons Lomazzo presents to explain the ability of the colours to *causare, rendere* or *generare* certain emotions. It is, however, explained in the immediate continuation of the sentence quoted: *il che da una loro inimicizia interna, per la quale sono causati, è generato, secondo la dottrina di Aristotele.* The chromatic colours, then, are held to be loaded with expressive power, generated by the conflict between the two contraries, white and black, of which they consist, according to Aristotle[7]. Only with respect to the sources Lomazzo is, in this case, in my opinion, old-fashioned[8]; his application of Aristotle's theory of the generation of chromatic colours is new and progressive, but also in accordance with the general shift to a more speculative art theory in the later part of the Cinquecento. According to Lomazzo, the white, black, dark and indistinct colours generate a mood of gloominess and melancholy; gold, yellow, light green, greenish, light purple, reddish and—curiously enough—blackish[9] colours generate a pleasant mood. Red, flaming, purplish, violet, rust- and blood-like colours cause excitement. Lomazzo dedicates one chapter to black, white, red, dark violet, yellow, green and turquoise respectivly[10], in which his emphasis on the agitating effect of red and the soothing effect of green is particularly noticeable. Calli 1595 shares the general theory of Lomazzo: *Dilettan dunque i colori e muovano l'affetto*[11]. He adds an interesting distinction between two different kinds of colour-perception: one that is superficial, only satisfying the eyes and causing a general *diletto,* and one that is complete and active, involving the participation of the soul in the expressive powers of colour[12]. Finally he touches, without proposing its solution, upon the adequate question whether a colour causes a certain, corresponding mood, or another—maybe even the contrary, mood[13].

1. Alberti 1435—36 (ed. (1956) 1967 p 63); Daniello 1536 (Barocchi 1960— I p 186 n 1); d'Olanda 1548 (*ibid.* 1971— p 261); Dolce 1557 (ed. 1960— I p 186). Cf. Horace, *Ars poet.* 99—107; Quintilian, *Inst. orat.,* xl, 3, 65 ff; Cicero, *De oratore,* III 59.
2. Ed. 1960— II pp 27 f. The vast subject of the religuous use of colours has been dealt with primarily in connection to abstract light and colour symbolism. As to individual colours in paintings, dresses and complexion fill the double function of cognitive *signum individuationis* and affective medium (cf. above B III 4, hierarchic perspective, and Klibanski *et al.* 1964, above B IV 2 note 214). The general lithurgic use of colour departs from the prescriptions in *De Sacro*

*Altaris Mysterio*, I. 65 by Innocent III († 1216), who advocated the use of five lithurgic colours—white (e.g. for Our Lady and Confessors), red (e.g. for the martyrs), green (e.g. for Sundays after Ephipany and Pentecost), black (e.g. for masses of the dead) and violet (e.g. for Advent); see *New Catholic Encyclopedia*, 3.

3. Lib. I chaps. 24—26; *ed.cit.* II pp 227 ff.
4. Cf. below p . . .
5. Lib. III chap. 11; ed. 1973- II p 177.
6. 1960 pp 272 ff. Barasch refers to "einer tiefen Schicht" . . . and "unserer psychishcen Erfahrung der Farben" or "das Urerlebnis der Farben."
7. Cf. above chap. I.
8. Cf. Klein 1970 p 114.
9. *Loc.cit.; nerei.*
10. Chaps. 12—18; *ed.cit.* II pp 178 ff.
11. Barocchi 1971— II p 2332.
12. *Loc.cit.: Dove quando l'animo si muove ad affetto, toglie essi occhio dall' oggetto, et affissandosi nella simbologia e significazione di quelli, tutto s'empie della giudicata et ad presentata passione.*
13. On the, to my knowledge, little investigated tendency of a certain association to actualize its opposite, cf. Portal 1837 pp 32 f: "La règle des oppositions est commune à la langue des couleurs et à tous les symboliques en géneral; elle leur attribue la signification opposée à celle qu'elles possèdent directement." As particularly evident cases are the polar significations of white (purity—death), red (love—passion) and black (penitence—death). Cf. *A Dictionary of Symbols*, London 1971 pp 54, 58 f and above chap. A II and n 65 on *bigio* (baseness-humility).

## 4. Ingenio e maniera

Whereas the expressive and symbolic properties of colour may—at least hypothetically—be used instrumentally and thus consciously and calculatedly, the notion of colour as an expression of the artist's personality implies the unconsciousness of this expression. Though the art theory of the Cinquecento acknowledged favourably the existence of a few geniuses, and while the notion that the paintings mirror the personality and experience of the artist was general[1], the very phenomenon was condemned; art theory aimed at an objective, uniform ideal. Perhaps it was understood that most personalities indeed deserve being supressed, but certainly the low estimation of the subjective element was in accordance with the general condemnation of the *doni,* the passive or innate[2]. The homages paid to the geniuses of, above all, Michelangelo and Titian are, therefore, exceptions which confirm the rule that the subjective was regarded as something fundamentally negative. Leonardo even fostered the notion that the artist is threatened by a primitive and irrational *giudizio*[3], which instinctively makes him inclined to imitate himself and to fall in love with people of his own appearance[4]. The negative attitude towards the subjective element

also explains the lack of an important aspect of the expressive properties of colour. It concerns the physical imprints of the artist's activity in the paint, and in particular the individual *rhytm of application,* which reveals the artist's characteristic motions. This property has, then, a certain affinity to calligraphy, and is completely independent of both the aesthetic, illusionistic and instrumental functions of art and of the dimensioning criteria of chromaticness, lightness and intensity[5]; it is generally—but not necessarily —manifested in a noticeable relief in the physical structure of the paint. It has already been noted that *sprezzatura* was regarded as a sign of masterly skill, but that—at the same time—the speed of execution was not permitted to result in a rough surface; the Venetian technique, tolerated alone in the case of Titian and for paintings intended to be seen from a distance, was generally condemned, since it not only drew attention to the artisan aspect of painting, but furthermore to a careless, cheap and undurable kind of craftmanship, a kind, finally, which counteracted illusionism and depended on the passive, immanent beauty of colour[6]. This is not to say that an inspired, suggestive sketching technique was not appreciated[7], but it was to be integrated as accents in a smooth, elaborate technique. Rhythm was given a great importance for emotional imitation and influence in the musical theory of Antiquity[8], but the notion of it in the Italian Renaissance art theory departed from Vitruv's definition of *eurytmia* as an adjustment of the actual proportions to the conditions of the accidental point of view[9]; Lomazzo 1590 even used it as a synonym for *disegno*[10]

A question of a quite different kind—however of limited importance— was whether the artist, when expressing or communicating emotions, himhelf has experienced them. This was considered a condition for efficient emotional influence by Horace and Quintilian[11]. The question belongs to the instrumental theory of expression, since it presupposes calculation and method of the artist.

1. Cf. as disparate authors as Ficino (*Theologia Platonica* 1470, in *Opera omnia* 1576 p 229; Wittkower 1963 pp 93 f and n 69; 281 ff); Vasari 1568 *passim;* Wittkower *op.cit.* pp 91, 283) and Lomazzo 1590 (*passim*), whose seven *governatori* designate different personalities.
2. Cf. above, chaps. B I 1, B III 3.
3. On other significations of *giudizio,* cf. above chap. B I 3 and note 11.
4. *Cod. Urb. Lat.* 1270; Barocchi *op.cit.* II pp 1274 f and nn 1, 2, with references to C. Luporoni, *La mente di Leonardo,* Firenze 1953 pp 133 f. Cf. Aristotle (*Meteor.* 373 b).
5. Cf. above chaps. B I 3, B III 4 (structural perspective).
6. Cf. Dolce 1557 (ed. 1968 pp 206 f), who considered it an insult against Titian to say that he *tinge bene.*
7. Aretino (undated letter to B. Valdaura, ed. 1957 I pp 107 f) and Vasari 1568 (for instance ed. 1878— VI p 563) on *colpi maestevoli.*

8. Plato, *Rep.* III 398—401; Aristotle, *Pol.* 1340—1342; cf. Gilbert-Kuhn (1939) 1972 pp 41 ff and n 89, 96, 98; 67 f and nn 76, 77, 86.
9. *De re aedificatoria* I, 2; Panofsky 1955 p 68 and n 19; 98 f and n 89; Pochat 1973 pp 44, 271.
10. Chap. 19; ed. 1973- I p 300.
11. Osborne 1970 pp 235 f; cf. Lee 1940 pp 217 f, on the influences of Horace (*Ars poet.* 102—3) in Dolce and Lomazzo.

# CONCLUSIONS

The Neo-Platonic notion that participation of light and colour is relative to participation of divine influence, is the basis for rather insignificant scales, using the relative lightness as a dimensioning criterion. Theophrastus' studies of the changes of local colour due to elementary changes caused by heat also occur as a basis of colour scales. More important for the practical use of colour was the criterion of hue; Alberti rejected the Aristotelian theory that the chromatic colours consist of certain proportions of white and black. Maintaining the differentiation between unchromatic and chromatic colours, he did not acknowledge white and black as actual colours, but only as tonal modulators of the actual (chromatic) colours, which he held to be only four, in accordance with the ancient elementary doctrine associated to the elements: red (fire), blue (air), green (water) and yellow (earth). The unusual names for blue—*cilestrino*- and yellow—*bigia e cenericcia*—were deliberately chosen in order to facilitate the rendering of *rilievo*. Alberti, then, presented the still valid rational systematization of surface colour. For practical reasons, both Filarete and Leonardo, who clearly depended on Alberti—the latter also associated yellow with earth —included white and black in their chromatic scales, which consequently lack the rationalism of Alberti. Alberti's system was nevertheless well established in the Cinquecento, and the frequent references to Aristotle are conventional and do not mean that Alberti's rational system was abandoned.

The concept of quantity was, in spite of the associations between mathematics, geometry and drawing, derived from Pythagorean philosophy, not altogether favourable; if drawing—learnable and even replaceable by optical devices—was held to constitute painting, everyone might become an artist. Quantity was also negatively associated with matter, whereas perceptual and physical immateriality was credited colour. Through the doctrine of the four elements associated to colour, quality made painting something superior, from both a philosophical and purely imitative point of view. At the same time is was, however, through Aristotles' notion that the chromatic colours consist of different quantities of white and black,

possible to regard colour as quantity. The illusion of volume, one of the marvels of painting, it was noted, could be achived in unchromatic or monochrome colours. Depending on technical, evolutionary, formal, conceptual and pedagogic criteria, however, *chiaroscuro* was assigned to either drawing or painting. The definitions of painting developed from strictly technical criteria, via conceptual/genetic and perceptual/imitative to an all-embracing, total kind. The comparisions between the arts or between artists and schools, frequent in Antiquity and the Middle Ages, contained, in spite of a tendency to degenerate to a social entertainment, urgent arguments and serious aspects, reflecting severe social conditions and the search for adequate aesthetic terminology. With regard to colour, the most important aspects were the universal expressiveness of colour, the intellectual, non-manual practice of painting, and the material durability and invariability of its physical manifestations.

The immanent beauty of colour was negatively acknowledged; gold was rejected as improper for illusionistic use and gaudy colours were associated with the Middle Ages, provinciality, vulgarity, ignorance, foreign influences, low artistic ability and low social status. Colouristic talent, coupled to *natura,* and governed by exterior influences was in the same way generally regarded negatively, since it was not the productive, creative outcome of artifice and achieved skill, which was coupled with drawing. The strive for regulated practice had two consequences for the notion of colouristic beauty: on the one hand the genius of Titian, when acknowledged, became the new stipulated colouristic ideal in the eclectic theory of the Cinquecento, and on the other there arose and reappeared theories of regulations for harmonic colour-combinations.

The sense-deceiving imitative universality of colour, its life-likeness, and its illusion of three-dimensionality and spatial depth were brought foreward as the virtues of painting. According to tradition, the immateriality of painting depended on the same property of the visual impressions, the *species,* a designation also used for mental concepts. The intellectual play offered by a physical object—the picture—and illusionism was appreciated, but the relative immateriality of the easel-painting in oil-colours was generally thought to be eliminated by a rough physical structure, which was tolerated only for monumental, generally fresco-painting, intended to be seen from a great distance; a smooth, polished structure remained the ideal.

Corrective imitation—figural and colouristic—was the dominant concept of the painter's relation to nature. Guided by a mental idea of perfect beauty, the result—according to both Platonic and Aristotelian tradition— of earlier sense-impressions, the artist was thought to ennoble and correct the partly defective reality. Keen judgement, originally regarded as an innate gift of competent comparision between present and stored, old impressions in the memory, finally became identified with 'general opinion',

marking the final levelling of the original, exalted spirituality of idea.

The Neo-Platonic emphasis on contemplation in order to focus the inner idea played a certain role in the Italian Renaissance art theory. A quick execution was held to reveal the distinctness of the idea and the mastery of the technical devices of art. The sketch was, however, also regarded as a materialized object of judgement and a state of correction. According to the same Neo-Platonic tradition, matter exercises resistance to form; the Renaissance Platonists, however, held that beauty may enter and dominate matter which has been 'prepared' in accordance with the 'classical' definition of formal beauty. Influenced by both the Neo-Platonic notion of resistance and by the only apparently similar Aristotelian metaphor that the artist actualizes the potential beauty in the amorphus matter, Michelangelo regarded it a heroic victory of creative genius to break down the material resistance and disclose beauty in the hardest possible materials, using the most labourious techniques—he preferred stone-cutting and fresco-painting to the smooth, submissive oil-painting. Even though fresco remained a 'heroic' technique, soft, formative materials and techniques which permitted subsequent corrections were generally praised, not only because the concept was thought to enter and dominate them more completely, but also because they possessed greater expressive potentialities, implied less manual labour, and their physical reality was less perceivable.

Of the partly sophistic arguments in the *paragone,* the argument that sculpture was superior to painting due to its greater durability and invariability, was seriously apprehended and inconsistently replied. Not only were these criteria of science, but—and above all—the painting was, in the state the artist handed it over to posterity, regarded the proof of his ability—an investment of his theoretical knowledge, aesthetic sensibility and imitative and technical skill. The techniques were ranked according to their relative durability and invariability. Oil-painting was holding a low position in this respect, but a smooth, polished structure was thought to be least apt to decay. When the disadvantages of the oil-medium—its tendency to yellow, loose its brilliance, transparency, and property to saturate the colours —were established, it was realized that the surface of an oil-painting had to be varnished. The traditional, medieval kind of oil- and oil/resin-varnishes shared the disadvantages of the paint medium and were difficult to remove for replacement. In the first decades of the Cinquecento, then, the traditional varnish disappears in favour of a new kind of pure resin varnishes which are, however also yellowing, easy to remove and replace. To clean discoloured and dirty paintings was regarded as a normal process. The problems of retouching damaged parts of paintings, on the other hand, gave rise to the development of restoration ethics. Respect for the artist's integrity was advocated, but the Church, using artistic images mainly for utilitrian, pedagogic reasons, had her paintings cleaned and retouched—

in particular after the Counter-Reformation—without any considerations of that kind. Possible the Neo-Platonic association of bright, light colours and divine influence contributed to the demand for cleaning.

One extremely pronounced case of fear for the decay of paintings was Leonardo. He recognized the yellowing of oil, the negative, irregularily altering effect on the different colours of a yellowish varnish, particularly fatal for blue and bluish hues. He remarked that it made the pictures look old and even suggested the use of glass as an "eternal" varnish. His notorious experiments in order to find less vulnerable techniques were distastrous—he experienced the decline and decomposition of several works and in the end, before giving up painting completely, he would take measures for the duration of paintings not yet commenced.

There existed, through Aristotle, a tradition, according to which the chromatic colours could be quantitatively, numerically defined, the same, originally Pythagorean tradition which was applied to the musical, anatomical and architectural theories of harmony. Even though the Aristotelian analogy between tones and colours was defective and his general theory early completely rejected (Alberti), there existed a deep, conventional belief in such an analogy. Using a terminology, based on this belief, one may establish a development from a preference for polar contrast (the relation between two complementary colours and between two very different colours with regard to hue, saturation, intensity and lightness) in the Quattrocento, via a preference for unison contrast (the relation between two adjoining colours, or between two equally very unsaturated, very light, dark or indistinct colours, regardless of hue) in the first half of the Cinquecento, to a shift back to polar contrast in the late Cinquecento.

The imitative universality of painting was stressed with reference partly to its ability to depict not only physical reality but also mental images, and partly to its ability to, with the help of colour, imitate the effects of innumerous phenomena, sometimes by a similar structural stratification of the paint layers, illustrating that drawing can only indicate the *genera* of objects, whereas painting, imitating the individual local colour, may differentiate between the different *species,* as for instance between different kinds of cloth and metals.

'Life-likeness', the sense-deceiving imitation of individual living and dead or vegetative objects, was another ideal property of painting, depending on colour. In general it meant the 'proper' or 'natural' colour—'life-likeness' may in such cases mean 'death-likeness'—but in particular it was applied to complexion and the category of depiction after living models.

The illusion of three dimensions of a flat surface was another marvel of painting, not necessarily but—due to the agreement that painting makes use of chromatic colours—rendered chromatically. According to ancient tradition, the volume was divided in three parts—the illuminated, the local

colour and the shadowed part; lustre was considered as integral in the illuminated part. The plastic and chromatic inconsistency of the medieval practice, which within a tripartition of the volume combined colours of different hue, lightness, saturation and intensity, still appears in Cennini's instructions. Alberti, however, neglecting consciously both the ancient (Theophrastus) and his own observations of the influences of reflected colours from the surroundings, developed a completely new colour systematization with the evident pragmatic aim of achieving plastic consistency by making the four chromatic colours—the very light yellow, the medium-dark red and green and the very dark ultramarine-blue—tonally equivalent. Constantly keeping the most saturated colour in the local-colour part and, according to his notion that white and black do not alter the hue of the four actual colours but only create variants of them, adding white in the illuminated part and black in the shadowed part, he achieved, at the same time, chromatic and tonal consistency within the volume and between all the illuminated objects in the composition and protected the local colour from exterior, altering influences. With one exception—the imitation of hue-changing cloth, *cangianti*—this method was well established in the succession of Alberti. Even Leonardo, who made innumerable, painstaking observations of the influences of the different kinds of light sources and reflections from the surroundings, had—in spite of pathetic efforts to reduce these effects—to surrender to the simplified, fundamentally unnatural, method of Alberti. During the entire period, the light in monumental paintings was held to be adapted to the real light, and the indirect, soft atelier light, recommended by Leonardo, remained the ideal. The only substantial contribution of the Cinquecento was the identification of different light styles as convenient for different subjects or as an expression of artistic individuality.

Through colour and clarity perspective, colour, methodically used to define spatial relations, gained a position equal to line. No definite establishment of whether vision comes into being by emission, immission or a combination of both, is to be found among the Renaissance art theorists. Formal optics, which also took the dissolving effect of distance in consideration, was more influential during the later part of the Cinquecento, but most of the ancient theories included observation and explanation of the succesive enfeeblement of distant images, which can also be found in paintings from Antiquity. Theophrastus had clearly established that the white colour of humidity in the air affects the local colour of distant objects. The sketchy, blurred image had, furthermore, been identified as a stylistic feature in Antiquity, and its psychologic implications, the concreative role of the beholder, had been examined. It cannot be excluded that already Cennini states that distance is accompanied by reduced saturation and increased lightness of the local colour of the observed object, but if

it is impossible to establish in this case, due to the contradictory meanings of *chiaro* and *fusco/oscuro,* it is quite clear that Alberti and Leonardo used the latter words in the sense "hazy", "indistinct". Alberti, then, noted the effects of colour perspective but was unable to systematize them. Leonardo's contribution was the systematic description, explanation and differentiation between linear, colour and clarity perspective, the latter of which may be described as the synthesis of the former two. Leonardo also assigned their respective imitative domains. During the Cinquecento, these observations were generally considered a commonplace; the only important contributions are the confirmation of the structural perspective—the use of varying physical structure of paint to render distance—and the application of clarity perspective to the observation of pictures. With few exceptions, a rough physical structure was only tolerated for paintings intended to be seen from a distance. The concreative activity of the beholder of blurred images was observed, but it was occasionally noted, that since clarity perspective works for the enfeeblement of the objects in the distant zone of the painting, there is no need to paint them hazily. Didactic, not illusionistic aims explain the hierarchic perspective, according to which the strongest illumination and the most conspicuous colours are attached to the most important members of the composition. The linear, colour and clarity perspectives were well adapted to the ancient need of emphasizing the most important or beautiful members of the composition.

In order to grasp the vast subject of the informative, symbolic, expressive and affective function of colour, the following terms and definitions, adaptions to colour of terms orginally designed for figural contexts, are proposed: (1) object-bound colour symbolism, expressed as local colour, based on either (a) convention or (b) analogy; the analogies are based on the ancient doctrine of colour as a revelation of the elementary composition; (2) abstract colour symbolism, expressed in the tonal and chromatic totality, based on intuitive response and derived from philosophy of light, Pythagorean number-symbolism, elementary analogies and immanent properties of the colours. The lack of consistency of the more specific significations ascribed to different object-bound colours confirms that some of them are conventional and others analogous. The latter are evidently derived from abstract colour symbolism, and form, together with this, a coherent system, surprisingly in accord with modern both intuitive theories and scentific experiments (within brackets below): yellow (warm, positive, active) was associated with warmth, activity and the generation of a positive mood; red (warm, positive, active, approaching) with agressiveness/ heat and activity; green (tepid, indifferent, resting) with rest, recreation and a comfortable mood; the low frequency of blue (cold, negative, passive, receding) in the sources is probably due to the fact that it did not occur as a common tincture; contrary to a few conventional, favourable associa-

tions, the dominating negative associations to envy and exaltation seem to have an elementary origin. In spite of some ambiguities, the same associations dominate in Lomazzo, who in his *Trattato* develops an instrumental, affective theory of colour, based on the ancient, originally Pythagorean musical theory of mental affection of numerical relations, applied to colour through Aristotles' theory of different proportions of white and black as the constituents of the chromatic colours. Artistic individuality of colour was acknowledged, but due to a negative attitude towards the pastose Venetian technique, the rhythm of application, independent of luminuous and chromatic qualities and revealed as physical imprints of the artist's personality in the paint, was almost completely neglected.

We may thus specify ten main objects of the artist's theoretical knowledge, keen judgement and technical skill, manifested in colour and generally believed to be regulated: I. (1) Colour systematization: the internal relations between the colours; II. Aesthetic interest/formalistic theories: (2) the harmonious relations between the colours; III. Interest in art as a reflexion or copy/naturalistic theories: (3) life-like rendering of complexion, revealing the race, sex, age, elementary and astral influence on the physical and mental status of the individual; (4) life-like rendering of the elementary composition of objects; (5) tonal and chromatic rendering of volume; (6) tonal, chromatic and structural rendering of space; IV. Pragmatic interest/instrumental theories: (7) chromatic assignment of relative importance; (8) symbolic signification; (9) generation of emotion in the beholder; (10) interpretation of the artist's personality. Needless to say, our possibilities to estimate the application of these conventions and theories in an Italian Renaissance painting depend on the authentic state of the colours in that painting.

# BIBLIOGRAPHY

In three sections: A. Sources from Antiquity and the Middle Ages, B. 1. Renaissance Sources and Source Literature, B. 2. Literature.

### A. Sources from Antiquity and the Middle Ages

Since the author does not claim to have read all the works given below, and since they are either easily accessible or specified in the notes, only the titles are given.

Abû Màsar. *Introduction to Astrology.*
Alexander of Hales. *De pulchritudine universo.*
Alhazen (Ibn al-Haytham). *De aspectibus,* or *Perspectiva.*
Al-Kindi. *De radiis stellarum.*
— *De aspectibus.*

Al-Razi. *Liber ad Almansorem.*
Albertus Magnus. *De homine.*
Anonymous. *Of the Constitution of the Universe and of Man.*
— *Picatrix*
— *Le Roman de la Rose.*
Aristoteles. *Categoriae.*
— *De anima.*
— *De caelo.*
— *De generatione animalium.*
— *De generatione et corruptione.*
— *De partibus animalium.*
— *De sensu.*
— *Ethica Nicomachea.*
— *Metaphysica.*
— *Meteorologica.*
— *Physica.*
— *Physiognomonica.*
— *Poetica.*
— *Politica.*
— *Posteriora analytica.*
Ps-Aristoteles. *De mundo.*
— *Mekanika'.*
— *Problemata.*
Augustinus, Aurelius. *De genesi ad litteram.*
— *De musica.*
— *De ordine.*
— *De trinitate.*
— *Epistola.*
Averoës. *Epitome of the Parva naturalia.*
Bacon, Roger. *De multiplicatione specierum.*
— *Opus maius.*
Boëthius, Anicius Manilus Torquatus. *De musica.*
Cicero, Marcus Tullius. *De Brute.*
— *De inventione.*
— *De natura deorum.*
— *De optimo genere oratorum.*
— *De oratore.*
— *Tusculanarum disputationum.*
Demetrius Phalereus. *De elocutione.*
Ps-Dionysius Areopagita. *Confessiones.*
— *Corpus Areopagiticum.*
— *De coelesti hierarchia.*
— *De divisione nominibus.*
Dionysius of Halicarnassos. *De priscis.*
Epicurus. *Letter to Herodotus.*
Eraclius. See Lebègue ca 1410.
Euclides. *Optica.*
Galenus, Cladius. *De colore.*
— *De placitis Hippocratis et Platonis.*
— *De usu partium. (De utilitate particularum).*
— *In Hippocratis librum de humoribus.*
— *Protrept. ad artes.*

Gellius. *Noctes Atticae.*
George of Trebizond. *De suavitate dicendi ad Hieronymum Bragadendum.*
Grosseteste, Robert. *De iride.*
Henry of Langenstein. *Qustiones super perspectivam.*
Hero of Alexandria. *Catoptrica.*
Hieronymus Stridonensis, Eusebius. *Epistolarium.*
Hippocrates. *Aphorisms.*
— or Polybus. *On the Nature of Man.*
Horatius Flaccus, Quintus. *Ars poetica.*
— *Ode.*
Hugo of St. Victor. *Didascalon.*
Isidore of Sevilla. *Etymologarium.*
Johannes Scotus Eriugena. *Expositiones I.S. super ierarhia coelesti S. Dionysii.*
Lucianus Samosatensis. *De domo.*
— *Zeuxis* or *Antiochus.*
Lucretius Carus, Titus. *De rerum natura.*
Macrobius, Aurelius Ambrosius Theodosius. *Commentarius in Somnium Scipionis.*
Oresme, Nicole. *De visione stellarum.*
Ovidius Naso, Publius. *Ars amatoria.*
— *Metamorphoses.*
Pecham, John. *Perspectiva communis.*
Philostratus the Younger. *Imagines.*
Philostratus the Elder. *Life of Apollonius of Tyana.*
Platon. *Hippias Major.*
— *Ion.*
— *Laws.*
— *Meno.*
— *Nomoi.*
— *Phaidros.*
— *Philebos.*
— *Republica.*
— *Sophist.*
— *Theatetus.*
— *Timaeus.*
Plinius Secundus, Gajus. *Naturalis Historia.*
Plotius. *Enneades.*
Plutarchus. *De amic. mult.*
— *Moralia.*
Polybus. See Hippocrates.
Ptolemaeus, Claudius. *Almagest.*
— *Cosmographia.*
— *Optica.*
— *Tetrábiblos.*
Quintillianus, Marcus Fabius. *De institutione oratoriae.*
da Sassoferrato, Bartolo. *Tractatus de insignis et armis.*
Seneca, Lucius Annaeus. *De brevitate vitae.*
Solinus, Cajus Julius. *Collectanea rerum memorabilium.*
Theodric Teutonicus de Vriberg. *De radialibus impressionibus.*
Theophrastus. *De coloribus.*
— *On the Causes of Plants.*
Theophilus Rugerus. *Diversarum Artium Scedula.*
Thomas ab Aquino. *In libros De anima expositio.*

— *Sent.*
— *Summa Theologiae.*
Trismegistus, Hermes. *Corpus Hermeticum. (Asclepius, Pimander).*
Vitello, Erasmus. *Perspectiva.*
Vitruvius Pollio, Marcus. *De architectura libri decem.*
— *De re aedificatoria.*
William of Conches. *Glossae super Platonem.*
— *Dragmaticon.*
— *Philosophia mundi.*
William of Ockham. *Commentary on the Sentences of Peter Lombard.*
Xenophon. *Memorabilia.*

## B. Renaissance Sources and Source Literature

When known, the indicated year refers—as in the text and the notes—to the actual time or origin. Barocchi is abbreviated "Bar.", Quellenschriften für Kunstgeschichte und Kunsttechnik des Mittelalters und der Renaissance", ed. R. Eitelberver von Edelberg, Wien 1871—. N.F., ed. A. Ilg, Wien 1888—, abbreviated "Quellens."

Adriani, Giovan Battista 1568. *A Giorgio Vasari.* In Vasari 1568, ed. 1878— I.
Agrippa of Nettesheim, Heinrich Cornelius 1530. *De incertitudine et vanitate scientiarum et artium.* Anversa. Venice 1547, 1549.
— 1531. *De occulta philosophia libri iii.* In *Opera omnia.* Lugduni.
Agucci, Giovan Battista ca 1610. *Trattato.* Partly in Mahon 1947 and Gombrich 1963.
Alciati, Andrea 1531. *Emblemata.* Augsburg. Paris 1542, Lyon 1557.
Alberti, Leon Battista 1435. *De Pictura.* Ed. C. Grayson, London 1972.
— 1436. *Della Pittura.* Ed. H. Janitschek, in "Quellens", XI. Wien 1877. Ed. L. Mallè, Firenze 1950. Ed. J. R. Spencer, New Haven (Conn.)-London (1956) 1967. Cf. Siebenhüner 1935, Clark 1945, Stokes 1954, Edgerton 1966, *ibid.* 1969, Gadol 1969.
— ca 1464. *De statua.* Ed. C. Grayson, London 1972.
Alberti, Romano 1585. *Trattato della nobiltà della pittura...* Roma. Ed. Bar. 1960— I.
— 1604. *Origine e progresso dell'Academia del Dissegno...* Pavia. Partly in Bar. 1971— I, II.
Aldrovandi, Ulisse ca 1582. *Modo di esprimere per la pittura tutte le cose dell' universo mondo.* Ined. MS Bologna B. 244; partly in Bar. 1971— I.
Alghieri, Dante ca 1310—20. *Paradiso,* from *Divina Comedia.*
Allori, Alessandro ca 1590. *Ragionamenti della regola del disegno.* Codex Pal. E.B. 16.4., Bibl. Naz. Firenze; partly in Bar. 1971— II.
Ammanti, Bartolomeo 1582. *Lettere agli accademici del disegno.* Firenze. Ed. Bar. 1960— III.
Anonyme. *Il Codice Magliabecchiano.* Ed. C. Frey, Berlin 1892.
— *MS Bologna* ca 1425—50. Ed. Merrifield (1849) 1967 II.
— *MS Marciana* ca 1503—27. Ed. Merrifield (1849) 1967 II.
— *MS Padua* ca 1580. Ed. Merrifield (1849) 1967 II.
Aquilano, Serafino ca 1500. *Sonetto.* In Cian 1894 and Bar. 1971— II.
Aretino, Pietro 1540, -45, -51, -54. *Lettere.* In Gaye 1839—40. Ed. E. Camesasca. 4 vols. Milano 1957—60. Cf. Sandström 1964; *ibid.* 1968, Klein-Zerner 1966, Bar. 1971— I.
Armenini, Giovan Battista 1586. *De'veri precetti della pittura.* Ravenna. Partly in Bar. 1971— I, II.

Averlino, Antonio see Filarete 1451—64.
de'Barbari, Iacopo ca 1501. *De la ecelentia de pictura.* Partly in Bar. 1971— I.
Barbaro, Daniele 1556. *I dieci libri dell'architettura di M. Vitruvio, tradutti et et commentati da M.B.* Venezia. Partly in Bar. 1971— II.
Beffa Negrini, Antonio. *Sonetto.* In Calli 1595.
Beffa, Giacomo. *Sonetto.* In Calli 1595.
Billi, Antonio ca 1520. Ed. C. Frey, Berlin 1892. *Il libro di A.B. esistente in due copie nella Bibl. Naz. di Firenze.*
Biondo, Michelangelo 1549. *Della nobilissima pittura e della conseguirla agevolmente e presto*... Vinegia. In "Quellens." 1873. Partly in Bar. 1971— I.
da Bisticci, Vespasiano ca 1490. *Vite di uomini illustri.* Ed. P. d'Ancona—P. Aeshlimann, Milano 1951.
Boccaccio, Giovanni. *Il Commento alla Divina Comedia.*
— ca 1350. *Decamerone.*
— *Genealogia deorum.*
Bocchi, Francesco 1584. *Eccellenza del San Giorgio di Donatello.* Fiorenza. Ed. Bar. 1960— III.
— 1592. *Opera di M.F.B. sopra l'imagine miracolosa della santissima Nunziata di Fiorenza.* Firenze. Partly in Bar. 1971— I.
Borghini, Rafaele 1584. *Il Riposo.* Ed. "Classici Italiani" 1807, 3 vols. Firenze. Partly in Bar. 1971— II.
Borghini, Vincenzo ca 1560. *Sulla disputa circa il primato delle arti.* Selva di notizie, Kunsthistorisches Institut K 383 16 nr 60765. Partly in Bar. 1971— I.
Borromeo, Carlo 1577. *Instructiones fabricae et supellictis ecclesiasticae.* Milano. Ed. Bar. 1960— III.
Bronzino, Agnolo 1547. *Lettera a Varchi.* Ed. Bar. 1960— I.
Calli, Antonio 1595. *Discorso de'colori di A.C., lettione degna e piacevole.* Padova. Partly in Bar. 1971— II.
Carbone, Lorenzo 1575. *Sonetto.* In Calli 1595.
Cardano, Girolamo 1563. *De gemmis et coloribus.* In *Hieronymi Cardani Mediolanensis*... *operum* II. Lugduni. Partly in Barasch 1963.
Castelvetro, Lodovico ca 1567—71. In *Opere varie critiche,* Bern 1727. Partly in Bar. 1971— I.
— 1567. *Poetica d'Aristotele volgarizzata e sposta per L.C.* Basilea. Partly in Bar. 1971— II.
Castiglione, Baldesare 1528. *Il Cortegiano.* Venezia. Ed. Cian, Firenze 1947.
Celio, Gaspare ca 1610. *Memoria.* Napoli 1638. Partly in Abbate 1965.
Cellini, Benevuto 1547. *Lettera a Varchi.* Ed. Bar. 1960— I.
— 1564. *Disputa infra la scultura e la pittura*... In *Oratione o vero Discorso de M. Giovan Tarsia*... Fiorenza.
— *Sonetti.* In *Opere,* ed. B. Maier, Milano 1968. Partly in Bar. 1971— II.
Cennini, Cennino ca 1400. *Il libro dell'arte.* Ed. F. Brunello, Vicenza 1971. Cf. Venturi 1925.
Cirillo, Bernardino 1549. *Lettera sulla riforma della musica di chiesa*... *al Cav. Ugolino Guastenezzo.* In Bar. 1971— I.
Comanini, Gregorio 1591. *Il Figino overo del fine della pittura.* Mantova. Ed. Bar. 1960— III.
Condivi, Ascanio 1553. *Vita di Michel Angelo Buonarotti.* Roma. Ed. R. Eitelberg von Edelberg. "Quellens." Wien 1874.
Contile, Luca 1574. *Ragionamento delle imprese.* Pavia.
Coscia, Giovanni 1594. *Discorso.* In R. Alberti 1604.
Cusanus, Nicolaus 1450. *De idiota.*

— 1459. *De aequalitate.*

Daniello, Bernardino 1536. *Della Poetica.* Vinegia.

Danti, Egnazio 1573. *La prospettiva di Euclide . . . colla prospettiva di Eliodoro Larisseo.* Firenze.

Danti, Vicenzio 1567. *Il primo libro del trattato delle perfette proporzioni.* Firenze. Ed. Bar. 1960— I.

Delminio, Giulio Camillo 1579. *L'Idea del Teatro.* In *L'Opere del M.G.C.* Delminio. Venezia. Partly in Bar. 1971— II.

Dolce, Lodovico 1557. *Dialogo della pittura, intitolato l'Aretino . . .* Vinegia. Ed. Bar. 1960— I. Ed. M.W. Roskill (*Dolce's "Aretino" and Venetian Art Theory of the Cinquecento*) New York 1968.

— 1565. *Dialogo di M.L.D. nel quale si ragiona delle qualità, diversità e proprità dei colori.* Venezia. Partly in Bar. 1971— II.

Doni, Anton Francesco 1547. *Lettere del Doni.* Firenze. Partly in Bar. 1971— II.

— 1549. *Disegno partito in più ragionamenti.* Venezia. Partly in Bar. 1971— I.

Ebreo, Leone (Giuda Abarbanel) ca 1501. *Dialoghi d'amore.* Roma 1535. Ed. S. Caramella, Bari 1929. Partly in Bar. 1971— II.

Equicola, Mario 1526. *Libro di natura d'amore.* Venezia. Partly in Bar. 1971— II.

— ca 1525. *Discorsi della pittura.* In *Institutioni di M.E.* Milano 1541. In Bar. 1971— I.

Ficino, Marsiglio 1469. *Sopra lo amore over Convito di Platone.* Firenze 1544. Ed. G. Rensi, Lanciano 1919. Partly in Panofsky (1924) 1968. Cf. Chastel 1954, Walker 1958.

— 1470. *Teologia Platonica.* (rev. 1482)

— 1489 (a). *De divino furore.*

— 1473. *De christiana religione.*

— 1496. *Comm. in Jonem.*

— 1489 (b). *De triplici vita.*

Filarete, Antonio Averlino 1451—63. *Trattato d'architettura.* Ed. W. von Oettingen (*A.A. Filarete's Tractat über die Baukunst*). In "Quellens." N.F. III Wien 1896.

della Francesca, Piero 1482. *De prospectiva pingendi.* Ed. G.N. Fasola, Firenze 1942. Cf. Siebenhüner 1935, Stokes 1944, Clark 1951, Gilbert 1968.

della Frata, Antonio 1551. *Il nobile; ragionamento di nobilità.*

Galilei, Galileo 1612. *Lettera a Lodovico Cigoli.* In Bar. 1971— I. Cf. Panofsky 1956.

Galileo, Vincenzo 1589. *Discorso di V.G. . . . intorno all'opere di M. Gioseffo Zarlino.* Fiorenza. In Bar. 1971— I.

Gauffurio, Franchino 1469. *Practica musicae utriusque cantus.* 1502.

— 1480. *Teoricum opus.*

— 1508. *Angelicum ac divinum opus musicae F.G.*

— 1518. *De harmonia musicorum instrumentorum.*

Gaurico, Pomponio 1504. *De sculptura.* Ed. H. Brockhaus, Leipzig 1886. Ed. A. Chastel-R. Klein, Genève-Paris 1969.

Gelli, Giovambattista 1551. *Tutte le lettioni fatte nell'Accademia Fiorentina.* Firenze. Partly in Bar. 1971— I.

Ghiberti, Lorenzo ca 1450. *I commentarii.* Ed. J. von Schlosser, (*Denkwürdigkeiten*), 2 vols., Berlin 1912.

Gilio, Giovanni Andrea 1564. *Due dialogi . . .* Camerino. Partly in Bar. 1971— I.

Giorgi, Francesco 1525. *De harmonia mundi totius cantica tria.* Venezia.

Giovio, Paolo ca 1523—27 (a). *Leonardo da Vinci Vita.* In Bar. 1971— I.

— ca 1523—27 (b). *Fragmentum Trirum Dialogorum.* In Bar. 1971— I.

Grazzini, Anton Francesco. See il Lasca.

Guarino Veronese ca 1450. *Epistolario.* Ed. R. Sabbadini. 2 vols. Venezia 1915 —19.

Lamo, Alessandro 1584. *Discorso intorno alla scultura e pittura.* Cremona. Partly in Klein-Zerner 1966.

Lancilotti, Francesco 1509. *Tractato di Pictura...* Roma. Partly in Bar. 1971— I.

Landilucci, Luca. *Diario.* Partly in Klein-Zerner 1966.

Landino, Cristoforo 1476. *Historia naturale di C. Plinio secondo tradocta di Lingua Latina in Fiorentina.* Venezia.

il Lasca (Anton Francesco Grazzini) ca 1560. *Rime.* Ed. C. Verzone, *Le rime burlesche edite e inedite di A.G., detto il Lasca,* Firenze 1882.

Lebègue, Jean ca 1410. *MS.* Bibl. Royal, Paris nr. 6741. In Merrifield (1849) 1967. Cf. Stechow 1966.

Leonardo da Vinci ca 1490—1510. *Trattato della pittura; Cod. Urb. Lat 1270.* Ed. H. Ludwig (*Das Buch von der Malerei*), "Quellens." XV—XVIII, Wien 1882. Ed. A. Chastel-R. Klein (*Traité de la peinture*), Paris 1960. Ed. A.P. McMahon (*Treatise of Painting*), 2 vols., Princeton 1956. Cf. Richter (1883) 1970, Gould 1947, Clark 1952, Heydenreich 1953, Agostini 1954, Rzepinska 1962, Zubov 1968, Stites 1970, Bar. 1971— I, II, Posner 1974, Ost 1975.

— *On Painting. A Lost Book (Libro A.)* Ed. C. Pedretti, Berkeley-Los Angeles 1964.

Ligorio, Pirro ca 1560—70. *Trattato di alcune cose appartenente alla nobilità dell'antiche arti e massimamente de la pittura, de la scultura e dell'architettura.* MS Torino, J.a. II. 16. vol XXIX. Partly in Bar. 1971— I.

Lomazzo, Gian Paolo ca 1564. *Libro dei sogni.* MS British Museum, Add. 12196. Ed. R. P. Ciardi 1973— I.

— 1584. *Trattato dell'arte della pittura.* Milano. Ed. R. P. Ciardi 1973— II.

— 1590. *Idea del tempio della pittura.* Milano. Ed. R. P. Ciardi 1973— I.

Maranta, Bartolomeo ca 1550—70. *Discorso... in materia di pittura.* MS Napoli II. c. 5. Partly in Bar. 1971— I.

Marino, Giovan Battista 1604. *Lettere.* In Abbate 1965.

Maurolico, Francesco ca 1575. *Photismi de lumine et umbra.* Napoli 1611.

Mazzoni, Iacopo 1587. *Della difesa della Comedia di Dante...* Cesena.

Michelangelo Buonnaroti 1547. *Lettera a Varchi.* Ed. Bar. 1960— I. Cf. d'Olanda 1548, Condivi 1553, Vasari 1568; Clements 1961, Bar. 1962, Frey 1964, Tolnay 1964.

Michiel, Marcantonio ca 1550. *Notizie d'opera del disegno.* Partly in Klein-Zerner 1966.

Molano, Giovanni 1570. *De picturibus et imaginibus sacris liber unus.* Lovanii.

Morato, Fulvio Pellegrini 1535. *Del significato dei colori...* Vinegia. Partly in Bar. 1971— II.

Nifo, Agostino 1529. *A.N. medicis libro duo. De pulchro primus. De amore secundus.* Padova. Partly in Klein-Zerner 1966 and Bar. 1971— II.

Occolti, Coronato 1568. *Trattato de'colori.* Parma. Partly in Bar. 1971— II.

d'Olanda, Francesca 1548. *Da pintura antigua.* Partly in Bar. 1971— I, II.

Pacioli, Luca 1497. *Divina proportione.* Venetiis 1509. Ed. C. Winterberg, "Quellens." N.F. II, Wien 1889. Partly in Bar. 1971— I.

— 1507. *De v corporibus regularibus.* Venetiis.

Paggi, Giovanni Battista 1591. *Lettere al fratello Girolamo.* In Bar. 1971— I.

Paleotti, Gabriele 1582. *Discorso intorno alla imagini sacre e profane...* Bologna. Partly in ed. Bar. 1960— II.

Petrarcha, Francesco ca 1354—66. *De remediis utriusque fortunae.* Partly in Baxandall 1971.
— *De statuis.*
— *Commento al Dell'amore celeste e divino di Giordano Benivieni,* Lucca 1731. Partly in Bar. 1971— II.
Pico della Mirandola 1493—94. *Disputationes adversus astrologiam divinatricem.* Piero. See della Francesca.
Pino, Paolo 1548. *Dialogo di pittura*... Vinegia. Ed. Bar. 1960— I. Cf. Gilbert 1946, *ibid.* 1968.
Pontormo, Iacopo 1547. *Lettera a Varchi.* Ed. Bar. 1960— I.
Portio, Simone 1548. *De coloribus libellus.* Florentiae.
Possevino, Antonio 1595. *A.P. Societatis Iesu Tractatio de Poësi et Pictura*... Lugduni. Partly in Bar. 1971— I.
Rafaello Sanzio ca 1514. *Lettera a Castiglione.* In ed. E. Camesasca (*Tutti gli scritti*), Milano 1956; Klein-Zerner 1966; Bar. 1971— II.
de'Rinaldi, Giovanni 1582. *Il monstruissimo mostro di G. de'R., diviso in due trattati, nel primo de'quali si ragiona del significato de'colori*... Ferrara; Venezia 1592. Partly in Bar. 1971— II.
Risnerus, Fredericus 1572. *Optica thesaurus Alhazeni Arabis libri septem*... Basilea.
da Sangallo, Francesca 1547. *Lettera a Varchi.* Ed. Bar. 1960— I.
Sanudo, Marino before 1533. *Sonetto.* In Cian 1894.
Savonarola, Girolamo 1497. *Trattato contro gli astrologi.*
Sicillo, Bernardo ca 1450. *Trattato dei colori nelle arme, nelle livree e nelle divise di S., araldo del re Alfonso d'Aragona.* Venezia 1565. Partly in Bar. 1971— II.
Sorte, Christoforo 1580. *Osservazioni nella pittura.* Venezia. Ed. Bar. 1960— I.
Speroni, Sperone, ca 1570—80. *Discorso in lode della pittura.* Partly in Bar. 1971— I.
— 1596. *Dialogo della Rhetorica.* In *Dialogi del Sig. S.S.* Venezia. In Bar. 1960— I.
Tasso, Bernardo 1547. *Lettera a Varchi.* Ed. Bar. 1960— I.
Tasso, Torquato. *Lezione del Sig. T.T. sopra il sonetto LIX di M.G. della Casa.* In *Opere di G. della C.,* Firenze 1707. Partly in Gilbert 1946.
Telesio, Antonio 1528. *A.T. de coloribus libellus*... Ventiis. In Goethe ed. 1963.
Telesio, Bernardino 1570. *De colorum generatione opusculum.* Neapoli.
Tiziano Vecellio 1516. *Lettera.* In Gaye 1839—40; Klein-Zerner 1966.
Trent 1563. *Canons and Decrees of the Council of Trent,* the 25th session. In Klein-Zerner 1966.
Tribolo, Nicolo 1547. *Lettera a Varchi.* Ed. Bar. 1960— I.
Vasari, Giorgio 1547. *Lettera a Varchi.* Ed. Bar. 1960— I.
— 1564. *Bozzetto a Le vite*... *1568.* MS Firenze "Lettere artistiche di diversi," II, 3 nr 2. In Bar. 1971— II.
— 1568. *Le vite de'più eccellenti Pittori, Scultori ed Architetti.* Firenze. Ed. G. Milanesi, 7 vols., Firenze 1878—85.
Varchi, Benedetto 1545. *Sopra il primo canto del Paradiso di Dante.* In *Opera di B.V.,* Trieste 1858—59, II.
— 1547. *Lezzioni*... *della maggioranza delli arti.* Firenze. Ed. Bar. 1960— I.
— 1549 (a). *Lezione sopra un sonetto di Michelangelo.* In *Due lezzioni di M. V*... Firenze.
— 1549 (b). *Libro della beltà e grazia.* In *Lezzioni di M.B.V*... Firenze 1590. Ed. Bar. 1960— I.

— 1564 (a). *Funeral Oration to Michelangelo.* Firenze. Ed. A. Ilg, "Quellens." Wien 1874.

— 1564 (b). *Dell'Amore.* In *Opere di B.V.,* Trieste 1858—59, II.

Vecchio, Orazio 1597. *Amfiparnaso, comedia harmonica d'Horatio V. da Modena.* Venetia. Partly in Bar. 1971— I.

Vellutello 1545. *Commentary on Petrarch.*

De'Vieri, Francesco 1586. *Discorsi di M.F. de'V., detto il Verino Secondo.* Firenze. Partly in Bar. 1971— I.

Villani, Filippo 1381—82. *De origine civitatis Florentiae et eiusdem famosis civibus.* Partly in Baxandall 1971. Cf. Venturi 1925, Panofsky 1960.

Zarlino, Giuseffo 1558. *Institutione armoniche.* Venezia.

— 1588. *Sopplimenti musicali del Rev. M.G.Z. da Chioggia . . .* Venezia.

Zuzzari, Federigo 1605. *Lettera a prencipi e signori amatori del disegno, pittura, scultura et architettura . . .* Mantova. In Bar. 1971— I.

— 1607. *Idea de'pittori, scultori et architetti . . .* Torino. Partly in Bar. 1971— I.

### B 2. Literature

When reprints or late editions are used, the year of the original edition is given in brackets. Names in capitals indicate who is treated in the works. The following abbreviations are used: "20th Int. Congr." for "Acts of the 20th International Congress of the History of Art (1961) 1963"; "Burl.Mag." for "Burlington Magazine"; "G B-A" for "Gazette des Beaux-Arts"; "J.A.A." for "the Journal of Aesthetics and Art Criticism"; "J.W.C." for "the Journal of the Warburg and Courtauld Institute." The following encyclopedias have been consulted: A Dictionary of Symbols, 2nd ed. J. E. Cirlot London 1971; Dictionnaire des Symbols, ed. J. Chevalier-A. Gheerbrandt, Paris 1969; Encyclopedia of World Art, 15 vols. (Rome 1958—) London 1959—; Enciclopedia Dantesca, 5 vols., Roma 1970—76; Enciclopedia dell'arte antica, 7 vols., Roma 1958—66; Lexikon der Christlischen Ikonongraphie, Rome-Freiburg-Basel-Wien, 1968— II 1970.

Abbate, F. 1965. *Idee cinquecentesche e seicentesche sul restauro.* In "Paragone", 181.

Ackerman, J. 1964. *The Structure of LOMAZZO'S Treatise on Painting.* (Diss.). Michigan.

— 1967. *LOMAZZO'S Treatise on Painting.* In "Art Bulletin" XLIX.

Agostini, A. 1954. *Le prospettive e le ombre nelle opere di LEONARDO DA VINCI.* Pisa.

von Allesch, G. J. 1925. *Die ästhetische Erscheinungsweise der Farbe.* In "Psychologische Forschung", Bd. 6. Berlin.

Althofer, H. 1962. *Die Retusche in der Gemälderestaurierung.* In "Museumskunde" XXXI.

Ames, A. J:r. 1925. *Depth in Pictorial Art.* In "Art Bulletin" VIII nr 1.

André, J. 1949. *Étude sur les terms de couleur dans la langue latin.* Paris.

Arentz, E. 1953. *Lyset og farven i kunsten* (Light and colour in the art). Oslo.

Arnheim, R. (1956) 1972. *Art and Visual Perception.* London.

Baeumker, C. 1908. *WITELO, ein Philosoph und Naturforscher des XIII. Jahrhunderts.* In "Beiträge zur Geschichte der Philosophie des Mittelalters", Bd. III, Heft 2. Münster.

Baldwin Brown, G. (1907) 1960. *VASARI on Technique.* New York.

Barasch, M. 1960. *Licht und Farbe in der Italienische Kunsttheorie des Cinquecento.* In "Rinascimento" 2.

171

— 1963. *The Colour Scale in Renaissance Thought.* In "Romanica et Occidentalia." Jerusalem.
Barocchi, P. 1958. *Finito e non-finito nella critica vasariana.* In "Arte antica e moderna."
— 1960—62. (Ed.) *Trattati d'arte del Cinquecento,* 3 vols. Bari.
— 1962. *La vita di Michelangelo nelle redazioni del 1550 e del 1568.* Milano-Napoli.
— 1971—73. (Ed.). *Scritti d'arte del Cinquecento.* 2 vols. Verona.
Baxandall, M. 1971. *Giotto and the Orators.* Oxford.
— 1972. *Painting and Experience in Fifteenth Century Italy.* Oxford.
Bayer, R. 1933. *LÉONARD DE VINCE. La Grâce.* Paris.
von den Bercken, E. 1928. *Über einige Grundprobleme der Geschichte des Kolorismus in der Malerei.* In "Münchner Jahrbuch der bildenden Kunst" Bd. V.
Berefelt, G. 1966. *On 'Symbol' and 'Allegory'.* In "Konsthistoriska studier tillägnade Sten Karling." Stockholm.
— 1976. *ABSe om bildperception* (ABSee of the perception of images). Stockholm.
Bialostocki, J. 1963. *The Renaissance Concept of Nature and Antiquity.* In "20th Int.Congr." II, Princeton.
Birsch-Hirschfelt, K. 1912. *Die Lehre von der Malerei in Cinquecento.* Rome.
Blunt, A. 1940. *Artistic Theory in Italy 1450—1600.* Oxford.
Bouché-Leclercq, A. 1899. *L'Astrologie Grecque.* Paris.
Bourke, V. J. 1960. *Selections from the writings of ST. THOMAS.* New York.
Brandi, C. 1949. *The Cleaning of Paintings in Relation to Patina, Varnish and Glazes.* In "Burl.Mag." XCI.
— 1953. *Il Restauro secondo l'Istanza Estetica.* In "Bolletino dell'Istituto Centrale del Restauro" XIII.
— 1963 (a). *Teoria del restauro.* In "Edizioni di Storia e Letteratura." Roma.
— 1963 (b). *Il trattamento delle lacune e la Gestalt-psychologie.* In "20th Int. Congr." IV. Princeton.
Brunello, F. 1971. See CENNINI ca 1400.
Butcher, S. H. 1951. *ARISTOTLE'S Theory of Poetry and Fine Art.* New York.
Champetier, G. 1962. *Physique des peintures, vernis et pigments.* 2 vols. Paris.
Chastel, A. 1954. *MARSILE FICIN et l'art.* Genève-Lille.
— 1959. *Le fragmentaire, l'hybride et l'inachevé.* In "Das Unvollendete als Künstlerische Form" Bern-München 1959.
Chevreul, M. E. 1839. *De la loi du contraste simultané des couleurs.* Partly in Holt (1947) 1957 III.
Cian, V. 1894. *Del significato dei colori e dei fiori nel Rinascimento italiano.* In "Gazetta Letteraria" 13, 14.
Ciardi, R. P. 1973-1974. Ed. *GIAN PAOLO LOMAZZO: Scritti sulle arti.* In "Raccolta Pisani di saggi e studi" 33, 34. 2 vols. Firenze.
Clark, K. 1938. *The aesthetics of restoration.* In "Proceedings of the Royal Institution of Great Britain" XXX No 141. London.
— 1945. *LEON BATTISTA ALBERTI on Painting.* In "Proceedings of the British Academy" XXX. London.
— 1951. *PIERO DELLA FRANCESCA.* London.
— 1952. *LEONARDO DA VINCI. An Account of his Development as an Artist.* Cambridge.
Clements, R. J. 1961. *MICHELANGELO'S Theory of Art.* New York.
Condrad, K. 1959. *Das Problem der Vorgestaltung.* In "Das Unvollendete als Künstlerische Form". Bern-München.

Crantz, F. E. 1976. *Lecture(s) du "De anima" à la Renaissance*. In "Platon et ARISTOTE à la Renaissance". Paris.

Dampier, W. C. 1948. *A History of Science*. Cambridge.

Dejob, C. 1884. *De l'influence du Concile de Trente sur la Littérature et les Beaux-Arts chez les peuples Catholiques*. Paris.

Diels, H.-Krantz, W. 1951—52. *Fragmente der Vorsokratiker*. 3 vols. Berlin.

ten Doesschate, G. 1962. *Oxford and the Revival of Optics in the Thirteenth Century*. In "Vision Research" I.

Dresden, S. 1976. *Platonisme et "non-finito."* In "Plato et Aristote à la Renaissance". Paris.

Dresdner, A. (1915) 1968. *Die Entstehung der Kunstkritik*. München.

Düring, I. 1966. *ARISTOTELES. Darstellung und Interpretation seines Denkens*. Heidelberg.

Edgerton, S. Y. J:r. 1966. *ALBERTI'S Perspective. A New Discovery and a New Interpretation*. In "Art Bulletin" XLVIII.

— 1969. *ALBERTI'S Colour Theory: a Medieval Bottle without Renaissance Wine*. In "J.W.C." XXXII. London.

Ehrenfeld, S. 1907, 1908, 1909. *Farbenbezeichnungen in der Naturgeschichte*. In "Jahresbericht des K.K. Deutschen Staatsgymnasiums zu Prag."

von Einem, H. 1959. *Unvollendetes und Unvollendbares im Werk Michelangelos*. In "Das Unvollendete als Künstlerische Form" Bern-München.

Elliott, E. C. 1958. *On the Understanding of Colour in Painting*. In "J.A.A." XVI nr 4.

Emond, T. 1964. *On Art and Unity*. (Diss.). Lund.

Evans, R. M. 1948. *An Introduction to Color*. New York.

— 1974. *The Perception of Color*. New York-London.

Ferri, S. 1946. Ed. *PLINIO IL VECCHIO: storia delle arti antiche*. Roma.

Frey, C. 1964. *Die Dichtungen des MICHELANGELO BUONAROTTI*. Berlin.

Frey, D. 1946. *Die Realitätscharakter des Kunstwerkes*. In "Kunstwissenschaftliche Grundfragen." Wien.

Gadol, J. 1969. *LEON BATTISTA ALBERTI—Universal Man of the Early Renaissance*. Chicago.

Gantner, J. 1958. *LEONARDO'S Visionen von der Sintflut und vom Untergang der Welt*. Bern.

— 1959. *Formen des Unvollendeten in der neueren Kunst*. In "Das Unvollendete als Künstlerische Form" Bern-München.

— 1969. *Die Farben im Werke Leonardos*. In "palette" nr 32.

Gaye, G. 1839—40. *Carteggio inedito d'artisti dei secoli XIV, XV, XVI*. 3 vols. Firenze.

Gettens, R. J.—Stout, G. L. (1942) 1966. *Painting Materials*. New York.

Gifford, E. S. 1958. *The Evil Eye*. New York.

Gilbert, C. E. 1946. *Antique Frameworks for Renaissance Art Theory: ALBERTI and PINO*. In "Marsyas" III 1943—1945. New York.

— 1968. *Change in PIERO DELLA FRANCESCA*. New York.

Gilbert, K. E.-Kuhn, H. (1939) 1972. *A History of Esthetics*. New York.

Gilson, E. 1955. *History of Christian Philosophy in the Middle Ages*. New York.

— 1957. *Painting and Reality*. New York-London.

Goethe, J. W. (1810) 1963. *Materialen zur Geschichte der Farbenlehre. Erster Teil*. Ed. d.t.v. Gesamtausgabe bd. 41. München.

— (1810) 1976. *Zur Farbenlehre*. Ed., notes and transl. to Swedish by P. Sällström. Stockholm.

Gombrich, E. H. 1954. *LEONARDO's Grotesque Heads*. In "Leonardo. Saggi e ricerche." Roma.

— (1960) 1972. *Art and Illusion*. London. (Swedish ed. 1972).

— 1962 (a). *Blurred Images and the Unvarnished Truth*. In "The British Journal of Aesthetics" II nr 2.

— 1962 (b). *Dark Varnishes: Variations on a Theme from Pliny*. In "Burl.Mag." XCII.

— 1963 (a). *Controversial Methods and Methods of Controversy*. In "Burl.Mag." CV.

— 1963 (b). *Introduction to "20th Int.Congr."* 1961, I.

— 1971. *Visual Methaphors of Value in Art (1963)*. In "Meditations on a Hobby Horse." London.

Gomperz, T. 1922—31. *Griechische Denker*. 3 vols. Berlin-Leipzig.

Gould, C. 1947. *LEONARDO DA VINCI'S Notes on the Colour of Rivers and Mountains*. In "Burl.Mag." Sept.

— 1974. *Space in Landscape*. In "Themes and Painters in the National Gallery" nr 9. London.

Van de Graaf, J. A. 1962. *The Interpretation of Old Painting Recipes*. In "Burl. Mag." CIV.

Grabar, A. 1945—47. *PLOTIN et les origines de l'esthétique médiévale*. In "Cahiers Archéologiques" I.

Grassi, E. 1962. *Die Theorie des Schönen in der Antike*. Köln.

Grassi, L. 1957. *Concetti di schizzo, abbozzo, macchia, "non-finito" e la construzione dell'opera d'arte*. In "Studi in onore di Pietro Silva." Firenze.

Grayson, C. 1953. *Studi su LEON BATTISTA AIBERTI*. In "Rinascimento" IV.

Grunewald, M. 1912. *Die Entwicklung des Karnationskolorites in der Venezianischen Malerei von den Anfängen bis auf Tiepolo*. (Diss.). Berlin.

Guthrie, W. K. C. 1971—75. *A History of Greek Philosophy*. 4 vols. Cambridge.

Hauser, A. 1951. *The Social History of Art*. 2 vols. New York.

Hautecoeur, L. 1972—73. *L'Artiste et son oeuvre*. "G.B-A." 2 vols.

Heaton, M. 1968. *Phenomenology and Psychology of Function and Disorder*. London.

Hendy, Ph. 1963. *Taste and Science in the Presentation of Damaged Pictures*. In "20th Int. Congr." IV. Princeton.

Hering, E. 1878. *Zur Lehre vom Lichtsinne*. Wien.

Hesselgren, S. (1952), 1969. *Färgatlas*. (Colour Atlas). Stockholm.

— 1954. *Subjective Color Standardization*. Stockholm.

Hetzer, T. 1935. *TIZIAN. Geschichte seiner Farbe*. Frankfurt a.M.

Heydenreich, L. H. 1953. *LEONARDO DA VINCI*. 2 vols. Basel.

Holt, E. G. (1947) 1957. Ed. *A Documentary History Of Art*. 3 vols. Princeton.

Hoppe, E. 1926. *Geschichte der Optik*. Leipzig.

Hospers, J. 1946. *Meaning and Truth in the Arts*. Chapel Hill.

Huyghe, R. 1962. *Art and the Spirit of Man*. London.

Hård, A. *Färgsystematik*. (Colour Systematization). "Svenskt Färgcentrums Fackskrift" nr 10.

— 1975. *NCS: A Descriptive Colour Order and Scaling System with Application for Environment Systems*. In "Man—Environment Systems" vol. 5 nr 3.

Itten, J. 1961. *Kunst der Farbe*. Ravensburg. Swedish transl. Stockholm 1971.

Haeberlein, F. 1939. *Grundzüge einer Nachantiken Farbenikonographie*. In "Römisches Jahrbuch für Kunstgeschichte" Bd. III.

Johanson, T. 1937. *Färg*. (Colour). Stockholm.

Kandinsky, W. 1912. *Über das Geistige in der Kunst*. München.

174

Katz, D. 1911. *Die Erscheinungsweisen der Farben.* Leipzig.
— 1930. *Der Aufbau der Farbwelt.* In "Zeitschrift für Psychologie", Erg.Bd. 7. Leipzig.
Keck, S. 1969. *Mechanical Alteration of the Paint Film.* In "Studies in Conservation", Feb.
Klein, R. 1961. *POMPONIUS GAURICUS on Perspective.* In "Art Bulletin" XLIII.
— 1970. *La forme et l'intelligible.* Paris.
Klein, R.-Zerner, H. 1966. Ed. *Italian Art 1500—1600.* In "Sources and Documents". New Jersey.
Klibansky, R.—Panofsky, E.—Saxl, F. 1964. *Saturn and Melancholy.* London.
Krantz, W. 1912. *Die älteste Farbenlehre der Griechen.* In "Hermes" XLVII.
Kristeller, P. O. 1961—65. *Renaissance Thought.* 2 vols. New York.
Kucharski, P. 1954. *Sur la théorie des couleurs et des saveurs dans le 'de sensu' Aristotélicien.* In "Revue des études grecques. LXVII.
Kurz, O. 1962. *Varnishes, tinted varnishes and patina.* In "Burl.Mag." CIV.
— 1963. *Time the Painter.* In "Burl.Mag." CV.
Laeuger, M. 1941. *Grundzätzliches über Kultur des Farbengefühls.* In "Kunst", Ja.
Langer, S. K. 1942. *Philosophy in a New Key.* Cambridge (Mass).
Lapicque, C. 1951. *La Couleur dans l'Espace.* In "Journal de psychologie normale et pathologique." Paris.
Laurie, P. 1911. *The Materials of the Painter's Craft.* Philadelphia.
Lee, R. W. 1940. *Ut Pictura Poësis: The Humanistic Theory of Painting.* In "Art Bulletin" XXII.
Leijonhielm, C. 1967. *Colours, Forms and Art.* (Diss.) In "Acta Universitatis Stockholmiensis. Stockholm Studies in Educational Psychology," nr 14.
Lejeune, A. 1948. *EUCLIDE et PTOLÉMÉE.* In "Recueil de travaux d'histoire et de philologie", ser. 3, fasc. 31. Louvain.
Lepik-Kopaczynska,, W. 1958. *Colores floridi et austeri.* In "Jahrbuch des Deutschen Archaeologischen Instituts" nr 73.
— 1962. *Apelles, der beruehmteste Maler der Antike.* Berlin.
Levi, L. 1954. *L'ARCIMBOLDI musicista.* In B. Geiger, *I dipinti ghirribizzosi di G. Arcimboldi.* Firenze.
Lewis, C. (1946) 1950. *An Analysis of Knowledge and Valuation.* La Salle (Ill.).
Lindberg, D. C. 1976. *Theories of Vision from al-Kindi to Kepler.* Chicago-London.
Litt, T. 1963. *Les corps célestes dans l'univers de Saint THOMAS D'AQUIN.* Louvain-Paris.
Mahon, D. 1947. *Studies in Seicento Art and Theory.* London.
— 1962. *Miscellanea for the cleaning controversy.* In "Burl.Mag." CIV.
Mâle, É. 1932. *L'art religieux après le Concile de Trente.* Paris.
Mazzeo, J. A. 1955. *Light Metaphysics.* In "Traditio" XIV.
Meiss, M. 1945. *Light as Form and Symbol in some Fifteenth-Century Paintings.* In "Art Bulletin" XXVII.
Munro, T. 1956. *Suggestion and Symbolism in the Arts.* In "J.A.A." XV, 2.
— 1970. *Form and Style in the Arts. An Introduction to Aesthetic Morphology.* Cleveland-London.
National Gallery (London). 1947. *An Exhibition of Cleaned Pictures.* Catalogue.
Nowotny, K. A. 1969. *Beiträge zur Geschichte des Weltbildes. Farben und Weltrichtungen.* In "Wiener Beiträge zur Kulturgeschichte und Linguistik. Ver-

öffentlichungen des Instituts für Völkerkunde der Universität Wien." Bd. XVII. Horn-Wien.

Osborne, H. 1970. *Aesthetics and Art Theory*. New York.

Ost, H. 1975. *LEONAORDO-Studien*. Berlin-New York.

Ostwald, W. 1919. *Die Farbschule*. Leipzig.

Panofsky, E. (1924) 1968. *Idea*. (Leipzig) New York.

— 1955. *Meaning in the Visual Arts*. New York.

— 1956. [*G.*] *GALILEO as a Critic of the Arts* (1954). "ISIS" vol. 47.

— 1970. *Renaissance and Renascenses in Western Art*. Uppsala.

Panofsky, E.—Saxl. F. 1923. *DÜRER'S Melancholia I*. In "Studien der Bibliothek Warburg", 2. Berlin.

Patillo, N. A. J:r. 1954. *BOTTICELLI as a Colorist*. In "Art Bulletin" XXXVI.

Pawlik, J. (1969) 1971. *Theorie der Farbe*. Köln.

Pedretti, C. 1964. See *LEONARDO*.

Plesters, J. 1962. *Dark Varnishes—Some Further Comments*. In "Burl.Mag." CIV.

Pochat, G. 1973. *Figur und Landschaft*. Berlin-New York.

— 1977. *Symbolbegreppet i konstvetenskapen*. (The Concept of Symbol in the Studies of Art). "Kgl. Vitterhets- historie och antikvitetsakademiens handlingar" nr 30. Stockholm.

Pollitt, J. J. 1965. *The Art of Greece 1400—31 B.C.* In "Sources and Documents". New Jersey.

Pope, A. 1949. *The Language of Drawing and Painting*. Cambridge (Mass.).

Portal, F. 1837. *Des couleurs symboliques dans l'antiquité, le Moyen-Age et les temps modernes*. Paris. Engl. tr. E. Rich, London 1851.

Posner, K. W. G. 1974. *LEONARDO and Central Italian Art 1515—1550*. New York.

von Prantl, K. 1849. *ARISTOTELES über die Farben*. München.

Previtali, G. 1964. *La Fortuna dei Primitivi*. Torino.

Rattleff, A. 1958. *Form, farve og emotioner*. (Shape, Colour and Emotions). Copenhagen.

Rawlins, F. I. G. 1938. *Optical Properties of some Common Varnishes*. In "Technical Studies", Ja.

Richter, J. P. (1883) 1970. Ed. *The Literary Works of LEONARDO DA VINCI*. 2 vols. Oxford.

Richter, M. 1940. *Grundriss der Farbenlehre der Gegenwart*. Dresden.

Richter, L. 1961. *Zur Wissenschaftslehre von der Musik bei PLATON und ARISTOTELES*. In "Deutsche Akademie der Wissenschaft zu Berlin. Schriften der Sektion für Altertumswissenschaft" nr 23. Berlin.

Roos, H. 1965. *THOMAS AQUINAS*. Copenhagen.

Rose, H. J. 1959. *Religion in Greece and Rome*. New York.

Ross, W. D. 1975. *The Development of ARISTOTLE'S Thought*. In "Articles on Aristotle", ed. J. Barnes, M. Shofield & R. Sorabji. London.

Rouchette, J. 1959. *La Renaissance que nous a léguée VASARI*. Paris.

Ruhemann, H. 1961. *LEONARDO'S use of sfumato*. In "The British Journal of Aeshtetics" I.

— 1968. *The Cleaning of Paintings*. London-New York.

Runge, Ph. O. (1810) 1969. *Die Farbenkugel und andere Schriften zur Farbenlehre*. Ed. J. Hebing. Stuttgart.

Rzepínska, M. 1962. *Light and shadow in the late writings of LEONARDO DA VINCI*. In "Raccolta Vinciana" XIX.

— 1970. *Historia koloru w dziejach malarstwa europejskiego*. Kraków.

Salza, Abd el-Kader. 1901. *Imprese e divise d'amore ed d'arme nell'"Orlando Furioso"*, *con notizie di alcune trattati del'500 sui colori*. In "Giornale storico della letteratura italiana", XXXVIII, nr 2.

Sandström, S. 1963. *Levels of unreality*. "Figura" N.S. nr 4. Uppsala.

— 1964. *PIETRO ARETINO som konstkritiker. En studie i värderingsmotiv*. (P.A. as a critic of art. A study in criteria of evaluation). In "Vetenskaps-Societetens i Lund årsbok". Lund.

— 1968. (Ed.). *Konstkritik* (Art criticism). 2 vols. Stockholm.

Sanpaolesi, P. 1934. *L'uso delle vernice nella practica pittorica*. In "Rivista d'Arte", Jan.

von Schlosser, J. 1924. *Die Kunstlitteratur*. Wien.

Schmid, H. R. 1975. *Lux incorporata*. Hildesheim-New York.

Schöne, W. 1954. *Über das Licht in der Malerei*. Berlin.

Seeck, G. A. 1964. *Über die Elemente in der Kosmologie ARISTOTELES*. München.

Shearman, J. 1962. *LEONARDO'S Colour and Chiaroscuro*. In "Zeitschrift für Kunstgeschichte", Bd. 25, H. 1.

— 1963. *Maniera as an Aesthetic Ideal*. In "20th Int.Congr." II. Princeton.

— 1965 *ANDREA DEL SARTO*. 2 vols. Oxford.

— 1967. *Mannerism*. London-Wisbech.

Siebenhüner, H. 1935. *Über den Kolorismus der Frührenaissance...* (Diss.) Leipzig-Schramberg.

Sjöström, I. 1978. *Quadratura. Studies in Italian Ceiling Painting*. In "Acta Universitatis Stockholmiensis. Stockholm Studies in the History of Art" nr 30. Stockholm.

Smyth, C. H. 1963. *Mannerism and Maniera*. In "20th Int.Congr." II. Princeton.

Stechow, W. 1966. Ed. *Renaissance 1400—1600*. In "Sources and Documents." New Jersey.

Stites, R. S. *et al.* 1970. *The Sublimations of LEONARDO DA VINCI, with a Translation of the Codex Trivulzianus*. Washington.

Stokes, A. 1944. *Art and Science. A Study of ALBERTI, PIERO DELLA FRANCESCA and GIORGIONE*. London.

Stolnitz, J. 1960. *Aesthetics and Philosophy of Art Criticism*. Cambridge (Mass.).

Strauss, E. 1972. *Koloritgeschichtliche Untersuchungen zur Malerei seit Giotto*. München-Berlin.

Svoboda, K. 1933. *L'Ésthétique de SAINT-AUGUSTIN et ses sources*. Brno.

Sällström, P. 1976. Ed. *Rapport från en tvärvetenskaplig kurs i ljus- och färglära*. (Report from a course in light and colour). Fysiska institutionen vid Stockholms universitet. Stockholm.

Sörbom, G. 1966. *Mimesis and Art. Studies in the origin and early development of an aesthetic vocabulary*. Diss. Uppsala.

Taylor, A. E. 1944. *ARISTOTLE*. Edinburgh. Swedish transl. Uddevalla 1971.

Tilghman, B. R. 1970. *The Expression of Emotion in the Visual Arts; a Philosophical Inquiry*. Haag.

Tolnay, C. H. 1964. *The Art and Thought of MICHELANGELO*. New York.

Ushenko, A. P. 1953. *Dynamics of Art*. Bloomington (Ind.).

Venturi, L. 1925. *La critica d'arte alla fine del Trecento; FILIPPO VILLANI e CENNINO CENNINI*. In "l'Arte" XXVIII.

— 1933 (a). *Sul 'colore' nella storia della critica*. In "l'Arte", May.

— 1933 (b). *Ancora del colore e della sua storia*. In "l'Arte", Nov.

— (1936) 1964. *History of Art Criticism*. New York.

Wachtmeister, C. 1976. *Om signalflaggans färger och flaggsignalens toner*. (On

the colour of signal flags and the tones of flag signals). In ed. Sällström 1976.

Waetzoldt, 1916. *Die Probleme der Farbenbescheibung*. In "Zeitschrift für Aesthetik und allgem. Kunstwissenschaft".

Walker, D. P. 1958. *Spiritual and Demonic Magic from FICINO to CAMPA-NELLA*. Studies of the Warburg Institute, vol. 22. London.

— 1976. *La tradition mathématico-musicale du Platonisme et les debuts de la science moderne*. In "Platon et Aristote à la Renaissance." Paris.

Warry, J. G. 1962. *Greek Aesthetic Theory*. London.

"Weaver Report." 1947. *Report of a Committee of Confidential Inquiry into the Cleaning and Care of Pictures in the National Gallery*. London.

Weil, E. 1975. *The Place of Logic in Aristotle's Thought*. In "Articles on Aristotle" I, ed. J. Barnes, M. Schofield & R. Sorabji. London.

Wellek, A. 1931. *Renaissance- und Barock-Synästhesie*. In "Deutsche Vierteljahrsschrift für Literaturwissenschaft und Geistesgeschichte," IX. Halle (Saale).

— 1935. *Farbenharmonie und Farbenklavier*. In "Archiv für die Gesamte Psychologie", Bd. 94. Leipzig.

White, J. (1957) 1967. *The Birth and Rebirth of Pictoral Space*. London.

Wittkower, R. W. 1949. *Architectural Principles in the Age of Humanism*. London.

Wittkower, R. W. & M. 1963. *Born under Saturn*. London.

Yates, F. A. 1964. *GIORDANO BRUNO and the Hermetic Tradition*. London.

Zubov, V. P. 1968. *LEONARDO DA VINCI*. (Moscow-Leningrad 1962). Cambridge (Mass.).

Zupnic, I. L. 1976. *Imitation or Essence: The Dilemma of Renaissance Art*. In "Platon et Aristote à la Renaissance." Paris.